Watercolour Landscapes

TIPS & TECHNIQUES

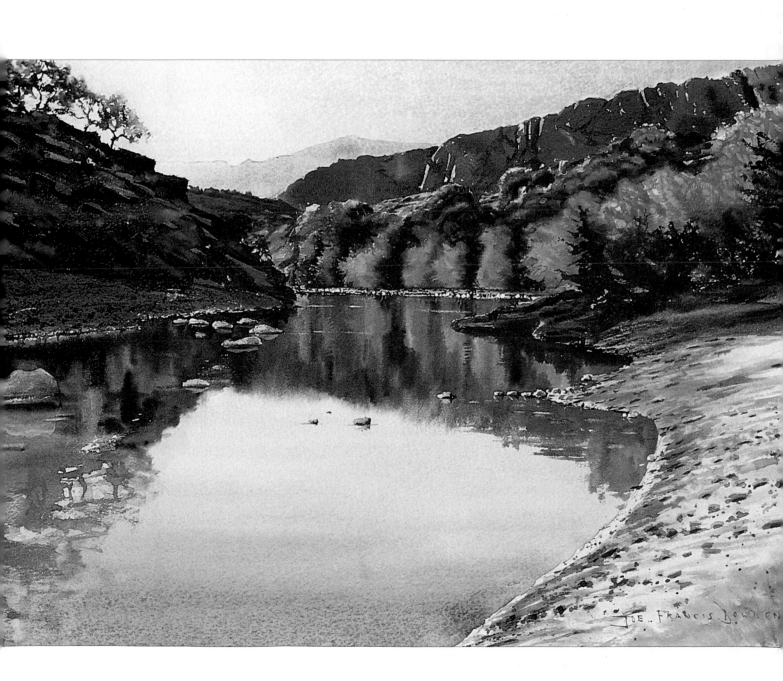

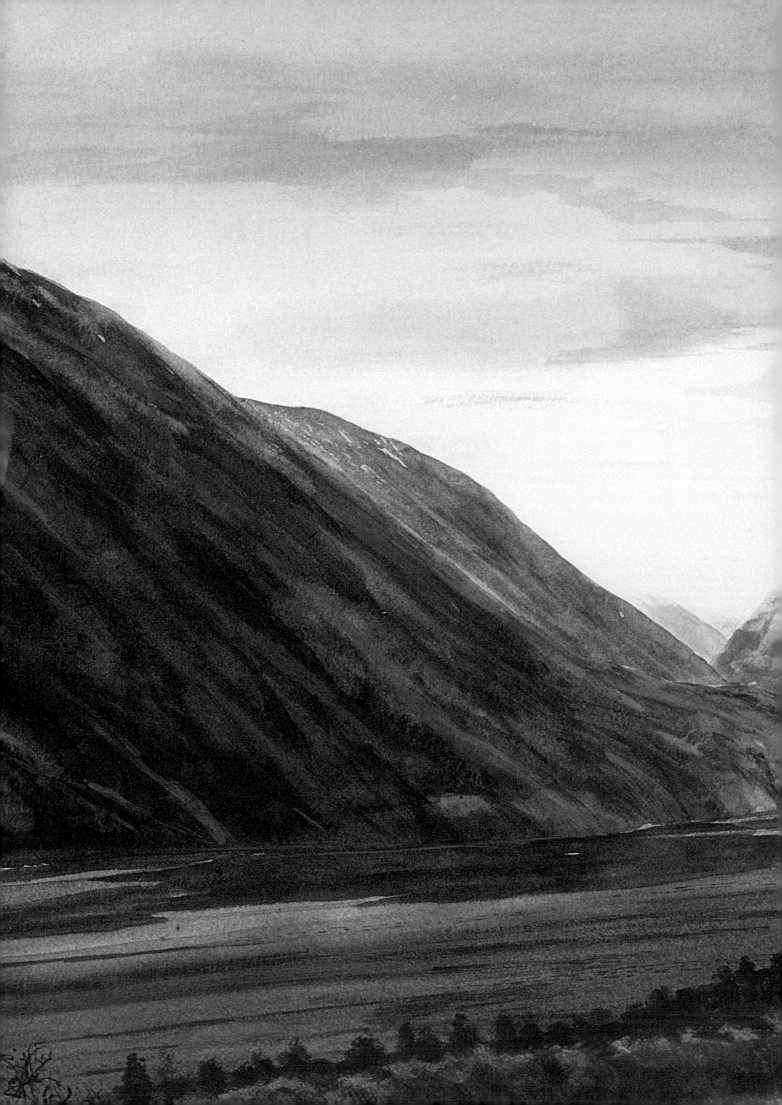

Watercolour Landscapes

TIPS & TECHNIQUES

Richard Bolton, Joe Francis Dowden, Geoff Kersey & Janet Whittle

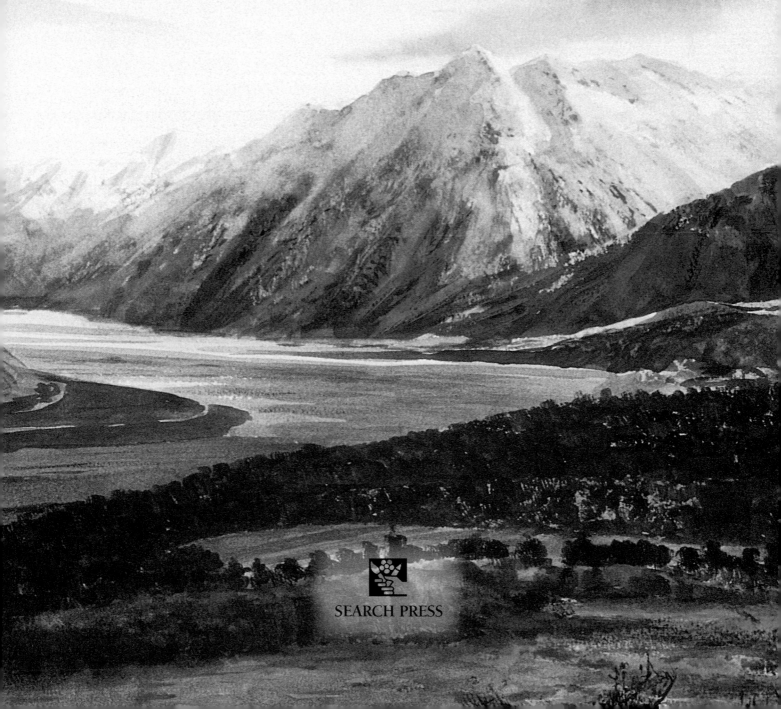

SEARCH PRESS

First published in Great Britain 2009

Search Press Limited
Wellwood, North Farm Road,
Tunbridge Wells, Kent TN2 3DR

Based on the following books published by Search Press:

Painting Landscapes & Nature by Richard Bolton, 2002
Painting Skies by Geoff Kersey, 2006
Painting Water by Joe Francis Dowden, 2003
Painting Flowers & Plants by Janet Whittle, 2003

ISBN: 978-1-84448-431-7

The Publishers and author can accept no responsibility for any
consequences arising from the information, advice or instructions
given in this publication.

Readers are permitted to reproduce any of the paintings in this
book for their personal use, or for the purposes of selling for
charity, free of charge and without the prior permission of the
Publishers. Any use of the paintings for commercial purposes is not
permitted without the prior permission of the Publishers.

Suppliers
If you have difficulty in obtaining any of the materials and
equipment mentioned in this book, please visit the Search Press
website for details of suppliers: www.searchpress.com

Publishers' note

All the step-by-step photographs in this book feature the
authors, Richard Bolton, Joe Francis Dowden,
Geoff Kersey and Janet Whittle demonstrating how to paint
in watercolour. No models have been used.

There are references to sable and other animal hair
brushes in this book. It is the publishers' custom to
recommend synthetic materials as substitutes for animal
products wherever possible. There is now a large range of
brushes available made from artificial fibres, and they are
satisfactory substitutes for those made from natural fibres.

Printed in Malaysia

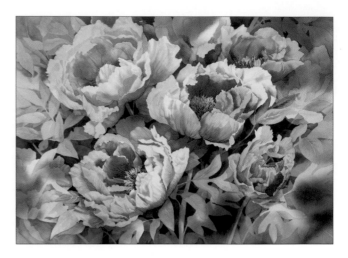

Page 1
Mountain Lake
by Joe Francis Dowden

*This ribbon of tranquil water appears mirror smooth, but the
presence of a myriad of tiny ripples is revealed by the slightly
blurred reflections. The water was painted wet in wet, running
many colours together. A little gum arabic was used to stop the
colours spreading out of control.*

Pages 2/3
Arthur's Pass
by Richard Bolton

*Snow is thawing on the hillsides of this mountain pass in
New Zealand. The cool, clear sky reflects on the mountains and
contrasts with the darker shades of the foreground. The sense
of distance is all-important in a view like this, and you can see
that the snow-clad mountains are more strongly defined as they
get closer to us. The same applies on the left, where the colours
are stronger on the hillside close to us, while the slope behind
has a blue, milky quality. Adding a little Chinese white to the
background colours is a good way of achieving this effect.*

Above
Peony Duchess of Marlborough

by Janet Whittle
*This complex flower grows in a friend's garden, and I saw it in full
bloom when conditions were absolutely perfect, just after the rain
with the sun shining.*

Opposite
Burnham Overy Staithe
by Geoff Kersey

*In this evening scene on the Norfolk coast, I have tried to capture
the intensity of the light, using the contrasts created by almost
clean white paper for the middle ground, surrounded by some
quite heavy darks. I painted the sky with just three washes -
quinacridone gold, burnt sienna and cerulean blue.*

Contents

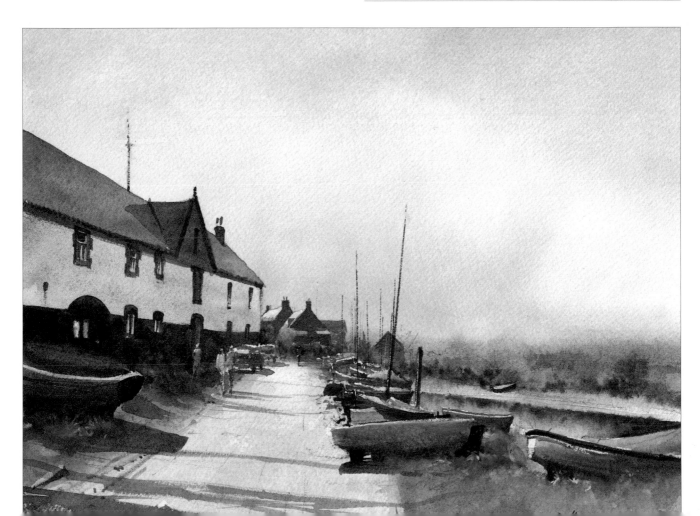

Painting Landscapes
& Nature

RICHARD BOLTON

Learn how to create beautiful watercolour landscapes, from composition and perspective, through to painting buildings, trees and foliage, skies, water and more. Five step-by-step projects show you how.

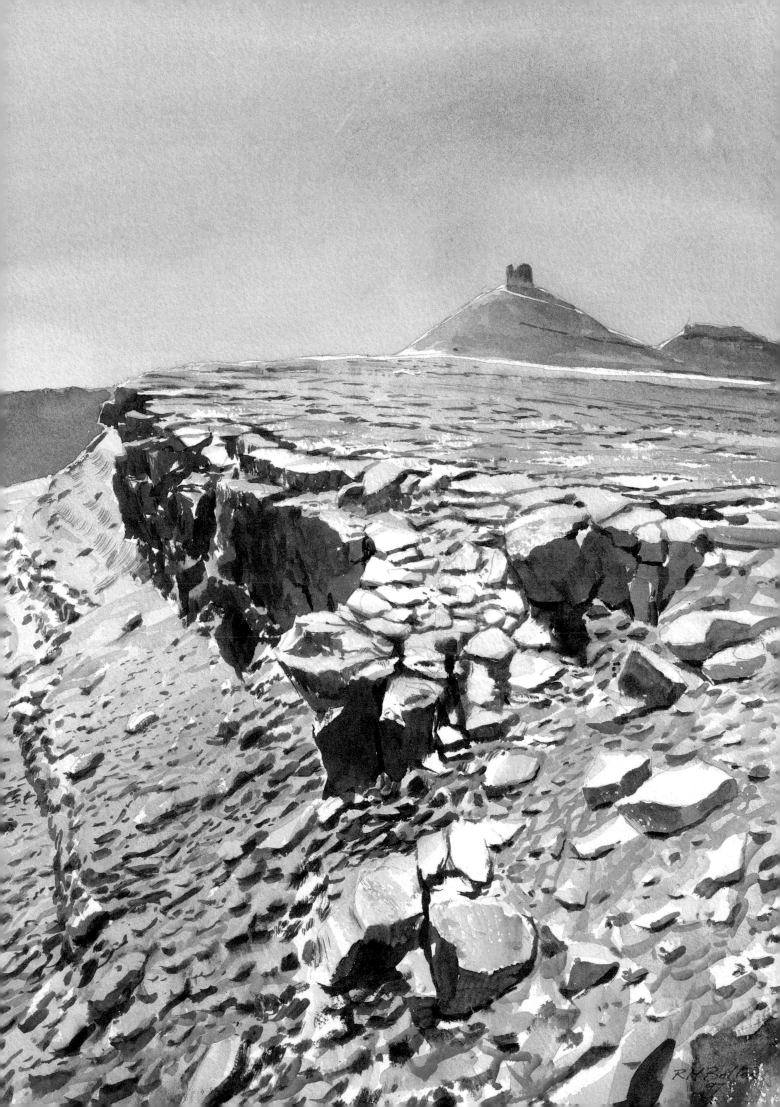

Introduction

For many painters the first introduction to watercolour comes as a gift, in the form of a compact tin containing a few tubes or pans of paint and a brush. It looks modest, but this basic kit is all that is needed to paint a masterpiece. Every master of the art has worked with a similar set. All the potential is there in the tin, so it is not surprising that for generations, watercolour has been such a popular pastime, and for many, a passion.

Watercolour is often referred to as the English art. In the nineteenth century, watercolour painting became one of those accomplishments, along with playing the piano, that every upright Victorian should learn. Queen Victoria was a good watercolour artist, and in an era before photography, servicemen in the navy were encouraged to paint, since it was a useful skill for keeping a record of coastlines and defences.

This enthusiasm took watercolour to new heights, and the achievements of some painters are truly breathtaking. Early masters of the art had to wrestle with less than perfect paper, and had to be inventive with their colour range, grinding down minerals in search of new colours. We are more fortunate: the range of colours and equipment available today gives us infinite choice.

This book concentrates on the painting of landscapes and nature, probably the most popular area of watercolour. It embraces landscapes from different parts of the world, as I take my paints with me on my travels. This is one of the great assets of watercolour: the painting equipment required to take on a journey is so small and compact that it can easily be included in one's luggage. Visiting distant lands and seeing its natural wonders first-hand is a life-enhancing experience, and to be able to transfer this experience to a painting makes it more enjoyable. I hope you find these pages an encouragement and assistance as you go on your own journey into watercolour painting.

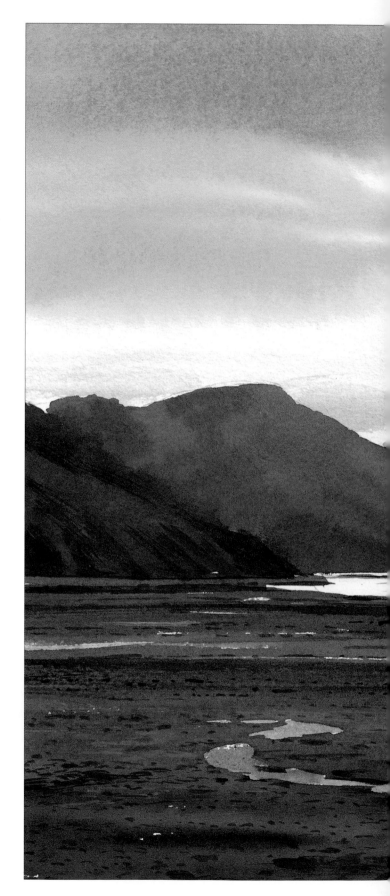

Glacial River Bed, Tibet
34 x 24cm (13½ x 9½in)
Water reflects sunlight in this scene, simply achieved by painting out in masking
fluid before applying paint. This keeps the white areas crisp and sharp-edged.

Materials

PAINTS

Watercolour paints come in tubes or pans and there is a wide choice of brands and colours to choose from. Tubes are the most accessible, as the paint is already wet, so little time is spent on loading the brush. Pans are moist and are also easy to charge a brush with. They are not to be confused with the old cakes of watercolour which required scrubbing to get any strength of colour. My paint tin is full of pans, which I refill from tubes. This method gives me the practicality of the paint set, and I can refill the pans from tubes of different brands, giving me a lot of room for experimentation. The central aisle of my paint tin is really meant to hold brushes, but I use it to contain more pans.

I only squeeze a little paint into the pans as I need it, as this way the colours stay clean, which can be a problem with full pans of paint.

Paints are often produced in two ranges, students' and artists' quality. The main difference is in the amount of pigment to vehicle, artists' quality being the strongest. The artists' range of colours is also greater. The other difference is that expensive pigments are often substituted by similar but cheaper alternatives. In this case, the tube will be marked 'Alizarin Crimson (hue)' or 'Cobalt Blue (hue)'.

Paints also have a light fastness register, which is noted on the tubes, since some colours are more fugitive than others and will fade faster. It is wise to keep all watercolours away from the sun as much as possible, and never hang a painting where it will catch direct sunlight.

My colours are loosely organised into groups, with the blues in one area and yellows in another. One pan is reserved for the opaque colours Naples yellow and Chinese white.

TIP

It can be difficult to twist the top off a tube of paint if it has become gummed up with dry paint. A pair of pliers close to hand can be very helpful.

My paint tin, filled with pans, with extra tubes of paint used to refill the pans as required.

BRUSHES

There is a bewildering variety to choose from. Traditionally the Kolinsky sable was considered the finest of watercolour brushes and it still is, but the price is a serious consideration. A good compromise is a mix of sable and synthetic, though I find many of the synthetic brushes are now also very good. Their prices vary greatly, and it would be wise to go for the best in this group.

Chinese brushes are also worth considering. They look completely different to the typical western brush with its metal ferrule. They are usually a straight tube, often a length of bamboo with the hairs protruding from the end. I have had a lot of success with these brushes, but choosing the right one is quite difficult, as many different hairs are used.

Large brushes

These are needed for washes and for covering large areas such as the sky. I use a 2.5cm (1in) flat ox-hair brush and a size 14 synthetic and sable round, and I also have a large, round Chinese-style brush that can hold a lot of paint. A large round still comes to a fine point, so can be very versatile.

Middle-sized brushes

Sizes 6 to 12 provide mid-range brushes, which are good all-round brushes used for the main bulk of the painting. I use two, one for painting and the other for softening edges.

Small brushes

A size 2 or 3 should be used for very fine work such as pebbles on a beach or grass. The long-haired rigger is used for long strokes. This brush got its name because it was used by marine artists to paint in the fine lines of rigging on a sailing vessel. The rigger is useful in landscape painting for grass, twigs and many other applications where very fine lines are needed.

Tip

Larger brushes tend to be more useful than small ones, as a large round brush in good condition will still come to a fine point. Smaller brushes are often selected because of their price.

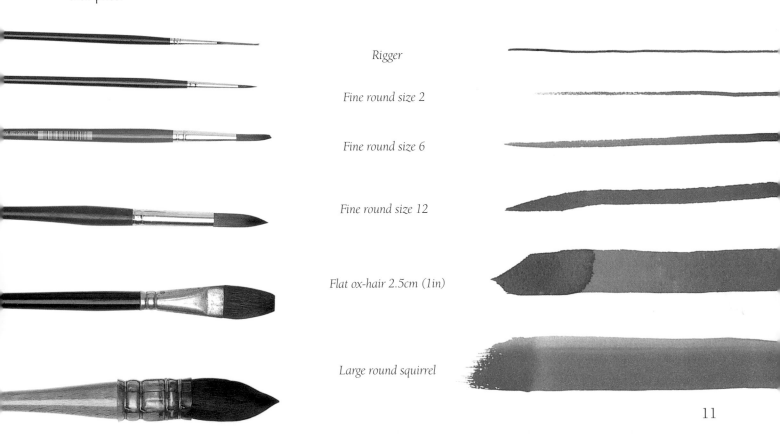

Rigger

Fine round size 2

Fine round size 6

Fine round size 12

Flat ox-hair 2.5cm (1in)

Large round squirrel

11

PAPER

Watercolour paper is produced from cellulose cotton or rag. Most papers we use are made from wood pulp and will brown with age, but watercolour paper will stay white indefinitely. Watercolour paper also has to be very strong to cope with the stretching process and the rough treatment it can get through some of the techniques involved in painting.

The choice of paper will greatly affect the outcome of your painting, so it is important to find a surface that suits you. Papers vary in surface texture and sizing (absorbency), and it is surprising the difference this can make. If you can obtain manufacturer's samples, this will be a great help, as you can look at them and experiment with brushstrokes, to get some idea of the character.

Paper falls into three main groups: Hot Pressed, Not and Rough. The most popular is Not, which has a lightly textured surface like cartridge paper, and can be used for all watercolour techniques. Rough, as the name suggests, has a heavily textured surface which will be extremely effective in any dragging techniques where a speckle of paint is required on the paper. Hot Pressed is smooth, so effects where paper texture is required will not work, but it has many other possibilities and is good for fine detail.

Paper comes in different thicknesses and is measured in grams per square metre (gsm). My favourite surface is a fairly thin paper, 190gsm Saunders Not, though I use other papers too. Many artists prefer to work on a thicker paper: 300gsm, which has the advantage that you do not need to stretch it (see page 22). This has to be balanced against the extra cost. I prefer to work on the drum-tight, flat surface of stretched paper. Once you find a paper that you like, try to stick with it, as this way you will learn exactly what it is capable of and get the best use out of it.

TIP

Learning to paint with watercolours can waste paper, so turn it over and use both sides.

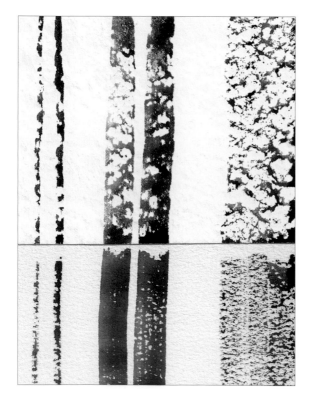

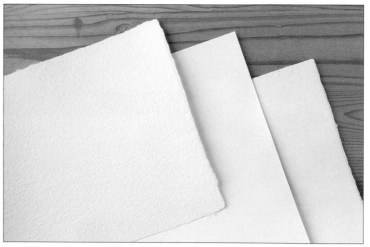

Rough, Not and Hot Pressed paper. Shown on the left are the effects produced by different brushstrokes on the three types of paper. Note the useful speckled effect created by a water-starved brush dragged across the Rough paper (top), and the more subtle speckle on Not paper (in the middle). The same brushstrokes come out as solid colour when used on smooth Hot Pressed paper (bottom).

OTHER EQUIPMENT

Painting board
These can be made from block board, plywood or MDF. If you are going to stretch your paper, make sure you have a least two boards so that you always have a stretched surface to work on. **Gummed tape** is used for attaching wet paper to the board for stretching.

Ruler
Use an **eraser** alongside a ruler if you want to rub out a straight line. A ruler can also be used with a brush for painting straight lines, but be careful to avoid paint seeping under the ruler and spoiling the work.

Hairdryer
This is used to speed up the drying process.

Palette
For mixing colours.

Masking fluid
Masking fluid is supplied in art shops as a liquid, clear or tinted. The tinted is best as it can be difficult to see where the clear fluid has been painted. It can be painted on to the paper to mask it from paint, and when the painting has dried, it can be rubbed away with an eraser or a finger, leaving behind white paper (see page 27).

Ox gall liquid
This is a wetting agent and makes the paper more receptive to watercolour. It can also be used as a dispersant, to create unusual effects (see page 27).

Pencil
Most paintings begin with some preliminary sketching. Use a soft pencil to avoid damaging the paper.

Eraser
To remove unwanted pencil lines, or to rub out painted areas in order to create highlights (see page 26).

Craft knife, penknife or razor blade
For scratching out (see page 26), or cutting out lines in a painting (see page 27). The flat edge of a razor blade can also be dragged across very dry paper to produce speckled highlights.

Sponge
For lifting off large areas of paint. A sponge can be used to create effects by dabbing (see page 27). Natural sponges are best but it is worth experimenting with small synthetic ones. A **sponge brush** can also be used.

Pliers
For twisting the tops off tubes of paint when they have become dried on.

Water container
Choose one with a large, flat base so that it can not be knocked over too easily. Mine is collapsible and was bought in China.

Paper towel or tissue
For removing excess paint, dabbing to produce highlights (see page 27) and for general cleaning up.

Candle wax
Used as a resist to create textural highlights (see page 26).

Salt
Sprinkle salt on wet paint, and as it dissolves it creates interesting patterns and textures (see page 27).

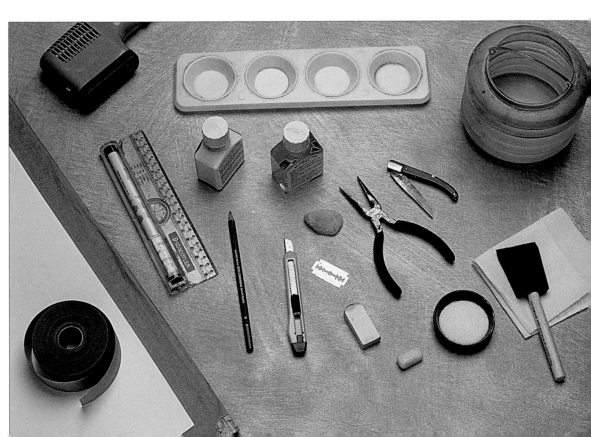

Painting outdoors

One of the benefits of watercolour painting is the minimal equipment needed to complete a painting. If you are out walking whilst on holiday or travelling, it is quite easy to take your painting equipment with you. Most paint tins are quite compact and will fit into a pocket or bag, but if you really want to travel light, there are small sets available that fold out to give you a palette and water container.

Paper can be bought in blocks, rather like a sketchbook, except that the pages are stuck down along all four edges. This will save you the job of stretching the paper and you will be able to leave your painting board at home. Really heavy papers do not need stretching, so this is another option.

Brushes need to be looked after to maintain their points, and are best carried around in a folder or plastic tube. Most painters make their own folders, either from cloth or bamboo matting. The latter is particularly good because it can be rolled up and yet gives good protection as well as allowing air to circulate.

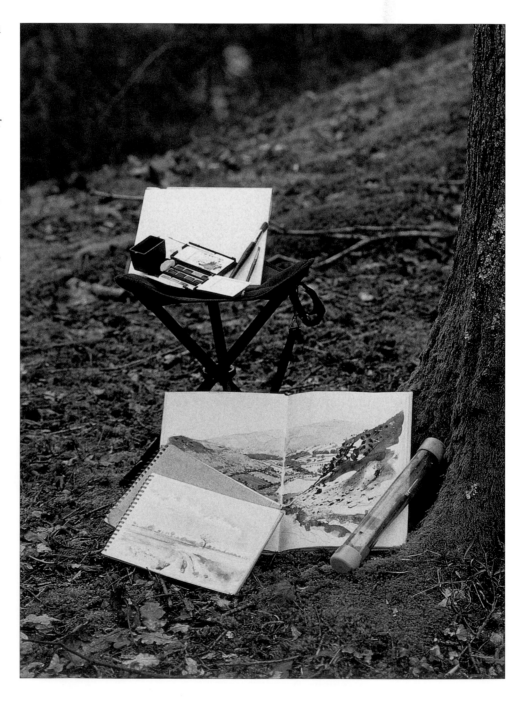

A lightweight three-legged stool; small paint tin with fold-out palette and water container; brushes, some in a protective tube; and sketchbooks.

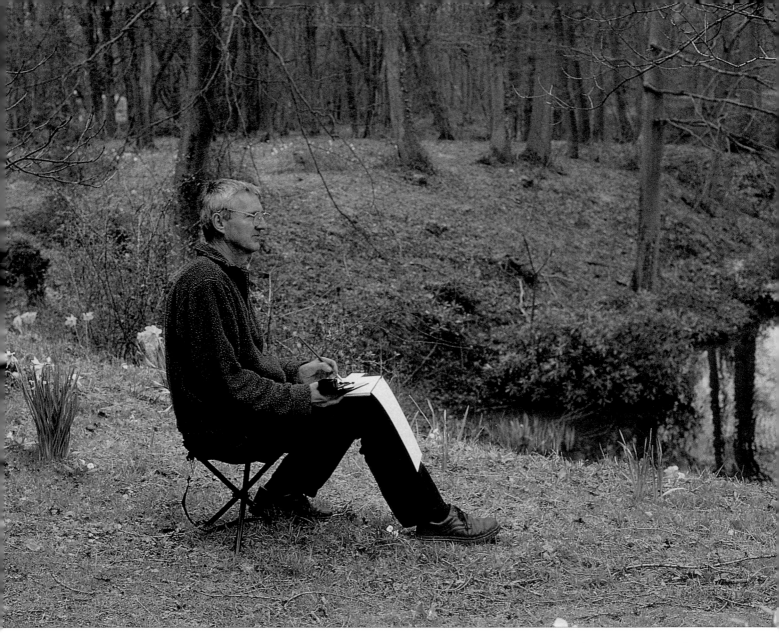

The artist at work outdoors

If you prefer to work at an easel, there is plenty of choice, from traditional wooden ones to modern camera tripod types. I prefer to sit and work with my painting on my lap. For this I carry a lightweight three-legged folding stool that I can sling over my shoulder when I am out walking. Painting equipment can fit into a small shoulder bag, and if you are using a compact set, you can even carry it in a waist bag.

Try to make yourself comfortable for painting, and if possible get out of the sun or wind. Weather conditions can be a big problem: on a warm, sunny day you might find that your paints dry too quickly, and in really hot conditions, you can find the paints drying in the palette before reaching the paper. In cool conditions on the other hand, you can wait ages for a wash to dry. Sunlight on paper can be quite dazzling, so angle yourself to avoid this as much as possible. Ideally you should have a couple of large umbrellas to shade your workspace, but unfortunately this luxury is too awkward for most of us to carry. Sunglasses can make painting in bright light much less stressful.

Colour

yellow ochre

raw sienna

cadmium yellow

Naples yellow

scarlet lake

alizarin crimson

Indian red

burnt sienna

burnt umber

intense blue

French ultramarine

turquoise

Prussian blue

cerulean blue

viridian

emerald green

sap green

Colours have their own characters and behave differently on the paper. Some colours are ground pigments and the fine particles can fall into the hollows of the paper, accentuating the texture of the paper. They can also be more easily removed from the paper by sponging or lifting out with a brush. These granular colours include raw sienna, burnt sienna, burnt umber, cobalt blue and ultramarine blue. Other colours are dyes and once on the paper leave a permanent stain: these colours include the Winsor range by Winsor & Newton, sap green and alizarin crimson.

This example shows how granular colours have been sponged away leaving behind sap green which is a dye and less easy to remove.

The chart on the left shows a fairly wide range of colours. As you experiment with them, you will develop preferences and end up with a handful of colours that you use a lot, and others that are introduced occasionally. I have a range of favourite colours which are always in my paint box. They are:

Raw sienna A strong, rich yellow. This can be used in all areas of painting, imparting a warm glow to skies or a richness to the landscape. It is ideal for foliage greens when mixed with ultramarine blue.

Naples yellow This is a strange colour, an opaque pale yellow. I find it useful in so many applications: it can be applied as a wash to give a warm tone to the paper, and it mixes with other colours to give a range of sensitive shades. As opaque gouache it is mixed with other watercolours for overpainting, the technique in which opaque colours are painted on top of transparent watercolours.

Scarlet lake Reds can be a bit disappointing: they look stunning when wet, but once they dry they seem to lose their magic. Scarlet lake is a good, bright red that stays bright after drying.

Alizarin crimson A strong, deep red that can give a warm blush to any mix.

Burnt sienna This is one of the colours I use the most. It is a rich orange brown and finds its way into most of my paintings. I add it to greens to give a good foliage colour, and I also use it for earth colours from soil to the bark of trees. It is particularly good for rust.

French ultramarine This is the blue I use the most. It is a granular pigment and can be lifted off the paper with a sponge or a damp brush. It

is a good mixer and is frequently combined with burnt sienna or burnt umber in landscape scenes.

Prussian blue A strong, dark, cold blue. I use this if I want a really dark colour. Combined with Indian red or burnt umber, it gives a colour approaching black. It has a high staining quality.

Cerulean blue A light blue that can be very useful in sky scenes. Mixed with other colours it can give subtle greys, well suited to my local scenery.

Viridian Mixed with burnt umber, Indian red or burnt sienna, viridian gives a useful range of foliage greens. A little goes a long way.

Emerald green Another good green for foliage, much lighter than viridian, which mixes well with other colours. I often use it with Naples yellow to give pale shades of green.

Winsor blue This is a new blue in my palette. When I was painting in Australia, I found the blues in my paint box were not blue enough for the Australian sky! This blue is strong and vibrant.

These examples show how colours interplay, and some of the possibilities as they blend with each other.

raw sienna

Prussian blue

cerulean blue

alizarin crimson

viridian

French ultramarine

burnt sienna

emerald green

scarlet lake

Winsor blue

Naples yellow

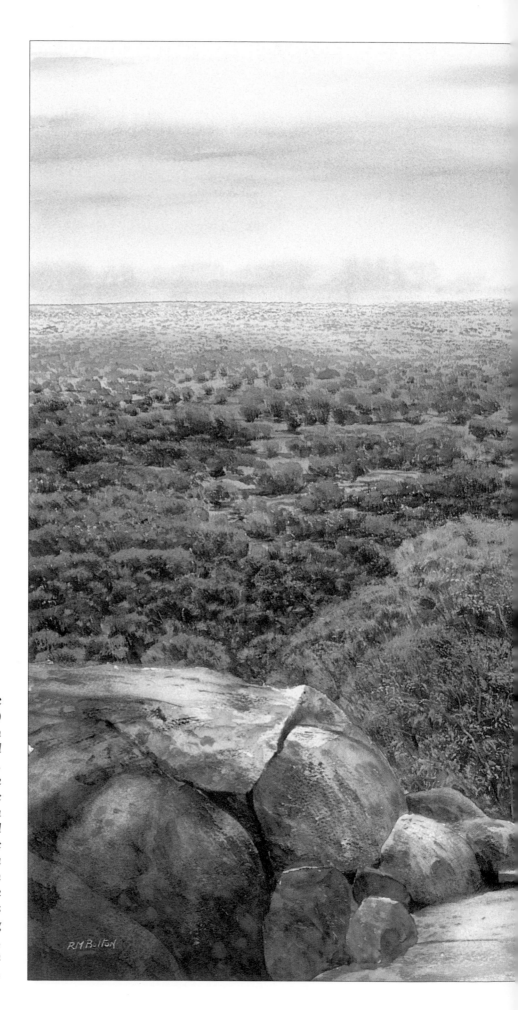

Undara Landscape

52 x 74cm (20½ x 29¼in)

The savannah grasslands in Northern Australia contrast greatly with the kind of landscape I am used to in England. The reds and yellows in this outback scene have been used strongly to capture the rugged landscape. I used raw sienna as the main yellow, as it gives a good golden colour. Other hot colours were used, such as Indian red, burnt sienna and scarlet lake. The rocky formation in the foreground required a lot of work to develop the patina of age. This was achieved by scrubbing the paint on, using the dry brush technique to give textures, and then working in the shadows with ultramarine blue and dioxazine violet.

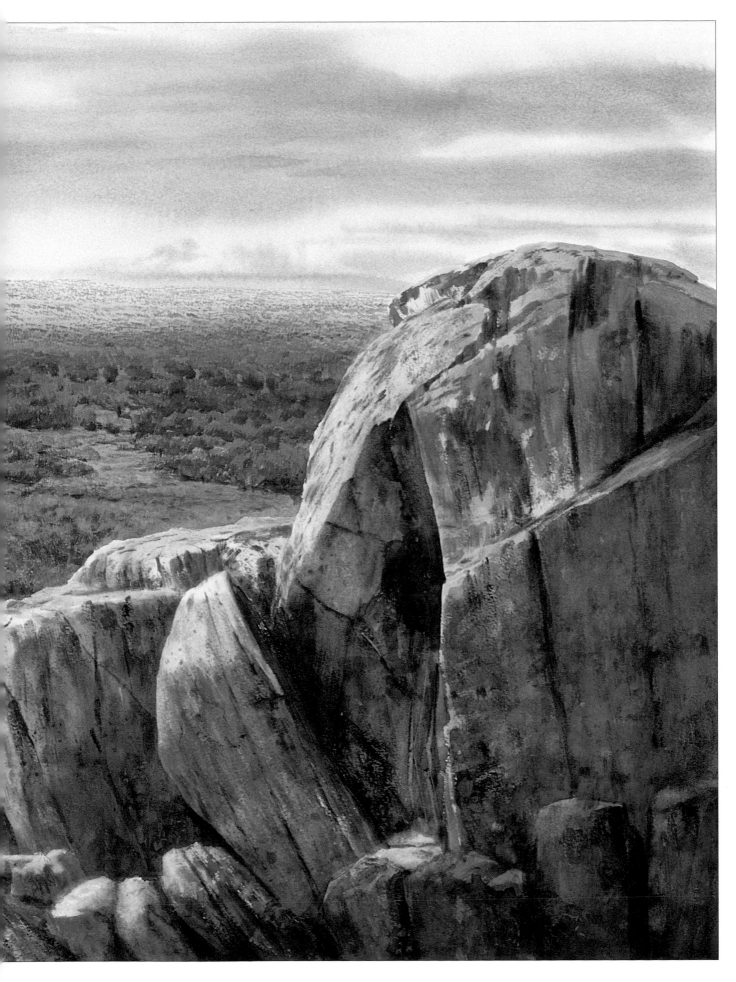

Tone

Tone is how we view a scene from light to dark. This can be confusing in a painting, because we are also working in colour. If we limit our palette to one colour, sepia, burnt umber or Payne's gray, we can work solely in tone to get a better understanding.

Before painting, look at the scene and pick out the darkest area. This is your benchmark – the darkest you can reach in your tonal range, so no other part of the painting should be painted this dark. In watercolour this is critical since, because of the transparent nature of the medium, large areas of dark colour can be difficult to handle. The lightest tone will be the white of the paper. In the scene you are painting, there may be only one or two points that reach this end of the scale – often a highlight in water or the sky itself. Masking fluid may be handy to mask these out. Between these extremes will be a range of tones to be assessed and built up in the process of painting.

This painting of the mill at St Ives has been painted in one colour, burnt sienna. Despite its limitations, it still captures the warm hues of a summer evening. The tonal range moves from the darkest area in the foreground detail to the lightest, which is the background sky and its reflection in the water. The brightness of the sky is also reflected in the windows; masking fluid was touched in here to preserve the whiteness of the paper.

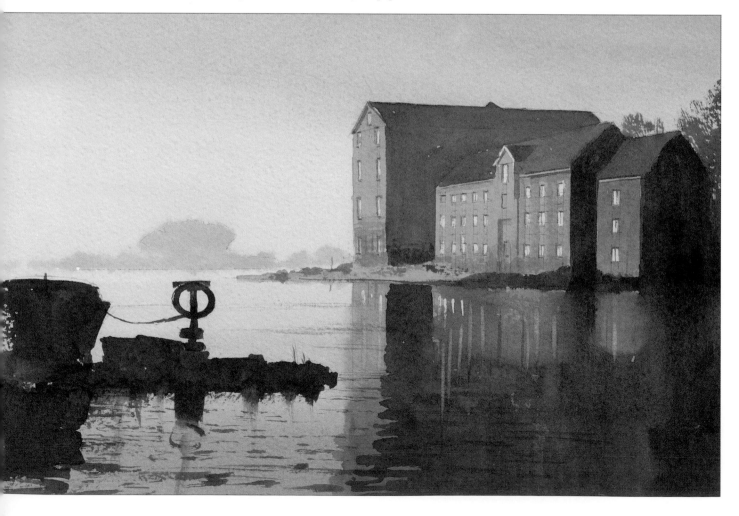

A Claude mirror is a useful device to gain understanding of tone. This is a sheet of glass blackened on one side and used as a mirror. To make one, paint a rectangle of glass with black paint and tape the edges, or use an old picture frame and put a sheet of black card behind the glass. When you look at a scene in the Claude mirror, the reflected tones will be a couple of degrees darker than in reality, and most of the colour will be removed. By exaggerating the tones in this way, the device can help you to see the possibilities of a subject. You need to paint facing your mirror, but with the scene you are painting behind you.

CONTRASTING

Contrasting is the technique of placing light shapes against dark and vice versa. I use this principle in most of my paintings to create dramatic effect. As the illustrations below show, simple views can become very picturesque when rendered in this way. The painting of the farmhouse on page 35 is also a good example: the farmhouse itself catches the light and contrasts starkly with the dark cloudy sky behind it.

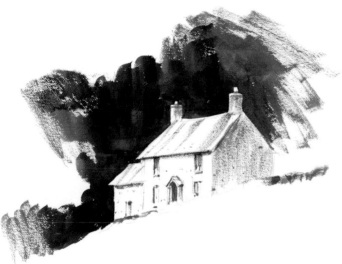

In this picture the house catches the light and creates a contrast with the darkness behind it.

Here the dark house and trees are contrasted with the much lighter background.

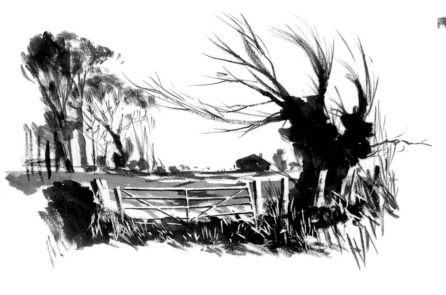

In this more complex picture, the fence and gate contrast with the darker middle ground, and the silhouetted trees with the lighter skyline.

Basic techniques

PAPER STRETCHING

Paper has to remain absolutely flat for wash techniques to work successfully, so you must avoid the puckering and shrinking that can occur when areas of the paper get wet. Heavy grades of paper such as 300gsm will remain flat when water is brushed onto it, so stretching this paper is unnecessary. Thinner papers will develop an uneven surface, making the application of an even wash impossible. To prevent this, the paper is soaked, laid on a board and taped down with gummed tape so that as it dries, it is prevented from shrinking. The end result is a sheet of paper that is as tight as a drum and perfectly flat, waiting for all those wash techniques.

The most popular way to stretch paper is to place gummed tape around the edge of the wet paper on the board. For one reason or another, this method does not always work, so here are some alternative suggestions to achieve success. I run a little wood glue around the edge of my paper before taping it down with gummed tape. Another simple method is to use a roll of cash receipt paper as tape, and stick it with ordinary PVA glue. This worked well for me in Northern Australia, where the gummed tape was ruined by the humidity. Some receipt rolls are of newspaper quality, but these are not strong enough, so go for the better quality.

1 Soak the paper in water.

2 Lay the wet paper on a board. You can then run a little wood glue around the edges of the paper as an added precaution. Wet strips of gummed tape and tape the paper to the board.

3 The paper is unable to shrink, and when it dries it will be drum-tight and perfectly flat.

WASH TECHNIQUES

Painting a large, flat area of colour is called applying a wash, and is fairly
straightforward, but becomes more complicated as you add further washes and
experiment with the possibilities that this technique opens up.

A basic wash

Start by mixing the colours in a palette. Make sure you
have mixed enough colour before you start, because it will
be difficult to mix more colour once painting has started.
The small tray with your tin of paints may not be big
enough. Prop the edge of your board up a little, and with
your largest brush, run a bead of paint along the top edge
of the paper. Re-charge the brush and run it below the first
line, so that the two lines run together. Continue down
the paper in the same way until you reach the bottom. The
last line will leave a large bead of wash at the edge of the
painting, which can be removed with the brush or with
some paper tissue applied to the edge of the paper.

Now you can see the possibilities of this technique. What if
you mix two colours on the paper, or paint one wash over
another? There is plenty of room for experimentation.

A granular wash

Granular colours such as raw sienna, burnt sienna, burnt
umber, cobalt blue and ultramarine blue tend to accentuate
the texture of the paper as the particles fall into the hollows
of the paper surface. This can create a useful effect.

A graded wash

A graded wash is applied in the same way as a basic wash,
only clear water is added, diluting the wash and creating a
blending effect from colour to clear paper.

A mixed wash

A smooth wash

However, if you prefer a smoother finish, try drying the
painting face down.

WET IN WET

Once you have experimented with wash techniques, it is only natural to wonder what will happen if a brush full of paint is placed on to the still wet wash. This can be very exciting, as the new colour spreads out across the paper, gently mixing with the first colour. The board can be tilted to encourage the introduced colour to move this way and that to create whatever effect is desired. You can, however, come across one of the big risks of the wet in wet technique. The colours do not always blend evenly as expected, but sometimes form ridges or hard edges which can ruin a painting.

The cause of hard edges is uneven drying. A completed wash should dry evenly, so it is important to keep the board level during drying. However, if further brushfuls of paint are added during the drying process, then the area that has just received the paint will be a lot wetter, and as the painting dries, there will be pools of wet against the dried wash. This is a difficult area to instruct in, as factors such as different papers can affect the outcome, so hands-on experience is best for finding solutions.

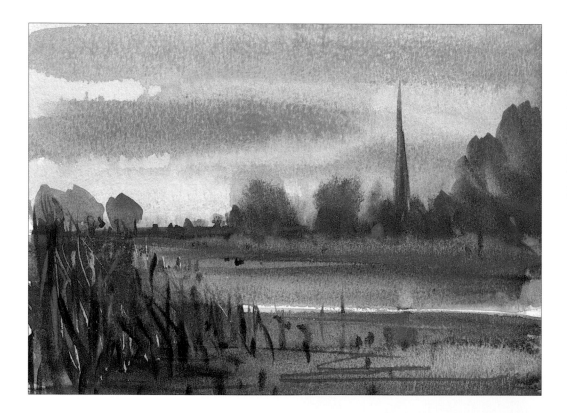

Fenland Scene
19 x 13.5cm
(7½ x 5¼in)
This painting was carried out at speed, working into a wet surface. Only the church spire and some trees to the right were added when the painting was dry.

Hard edges can form strange and beautiful patterns, but can also ruin a painting if they are unplanned.

The painting shown below of a view across fields gives a good example of working wet in wet. Most of the scene was worked by adding brushfuls of paint to a wet surface, enabling me to capture the skyscape quickly. The paper was brushed from top to bottom with a wash of raw sienna and a touch of scarlet lake. While the wash was wet, a dilute mix of cerulean blue was brushed into the sky area, with areas left out for the clouds. While the paper was still wet, I painted the clouds with a mix of ultramarine blue and alizarin crimson. The colours mixed on the paper. I left gaps where the warm colours of the initial wash of raw sienna and scarlet lake shine through as the sunlit edges of the clouds.

The wet in wet process was continued in the lower section of the painting. Another wash of raw sienna and crimson lake was added and the dark shades in the fields were introduced with a mix of alizarin crimson, Prussian blue and burnt sienna.

The main groundwork of the painting was now allowed to dry. The rest of the painting was continued as normal, brushing in detail and using dry brush techniques to create the ragged edges of foliage and to develop the texture of the fields.

A View Across Fields
27 x 21cm (10½ x 8¼in)
The wet in wet technique was used to capture the sky and the foreground of this painting. Details and texture were added later.

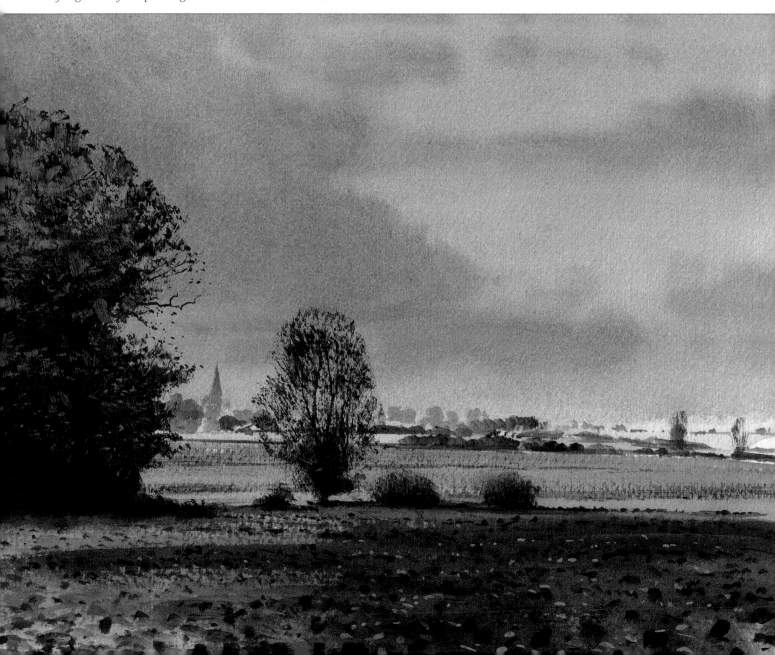

THE DRY BRUSH TECHNIQUE

For dry brush work, we remove excess paint from the brush so that there is just enough left to make a mark on the paper. The brush can then be dragged and rubbed on the paper to impart some useful textural effects. Getting the right amount of paint on the brush is tricky: too much and a heavy blob will be deposited on the paper, too little and no mark will be made. A lot of time is spent removing paint from the brush in between actively painting. To get the wetness of the brush right, dab your brush against the edge of the palette and then touch a paper tissue to the edge of the hairs near the ferrule, to take away more water without removing any paint.

The technique is useful for any area where texture is required: a brick wall, the ragged outline of trees or a ploughed field. It can be employed with a fine brush to do very detailed work, and with a large brush where the broken paint surface could give the speckle of light on an expanse of water. It works best on paper with a textured surface.

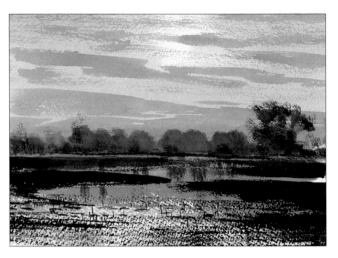

Right: heavily textured papers give a more broken quality to dry brush work. Here the brush has been dragged across the background, leaving a speckle of paint. Above right: dry brush is very effective for textured surfaces like brick and stone.

OTHER TECHNIQUES

Most effects are produced with the brush, but there are other tools and techniques that can be very helpful to convey a range of qualities.

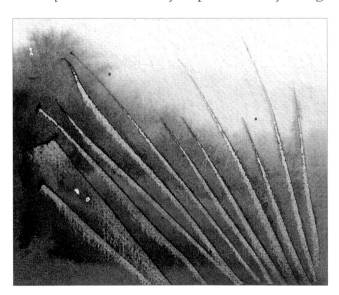

Scratching out
Paint can be scratched from the surface of a painting with a razor blade, craft knife or penknife. Wait until the paint is nearly dry – this is when it loses its shine. If scratched out too early, the marks on the paper will fill in with colour and dark lines will be produced instead of pale scratches. If the painting has dried too much, sweep a brushful of water on to the paper and it will become workable again.

Wax resist
Candle wax can be rubbed on to the paper to form a resist. It is a rather haphazard technique, but I find the speckle of highlight it gives particularly useful for capturing the rugged texture of tree bark, and the roughness of stone walls.

Rubbing out
The eraser can be used to remove some paint, to produce highlights. I find it very effective in creating soft highlights on water. If rubbed along the edge of a ruler, a straight highlight can be made. A stronger highlight will be achieved if the paper is scuffed with a razor blade first. Even fine sandpaper can be used in the same way as an eraser.

Masking fluid
The liquid is brushed on to the paper and dries to a latex resist. When you want to remove it, it can be rubbed away with a finger or an eraser. It is best to use an old brush to paint it on, as it tends to gum up brushes.

Dabbing
This is a technique for adding texture, and is particularly good for giving a soft, irregular outline to trees and foliage. After painting an area, dab it with a sponge, some screwed-up paper tissue or a piece of cloth. This technique requires some experimentation.

Spattering
The effects of spattering can be very varied, depending on how it is done. The easiest way to achieve a fine spatter of paint is to tap the brush against a finger. Another way is to charge a bristle brush with paint and to drag your thumb across the bristles. Be sure to mask the work area, as paint spots will fly in all directions.

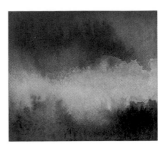

Ox gall
This can be used as a dispersant, to create unusual effects. A touch of ox gall liquid, added to a fluid area of paint, will cause the colours to move rapidly away. The results are unpredictable, but interesting.

Salt
Normal table salt can be sprinkled into a mix of wet paint. As the salt dissolves, a pattern of spidery shapes appears on the paper. Again, this is a rather unpredictable technique, but it can be very effective. Snow scenes are a popular choice of subject for this technique, but I have found it useful in all kinds of areas when I want something a little livelier than a straightforward wash for the background.

Sponging
I use the sponge mainly for lifting out large highlights and for clearing an area that has become overworked. Some painters find it particularly good for working in sky effects.

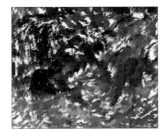

Split brush
The brush is encouraged to break up into a number of points: the trick is to find a brush that will readily do this. I find the Chinese brushes work best. To get the hairs to splay out, dab the brush into the mixing tray, then dab it up and down on the paper to create a texture of foliage, or broken cloud. Rotate the brush continually in your hand, to avoid making a repetitive pattern. Avoid having too much paint on the brush, as this will produce large blots of paint. Needless to say, this is not a job for your finest sable, and it is best to reserve a brush specially for the task.

Cutting out
Really fine, sharp lines can be cut out of the paper. This is a delicate operation but very effective. Using a sharp craft knife and a ruler, cut two lines close together, making sure you do not cut right through the paper, then peel away the sliver of paper in between. This can be used as a rescuing technique where a highlight should have been left on the paper, but has been painted over.

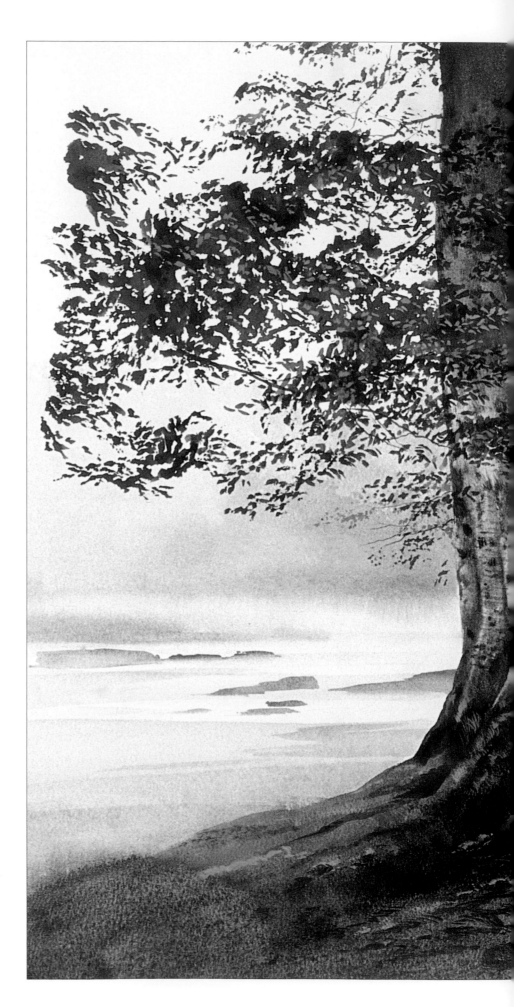

Footpath Beside the Wye, Mid-Wales
60 x 39cm (23½ x 15½in)
The sun's rays breaking through the canopy of foliage add a great deal to the atmosphere of the scene. This was achieved by lifting the paint from the paper with a damp sponge. It took a few light strokes to reach the desired result.

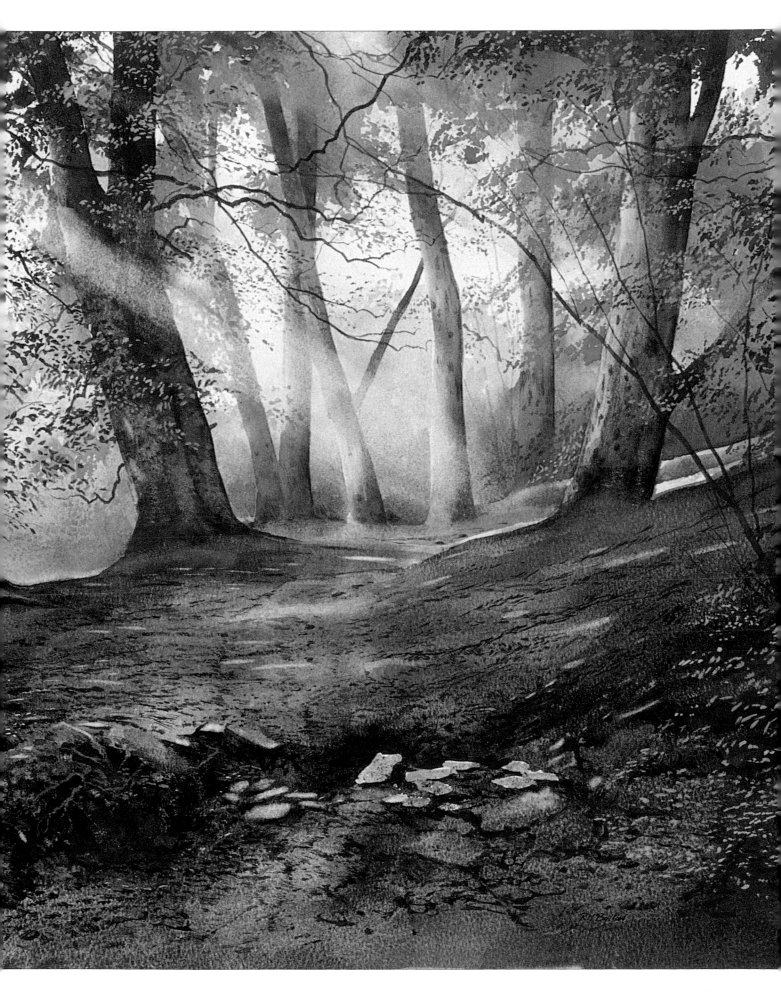

Composition

The bridge at St Ives is a popular subject and has been painted by visiting artists many times over the years. I have observed that they nearly always view it from the same spot, a little way upstream, with the bridge sitting full-square in the middle of the composition, as in the first picture below.

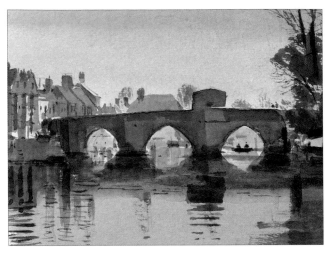

This is a good view but rather obvious, and the fun in composition is to find something a little different that might surprise the viewer and give you a challenge. Taking time to walk around the area throws up a lot of alternative views.

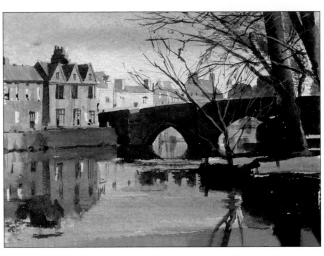

In this view, the bank of trees on the right partially masks the bridge, which I rather like, and the reflections are really exciting, taking full advantage of the buildings.

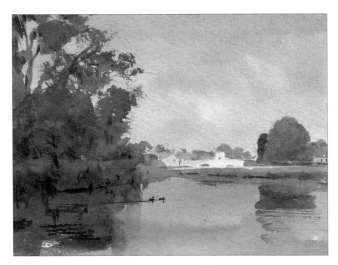

Walking along the riverbank, I get a different view at every turn of the river. Even when I am quite a distance from the bridge, it still leads the eye to the centre of the picture.

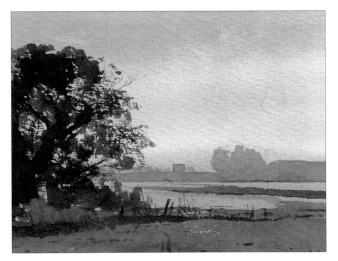

This view shows how looking at a scene on a different day can change everything. Only the silhouette of the bridge is now visible. In nature you do not get straight lines, so even that square shape in the distance is sufficient to draw the eye into the picture and make an effective composition.

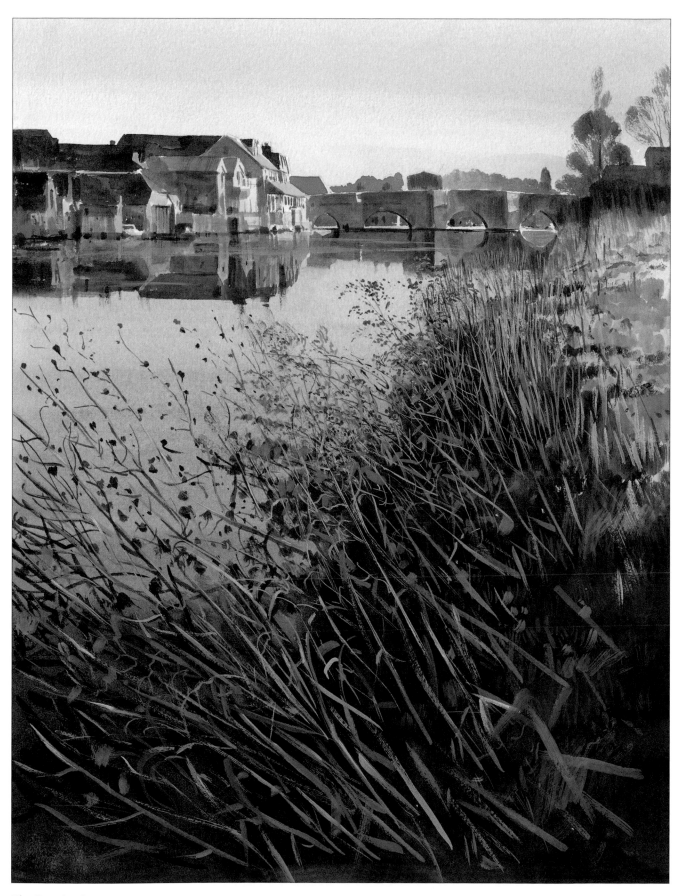

The Riverbank at St Ives
27 x 35cm (10½ x 13¾in)
In this painting the foreground has been used as a compositional aid: the irregular shapes here contrast well with the geometric lines of the old town on the horizon.

Perspective

To get a feeling of distance, it might help to divide the painting into sections: foreground, middle distance and distance, rather like a theatrical set. In landscapes, stronger colours and detail will be in the foreground and more delicate shapes are needed in the background. I always paint from the background, forwards. This makes practical sense, since you are laying stronger colours over lighter ones. For this reason, most paintings begin with the sky.

In order to create a feeling of distance, the background needs to be painted with sensitivity. Overworking or hard edges will destroy the illusion of distance. Colours become more muted when viewed from far away, edges are less distinct, and the atmosphere tends to lend blueness to the distant view.

The first example (top) has been poorly painted. The use of too much water has caused lots of hard edges to form, and the sense of distance is lost. In the bottom example I have kept the edges soft and the appearance of distance is much stronger.

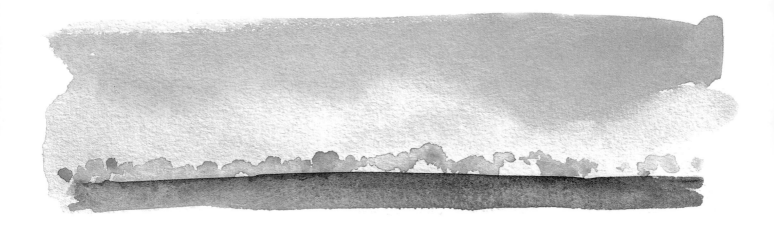

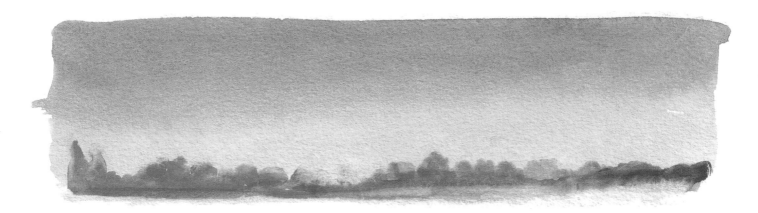

FIGURES

Figures in landscape can cause major problems of proportion, and getting the scale right is difficult. I use a simple drawing device that, if kept in mind, should be a great help. With your eye level on the horizon, all figures should be approximately on the same eye level line. However far away they are, they will then fit in the painting. This trick works if you are painting a level surface – things become more difficult if there are gradients!

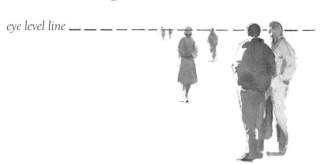

eye level line

My simple drawing device for placing figures in a landscape.

REFLECTIONS

Reflections are a rewarding subject to tackle, but can be confusing. It is rare to get a perfect mirror image as shown in the drawings – usually there is some disturbance that can have all kinds of effects. Be sure to pay particular attention to the vertical lines in the reflection, which should match up with the scene above.

An easy way to picture how reflections work is to think of an object with half the view above the water and its identical self upside down underneath.

This scene shows the church with its reflection, which is the same image inverted. Note that, when the water line is not visible (as above) or the reflected object is set back from it, you need to imagine the water surface extending to the base of the object. The imagined mirror image begins at the base of the object, but of course only the part that is in the water is drawn.

Reflections in puddles follow the same rules as any other reflections: the image of this spired church is inverted below the horizon line.

Buildings

Architectural subjects can tax our drawing skills, though usually in a predominantly landscape scene this is not a great problem. Buildings can be a great help in a landscape setting: the contrast between the regular lines in architecture and those of nature can enhance a painting and give a useful focal point to a scene. As is often the case, small details can bring a painting of this kind to life. Patches of rust on a tin roof, the fine woodwork round a window or the texture of brickwork can all be used to great effect. It helps to pay attention to detail at the drawing stage: the angle of window sashes and the size of doors and windows are best worked out before committing to paint.

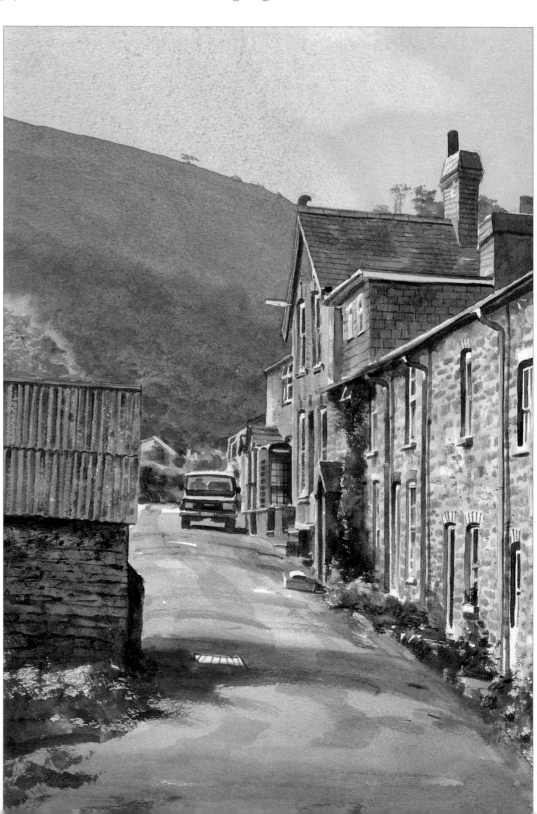

Hillside Village

21 x 31.5cm (8¼ x 12½in)
In this painting, the terrace of housing on a Welsh hillside gives quite a complicated arrangement of doors and windows. I took care at the drawing stage to get the proportions and perspective right. The thin white lines of sashes and window frames require some delicate brushwork. It is possible to use masking fluid but better results are achieved by using a fine brush and painting the windows in, leaving the white of the paper for the sashes. Manhole covers and irregularities in the road add charm to the scene.

Cars are an interesting addition to a painting. They are such a part of our lives that it is hard to avoid them, but great care is needed: a badly painted car will really catch the eye.

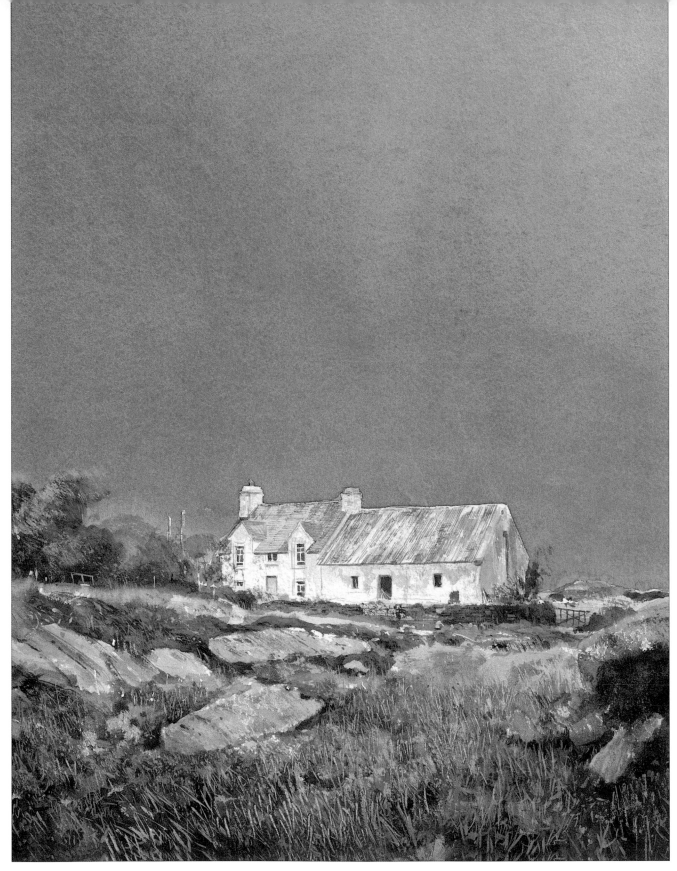

Farmhouse

25.5 x 34.5cm (10 x 13½in)

In this painting, the dark clouds contrast with the face of the old farmhouse to dramatic effect. Masking fluid was used to paint out the house before I started working on the sky. The sky was completed in a couple of washes: firstly cerulean blue and a little alizarin crimson, which, when dry, was followed by ultramarine blue, alizarin crimson and a little burnt sienna. The darkest part of the sky wash appears behind the house to emphasise the contrast.

Wax resist and then masking fluid were applied to the foreground to give texture to the rocks and to mask them against a couple of brushfuls of raw sienna. Indian red and burnt sienna gave me the rust colours amongst the heather, and this was followed by some scratching out with the corner of a razor blade while the colours were still damp, to introduce the fine stalks of grass.

Figures and animals

If your painting is going to include a figure in the foreground, you should get a model to stand for you, or take some photographs to enable you to portray the figure convincingly. Figures that are in the middle ground or in the distance are sufficiently far away to enable the painter to make them up. However, this is an area in which a lot of skill is involved, and poor figure work can let down an otherwise good painting. Figures are the first thing that captures our attention in a painting, so plenty of practice in this area can make quite a difference.

All artists develop their own ways of handling this subject. Here are two ways in which I introduce figures on to a dark background.

Masking fluid

You can mask out the figure at the planning stage of the painting, and this will give you a sharp white background to work on later. However, the sharp edges can make the figure look a little unnatural. For this reason, it is sometimes better to mask out only the highlights of the figure's head and shoulders.

Opaque colour

My preferred method is to paint out the shape of the figure in opaque Naples yellow, and then work with my transparent colours over this. It is easier to make changes with this method than with the masking fluid technique, and I prefer the softer look. The base colour of Naples yellow can be adapted as necessary by adding colours from the tray, so if a grey is needed, then a little red and blue, it gives me the appropriate mix.

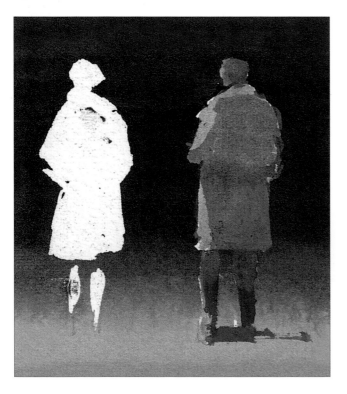

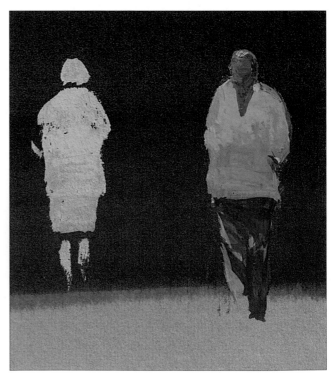

TIP

If you are not confident with the scale of the figures you wish to introduce, try cutting them out of paper and moving them around on your sketch before drawing them.

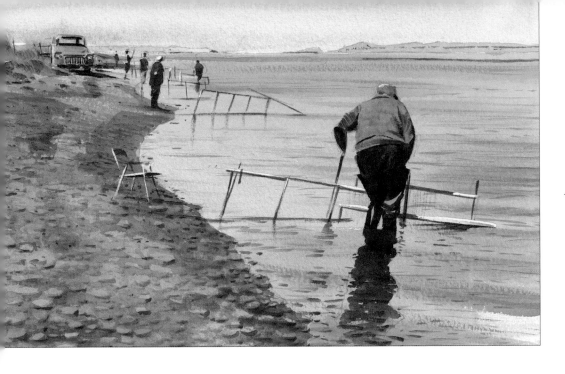

Whitebait Fishermen on the Opihi River, New Zealand

28 x 17cm (11 x 6¾in)
Here I painted the water as though the main figure was not there. I used masking fluid to retain highlights on the fisherman's hat and the net supports. The fisherman and his reflection were then painted in. This way, the water continues smoothly across the view without any interruptions which might have appeared had I tried to paint around the fisherman.

Cattle Grazing on the Banks of the River Ouse

58 x 39cm (22¾ x 15½in)
Most landscapes are complemented by the introduction of animal life. In this rural scene, the cattle were introduced by overpainting with Naples yellow. First their shapes were painted in, and then when I felt that their outlines were right, the colours and tone were introduced.

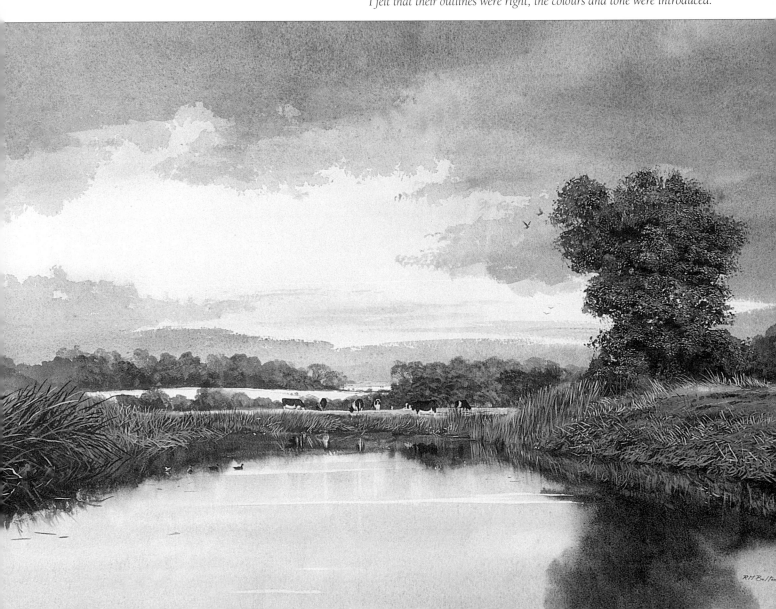

Atmosphere

Atmosphere is an intangible quality bound up with light and colour. There are some days that are perfect, and in every direction you can see possibilities for a painting. On other days there is nothing to inspire you.

Unfortunately, our most pleasant, warm, sunny days are not always the best for providing atmospheric light. In the middle of the day when the sun is overhead, things can look very ordinary, and you might have to use your imagination to make a painting interesting. When weather conditions are more acute, there is likely to be more atmosphere: rain, wind and snow are always valuable ingredients to a painting. It is always worth a good walk after a violent storm: the flooding and reflections can make good subjects. The lighting in winter can be very interesting; the sun never lifts very high in the sky and this can give us some very dramatic lighting effects.

Dried-up Riverbed
54 x 35cm (21¼ x 13¾in)

In this painting, the stones on a dried-up riverbed in Central Australia reflect back the warm glow from the sun while the shadows stretch out from the trees. It works well as a composition: the old riverbed leads us into the picture to a golden bank of undergrowth and a distant glimpse of trees and a hill.

The need to paint stones and pebbles crops up a lot in landscape painting and these subjects are harder to paint than they look. Simply dotting with the brush will not be very convincing: stones are different colours and shapes, and they are also subject to the laws of perspective: they get smaller the further away they are. You have to convey the differences in colour and shape without the painting looking mechanical or overworked.

To get the atmosphere, I chose to paint this scene at the end of the day so that I would benefit from lengthening shadows. At midday, much of this would have been bleached out by bright sunlight.

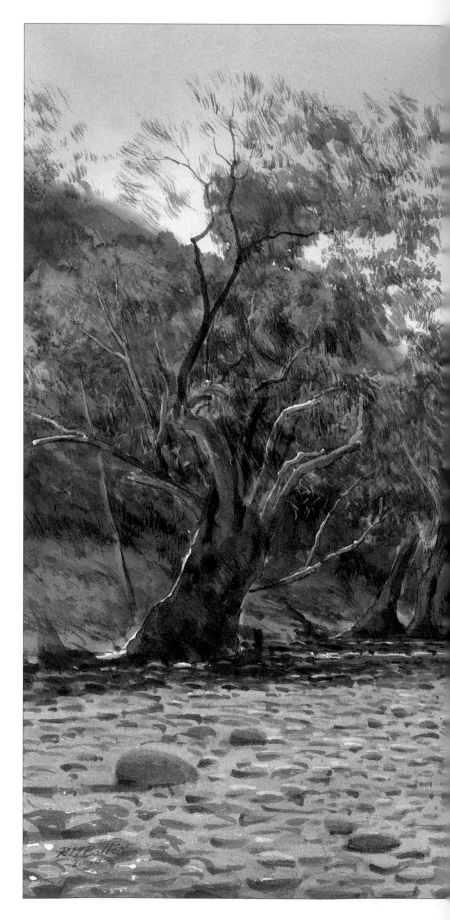

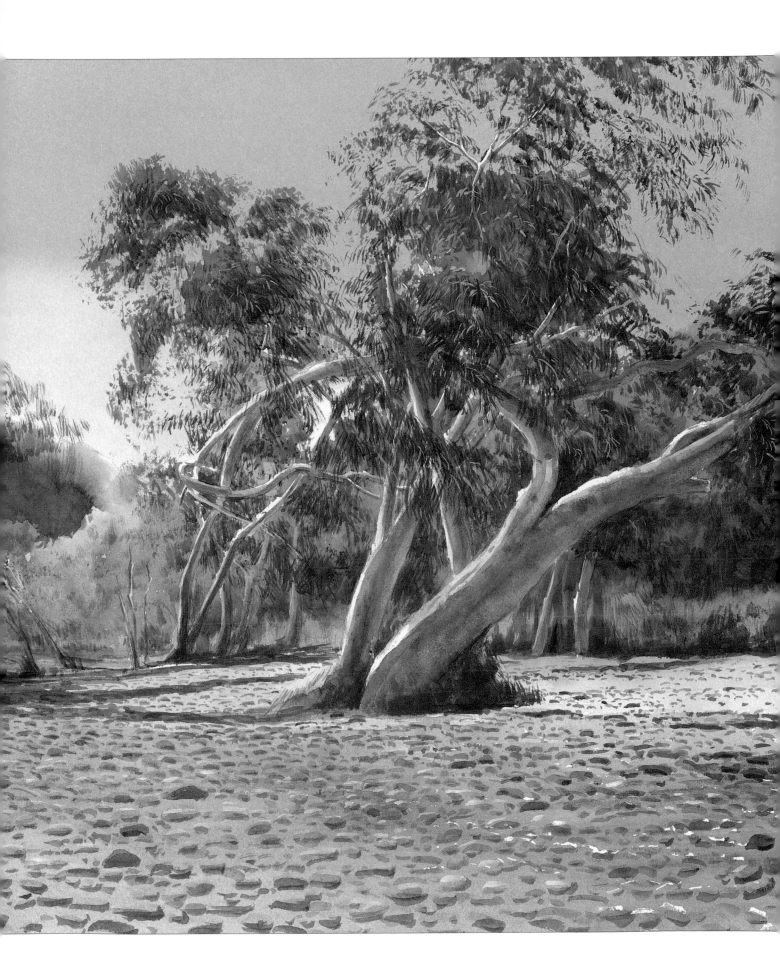

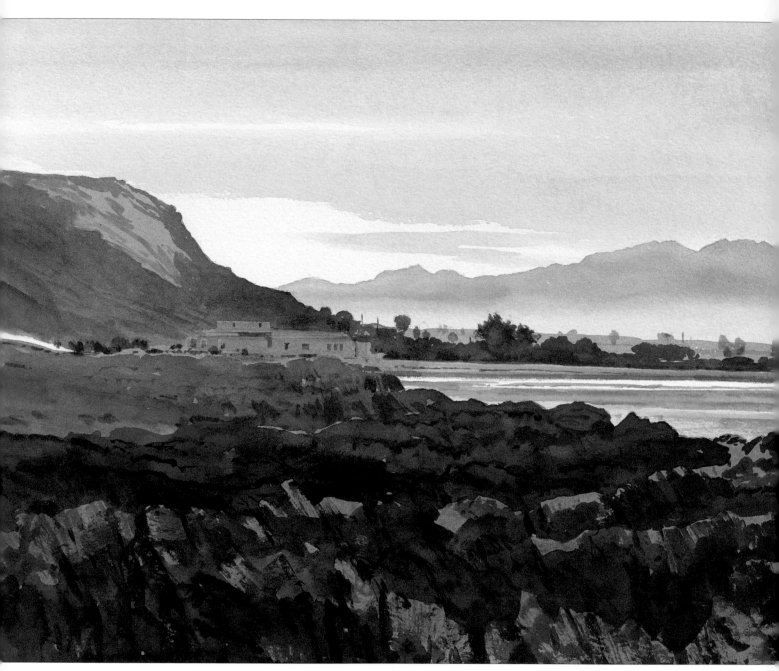

Sundown

35 x 28.5cm (13¼ x 11¼in)

This painting captures the moment just before the sun sets behind the hills. The whole bay is cast in shadows. As described on page 30, landscapes can often be divided into three sections: distance, middle ground and foreground. Here, each has been painted with a different colour range to set them apart. In the distance a mellow mix of alizarin crimson and intense blue has been used. The middle ground has been painted with burnt sienna, Indian red and ultramarine blue, and the foreground is a cool mix of Prussian blue, ultramarine blue and alizarin crimson. The scene has been worked very quickly with little room for detail, though care was taken to include the buildings at the water's edge that give a point of interest to the view.

Evening Light

29 x 21cm (11½ x 8¼in)

The evening is a rewarding time to think of painting: the lengthening shadows, the rich tones and golden light all make for an atmospheric painting. Even if you do not live in a picturesque environment, it is likely that you will find something worthy of painting at this time.

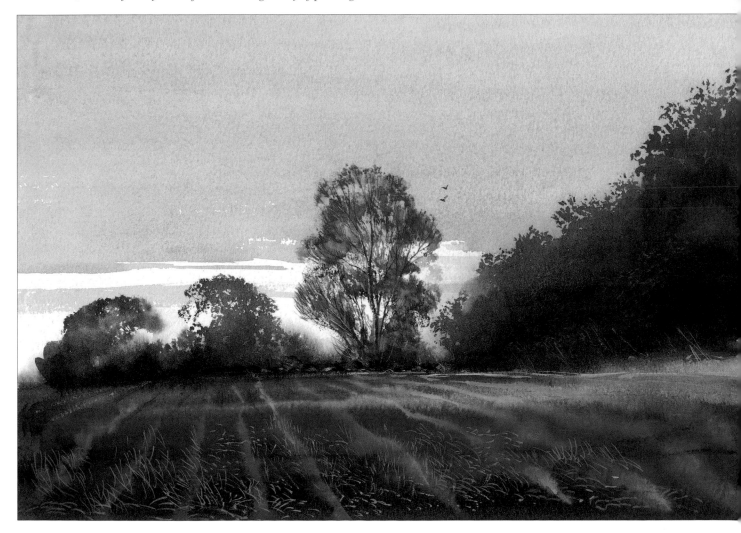

Reflections in the River Wye

56.5 x 41cm (22¼ x 16¼in)

The rocks reflected in the river in this painting are called 'the devil's shoes', and were a favourite spot for me to scramble up as a child, to see if I could spot a trout.

Atmosphere can be found in many ways and here it is the grey, overcast day that has given the painting its tranquil, cool quality. Many of the greys are made from a mix of burnt sienna and cerulean blue. Cerulean blue is a pale blue and is very effective for creating these cool shades. In the background, the paper was brushed with water before applying the colour, so that the colours would feather out and give soft edges. When dry, the same mix of colour was used to give some shape to the background foliage. In the foreground, ultramarine blue was mixed with burnt sienna to paint the tree trunks and riverbank.

Attention was given to the trees to give them shape by adding colours wet in wet and lifting out colours with a small brush to define the crevices and bumps in the bark. There was a lot of green moss on the trunks, and this was added by mixing sap green with burnt sienna and applying the mixture wet into wet. The lighter green of the foliage was mixed from emerald green and Naples yellow, and was then painted on with a small brush.

The river is mostly a mix of burnt sienna and ultramarine blue. A little masking fluid was used to touch out some fine highlights near the foreground. The bands of light across the water were added when the painting was dry. This was done by scratching the paper with a razor blade and using the edge of a ruler to keep the lines straight. The lines were then rubbed with an eraser to bring out their whiteness.

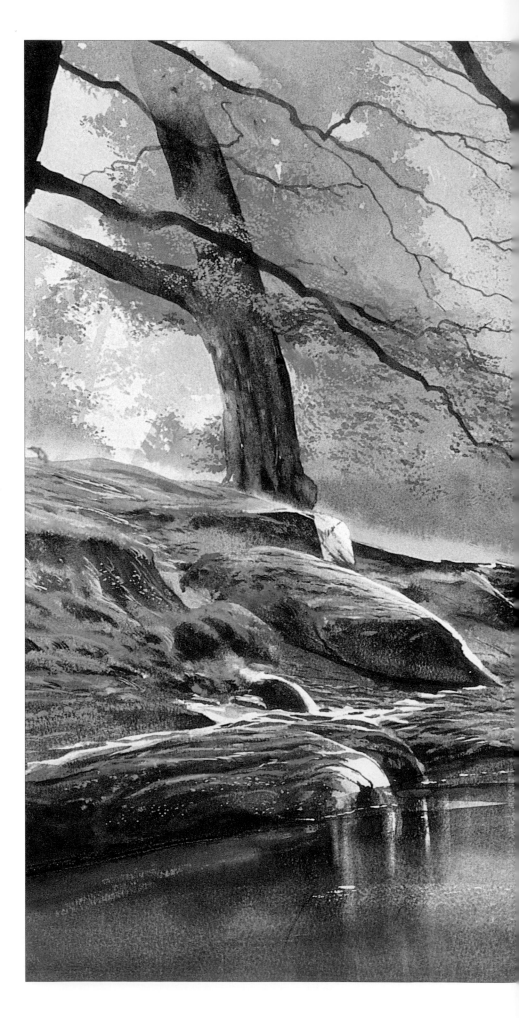

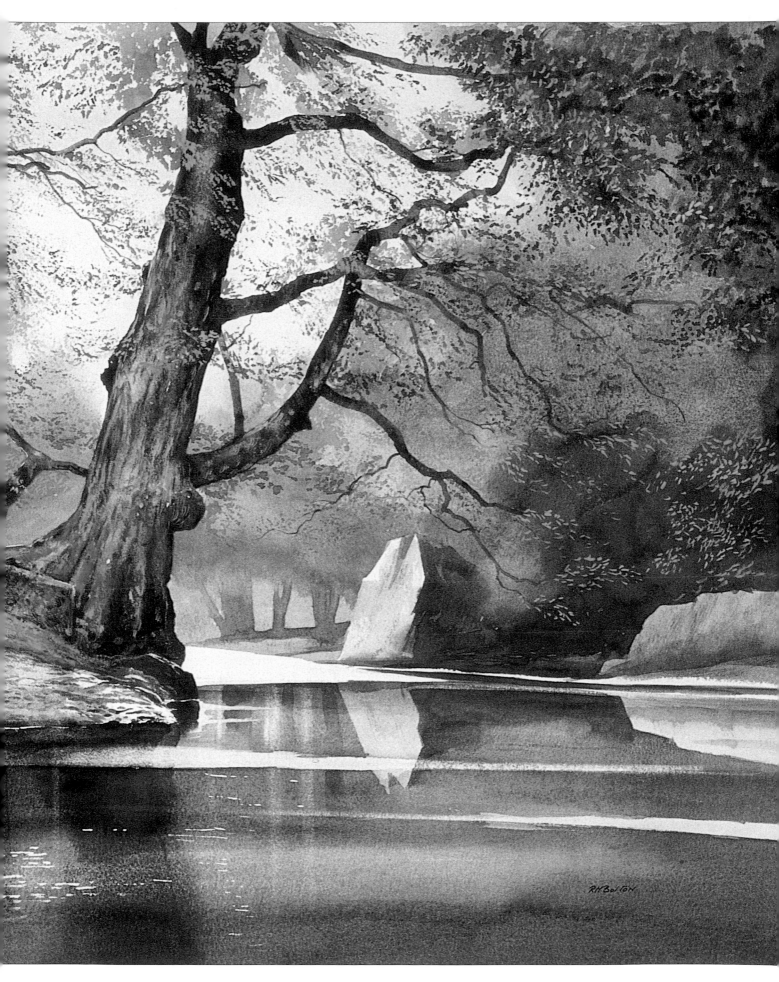

Skies

The sky is an ever-present subject that changes from day to day and hour by hour. Its importance to a painting is fundamental, as it is often this that creates the atmosphere and makes a major contribution to the design of the composition. It is best to avoid drawing in the sky area, as lines can show up later, and with some papers, the use of an eraser can leave permanent marks that become evident when you lay a wash.

All the effects of wash painting and wet into wet play a big part in painting skies. It is an area in which you are not in complete control. Colours are brushed in and allowed to mix on the paper. The board is tilted to encourage movement, and you have to react quickly to these changes. Hard edges are always a problem, and having a lot of water on the paper always creates risks, so try to remove some of the excess water by touching the edge of the painting with a paper towel or tissue.

Water Meadow, St Ives
35.5 x 25cm (14 x 9¾in)
The colours were brushed onto a wet surface to create the softened edges of cloud as the colours mixed on the paper. The background wash is mainly turquoise with a touch of alizarin crimson. While this was wet, a stronger mix of the same colours, this time with more alizarin crimson, was brushed in to form the soft clouds. The sharper lines of clouds in the distance were painted when the sky was dry. The edges could still be softened by running a wet brush along the edge of the paint. To get the smoky colour I added a little raw sienna to the mix.

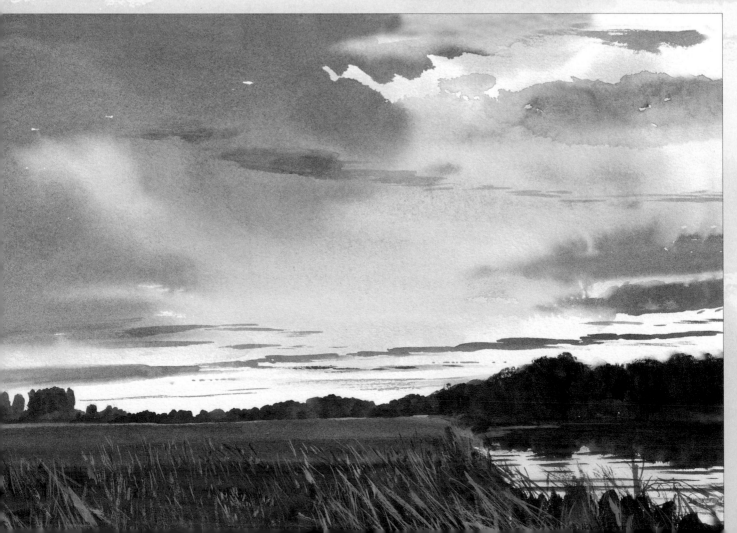

DIFFERENT SKIES

This ragged-edged sky was created using the split brush technique (see page 27), dabbing the brush up and down and splaying the hairs out to give a broken edge.

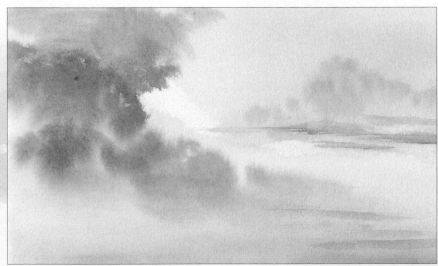

In the painting on the left, ultramarine blue has been painted into the wet surface of Naples yellow and a touch of alizarin crimson, to blend together softly on the paper.

The sky on the right was created from a base wash of raw sienna and intense blue, followed by a little alizarin crimson and ultramarine blue, which were brushed on to the wet paper. When dry, the harder-edged clouds were added in alizarin crimson and ultramarine blue.

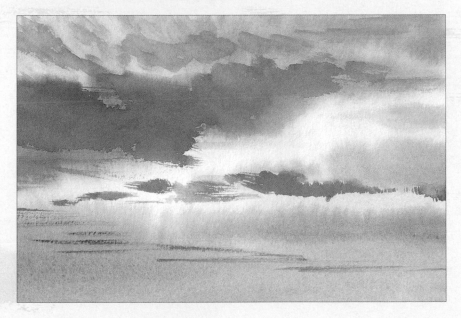

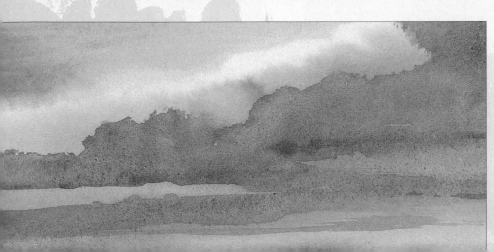

The base wash in the painting on the left was a mix of raw sienna with a touch of scarlet lake, merging into some Winsor blue. While the paper was still wet, ultramarine blue was brushed on to give the dark underside of the clouds.

Sunset on the River Ouse

I often find myself looking up to the sky, noting unusual effects and trying to figure out if I could create them on paper. Sunsets create particularly striking lighting effects to challenge the watercolour artist, and this scene also features the sun's reflection in the water.

Like many sky paintings, this one involves painting wet into wet over an initial wash. You need to paint quickly over a large area to work the sky, and several techniques are required to create the different clouds: some are softer-edged than others.

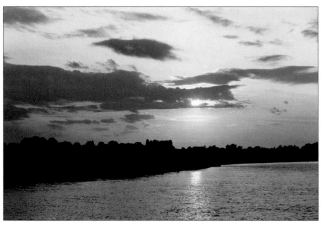

The reference photograph, which I kept by me whilst painting and referred to for details of tone, colour, form and texture.

The preliminary sketch. Keep pencil lines to a minimum in the sky area. Lines pressed into the paper can leave unsightly marks if they fill up with paint.

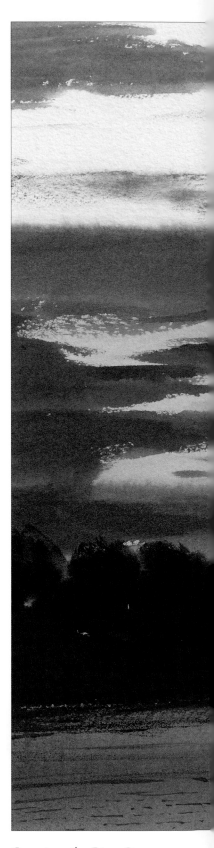

Sunset on the River Ouse
350 x 260mm (13¾ x 10¼in)
The finished painting. The painting of the sky relied on a speedy application of colours and a sureness of approach.

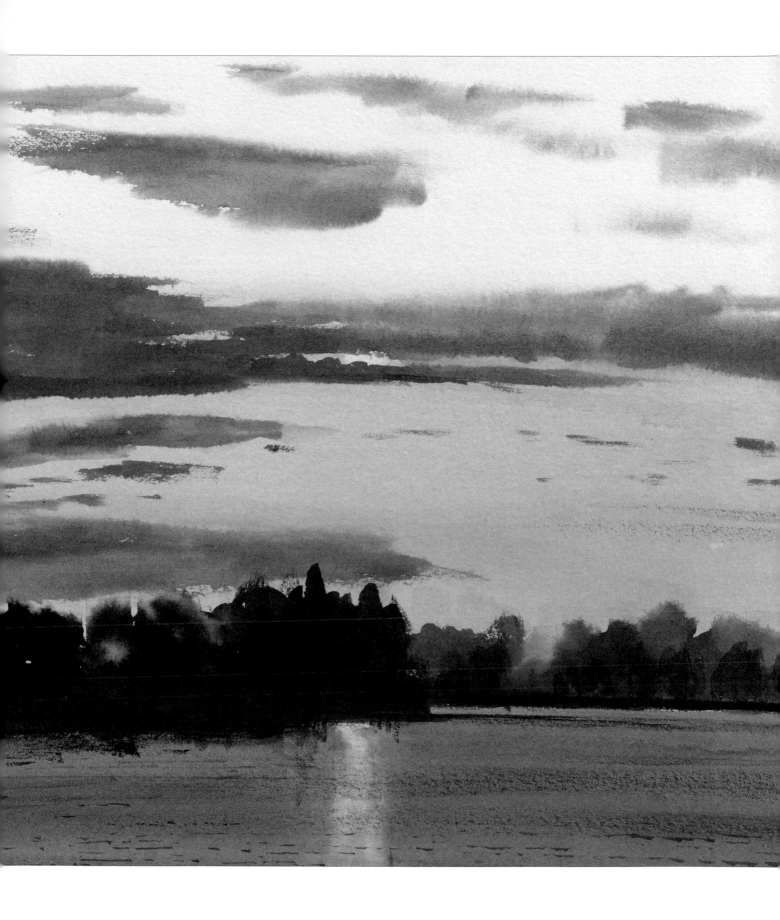

YOU WILL NEED

Not paper, 350 x
260mm (13¾ x
10¼in)
Raw sienna
Cadmium yellow
Naples yellow
Scarlet lake
Ultramarine blue
Cerulean blue
Prussian blue
Indian red
Chinese white
Crimson lake
Sponge brush
Size 14 round wash
 brush
Size 6 and size 12
 brushes

1 Mix a wash of raw sienna, cadmium yellow and a little Naples yellow, with a touch of scarlet lake. Using a large round brush, wash lightly down from the top of the painting, and more darkly down towards the river's edge. Continue over the river area, down to the bottom of the painting, but leave an area white for the sun's reflection. While the wash is still wet, lift out a circle for the sun with a dry brush. Allow the painting to dry.

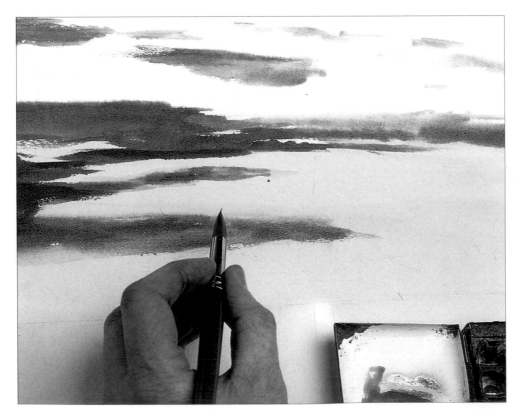

2 Mix together ultramarine blue, cerulean blue and a little scarlet lake. Wet the lighter area of the sky, and paint in the blue clouds with this mix and a size 12 brush. Darken the mix for the clouds in the middle of the painting, and soften their edges using a wet brush.

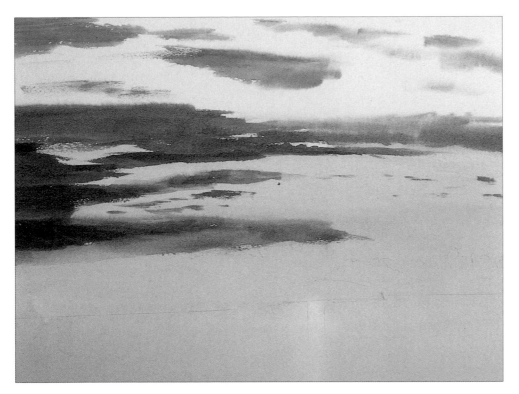

3 Finish painting in the dark areas of cloud, then allow the painting to dry. Note that the dark blue dries much lighter, as shown in the next picture.

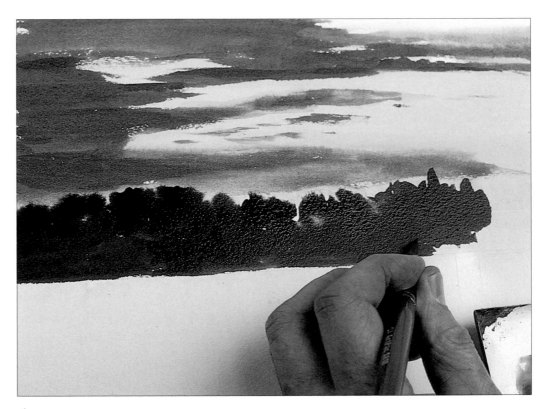

4 Make a dark mix of Prussian blue and Indian red for the foliage on the riverbank, but don't mix the colours too thoroughly, as the foliage will look more realistic if the shades vary. Paint in the foliage using a size 12 brush.

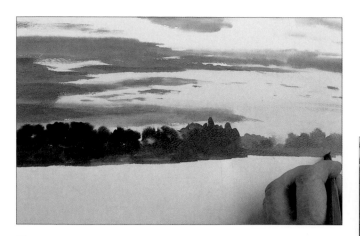

5 Add opaque Chinese white to the mix, and paint in the background trees. The milkier blue will automatically make these trees look more distant.

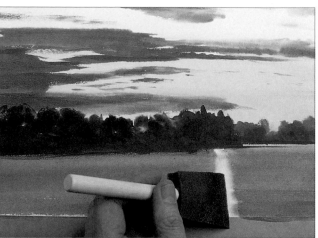

6 Make a greyish mix using cerulean blue, ultramarine and scarlet lake for the water. Wet the foreground, and then wash on the mix using the large round brush. Lift out the sunlit area of the water using a sponge brush as shown.

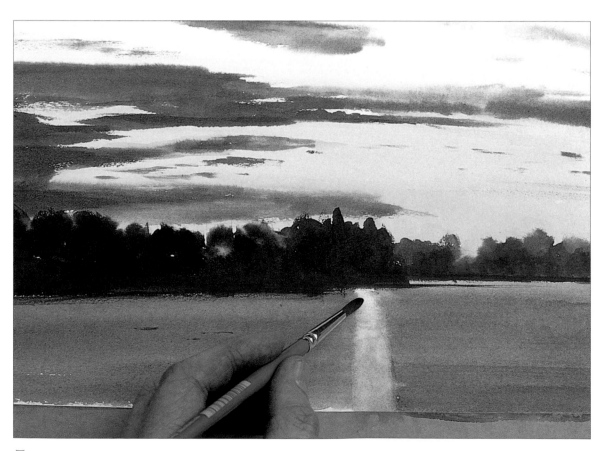

7 Paint in the orange tint in the sun's reflection using a mix of crimson lake and cadmium yellow and a size 6 brush, then soften the edges using clear water.

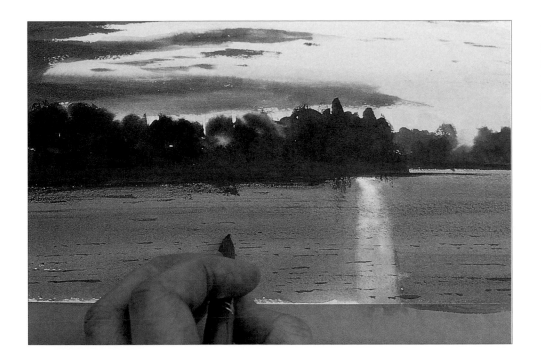

8 Mix Prussian blue and Indian red, and with the tip of a brush, paint in the shadow on the water and the finer details of the water's surface.

The Ouse at Great Barford
57 x 39cm (22½ x 15½in)
The sky in this scene was made in three layers of wash. The first was Naples yellow, leaving a clear highlight in the centre. The second layer of colour was ultramarine blue softened by a brush along the painted edge. With the third wash, a mix of ultramarine with a touch of burnt sienna, some edges were left sharp and others were softened.

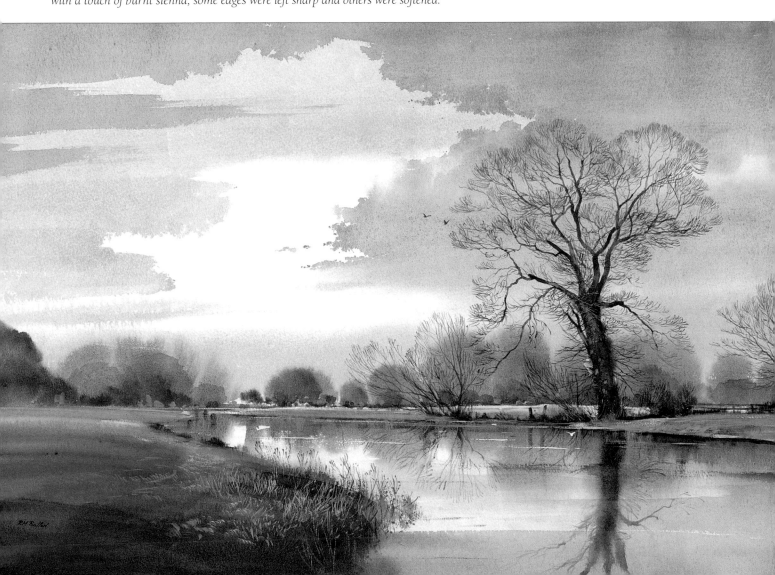

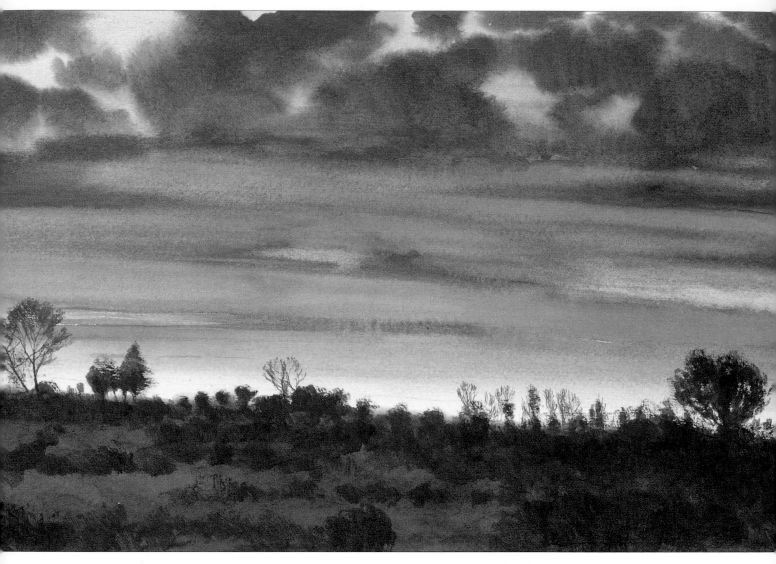

Outback Sunset

35 x 23cm (13¾ x 9in)

To capture this effect, the sky was painted quickly wet in wet: the bands of orange and pink first and the background blue sky second. While the wash was still wet, a brush was dragged a couple of times across the sunlit bands to soften and blend the colours. Working like this can be a bit unpredictable, and a careful eye should be kept on the painting as it dries, to look out for darker colours drifting into the lighter sections.

Evening Sky

34 x 24cm (13½ x 9½in)

Dramatic skies are often cast just before sundown. The soft qualities of this scene were achieved by painting wet into wet, followed by some work with a fine brush to add the wisps of cloud. There is often a band of light on the horizon in sky paintings; this is very useful here as it accentuates the silhouette of the tree line.

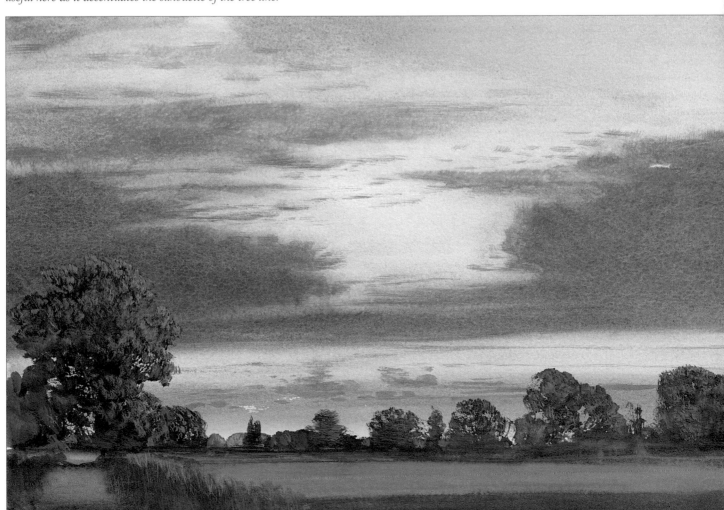

Trees and foliage

Trees are a major component in landscape painting, and are likely to feature in most of the scenes you wish to paint. A winter landscape of trees can be spectacular with all the branches and twigs exposed, and since there is no foliage, a lot more scenery is on show. This all changes in the summer as the landscape becomes draped in green. This is a taxing area for the watercolour painter: large areas of green can look lurid in a painting, so a good deal of sensitivity is required to make it work. Our preconceptions can also get in the way: we automatically think trees are green, and mix colours accordingly. In my experience, I find I need to mix less green than I think I need – so if I am mixing viridian and Indian red for a dark shade of foliage, I will only need to add a little viridian. A few flecks of bright green added later as overpainting may be all that is needed.

It really pays to study previous masters of watercolour to see how they painted this challenging subject; every painter seems to have developed a characteristic style of his or her own.

There are many ways of approaching a subject, and using a variety of techniques, as shown on the opposite page, you can create a range of subtly different qualities.

The Spreading Oak
45 x 28cm (17¾ x 11in)
The split brush technique is well illustrated in this painting. To form a ragged edge of foliage, the brush tip was splayed out into a number of points and then dabbed gently on to the paper to create the patchwork of leaves.

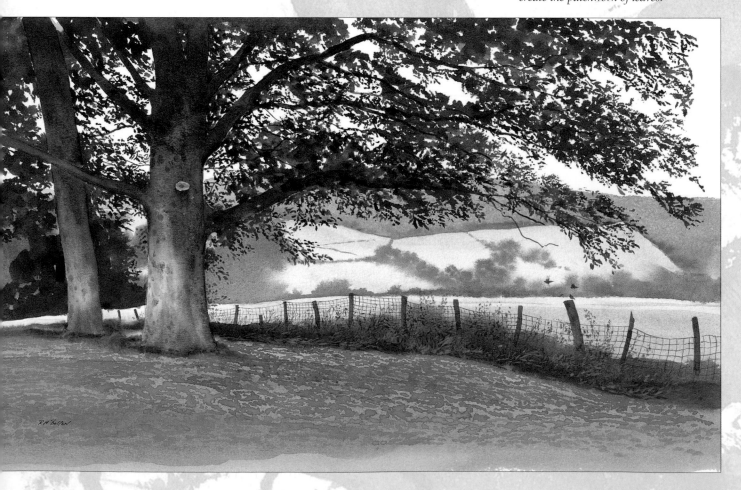

FOLIAGE

The wet in wet technique gives a soft, moody quality and works well in the distance and mid-ground. In the foreground, more work is needed to show the build-up of leaves and twigs.

Dry brush is a very effective technique, and the texture of the paper can be used to give the broken quality of foliage.

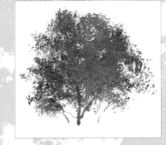

The split brush technique. The hairs of the brush are splayed out and then dabbed up and down of the surface of the paper, giving a convincing dappled quality to the foliage. Rotate the brush continually in your hand, to avoid making a repetitive pattern, and avoid having too much paint on the brush.

TWIGS

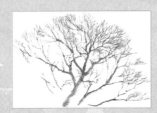

A very fine brush can be used to paint in all the detail of twigs. The rigger brush can be very useful in this area, and its long hairs are excellent for lots of sweeping, thin lines.

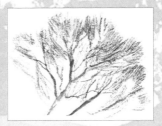

A less time-consuming way to paint twigs is with the dry brush technique. You have to be sure that all excess paint has been removed from the brush before painting, as a mistake here could be costly.

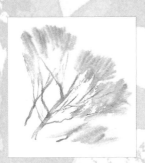

These twigs have been suggested by the wet in wet technique, which can also be very effective.

TRUNKS

Colours have been dropped into the initial wash on this trunk wet in wet, to give a suitably mottled look.

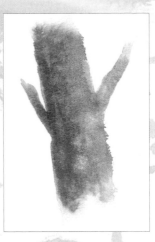

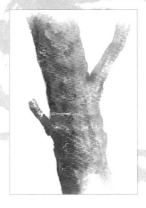

Candle wax works well to impart a textured look. Rub the candle on the paper before painting, and the wax works as a resist.

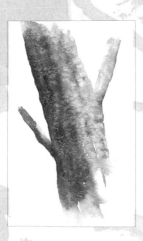

Create a textural quality by sprinkling salt on to wet paint. Here you can see the dappled effect this technique produces in a mix of sap green and burnt sienna.

Summer Afternoon

I was attracted to this scene by the rosy glow from the sun, picked up on the trunk of the tree.

 The painting is not an accurate record of the scene: one or two changes have been made to suit my purposes. In particular, some heavy foliage was left out around the base of the tree, in favour of showing more of the woodwork. Detail has been kept to a minimum in favour of a lively approach.

Opposite
Summer Afternoon
26 x 34cm (10¼ x 13½in)
The finished painting. The golden tones of this scene seemed perfectly to catch the atmosphere of a summer afternoon.

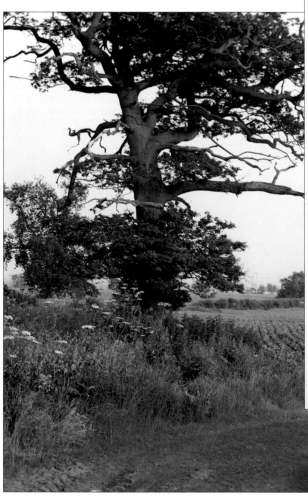

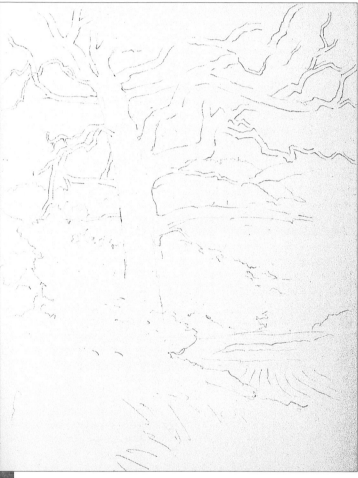

The preliminary sketch. Time spent on the sketch is never wasted. It is much easier to correct an error at this stage than later on. In particular, check that the scale of the branches and trunk is right – there seems to be a kind of formula to the way branches grow and divide, and it is easy to get the balance wrong. Take a moment to stand back and see if your drawing looks right.

This is the photograph of the scene that inspired the painting. I kept it by me during the painting, referring to it for details, colour and tone. However, as you can see from the painting shown opposite, the finished piece was never intended as a faithful reproduction of the photograph, but as my own interpretation of the scene.

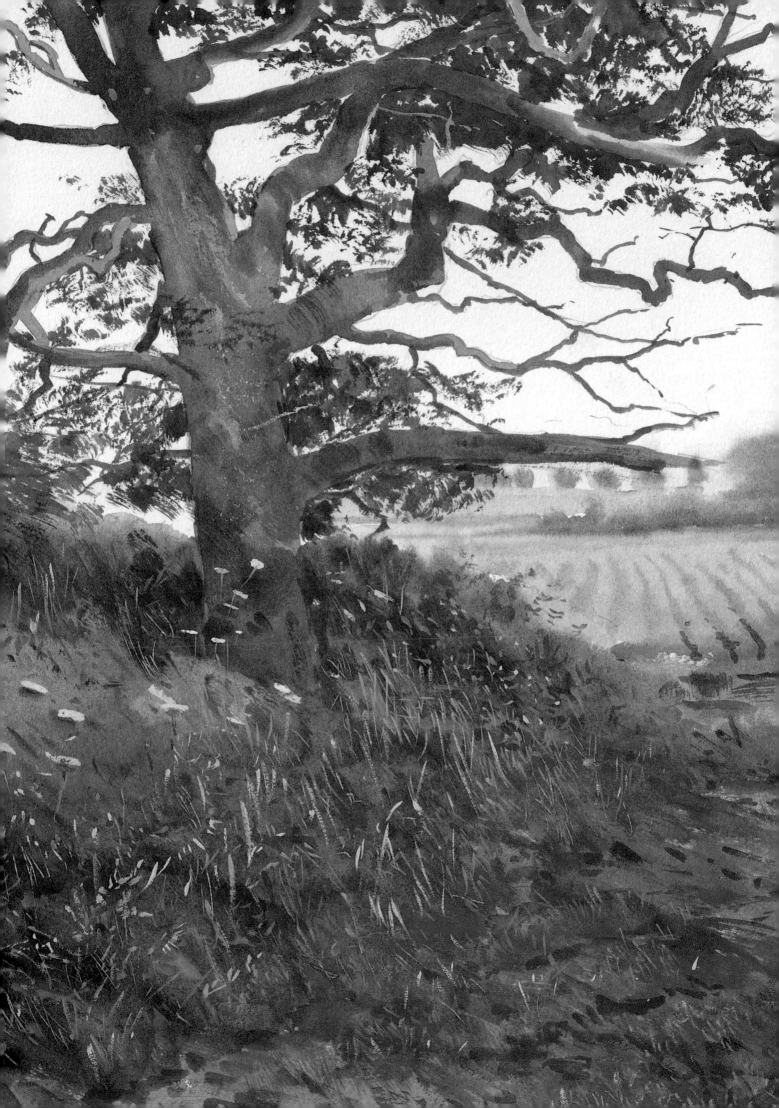

1 Rub candle wax on to the tree trunk. This will add to the texture of the bark when it is painted.

2 Mix a wash with a little alizarin and ultramarine. Take a large wash brush and wash from the top of the picture down to the horizon line. Add a little more blue just above the horizon line; this will create the illusion of distance. Brush over this with clear water.

3 Mix a wash of Naples yellow and raw sienna for the foreground. Wash it on and merge it with the watery edge of the blue.

4 Add more raw sienna to the wash towards the bottom of the picture, creating an earthy tone in the foreground.

5 Using an old brush, paint masking fluid on to the cow parsley heads. This will preserve the colour of the wash in these areas, even when other colours are painted on top.

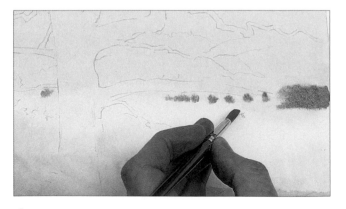

6 Brush clear water above the horizon line. Using a size 6 brush, paint in the area of the background trees with ultramarine blue and burnt sienna.

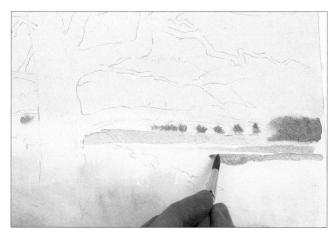

7 Begin to fill in the green of the background fields just below the horizon using emerald green and raw sienna. Remember that you usually need less green in a mix than you think!

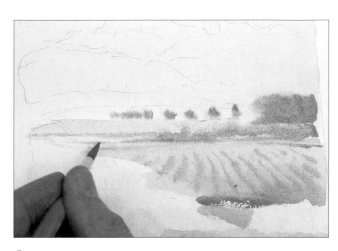

8 Add more ultramarine to the green mix to create the lines of the crop in the field. Painting wet into wet, use burnt sienna mixed with emerald green to paint the distant hedge. Add scarlet lake to the mix to deepen the colour of the earth between the hedge and the field.

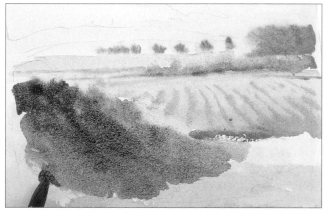

9 Soften the foreground with clear water. Using a size 11 brush, work on the grass with a mix of viridian, raw sienna and burnt sienna.

10 Fill in the foreground texture of the grass. The green should be stronger and less brown towards the foreground.

11 Use the dry brush technique, holding the brush on its side and scuffing it over the surface of the dried earthy wash, to create the foreground grasses.

12 Detail the shadow at the base of the tree, and under the flower heads, using a mix of alizarin crimson and a little ultramarine blue.

13 Mix scarlet lake with Indian red for a rusty shade of red, and paint the tyre tracks in the mud in the foreground. Add ultramarine blue to the mix for the shadow in the bottom right-hand corner.

14 Develop the colour of the foreground grasses using emerald green for the lighter parts, and for a darker green, ultramarine and viridian. Use a craft knife to scratch out a grassy texture.

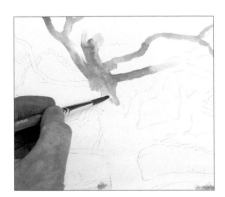

15 Using a size 6 brush, begin to fill in the base colour of the tree: a mix of raw sienna, burnt sienna and scarlet lake. Soften some areas with water first.

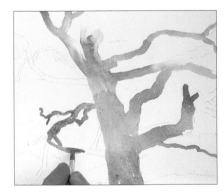

16 Continue filling in the finer branches. Vary the strength of the mix, as this will help to suggest the irregular texture of the bark.

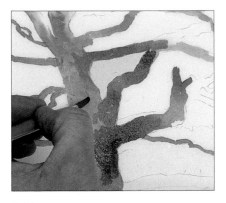

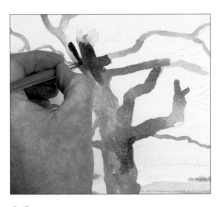

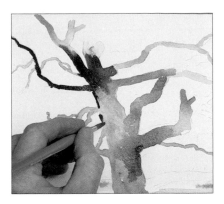

17 Add viridian to the mix and run it in while the paler paint is still wet, to build up the complexity of colours in the bark. The candle wax will begin to show through, adding texture.

18 Mix ultramarine blue and alizarin crimson to make a purply red for the dark shadows.

19 Add shadow to the side of the tree and soften the line with a wet brush.

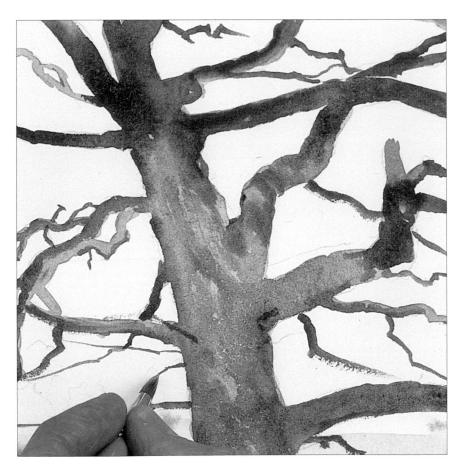

20 Carry on filling in the different colours and textures of the bark, painting wet in wet.

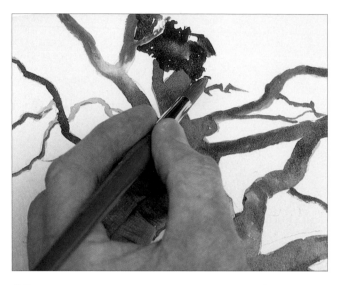

21 Using a size 11 brush, start to paint the dark area of foliage with a mix of alizarin crimson and viridian.

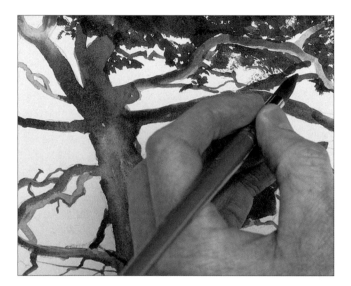

22 Mix alizarin crimson, ultramarine blue, viridian and raw sienna and paint in the rest of the foliage.

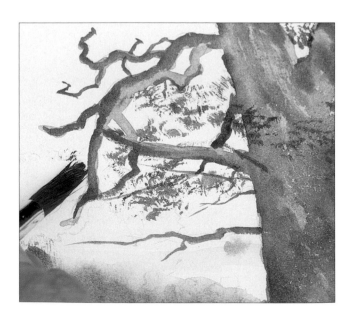

23 Using very little viridian, but lots of alizarin crimson, scuff paint on using the dry brush technique to suggest the texture of leaves. Add burnt sienna to counteract the mauvness of the foliage that needs to look greener. The split brush technique is used to paint in the finer leaves against the sky.

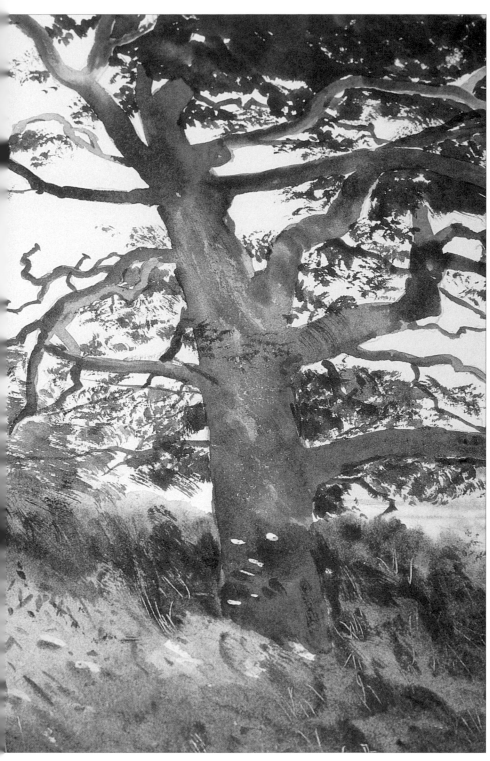

The painting almost complete. When you have come to the end of the above steps, it is well worth standing back to see how the painting works from a distance. Weaknesses can then be approached and adjustments made. I have also picked out a few details in the finished piece (right, and on page 57): some shadows among the branches have been emphasised, and touches of paint have been added to capture random leaves or twigs. I have overpainted some yellow grasses using opaque Naples yellow.

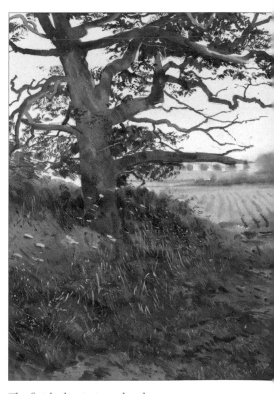

The finished painting, also shown on page 57.

63

Gum Tree
345 x 520mm (13½ x 20½in)

The twists and turns of a tree can make a good composition. This Australian gum tree seems to spiral out of the ground, the exposed roots adding to this effect. The rich, warm colours are mostly burnt sienna and raw sienna, while on the distant riverbank a soft haze of foliage has been suggested by sprinkling a little table salt into the wet paint. It is important in a painting like this to get a good contrast between foreground and background, so I avoided unnecessary detail in the background, to give emphasis to the tree. The foliage in the upper branches is mostly burnt sienna and viridian, but many individual leaves have been picked out with opaque Naples yellow, mixed with a little emerald green.

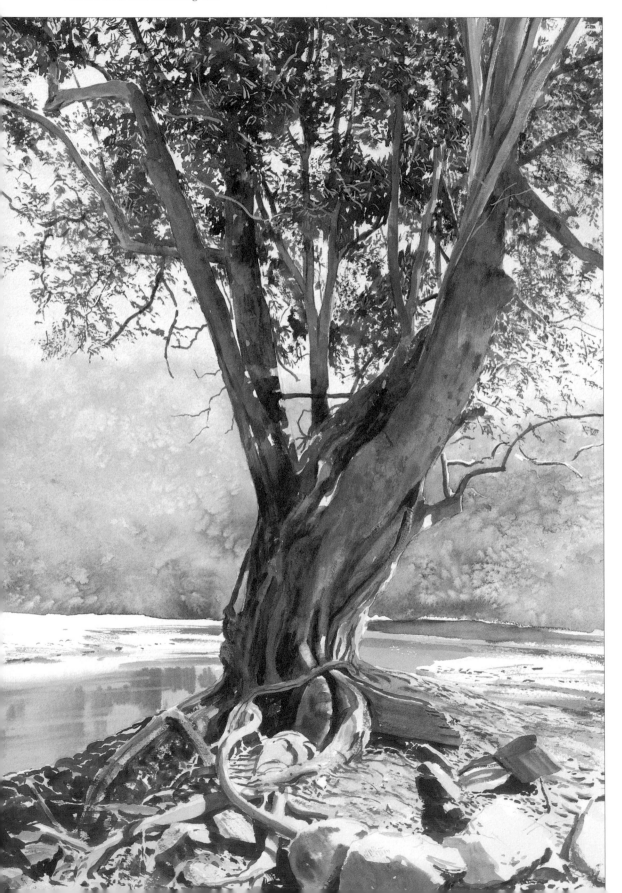

Cow Parsley

41 x 25cm (16 x 9¾in)

Foliage can be very dark in shadow, and in this scene it is used to contrast with the white heads of cow parsley. Much of the painting was worked wet into wet, giving a soft, blurred feeling in keeping with the warm, hazy late-summer day. Burnt umber, Prussian blue and viridian were painted on to a wet surface of Naples yellow and raw sienna. Detail was added when the painting was dry. Some split brush painting was used to give a bit more description to the trees and then some overpainting with Chinese white and Naples yellow was used to paint the grass and the cow parsley.

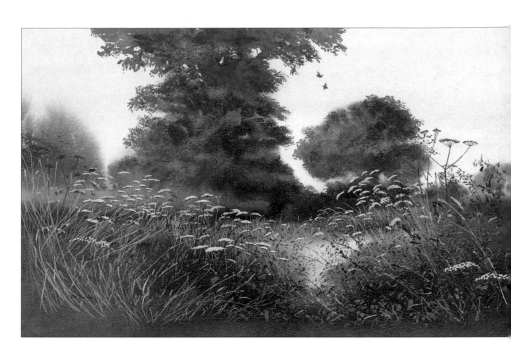

Hilltop Tree

27 x 34.5cm (10½ x 13½in)

As the sun went down, the tree in this painting caught the last rays of the sun. It was situated on the top of a hill in Kaikoura, New Zealand. I blended together cerulean blue and Naples yellow to give the background wash, and cerulean blue and burnt sienna to form the hillside in the foreground. Cerulean blue is a good colour for mixing pale, cool greys. Where the sun catches the foliage, I used masking fluid to retain the whiteness of the paper. The colours of the tree were made from burnt sienna, Indian red and ultramarine blue. The masking fluid was removed and the brighter orange patches of foliage were then brushed in. A little overpainting with Naples yellow was needed in the dark areas to describe the clumps of foliage, while in the foreground, burnt sienna and raw sienna were combined to paint in ridges of grass on the hillside.

Water

There is something very special about water. I have the feeling that I can always construct a painting if there is water involved. Its fluid nature, the colours and reflections, and its abstract quality can always lift a painting. The play of light on water has many subtle variations, and there are a number of techniques we can use to capture them on paper.

Reflections at Houghton Lock
30 x 22cm (11¾ x 8¾in)
The water in this scene has that dark, inky quality that I find irresistible in watercolour. There is little colouring here: the bank and trees form dark shadows of burnt umber and sap green against a background wash of Naples yellow with traces of red and blue. The distant tree line is a cool blue-grey – a mix of cerulean blue and Naples yellow.

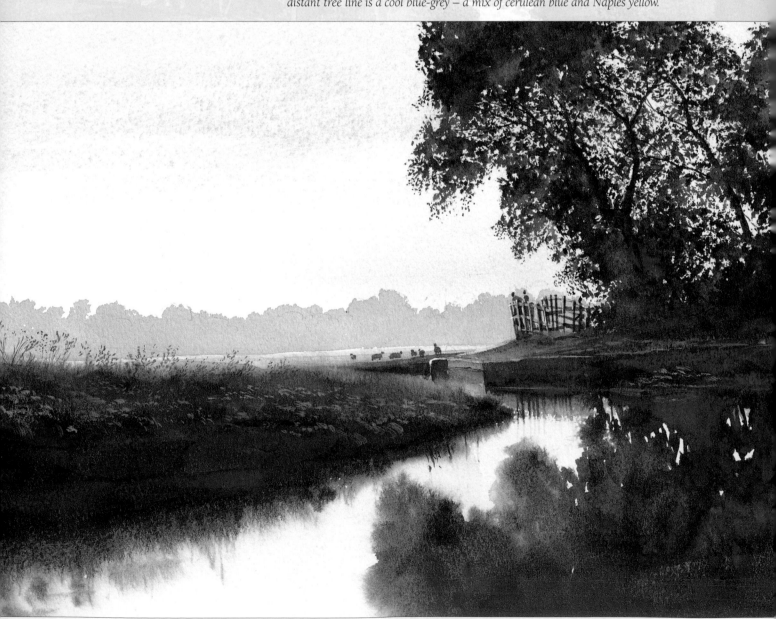

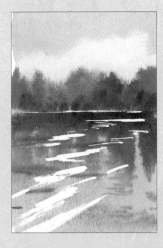

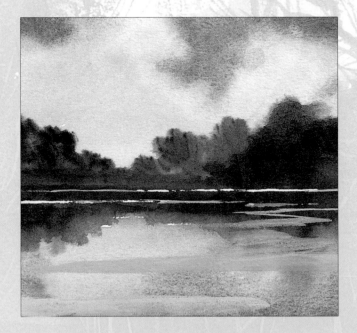

In the example on the left, I have used a little masking fluid in the distance to create sharp white lines, but the softer diagonal lines were achieved by overpainting with Chinese white mixed with a little blue.

Masking fluid (see page 27) will give a sharply defined lighting effect on water, and if necessary, a complicated pattern can be masked out in this way.

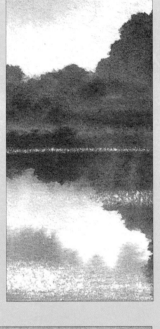

For a more speckled highlight, scratching out works well (see page 26). In this example (right), I have used a scalpel for the fine lines in the distance, and the broader lines were made using sandpaper.

For very soft results, rubbing out with an eraser is effective (see page 26). If you want to create a straight line, run the eraser along the edge of a ruler.

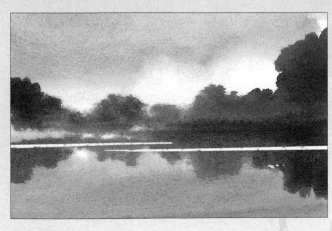

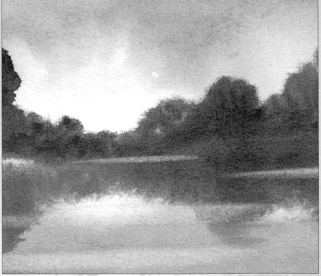

Cutting out (see page 27) can make a very sharp white line. I carefully cut two lines close together and strip out the thin sliver in between them. This is particularly useful if you missed the opportunity to mask out the area earlier.

To lift out, rub a wet brush over a section of paper a few times and dab away excess paint and water with a paper tissue. Larger areas may be removed with a sponge.

Winter Reflections

This scene is ideal for demonstrating watercolour techniques, since it includes not only the water and reflections but also sky, a grassy bank, foreground foliage and plenty of winter trees that lend themselves to dry brush work.

The water creates its own particular challenges. Watercolour is the ideal medium for capturing the fluid quality of water, but in applying the second layer of wash in this painting, you need to be careful not to lift off any of the first, leaving an unpleasant, patchy result. You also need to bear in mind that the tonal range of reflections is usually a little darker than the scene reflected.

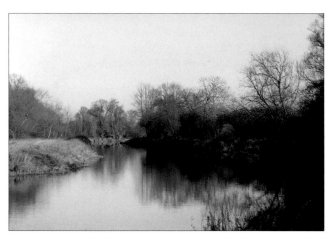

The reference photograph. This was particularly useful in this project, as there is a lot of detail in the winter trees. It was also used to check the tones of trees and their reflections.

The preliminary sketch is quite simple here. Use very light pressure when outlining the trees, otherwise you will leave unattractive lines in the wet paint.

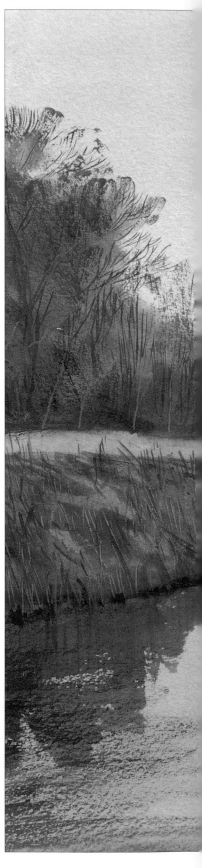

Winter Reflections
34 x 27.5cm (13½ x 10¾in)
The finished painting captures the mood of the scene. When you have gained confidence, results like this can be achieved quite quickly.

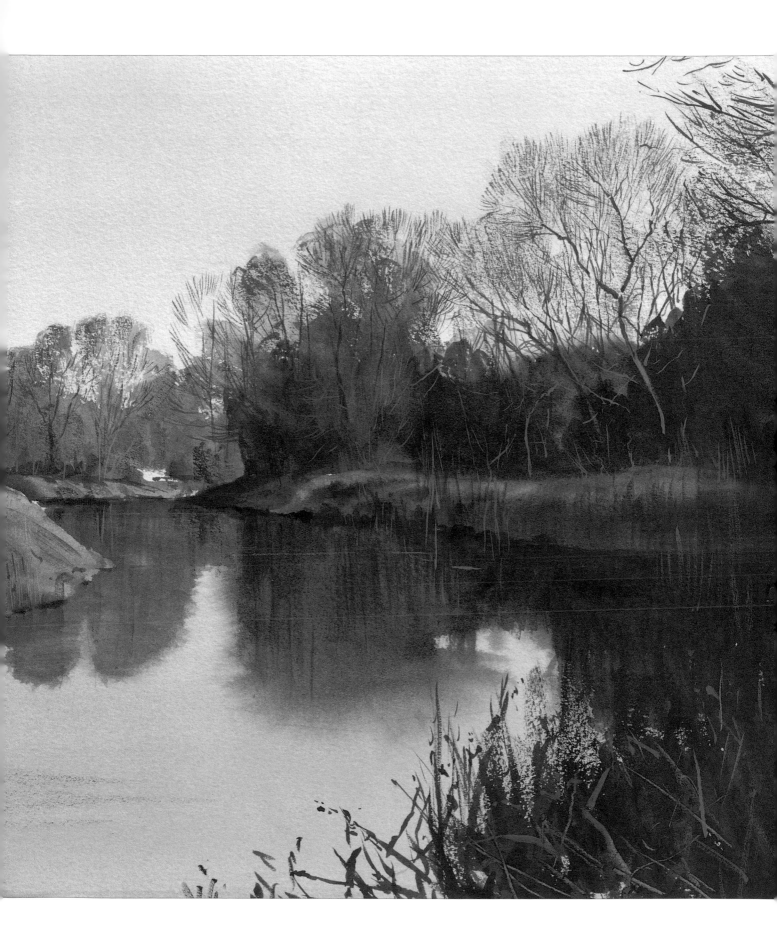

1 Wash over the whole area of sky and water with Naples yellow and crimson lake. Create a variegated wash by painting from right to left, beginning with mainly Naples yellow and adding more crimson lake to make the wash pinker on the left-hand side. Allow the wash to dry completely.

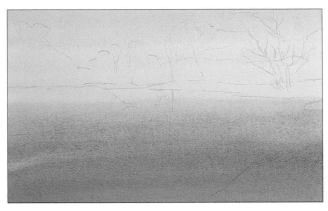

2 Use a large, soft wash brush that holds plenty of water for the second wash. Load the brush with intense blue for a strong, bright blue and wash down from the top. Wash with clear water in the middle band of the painting, and then with more blue at the bottom. Paint using only one brush stroke on any one area, or the brush will lift off the first wash from underneath. Allow the second wash to dry.

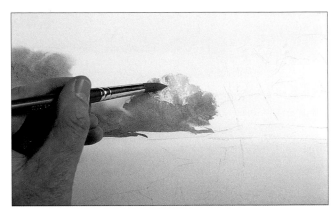

3 Soften the area of the background trees using clear water. Mix raw and burnt sienna and Naples yellow with a little ultramarine and alizarin crimson. Load a size 12 brush with the mix and remove excess water from the brush by dabbing with a paper tissue. Using the side of the brush and the dry brush technique, lightly touch it to the surface of the paper to create the distant trees.

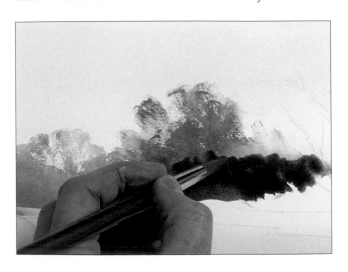

4 Soften the lower edge of the trees where they meet the grass, using clear water. Make a darker mix, adding more alizarin crimson and ultramarine to burnt sienna and raw sienna, for the right-hand side of the painting. Paint in the dark areas. Add more blue for the darker parts, and soften the edges with clear water.

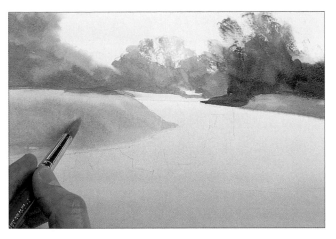

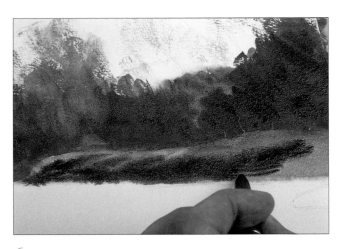

5 Mix Naples yellow and crimson lake and paint in the riverbank in the middle ground of the picture.

6 Continue painting in the twiggy areas of the trees using the dry brush technique and the dark mix. Wet the riverbank area on the right-hand side of the painting and use Indian red mixed with ultramarine to paint in the shadows.

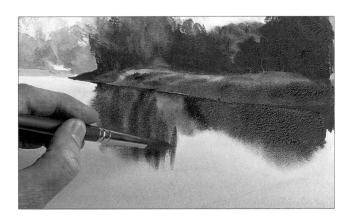

7 Wet the area of the reflection on the right-hand side of the painting. Mix Indian red and ultramarine and paint in the reflection. The paint will bleed into the wet background, creating soft edges. Add raw sienna as you go across towards the middle.

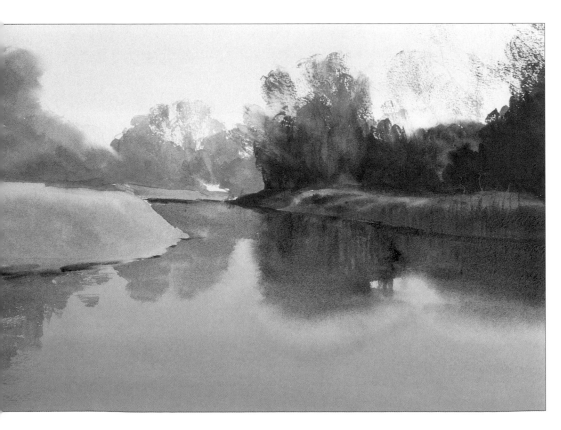

8 Use a watered down version of the same mix to paint in the reflections on the left-hand side. Use vertical strokes to create the textures and reflections on the water. Use burnt sienna for the line between the bank and the water on the left-hand side. Allow the painting to dry.

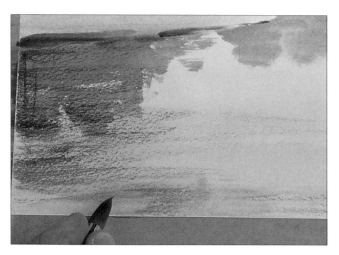

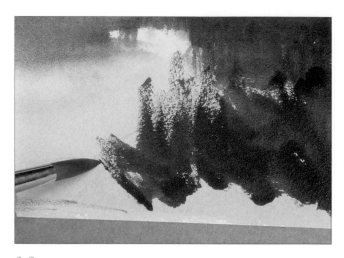

9 Mix Indian red and ultramarine and add dark reflections and shadows on the left-hand side of the water.

10 Begin to fill in the undergrowth in the foreground using a mix of Indian red, ultramarine and burnt sienna and a size 12 brush.

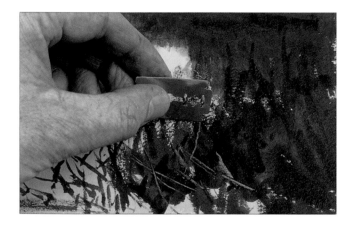

11 Using raw sienna, paint in the grass stems in the foreground undergrowth. Then take a razor blade and, while the paint is still wet, scratch out the texture in this area.

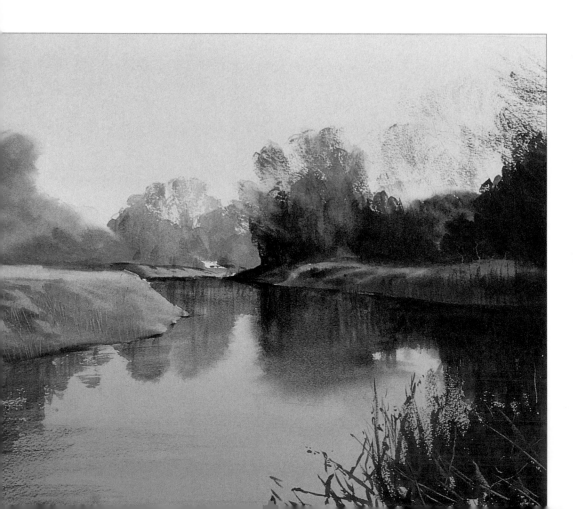

12 It is now time to begin adding finer details. Use burnt sienna and ultramarine to add vertical lines in the water. Mix ultramarine, raw sienna and crimson lake and add shadows and grass to the riverbank. Use a mix of scarlet lake and raw sienna for the water's edge. Paint a warm line along the top of the bank using cadmium yellow mixed with scarlet lake. Finally, scratch out the grasses on the left-hand bank using a razor blade or craft knife.

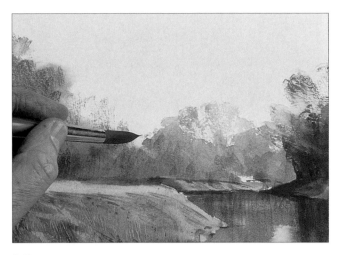

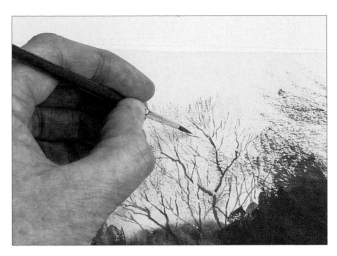

13 Add detail to the bank and the distant trees above it on the left-hand side of the painting, using burnt sienna.

14 Paint in the fine detail of the branches and twigs on the right-hand side using raw sienna, Indian red, burnt sienna and ultramarine blue. Use a size 6 brush for the branches and a size 2 for the very fine twigs.

15 Continue with the twigwork. Overpaint the highlights on the tree trunks using Naples yellow mixed with scarlet lake. Using the same mix, overpaint the foreground foliage and the surface ripples on the water.

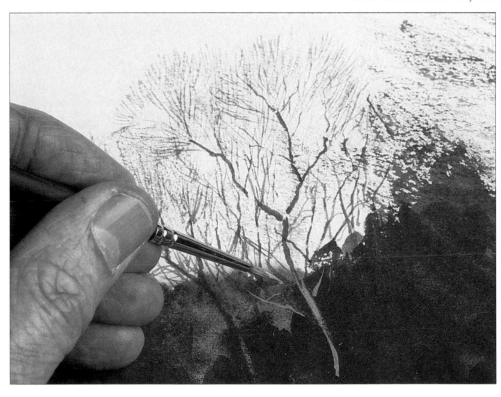

TIP

At this stage it is worth standing back and looking at the painting as a whole to see what needs to be added. With this painting I decided to add warmth to the reflections in the middle using raw sienna and scarlet lake on a size 12 brush.

The finished painting, also shown on pages 68–69.

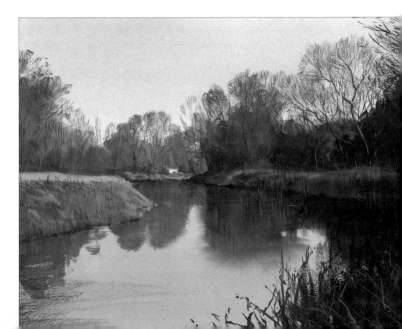

Ghost Gums

28 x 34.5cm (11 x 13½in)

A common sight at the water's edge in Central Australia are the ghost gum trees. Their white trunks reflect in the blue waters, making an excellent subject for watercolour. Masking fluid is useful here for painting out some of the branches that would otherwise be difficult to paint around. The landscape was brushed in briskly with a mix of Naples yellow and a touch of scarlet lake, leaving small areas in the background where the blue of the sky is visible. Detail and shape were then added with burnt sienna, scarlet lake and Indian red. Some of the shadows are quite vivid in colour: the dark shadow to the left was mixed with dioxazine violet and Indian red.

The base colour for the foliage is the same colour mix as the landscape. This was then worked over using the dry brush technique with a mix of raw sienna and ultramarine blue to give the patina of leaves.

The reflected scene was painted a little deeper in tone, and some edges were softened near the bank to give a convincing watery feel. A few brushstrokes were added to the surface of the water using a little Chinese white and Naples yellow, where there is movement in the water or where the light catches it.

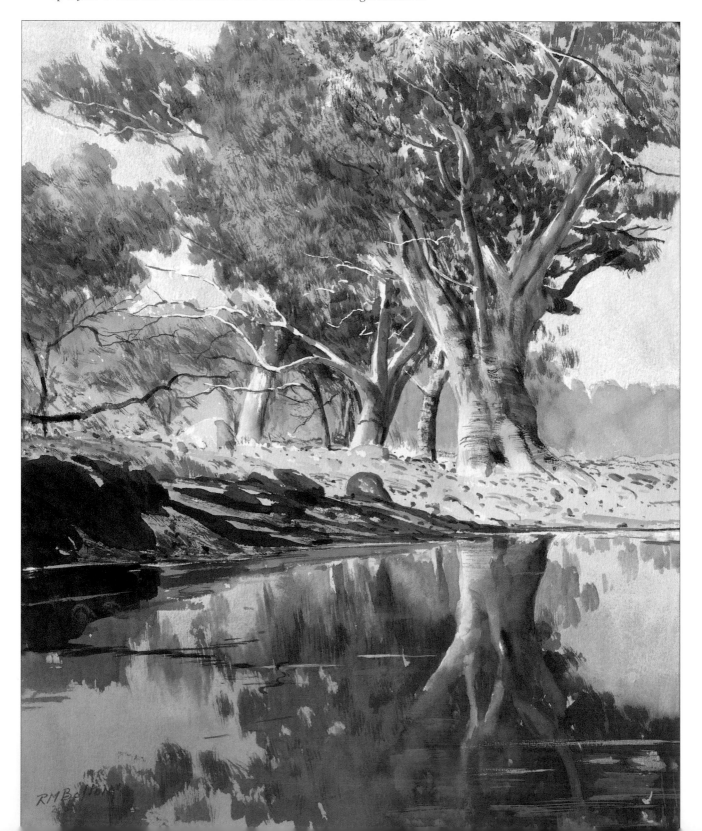

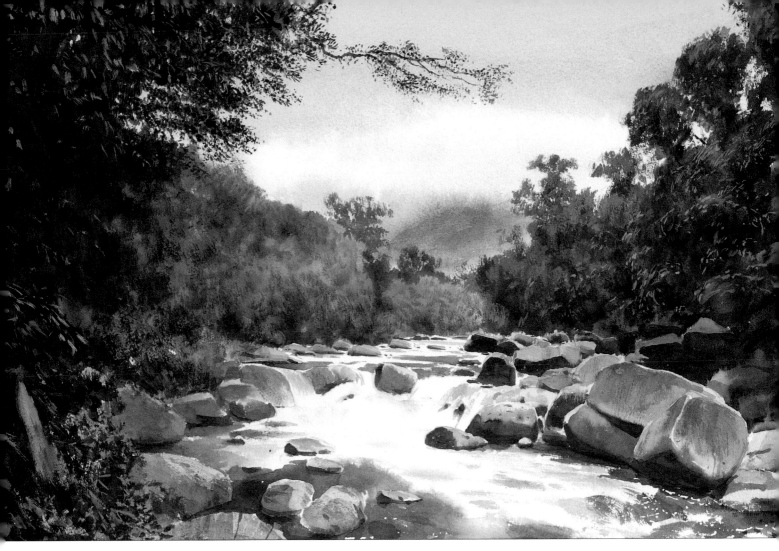

Mossman Gorge

53 x 35cm (21 x 13¾in)
The foliage here is quite a drab green, and would make rather a sombre scene if it were not for the foaming water cascading round the rocks. The white of the water contrasts well with the dark foliage. I used some masking fluid in some of the areas that would be difficult to brush around.

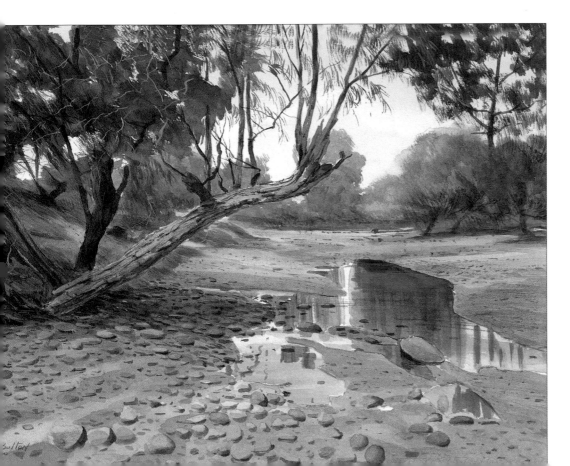

Riverbed Reflections

35 x 26cm (13¾ x 10¼)
It is surprising how simple things can make an attractive painting. Here I have concentrated on a patch of water, a few stones and a stunted tree. It is the puddle of water reflecting the blue sky that brings the painting to life. The painting has been kept simple, with only a suggestion of detail here and there. The closest work was picking out the ragged quality of the bark of the small tree.

75

Hills and mountains

It is important to remember, when tackling this area of landscape painting, that hills and mountains always have a discernible structure. If you look closely, you will see that there is a pattern to the way rock breaks up and to the way valleys are formed. The nearest mountains I have to paint are the Cambrians in Wales, said to be some of the oldest in the world. Here, the mountains are worn down to rounded humps and contrast dramatically with the towering, jagged peaks in Tibet that I have also painted.

When painting hills and mountains, it is easy to get caught up in detail and lose the sense of scale and distance. You need continually to stand back and assess your progress. It is easy to get the skyline wrong where it meets the mountains. There may hardly be a line at all if there is any haze, so avoid painting the sky down to the mountains and the mountains up to the sky. This is an easy mistake to make, but will give you an unnatural-looking hard line dividing the two, as shown below.

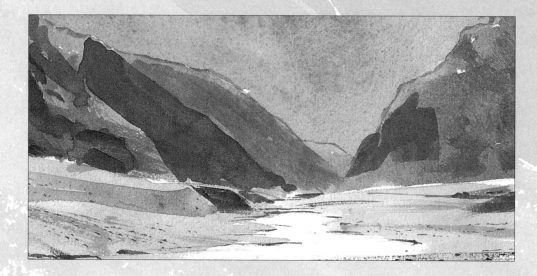

In this example, I have painted the background sky down to the outline of the mountains, and then met this line when brushing in the mountains. You can see why this does not work: a line has developed between the two.

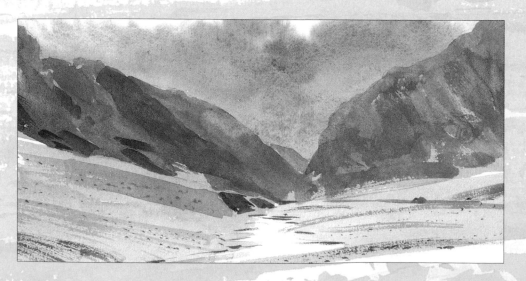

Here I have painted the sky right down to the base of the mountains, so that when I brush in the mountains, I do not create an unnatural-looking line.

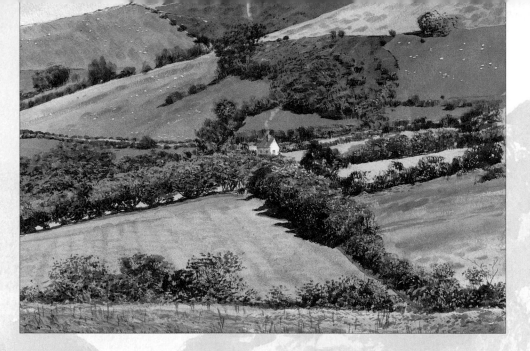

Hillside, Mid-Wales

31 x 22cm (12½ x 8½in)
The small white cottage offers a good focal point in the picture, and the patchwork of fields makes an interesting pattern. The ragged quality of the hedges has been created using a size 6 brush and the dry brush technique, carefully avoiding overloading the brush to get the correct textural qualities.

Yumbulangang Monastery

73 x 53cm (28¾ x 20¾in)
Situated on a rocky peak, the Tibetan monastery in the painting below presents a dramatic outline against the sky. The background was painted with speed and vigour to keep the painting lively. The mountains in the foreground were also painted in broadly with a mix of ultramarine blue and Indian red, and then the rough texture of the rocks was scrubbed in using the dry brush technique, with a lot more Indian red in the paint mix.

The figures add a welcome touch of colour. Figures are also useful indicators to scale in a landscape. Since the girl is wearing a white shirt, I had to use masking fluid at the outset to prevent losing the white of the paper during painting. Masking fluid was also used for the hands and faces. The darker colours of the skirts and headgear were overpainted.

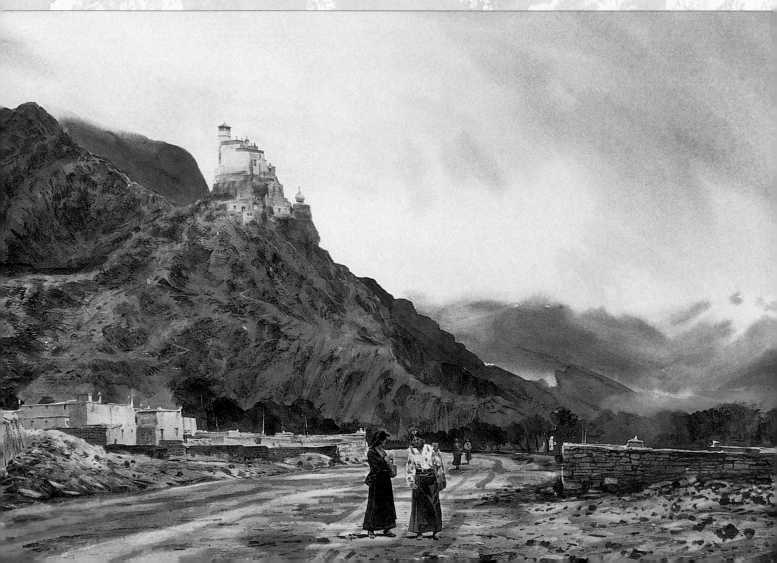

Mountain Stream

This is a painting of a valley in the Himalayas. However, the scene is quite modest and could represent a mountain scene in many parts of the world. As always, water adds something to the scene: in this case a babbling brook adds movement in the foreground.

The painting combines many different techniques. Masking fluid is used to mask out the white parts of the water and some of the highlights. The dry brush technique has many functions here: it creates a speckled effect on the green hillside, the texture of the rocky outcrops and the appearance of movement in the foreground water.

When painting the foreground, you need to work with the usual speed and spontaneity of the watercolour technique, creating the effect of a rocky area but without getting lost in the detail.

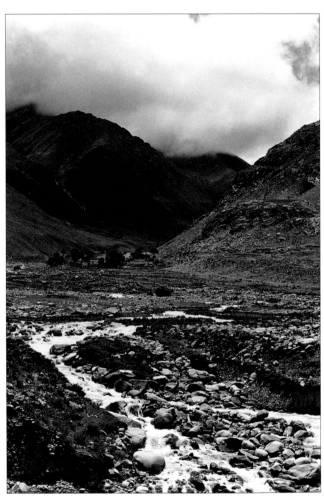

The reference photograph. You can see that the rocky area in the foreground has been reproduced fairly faithfully in the painting. Water brings a picture to life: this cascade of foaming water creates a lively pattern against the darker tones of the hillside.

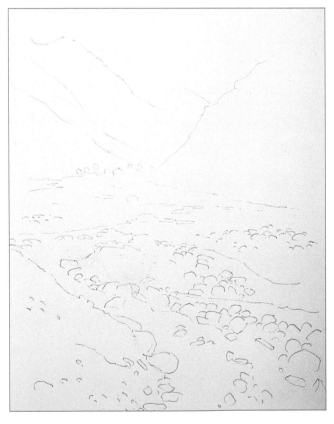

The preliminary sketch. Take a bit more time over drawing the rocks and stones in the foreground as it will be a great help as you work around them with the brush.

Opposite
Mountain Stream
26 x 33.5cm (10¼ x 13¼in)
The finished painting.

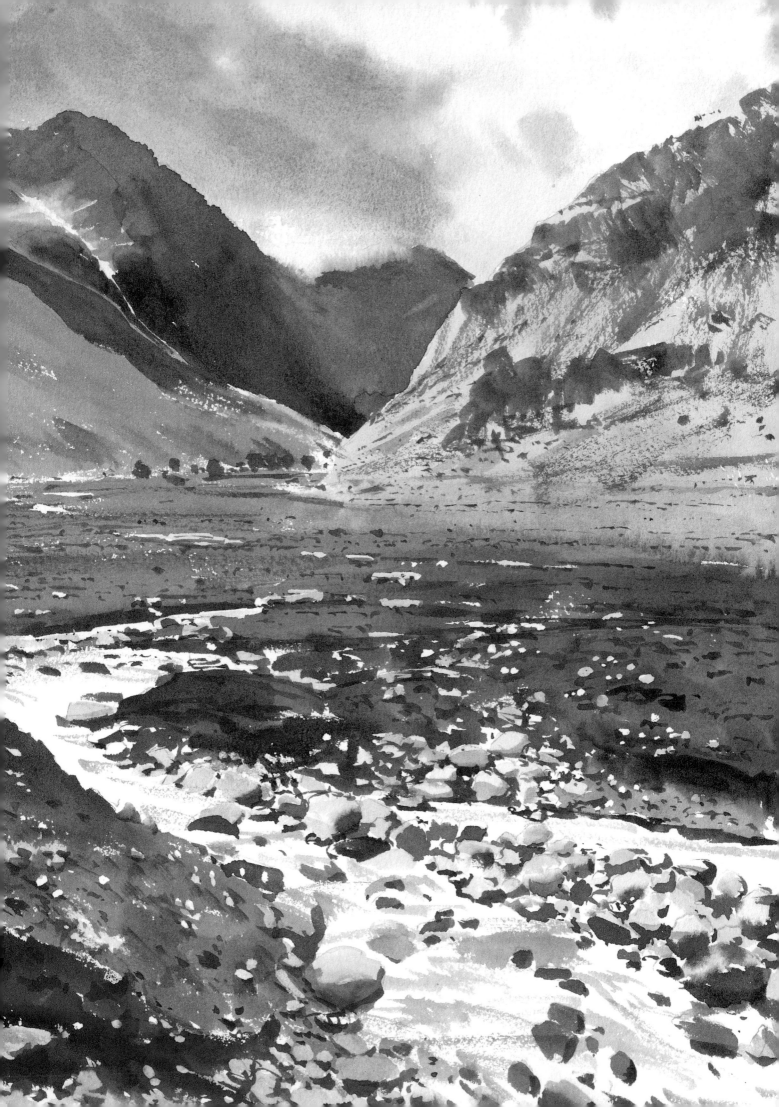

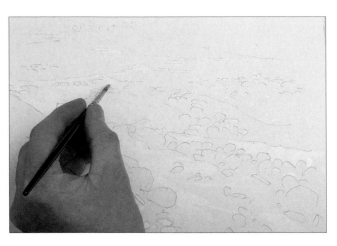

1 Mask out the white areas of the river and the highlights on the stones using masking fluid and a fine old brush.

TIP

A large brush will come to a fine point as well as a small one. Use two size 12 brushes for this project, one with clear water for softening edges – otherwise you will waste a lot of paint continually rinsing out your brush.

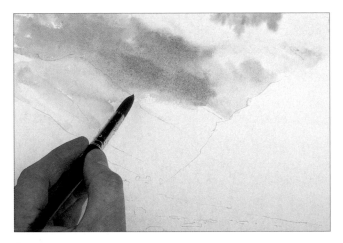

2 Wet the sky area of the painting, and some of the distant mountains, with clear water. Pick out the blue in the sky and the distant mountains using cerulean blue and a size 12 brush, painting wet in wet and allowing the blue to run into the wet paper. Paint the clouds wet in wet using a mix of ultramarine blue with a little burnt sienna. Paint a little vermilion into the white areas of the sky. Allow to dry.

3 Paint the dark mountains in the background using Prussian blue, cadmium yellow and burnt sienna. Soften the edge of the mountains where it meets the low cloud by running a wet brush over it.

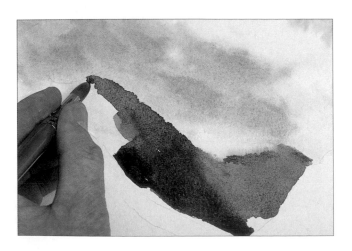

4 Create the jagged edge of the mountain by painting with the tip of your brush.

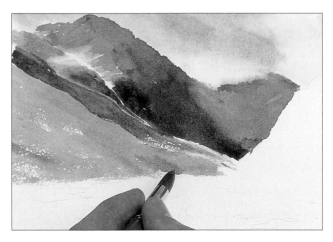

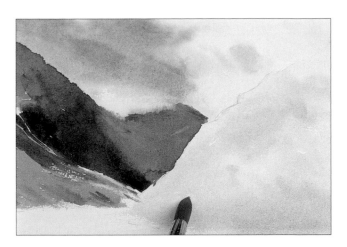

5 Fill in more of the dark mountain area using the same mix of Prussian blue, cadmium yellow and burnt sienna. Leave a white line for the stream. Using a lighter mix, fill in the more sunlit slopes, joining them to the darker areas to create soft edges. Use the dry brush technique to create a speckled white effect.

6 Wash in the warmer mountainside using a mix of raw sienna and burnt sienna.

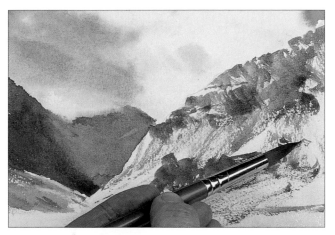

7 Use the dry brush technique and a mix of burnt sienna and ultramarine to paint the rocky outcrops on the warmer mountainside. The brush should be on its side, scuffing across the surface of the paper to achieve the desired rocky texture. Paint dots of shadow under the rocks with the same colour mix.

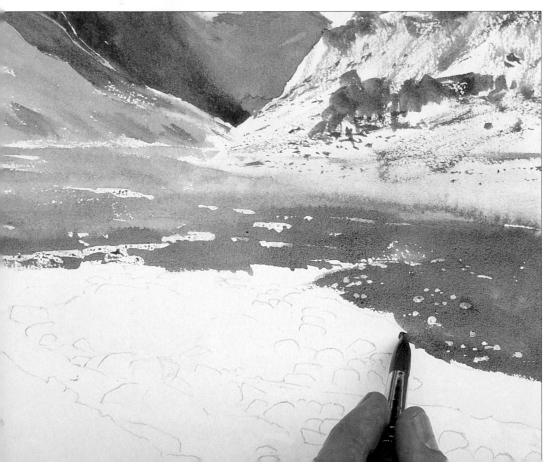

8 Paint in the greenish area towards the foreground using a mix of Prussian blue and a little raw sienna and burnt sienna. The brush should be fairly dry, so that the paint creates speckles on the surface of the Not paper. Soften the edges where the green meets the rock colour using clear water. As you paint nearer the foreground, use a stronger colour mix. Combined with the paler shades in the background, this creates the illusion of distance known as aerial perspective. The masked out areas will begin to show through at this stage.

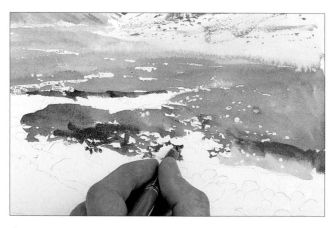

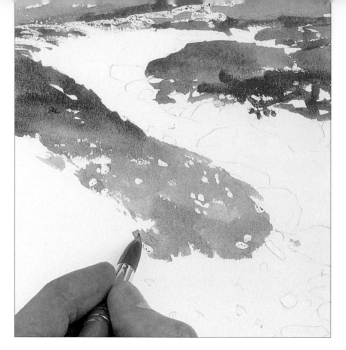

9 Start describing the rocks in the stream using the very tip of the brush and the same dark green mix as before. Do not get lost in the detail: create broad shapes and work quickly to maintain the spontaneity of the watercolour painting process.

10 Use the same mix to paint in the distant trees. Add a little emerald green and paint the grassy bank in the foreground.

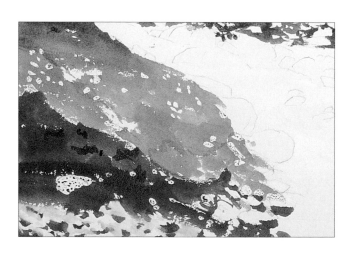

11 Wet the dark area under the grassy bank, and its reflection in the water, and paint it with a mix of Indian red and Prussian blue. Soften the edges with clear water.

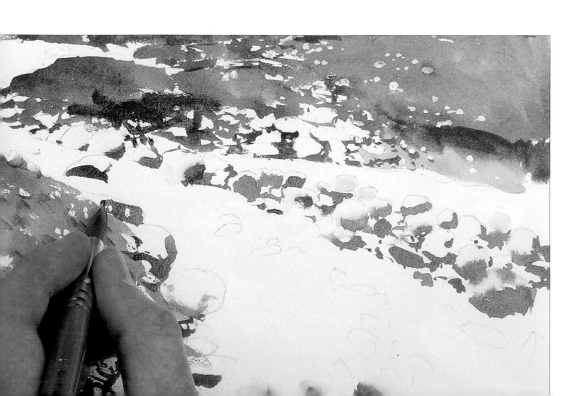

12 Use a mix of ultramarine blue and burnt sienna and the dry brush technique to work the rocks in the foreground. Softening the edges of rocks with water helps to describe their roundness.

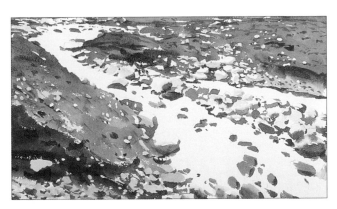

13 Rub off the masking fluid using an eraser. Paint in the highlights on the foreground rocks using a little ultramarine.

14 Continue adding form to the rocks in the foreground and middle distance, as well as other details, using ultramarine.

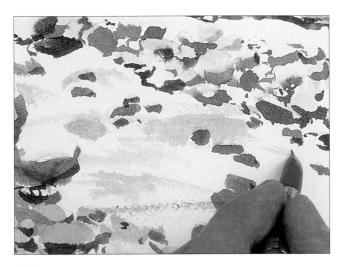

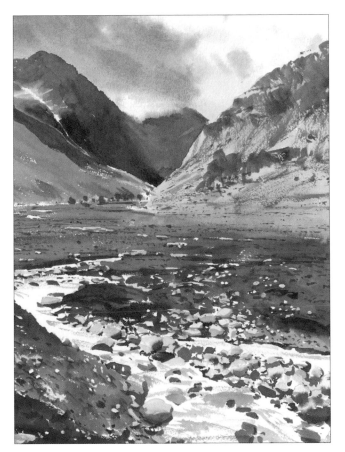

15 Mix cerulean blue, burnt sienna and raw sienna and use the dry brush technique to create the effect of movement in the water.

After standing back from this painting, I added warm highlights to some of the foreground and middle ground rocks using a mix of Naples yellow and vermilion.

The finished painting, also shown on page 79

Following pages:
Arthur's Pass
66 x 41cm (26 x 16¼in)
Snow is thawing on the hillsides of this mountain pass in New Zealand. The cool, clear sky reflects on the mountains and contrasts with the darker shades of the foreground.
The sense of distance is all-important in a view like this, and you can see that the snow-clad mountains are more strongly defined as they get closer to us. The same applies on the left, where the colours are stronger on the hillside close to us, while the slope behind has a blue, milky quality. Adding a little Chinese white to the background colours is a good way of achieving this effect.
This painting is a good example of avoiding hard lines between mountaintops and sky, as described on page 76: the snow-clad mountains merge with the sky, and are defined by their shadows only.

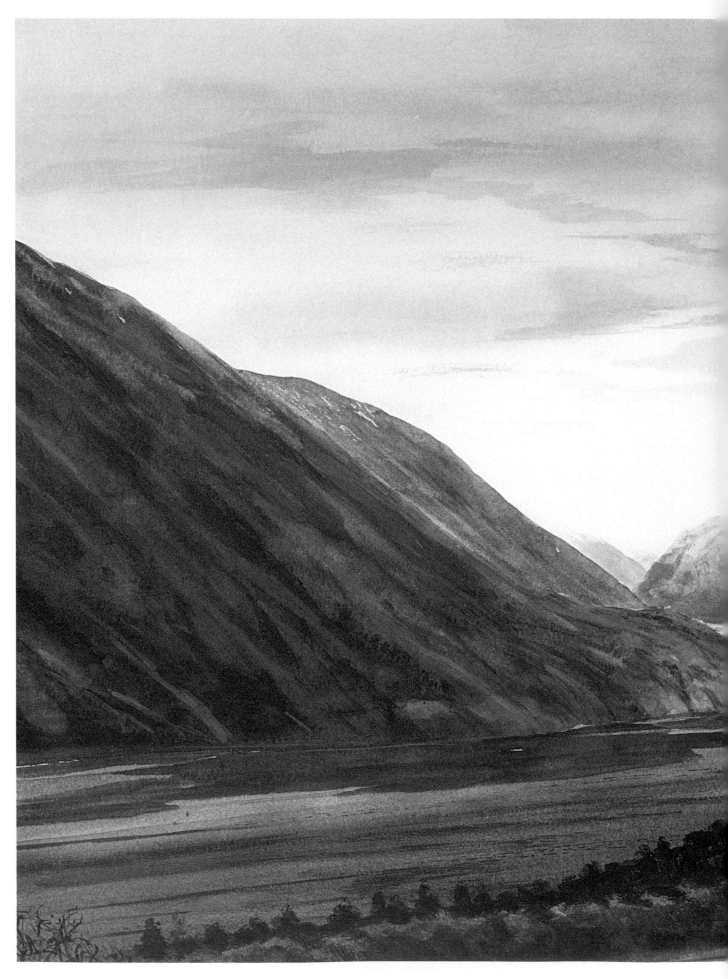

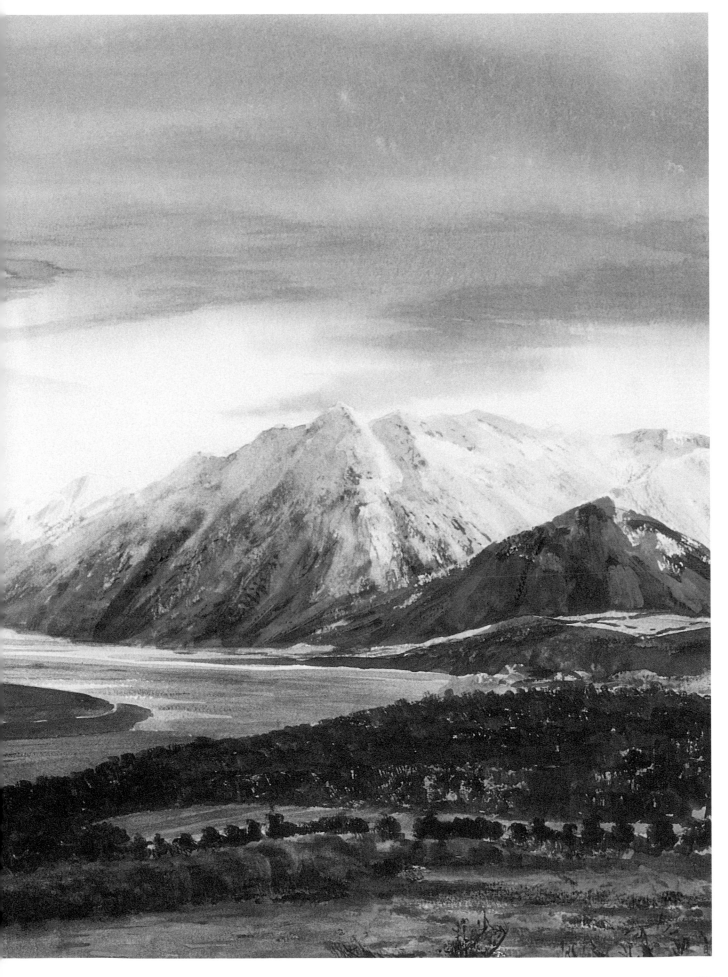

Snow and ice

Snow can be very dramatic in watercolour as the white of the paper shines through, giving the scene luminosity.

The thistles in the painting below make an interesting subject on a bitterly cold day, with their shadows cast by a watery sun.

There is little colour in this painting: it is mostly ultramarine blue and burnt umber, though there are touches of alizarin crimson on the thistles and a little added to the blue of the snow. Masking fluid was useful here to mask out track marks and highlights in the mud.

Church spires often feature in an English scene, and are a useful aid in composition. They help to indicate scale and distance, though care needs to be taken when painting to ensure that a spire is straight and vertical – it is very difficult to correct something that is set against the skyline.

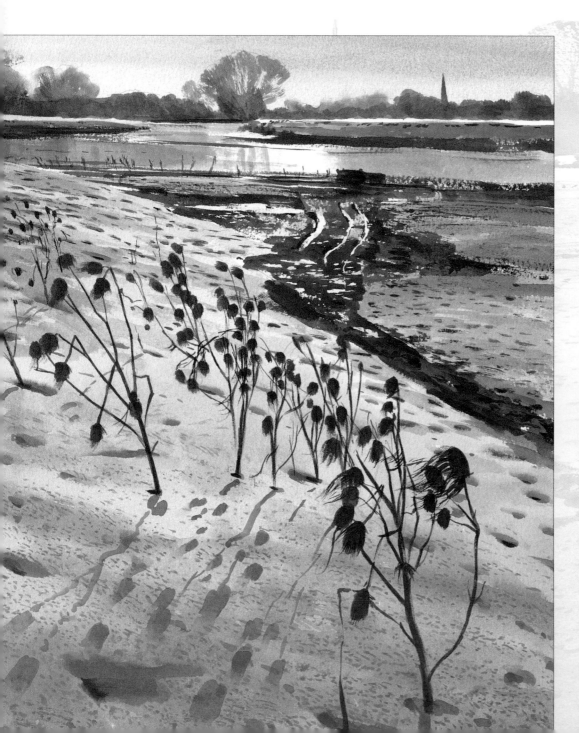

Thistles
26.5 x 34.5cm (10½ x 13½in)

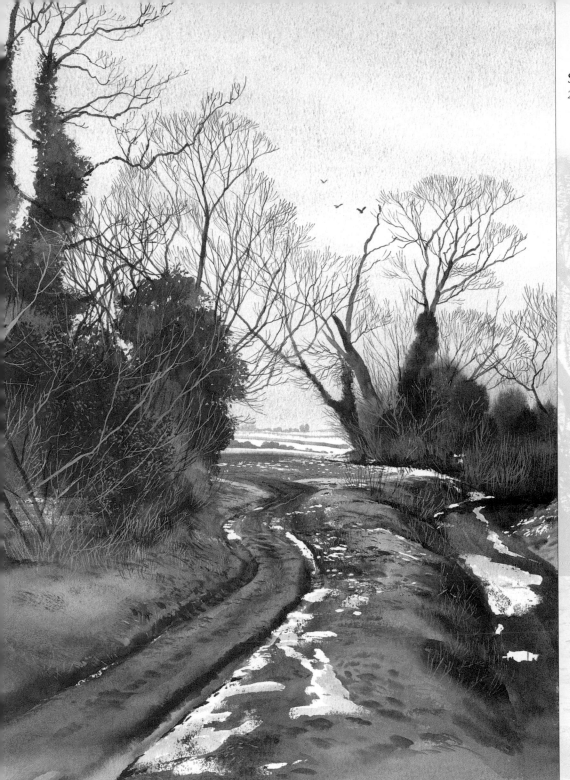

Snow Thaw
27 x 39cm (10¾ x 15½in)

In a painting like the one shown above, patches of snow are best masked out from the start. The great advantage of masking fluid is that it can be painted on in quite broad areas, but it can also be used for quite detailed work. In the field in this painting, small spots have been masked out to create the distant specks of snow.

The branches and twigs are a good subject to paint with the rigger brush. The long, thin hairs are ideal for sweeping in the many long, fine lines. In the same manner, some lighter blades of grass and twigs have been overpainted with a mix of Naples yellow gouache mixed with a little burnt sienna.

Tracks in the Snow

Simple scenes can take on great charm after a fall of snow. Even these tractor tracks in the mud look picturesque filled up with snow.

Snowy landscapes combined with brightness in a winter sky can create subtle and unusual lighting effects. These are captured in this painting by using four washes, one on top of the other.

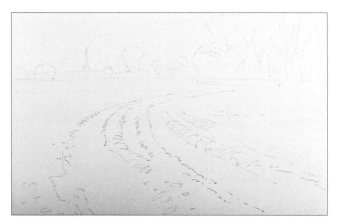

The preliminary sketch. Minimal drawing is required here, but take care that the church spire is correct, and perfectly vertical. It is the first thing that will catch the attention of the viewer.

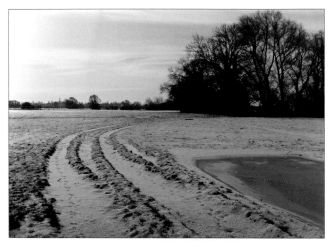

I composed this photograph with a painting in mind, with the tyre tracks leading the eye into the scene.

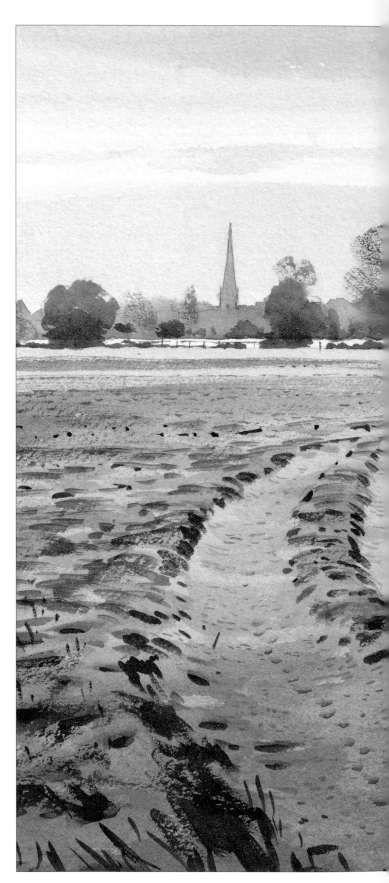

Tracks in the Snow
35 x 25.5cm (13¾ x 10in)
The finished painting

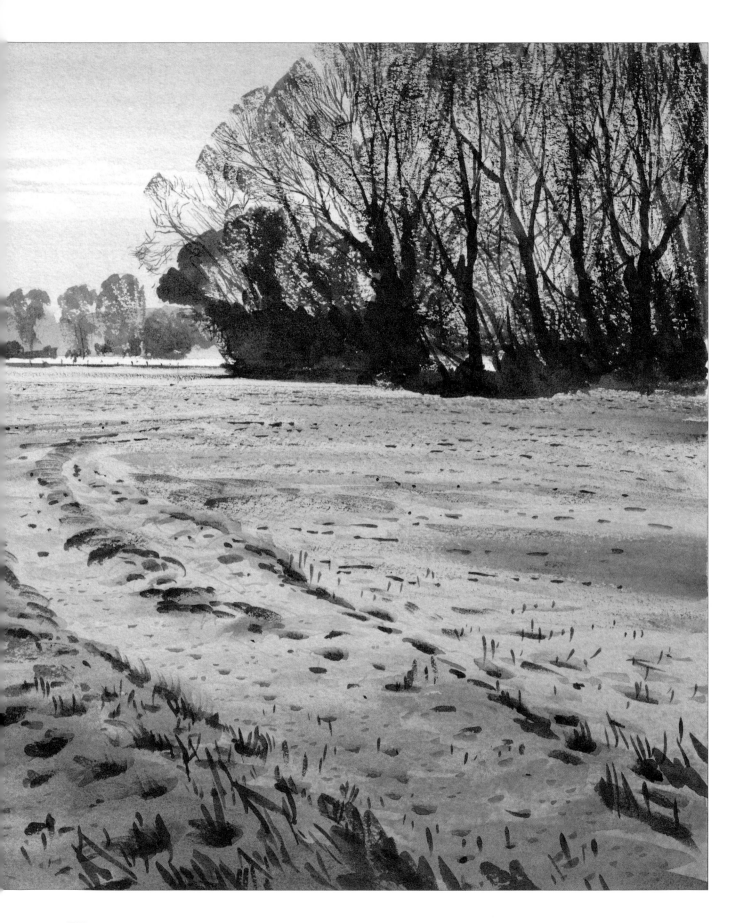

TIP

To make snow convincing, add animal tracks and footprints, dab the shadows of the
footprints in the snow and then soften the upper edge with clear water.

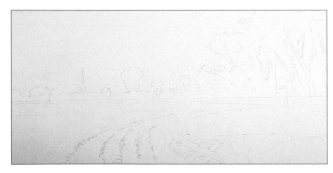

1 Apply a background wash for the sky, using a mix of
Naples yellow, cadmium yellow and a touch of scarlet lake.
Use a size 12 round brush and wash only down to the
horizon line.

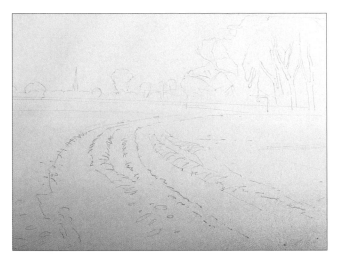

2 Start the second wash with the same mix at the top of
the painting. Add some more scarlet lake, making the colour
stronger as you come towards the foreground. Allow to dry.

3 Mix the sky wash from ultramarine with a little alizarin
crimson. Wash down from the top using a size 12 round
brush, leaving spaces for lighter areas of the sky. Soften the
edges using clear water. Allow to dry.

4 Mix a wash for the field
using ultramarine with
a little alizarin crimson.
Leave a strip of light in
the background and wash
down. Nearer the bottom
of the painting, the colour
should become stronger.

TIP

Take excess paint off
the bottom edge of the
painting by wiping with a
paper tissue, otherwise
there is a danger that
the wet paint will bleed
back into the dried wash
and create an unwanted
hard edge.

5 Soften the horizon line with a wet brush. Paint in the church spire and distant trees, using a mix of cerulean blue with a little alizarin crimson. Add a little opaque Chinese white to create the effect of distance.

6 Paint the trees and hedgerows just in front of the horizon line in burnt sienna mixed with ultramarine and a little alizarin crimson.

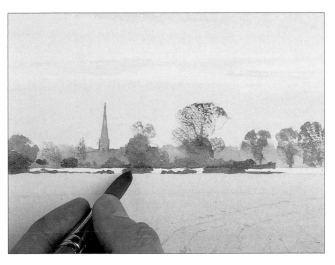

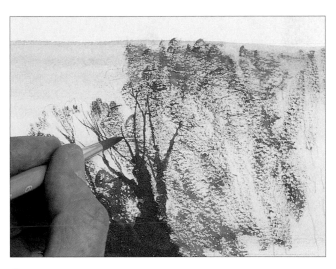

7 Use the dry brush technique, scuffing the paper with the side of the brush, to create the speckled effect of the winter trees. Add fence posts and other details.

8 Make a strong mix of burnt sienna, ultramarine and alizarin crimson. Take excess water off the size 12 brush with a paper tissue. Build up the large tree with the side of the brush to create the ragged edges. Pick out the branches with a size 6 brush.

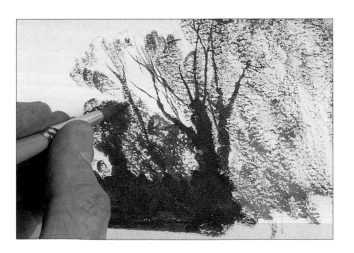

9 Pick out the finer details of the twigwork using a size 2 brush and the same strong mix, and working quickly to avoid becoming bogged down in the detail.

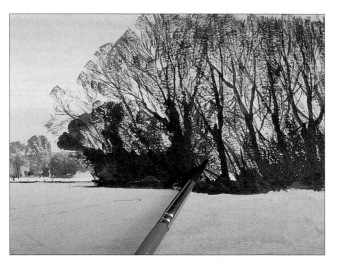

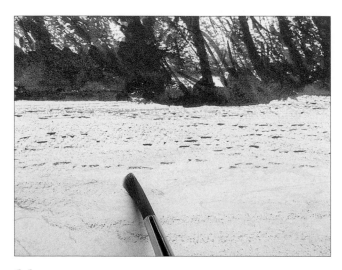

10 Block in the trunks using the dark mix and a size 12 round. Use a size 6 brush to complete the detail.

11 Drag a dry size 6 brush with a little of the same brown over the snow area to create texture. Take a size 2 brush and using the same colour, touch in the tufts of grass poking through the snow.

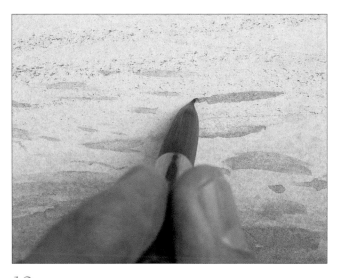

12 Paint in the shadows on the snow with ultramarine, and soften the edges using a wet size 12 brush.

13 Fill in the larger shadowed areas using ultramarine.

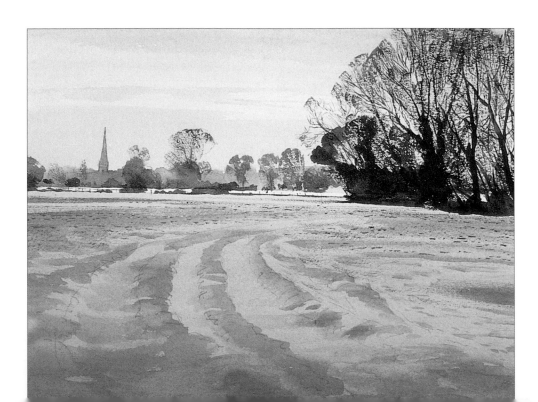

14 Paint in tyre tracks and all the remaining shadows on the snow, using ultramarine. Vary the depth of colour to suggest the dappled effect of light and shadow on the snow. Allow to dry.

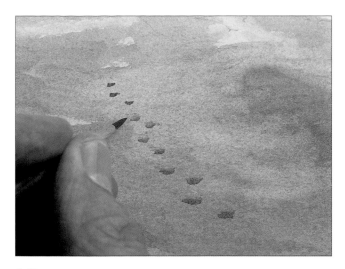 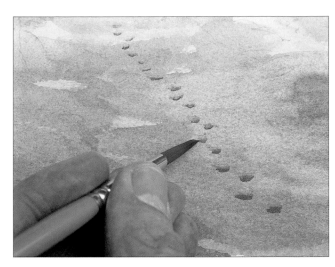

15 Paint in the footprints in the snow using a size 2 brush with ultramarine mixed with vermilion to grey it.

16 Soften the edges of the footprints using a wet size 6 brush.

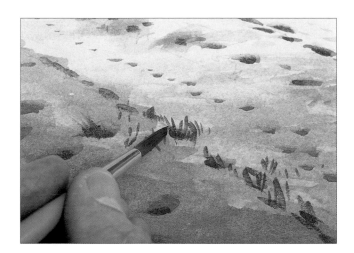

17 Mix sap green, burnt sienna and ultramarine and use a size 6 brush to paint in the areas of earth showing through the holes in the snow. Soften the top edges with a wet brush, to make it look as though tufts of wintry grass are growing through the holes. In the foreground, strengthen and warm the colour of the grass by using Indian red mixed with sap green.

Having surveyed the painting as a whole at this stage, I went on to add further tufts of grass over the blue shadowed areas, and details of tracks in the snow.

The finished painting, also shown on pages 88–89.

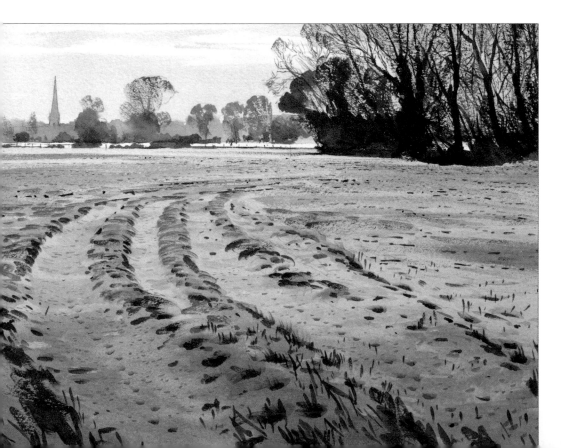

Problem solving

One factor that puts people off watercolour more than any other is the idea that a painting is permanent and that errors will remain there indelibly for ever. This is not quite true: we cannot make changes as easily as a painter in oils, but there are ways in which paintings can be rescued. As an example, I have taken a painting that has not worked out of my drawer.

The scene below showing the pollarded willow has become overworked and dull. This is a common problem that has ruined many a watercolour painting. Rather than discard this one, I have decided to try and rescue it.

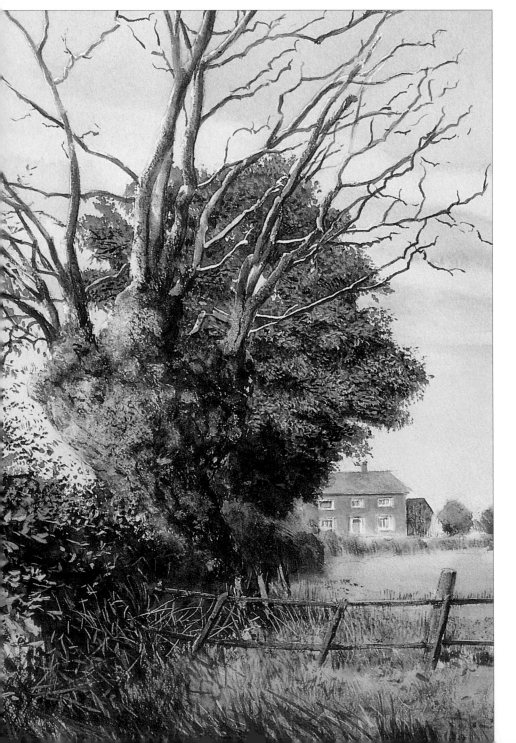

1 The first stage is to remove paint from where it has become overworked. This is done by sponging away paint from the tree trunk and surrounding undergrowth. Take care at this stage not to flood the painting with water: use just enough to wet the sponge. After a few gentle wipes, much of the colour will be removed, leaving a pale grey background – in this case a good colour for the tree trunk.

2 You can lift out some of the paint from the sponged area by dabbing carefully with a paper tissue.

3 Lift out any unwanted texture from the smaller areas such as the branches using a fine brush dipped in clear water. An oil painter's bristle brush is particularly good because it can scrub away the paint without doing any damage to the paper.

The finished painting. Once the overworked areas had been lifted out, I was able to have another go at painting them. The foreground is still in deep shadow but the detail of the willow is more effective this time.

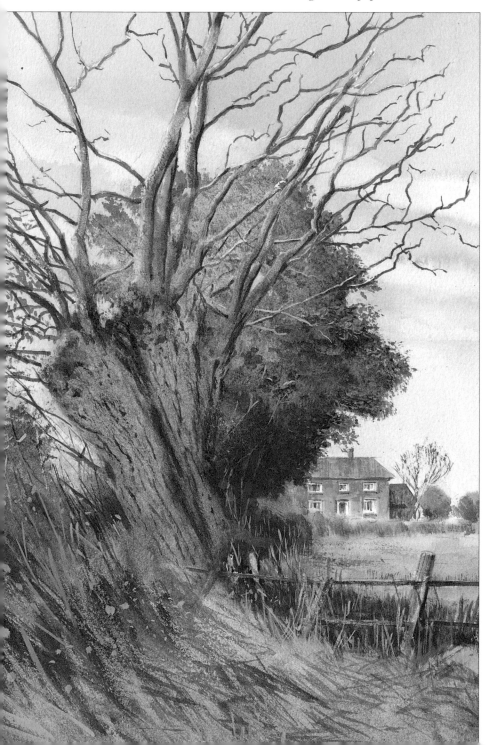

Corrections in the sky are much harder to achieve. Small areas sponged away are likely to stand out too much, so it is often best to wet the entire sky area and treat it as a whole. Use as large a brush or sponge as possible, to avoid streaks or marks.

Sometimes dark spots can be made in the sky where a tiny piece of rubber or dust attracts the surrounding paint. This is best avoided in the first place by sweeping the paper clean before starting a wash. When it does happen, the speck of dirt can be carefully lifted away on the tip of a damp fine brush. On no account use a brush fully charged with water: it will disperse on to the painted surface and leave an ugly patch on your painting. When dry, spots can also be removed by gently touching with a damp brush to remove colour, then dabbing with a paper tissue. A gentle touch is needed to avoid ending up with a white patch.

It might be tempting to try overpainting to rescue a painting by covering up the problem. This is unlikely to work, however. Watercolour is a transparent medium, and overpainting can spoil this quality, so is best reserved for minor additions of detail or texture. A popular way to disguise spots that disfigure the sky is to turn them into birds in flight: some of our greatest painters used this technique, so you would be in good company!

Hard edges can form when a wash dries, and this can be a serious problem. The greatest risk comes when you put a lot of water on the paper, hoping for a dramatic effect – usually in the sky. There is little you can do if hard edges form here: even if you immerse the painting in water and scrub, the marks will still remain. The only solution is to avoid them in the first place. To do this, tilt the painting and drain off excess water, and then use a paper towel to mop up round the edges. Place the board on a level surface and allow it to dry slowly. I like to add a little Naples yellow to my washes, as this seems to help prevent hard edges forming. Different papers have different characteristics, and you may be lucky and find that hard edges do not form on your preferred type of paper.

Washes can be built up in layers, one on top of the other. The danger is that the second wash may dissolve the first and you will see the evidence of this as stripes appear when you complete the second step. If the second

Hard edges like this are quite dramatic but can be a disaster in a sky wash.

wash is added while a section of the first wash is still damp, a whole section will be lifted away, leaving an ugly, irreparable mark.

Always make sure that the painting is completely dry before progressing. When you start the second wash, make sure you are using the biggest brush possible: the quicker and more efficiently you can complete the task, the better. As you apply the paint, ensure that the brush passes over each section once only. If you try to go back and make an amendment, this will lead to the lifting of the first wash. In small paintings, these problems are not so great, but in large paintings the risks increase greatly.

If for some reason the wash does emerge with stripes, the best thing to do is to take a clean sponge and clean as much of the paint away as possible, rubbing the paper gently so as not to damage it. This should remove the stripes and enable you to have another go.

The River at Funhuan (China)

41.5 x 32cm (16¼ x 12½in)
Given the difficulty of repairing mistakes in watercolour, it is important to get details like brickwork right the first time, as in this example. It helps to draw some fine construction lines first to keep the rows of bricks level. I also count the rows in a section to get the scale right. If you don't do this, it is very difficult to correct mistakes later. As I paint, I vary the colours as I go along, to bring out the age and irregularites of the structure.

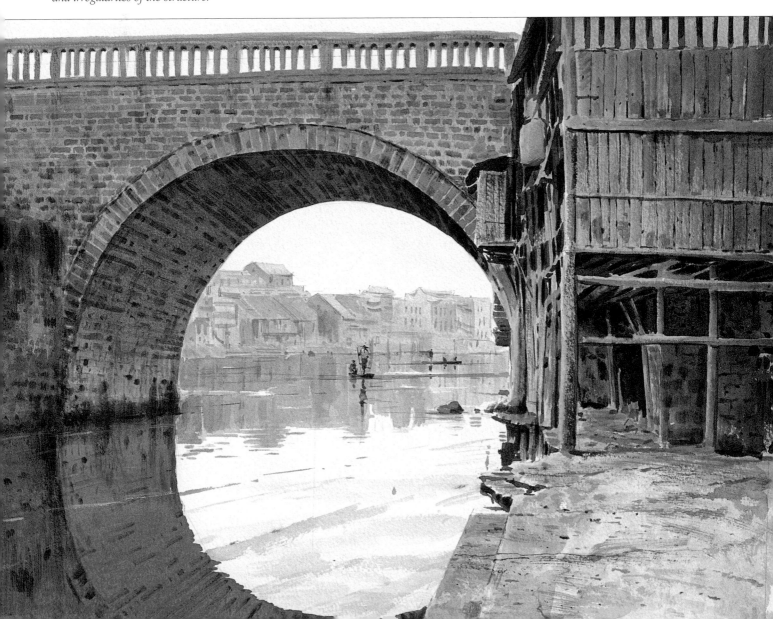

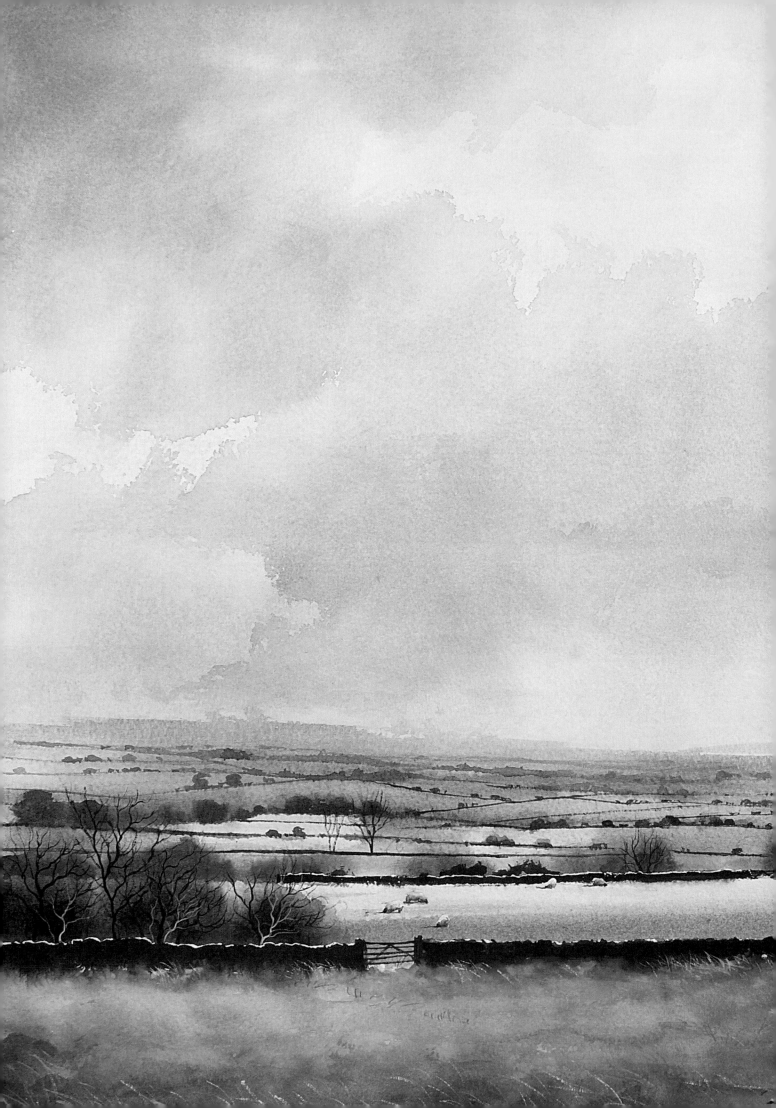

Painting Skies

Geoff Kersey

Learn how to paint a clear winter sky over a crisp snow scene,
a sky reflected in water, a stormy sky, a sunset in Venice and
more. Six easy-to-follow demonstrations show you how.

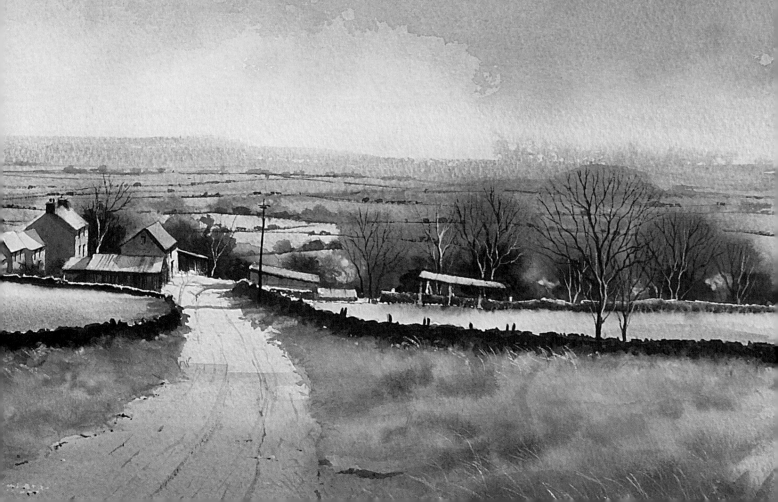

Introduction

Because the sky affects all the other main aspects of a landscape painting, I decided at the outset to make this section of the book about much more than just skies. I have endeavoured with each project to include sufficient information to help the reader to continue on from the sky to complete paintings with a coherent design, plus a sense of place and atmosphere.

When I am teaching watercolour landscape painting, I hear myself time and time again saying to students that the sky is the most important aspect of a landscape painting, as it sets the whole mood and atmosphere. I often advise aspiring artists that if the sky has not worked out, it is probably not worth continuing with the painting – better to put that one down to experience and start again. I put this advice into practice myself, and have a collection of abandoned projects to prove it.

I believe painting skies is actually the best way to learn how watercolour behaves. Practising the different techniques explained in this book is an excellent way to become more competent with the medium, learning to control it more effectively and discovering what it will and will not allow you to do. There will be disappointments and many mistakes along the way – this is how we learn – but in my experience, practice always pays off, and the successes will soon start to out-number the failures.

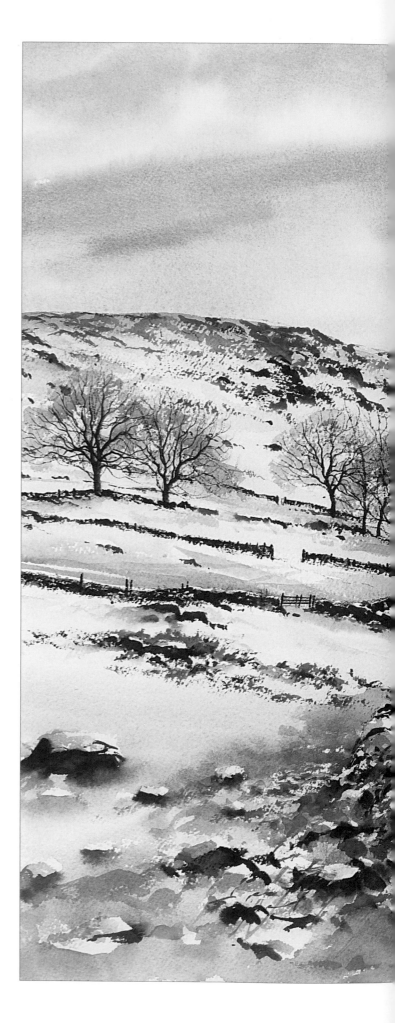

Winter on Baslow Edge
73 x 48cm (28¾ x 19in)

The grit-stone edges, which run for many miles through the Peak District, have provided me with numerous painting subjects over the years. In this scene I laid in a thin wash of quinacridone gold behind the hills, which made the blue/grey shadows and glimpses of white paper along the edge look cold and stark against the afternoon sky. I then introduced a few glimpses of the same colour in the middle distance and foreground to continue this theme.

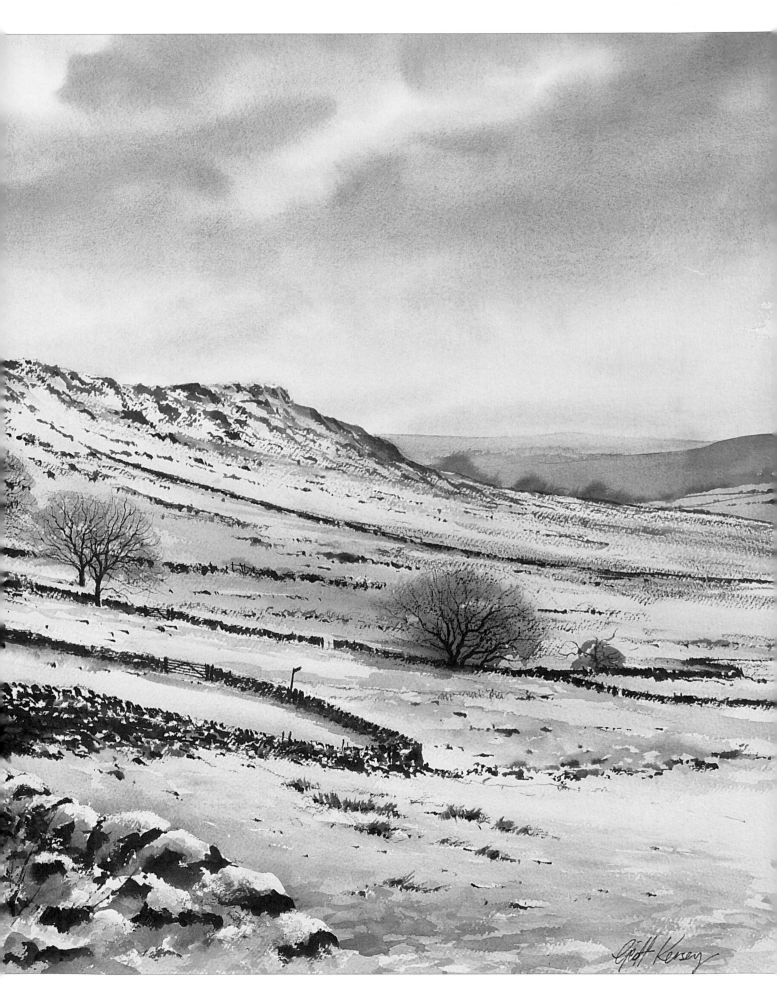

Materials

Choosing the right materials is a very subjective thing, as most artists have preferences based on previous experience. The choice is often influenced by familiarity, in that with products you have become used to, you know more or less what effect you are going to get. I recommend keeping an open mind, however; always be willing to try out a new colour or a brand of paper you have not used before.

Avoid the very cheapest materials, as you get what you pay for, but even good materials do get past their best. I have often noticed people in my classes struggling to depict detail with worn, blunted brushes, or trying to lay a wash with a brush that is too small, thus slowing themselves down and ending up with 'cauliflowers'. You will not be able to mix a good, fluid wash from a dried up tube of paint, and do not struggle with cheap paper that is either too thin or has a poor surface. You can not keep a painting clean and fresh looking if you are mixing your paints in too small a palette without enough separate sections, that has not been kept clean; and old, deteriorated masking fluid is likely to tear your paper when you remove it.

A selection of Hot pressed, Not and Rough papers.

Paper

I believe that choosing the correct paper has the biggest impact on the finished work, making certain effects much easier to achieve.

There are three basic surfaces, Hot pressed (smooth), Not or cold pressed (medium), and Rough, which is exactly as the name suggests. I prefer in general to use Rough as I use quite a lot of dry brush effects and the texture of the paper really lends itself to this, almost doing it for you. Occasionally I will use Not, particularly if I need a lot of fine lines and detail. Some brands of Not paper do still have a reasonable amount of texture.

The weight or thickness of the paper is also important. Most of the time I use 140lb (300gsm) but I do stretch it to prevent it from cockling. You can avoid stretching by using really heavy papers such as 300lb (640gsm), but I find that the surface changes with the weight and these papers are often double the price.

Lastly you need to consider the make up of the paper. Many cheaper papers are made from wood pulp, which creates a softer, less tough surface than the more expensive, cotton-based papers. These are more resilient, accept masking fluid without it damaging the surface and perform better all round.

Far left: Rough paper. The texture of the paper breaks up the brush marks to indicate foliage. Centre: Not or cold pressed paper. The foliage is still quite convincing, but it appears more solid as there are fewer white spaces. Left: hot pressed paper. With this smooth paper it is very difficult to achieve a broken or textured effect.

PAINT AND PALETTES

In common with many of the professional artists I know, I prefer to use artists' quality tube colours. As the paint squeezed from a tube is already half-way to liquid, it is much easier to make a good, fluid mixture and you do not have to rub away at a pan, blunting your brush. Pans are very useful for outdoor sketching, as they are simpler and less cumbersome to carry, but to get colour from a pan you need to add water, so it becomes more difficult to mix the stronger, richer colours.

In recent years I have noticed an improvement in students' quality paints and if cost is an issue, they make a decent alternative. Artists' quality paints however, do contain a higher ratio of pigment to gum so they tend to go further and last longer. There is also a larger range of colours available in the artists' quality and some of them do seem to be more vibrant.

My basic palette of colours is: cobalt blue, French ultramarine, quinacridone gold, cobalt violet, raw sienna, rose madder, aureolin, cerulean blue, burnt sienna, cadmium red, viridian, neutral tint, Naples yellow, lemon yellow and light red.

I also have a tube of white gouache for certain effects, but I do not keep it or mix it in my palette as any residue from it can make subsequent mixes grey and chalky. I do from time to time introduce other colours, but because there are only so many wells in the palette, I keep another palette handy for mixing these.

There are numerous palettes on the market, and again your choice will be subject to personal taste. I prefer a folding palette, so that at the end of a painting session, I can lay a piece of wet tissue over the fresh paint and close the lid to seal in the moisture. Once the fresh paint has dried out, it is never as good to work with as when it is in its semi-liquid state, so it is worth taking the time to do this. If I do not paint for a few days, I open up the palette and re-wet the tissue.

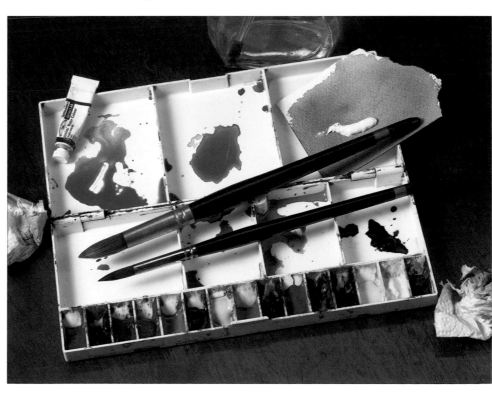

BRUSHES

I favour good synthetic brushes over sable, but I
think this is more a case of what I am used to. I find
synthetic brushes are springier and therefore return
to shape immediately they are lifted off the paper.
This makes them easier to control and not prone to
going limp. I have tried squirrel mops, hakes and
many brushes I have seen being promoted as having
an almost magic formula, but I keep returning to
basic synthetic rounds and flats. The one exception is
the extra large filbert or oval wash brush made from
part squirrel and part nylon. I often use this brush
for skies as I find it has the best of both worlds: it is
very absorbent and its flat profile enables me to cover
a large area of paper quickly, without the potential
for square shapes in the clouds that can result from a
standard flat brush. I also use a rigger or liner/writer
brush for fine twigs and branches.

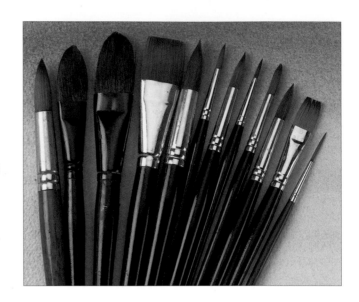

SKETCHING MATERIALS

When it comes to sketching I like to experiment with a variety of materials and
I feel more at liberty to work with different media. This is probably because I am
not trying to create work for sale or to exhibit – indeed I do not usually show my
sketches to anyone. This helps me to work more freely, to draw and sketch to
some extent for its own sake. It often happens that you can produce your most
creative and spontaneous work when you are not trying too hard.

 My main sketching materials are simply a sketchpad, a 2B pencil, a 6 or 8B
graphite stick and a putty rubber. I also use water-soluble graphite pencils to
create simple monochrome sketches and have recently discovered water-soluble
coloured graphite
pencils, which seem to
have plenty of potential.
For more details of my
approach to sketching
and the materials I use,
see the 'Drawing and
sketching' chapter on
pages 106–107.

OTHER MATERIALS

Gummed tape, staple gun and painting boards I sometimes use gummed tape for stretching paper, but it does not always stick to the paper's rough surface. You can use a staple gun instead, but only on a tough cotton or rag-based paper; wood pulp papers tear as they contract while drying. It is difficult to remove the staples from MDF board, which has the added disadvantage of being heavy, so I prefer 1.3cm (½in) plywood, which I buy from the DIY store and cut to size myself.

Hairdryer I use this to speed up the drying process during painting demonstrations. When time allows, I prefer to let washes dry naturally.

Ruler Very useful for painting straight lines such as telegraph posts or boat masts. Also for comparing the sizes of objects, to get a feeling for the correct ratios.

Craft knife This is for cutting paper and tape, but it can also make a good tool for scratching out to create grasses or twigs against a dark background.

Natural sponge I use this to give the clean paper a nice, even coating of water.

Soap This helps protect your masking fluid brush. I rub the brush on to a bar of soap before dipping it in the masking fluid, and it acts as a barrier.

Daylight bulb When painting in the studio, I always illuminate my work with two daylight bulbs in angle-poise lamps. These are designed to replicate natural light, and enable me to work in the same light conditions at any time of day and at any time of year.

A daylight bulb.

Stiff brush A stiff bristle brush like the type used in oil painting is useful for carefully removing areas of dried paint to make minor corrections.

Putty eraser This is the best type of eraser for removing graphite marks without damaging the paper surface.

A painting board, gummed tape, paper tissue, hairdryer, water jar, kitchen paper, ruler, craft knife, stiff bristle brush, candle, natural sponge, soap, putty erasers, masking tape, masking fluid and staple gun.

Masking tape This can be useful for masking out a totally flat horizon, or to leave a clean edge all round your finished painting.

Masking fluid In most of my paintings I use masking fluid in the early stages. I use a brand of thin fluid, which is kinder to brushes and the paper surface.

Candle Used for the wax resist technique, as in the painting on pages 156 and 157.

Kitchen paper This can be used for lifting paint to create sky effects.

Water container It is important to have plenty of clean water. I use a couple of large jars and change the water regularly.

Drawing and sketching

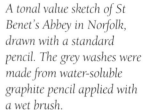

When I sketch outdoors, I do not put much detail in the sky with a pencil, as line is not the best medium for catching the fluid, soft, vaporous effects I am usually trying to achieve. As long as I return to the studio with enough information to work into a finished painting, I can more or less invent the sky based on previous experience, or work from a photograph, possibly with the additional help of a few colour notes.

In all the time I have spent teaching watercolour painting, I have never seen a good painting created from a bad drawing. Even loose, freely painted watercolours need to have a basic draughtsmanship and a sense of perspective and shape.

Unfortunately, for many people attending classes, the painting is the exciting part and the drawing is the necessary but uninteresting bit you have to go through before you can get cracking with the brushes. This virtual fear of drawing is often due to a lack of confidence which can be remedied by practice, and it is for this reason that time spent drawing and sketching is never wasted. Not only will it increase your drawing skills, but even more importantly, it will develop your powers of observation.

It is amazing what you can create using just pencils, paper and a putty rubber, but there is an ever-increasing range of materials that are fun to experiment with.

The drawing below is a tonal value sketch of St Benet's Abbey in Norfolk. I used an 8B water-soluble graphite pencil – some brands refer to this as dark wash – and a standard 2B pencil. I started by sketching in the main shapes in line only, with the standard pencil. I then scribbled a patch of graphite on a separate piece of paper using the water-soluble pencil, and rubbed over this with

A tonal value sketch of St Benet's Abbey in Norfolk, drawn with a standard pencil. The grey washes were made from water-soluble graphite pencil applied with a wet brush.

a wet number 8 brush to create a wash. By varying the amount of water you use, you can create grey washes of varying intensity to paint into the scene, in the same way as you would use hard watercolour pans but without the colour. You are creating a monochrome study in which it is essential to explore the full range of tones from very pale to almost black. You can then tighten this up by adding detail using either or both pencils. With this simple method it is amazing how much life you can get into a simple sketch.

The colour sketches shown below were done with coloured water-soluble graphite pencils, which I think will prove to be an excellent sketching medium. They are made of water-soluble graphite like the pencil used in the black and white sketch on the opposite page, but they come in a range of colours that become considerably brighter when you introduce water (see right). I have found I can get some interesting effects by using some scribbled patches of colour to create washes, and then sketching directly onto the wet background. This is very similar to the method used in the black and white sketch opposite, but with the addition of colour.

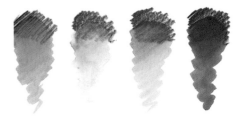

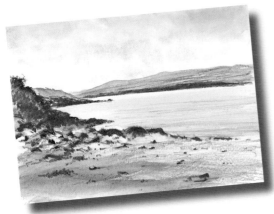
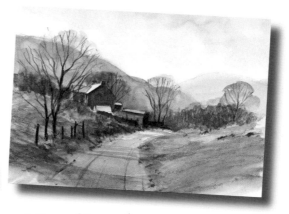

Sketches made using coloured water-soluble graphite pencils.

As a preliminary to a larger painting I often do a half-hour watercolour sketch like the one on the right to get the feel for the subject and try out some colour mixes. This is a 23 x 12.5cm (9 x 5in) evening study. Power station chimneys would not normally be thought of as an attractive inclusion in a landscape but I think in this scene they add a focal point and an opportunity to create a feeling of distance by making them slightly smaller and paler as they recede.

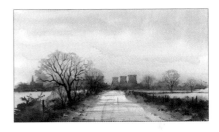

A watercolour sketch.

One of the simplest but most effective methods of establishing tonal values is the humble pencil, as used in these three sketches. I favour a 2B as it will give good strong marks if pressure is applied. I like to combine this with an 8B graphite stick, which is made of the same stuff as a pencil but is a lot broader, allowing you to work rapidly, filling in large areas of tone and preserving a feeling of spontaneity.

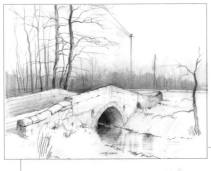

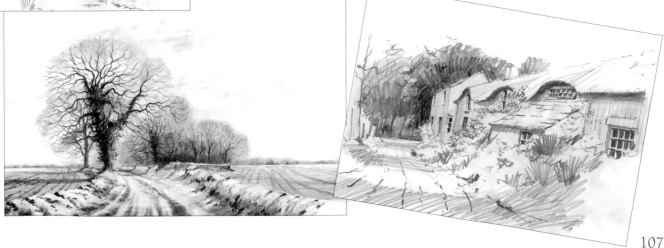

Using photographs

When I hold an exhibition of work at my gallery in Derbyshire, I always find it interesting to talk to the visitors. One of the most frequently asked questions is, 'Did you do these paintings on site?' I think people like to imagine the artist out in the wilds, painting directly from nature in all elements. While I think that painting outdoors is a very good discipline and can often give the finished work a feeling of spontaneity, I don't believe it is essential to creating a successful painting. You can still get that feeling of spontaneity and capture the mood and atmosphere of the scene by working from photographs if you bear in mind a few important guidelines.

The main thing to remember is that it is better to work from your own photograph. It is important that you composed the picture yourself and you know the place and are inspired by it. I also think it is a good idea to work on the painting as soon as possible after taking the picture; for this reason, the digital camera is a boon to artists.

The next thing to remember is to interpret the scene, rather than making a slavish copy of it. Take a bit of time at the outset to think what you want to achieve and ask yourself if you are happy with the composition, if not, what changes can you make to improve it? Thumbnail sketches can be useful at this point. Simplification – knowing what to put in and what to leave out – is also important. Interpreting your photographs and turning them into effective paintings takes a bit of practice and experience, so in this chapter I will show you some methods and techniques to make it easier.

On my last visit to the Lake District I was walking along the shore of Derwentwater. The afternoon sky was cloudy, with occasional gaps through which the sun shone, briefly illuminating the rippled surface of the water, creating bright shimmering reflections. It was a perfect opportunity to gather some subject material for paintings. When it came to creating a painting a week later in my studio, I found I preferred the composition in the top photograph, but liked the reflections in the bottom one, so I combined the best of both to create the painting shown below.

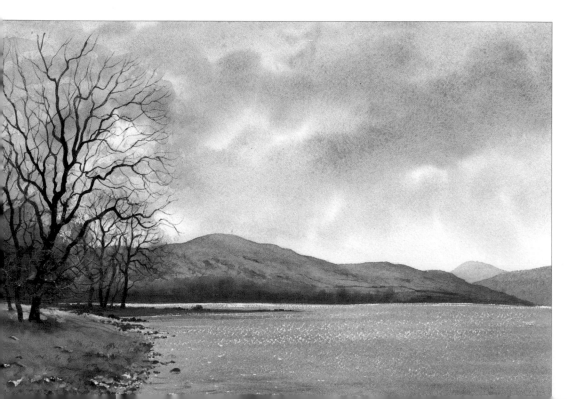

I decided to lighten the scene slightly to avoid too many black silhouettes and I included more detail. Laying in some grey washes, made with cobalt blue mixed with light red followed by cerulean blue mixed with rose madder, I created the sky. Before painting the water I gently rubbed over the dry paper with a wax candle. This was then over-laid with the colour mixes used in the sky. The wax resist created the sparkling effect.

The painting below is from a scene I came across on my way to a demonstration for an art club in Norfolk, early one frosty December morning. Conscious of the limited time, I parked the car and quickly took a few photographs; this is a good argument for always having your camera with you. Quick sketches done on site can be an excellent source of material and it keeps up your drawing practice, but I still believe I get more information from the camera.

On looking at the photograph (right), I decided to lower the horizon line to give me more sky – always a good feature in Norfolk – and bring the white-washed building, which is the focal point, over towards the right (see Composing from photographs on page 111). This left just a large, dark bush on the left-hand side which I didn't think was very interesting, so I imported a building and an old ivy-clad tree from another photograph I had taken just a few yards further down the lane (see right, below). I always enjoy the opportunity to show orange pan tiles against a blue sky, these colours are opposites and if they are placed together it gives the painting a lift. I used a mixture of Naples yellow and light red for the lower part of the sky and a cobalt blue wash followed by a neutral tint wash in the middle and upper part. Note also how I have darkened the trees to the left of the house to increase the counter-change and draw the viewer's eye to the focal point.

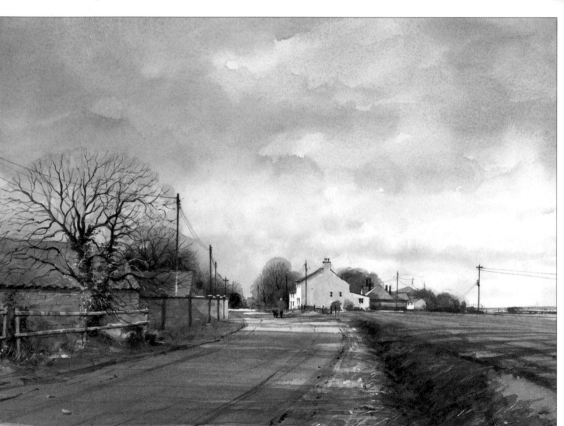

I received an email a few months later from the chairman of the art club I had been visiting, who had come across the finished painting at an exhibition. He recognised it immediately as being very near his home. He knew the place in the painting as soon as he saw it and said how much he liked it, but never mentioned anything about the liberties I had taken and changes I had made. Of course this could be because he was too polite, but I do believe you can get away with some fundamental changes to a scene, so long as you capture the feeling of the moment and essence of the subject. Use your photographs as an inspiration and a starting point rather than a rigid image to copy.

In the scene shown below I wanted to paint a wide, panoramic painting. I do not have a camera that can do this so I taped two photographs together. Getting a perfect join does not really matter, as the photographs are not an end in themselves but a means to an end.

I decided to leave out the cars as I felt they obscured any foreground interest, and I added the washing line to introduce a splash of colour and a suggestion of habitation. I do not always add figures but felt that the lone walker helped the composition and led the viewer into the scene. The phone box and speed restriction sign next to the dark green bush were left in, mainly to provide me with a contrasting splash of red. This is the same principle of complementary colours used in the painting on page 109.

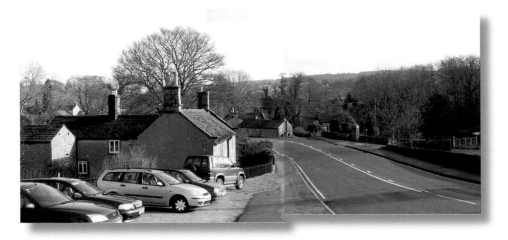

I decided to increase the warmth in the picture by using a soft pink glow made from Naples yellow mixed with rose madder. This was washed over the whole sheet of paper right at the outset to give the feeling that the whole scene is bathed in a milky, wintry, afternoon glow. After this wash was dry, I wet the sky area again with clean water and laid in a wash of cobalt blue mixed with a hint of cerulean blue at the top, fading this down towards the horizon.

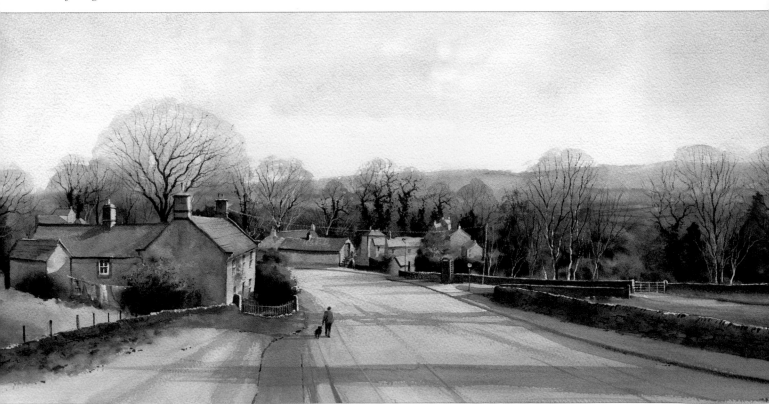

COMPOSING FROM PHOTOGRAPHS

It is always a good idea when composing your painting to remember the rule of thirds. This means that if you divide your paper into three equal sections across and three down, the four points at which these lines cross are excellent places to position your focal point (see Diagram 1). Note how in the example below, a compositional sketch for the painting on page 109, the house, which is the focal point, is positioned at point D. I moved the house there from the position it occupied in the photograph to improve the composition.

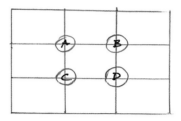

Diagram 1

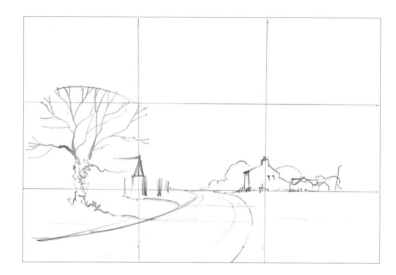

Another aspect of the rule of thirds is the simple L-shaped composition, shown in Diagram 2, right. Note how I have used this in the painting on page 108, the compositional sketch for which is shown below. L-shaped composition has also been used in the painting on page 109.

Diagram 2

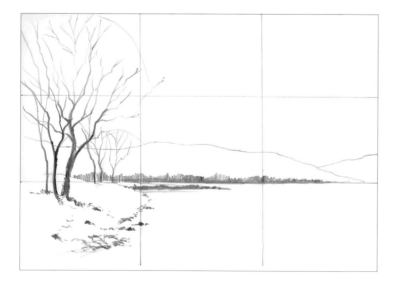

It is a good idea to train yourself to consider these compositional points when you are taking photographs, but remember that the photograph is only the starting point and you can make compositional alterations when you come to draw the scene ready to paint it.

Colour

In order to evoke atmosphere and successfully depict the landscape in different seasons, weather conditions and times of day, you need to have at your disposal a range of colours and tones that you can mix easily from your palette. This is particularly important if you are exhibiting a collection of work, and want to show some variation and breadth. Whilst it is good if the viewing public can easily recognise your paintings as being yours, this should be due to style and interpretation, not because every piece is rendered with the same limited colour formula.

It is a good idea to experiment, but I do not advocate trying to use every colour available. In a quick look through an art materials catalogue recently, I counted twelve variations on blue, twenty-two reds and at least twenty different yellows. It is amazing, however, the range you can create with just a few of these. The suggestions below make a good starting point.

In this chapter I have broken down sky colours into three categories: blues, greys and yellows.

TIP

Do not be afraid to experiment with new colour combinations and permutations.

BLUES

I mainly use three blues: cobalt blue, French ultramarine and cerulean. These all have different properties, but the main difference is in colour temperature: ultramarine is a warm blue, cerulean is cool, and cobalt falls somewhere in between. Look at the example below, which shows how you could use ultramarine at the top of a sky, graduating into cobalt in the middle and finishing with cerulean at the bottom. The idea behind this is that if the sky gradually appears paler and cooler towards the horizon, it helps to create a feeling of aerial perspective, or the illusion of distance.

GREYS

French ultramarine (warm)

cobalt blue (intermediate)

cerulean blue (cool)

A graduated wash using progressively cooler blues towards the horizon to create aerial perspective.

There are basically three greys that you can buy ready made – see right. You will see as you work through this book a few examples of skies painted using greys straight from the tube; however by using various mixes of blues and reds/mauves you can create numerous greys from cool to warm, from dark to light. I find a good rule of thumb is to use whichever blue is dominant in the particular sky you are painting to create the greys. Look at the examples shown below.

The big advantage of mixing greys is that you can create many variations by altering the ratio of the colours; for instance the more red/mauve added, the warmer the grey, whereas a lot of blue in the mix will create a cooler effect. In many examples the ingredients separate slightly, almost creating new colours within a colour. Good colours for achieving this effect are ultramarine, cerulean blue and light red (see below).

neutral tint Payne's gray Davy's gray

 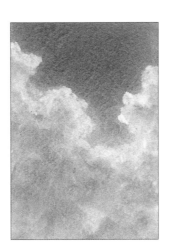 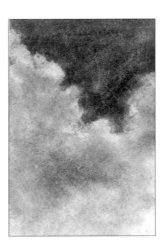

Far left: a cerulean blue sky. The grey is cerulean blue with rose madder. The blue and rose madder separate to create cool and warm greys within the cloud shadows.
Middle: a cobalt blue sky. The grey is cobalt blue with cobalt violet and burnt sienna. There is some separation of colours.
Left: a French ultramarine sky. The grey is ultramarine with light red – a good combination. If the light red dominates, the grey is warmer; if the blue dominates, it is cooler and darker, making a more threatening sky.

YELLOWS

Yellows also play an important part in the sky, as they are often required to take the stark whiteness off the paper and put a hint of a glow into the background. I find Naples yellow very useful as it is more of a cream colour than actual yellow and helps you to avoid inadvertently ending up with a hint of green. One note of caution: Naples yellow contains a lot of white so if it is too strong, it can result in a chalky grey mixture. Raw sienna is another one that is not overtly yellow, especially if you add a hint of red in the form of burnt sienna or light red. Aureolin is excellent for sunsets. I have recently discovered quinacridone gold, a very strong, very transparent yellow/orange, also ideal for putting a glow in the sky especially if you are depicting late afternoon or early evening in late summer or autumn. Look at the examples below: these are just a few of the mixes you can use as part of a sky. Take time to experiment with the different combinations.

raw sienna

raw sienna with a touch of burnt sienna

Naples yellow

Naples yellow and rose madder

aureolin

aureolin and vermilion

quinacridone gold

Techniques

WET IN WET

Always prepare all your mixes before you begin, since once you start to paint wet in wet, everything needs to happen very quickly. If you do not work quickly enough, you will soon find that rather than painting wet into wet, you are painting wet into damp. This causes uneven drying marks, often known as 'cauliflowers'. For this exercise, mix Naples yellow with a little rose madder; cobalt blue with a touch of rose madder to warm it; cobalt blue with a little more rose madder and burnt sienna added to make a warm grey.

TIP

Wash the brush well after using Naples yellow. The white in it will turn a chalky grey if it comes into contact with blue.

1 Wet the background with a sponge and clean water, working horizontally from the top down. There should be no puddles of water, just an even coating.

2 Take the filbert wash brush and pick up the Naples yellow and rose madder mix. Use the side of the brush to float in a tint in the bottom half of the sky to take the white off the paper. Using the side of the brush avoids the effect of a visible repeated shape of the brush point, which would not look natural.

3 Next, pick up the cobalt blue and rose madder mix and paint it across the top, leaving some areas white. These white areas give the impression of cloud and light.

4 Pick up the warm grey mix and paint it in wet in wet to make the sky darker at the top.

TIP

Make sure that your sky is darker at the top, lightening towards the horizon. This helps to create a feeling of distance by means of aerial perspective.

TIP

Your brush may shed hairs on to your painting. When painting wet in wet in this way, it is important to leave the hairs where they are until the painting is dry.

5 Mix the same grey with the Naples yellow and rose madder mix and suggest cloud shadow in the lower part of the sky.

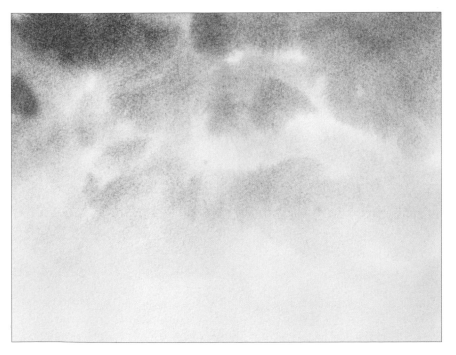

The finished sky.

LIFTING OUT

First make two blue mixes, one warm for the top part of the sky and one cooler. Painting a cooler blue near the horizon helps to create the illusion of distance. The warmer mix is cobalt blue and ultramarine blue; the cooler one is made from cobalt blue and cerulean blue.

1 Wet the whole sky area with a sponge. Take a 2.5cm (1in) flat brush and paint the cobalt blue and ultramarine blue mix from the top down, applying plenty of colour.

2 Half-way down, change to the cooler blue mix. Towards the horizon, fade out the cool blue by adding clean water.

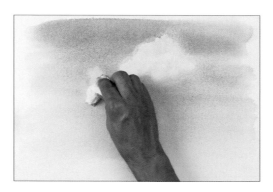

3 While the sky is wet, take a piece of paper tissue and lift out cloud shapes. This needs to be done immediately, as once the paint has started to dry, it will not lift off.

4 Continue lifting out cloud shapes, working quickly while the paint is wet. Vary the shape and size of the clouds to keep them looking natural. You will find that the more pressure you apply, the more paint you lift off. If you apply less pressure to the lower part of a cloud, it leaves a hint of blue, making the cloud look more three-dimensional.

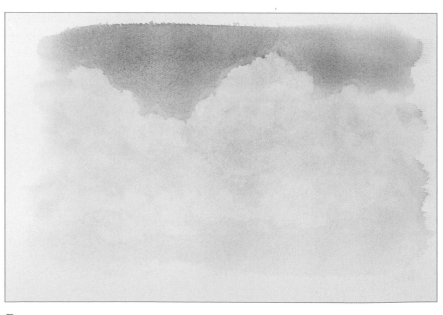

5 When you have finished lifting out cloud shapes, allow the painting to dry. You will often find that you already have a good sky and you do not need to do any more to it. However, you can develop the sky further by following steps 6 and 7.

6 Mix cobalt blue with rose madder and a touch of burnt sienna to make a warm grey. Take the no. 16 brush and re-wet one cloud shape, leaving dry paper round the top of the shape.

TIP

You need to wet one cloud at a time to add the cloud shadows, otherwise in the time it takes you to work on one, the others will have dried.

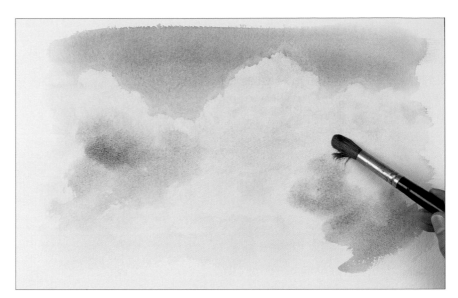

7 Drop in the grey to create a cloud shadow. Working from the centre of the wet area, watch the colour as it spreads slowly into the wet background. You want to achieve soft, diffused shapes, not hard edges. If you see hard edges forming, you can soften these with a damp, clean brush.

The finished sky. This method was used to create the sky in the painting on page 155.

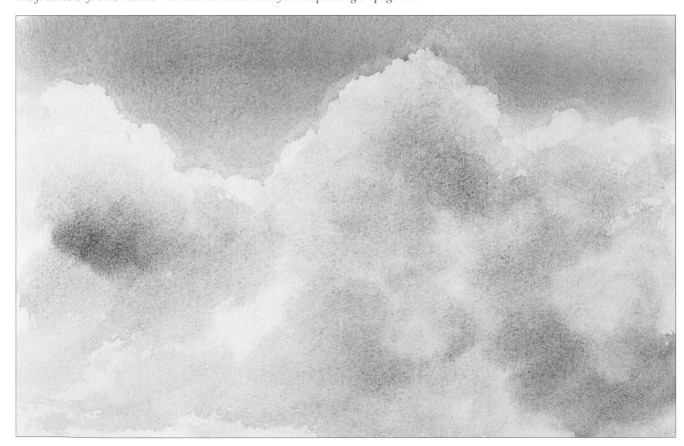

A GRADUATED WASH WITH STREAKS LIFTED OUT

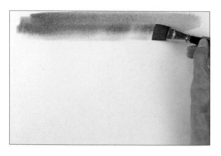

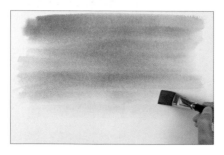

TIP
Angle the board slightly to ensure that different mixes blend in without creating stripes.

1 Mix ultramarine blue and cobalt blue. Wet the paper with a sponge. Take a 2.5cm (1in) flat brush loaded with colour and begin to paint from the top down with horizontal strokes.

2 Work down the sky area and about two-thirds of the way down, add clear water to fade out the colour.

3 Clean the brush and dry it on a tissue. Holding the brush on its side, lift out streaks of cloud from the wet wash, twisting the brush as you go. Lift out the streaks at a slight angle.

4 Continue lifting out streaks, cleaning and drying the brush as you go to keep the brush thirsty. This is important because if you do not keep the brush clean, you will just be moving the blue around rather than lifting it out.

5 Lower down the sky, make smaller streaks. If the streaks get smaller nearer to the horizon, it helps to create the essential feeling of distance.

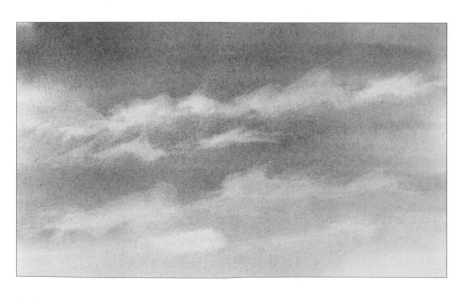

The finished sky.

A WET ON DRY SKY

First prepare three washes: cobalt blue; Naples yellow with a little light red; and neutral tint.

1 Wet the paper using a no. 16 brush and clean water, leaving a few dry spaces which will later suggest clouds.

2 Float the blue wash into the water on the paper and see what shapes emerge. Some of the best effects created using this method are accidental.

3 Clean the brush thoroughly before picking up the Naples yellow and light red mix. Paint this towards the bottom of the painting and in the dry areas. Allow the painting to dry.

TIP

Use thin washes for glazes so that they do not obscure the dried paint underneath.

4 Glaze on another layer of colour with the no. 16 brush and the neutral tint wash. Start at the top left.

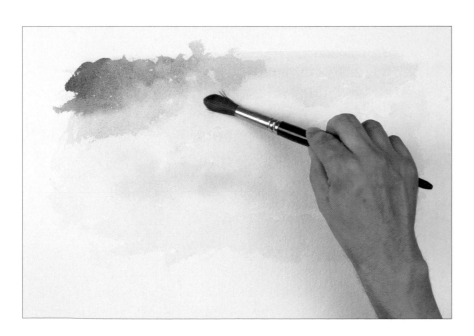

5 Use a clean, damp brush to soften in the dark clouds.

119

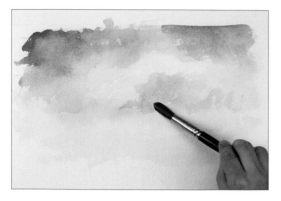

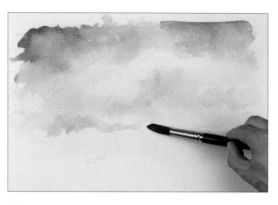

6 Paint more dark cloud at the top right-hand side using the neutral tint wash, then add cloud shadows in the middle and soften the edges using clean water.

7 Paint smaller cloud shapes towards the horizon, still using the neutral tint wash, and soften them in the same way.

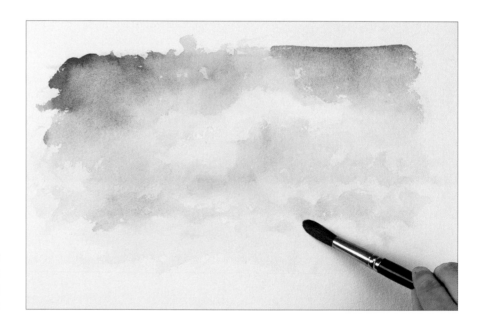

8 Soften any hard edges in the sky using clean water. Make sure the brush is not too wet as it is important not to flood the paper.

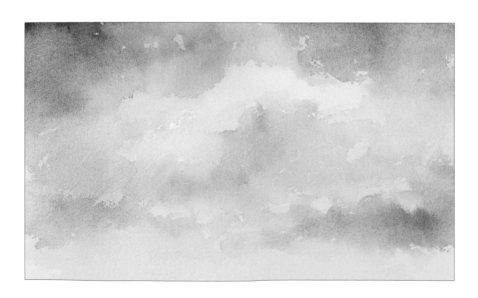

The finished sky. Many of the best effects in this type of sky are accidental, but do not be discouraged if all the accidents are not happy ones – it happens to all of us. Practice is the key.

EVENING GLOW

Prepare the following thin washes before working wet in wet: Naples yellow and quinacridone gold; cobalt blue and rose madder; rose madder; light red; and cobalt blue and rose madder with a touch of light red.

1 Wet the paper first with a sponge and clean water. Use a no. 16 brush to paint the Naples yellow and quinacridone gold mix across the bottom of the sky.

2 Sweep in the cobalt blue and rose madder mix at the top of the sky.

3 Still working wet in wet, paint the rose madder wash in between the yellow and blue washes.

4 Add streaks of light red in the yellow part of the sky.

5 Use a no. 12 brush and light red to drop in clouds.

6 Add more clouds using the light red, making smaller marks as you come down towards the horizon.

7 Pick up the grey mix made from cobalt blue, rose madder and light red, and drop in darker clouds.

8 Add more grey clouds, working quickly wet in wet.

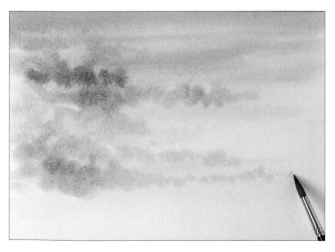

9 Use the tip of the brush to make smaller marks lower down the sky.

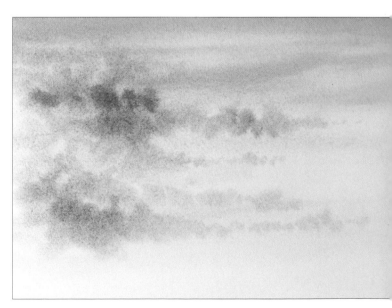

The finished sky.

121

A STORMY SKY

Mix washes of aureolin and burnt sienna for a golden glow; cobalt blue and rose madder for purple; and neutral tint with a touch of rose madder for a warm grey. Also prepare a wash of sepia and one of cobalt blue.

1 Thoroughly wet the paper. Take a large filbert brush and paint a patch of warm glow in the middle.

2 Clean the brush and introduce purple from the top, leaving some white paper. Allow the colours to blend.

3 Add a touch of cobalt blue at the top of the sky.

4 Paint in a little neutral tint and rose madder from the top two corners to frame the light in the middle.

5 Add sepia for very dark clouds, allowing the washes to mix on the paper.

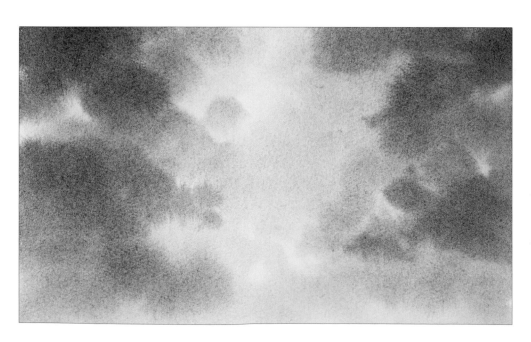

The finished sky. The strong wet into wet washes in this sky produce a dramatic effect, but do not apply paint for too long, or you run the risk of making it too dark. The drama of this sky comes from the contrast of light against dark. Look at the painting on pages 156–157 to see how this dramatic contrast has been carried through into the landscape.

A SUNSET

Prepare washes of cobalt blue and rose madder to make purple; aureolin and burnt sienna to make orange; cobalt blue; and cobalt blue, rose madder and burnt sienna to make grey.

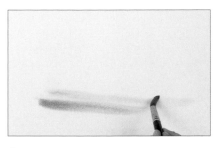

1 Wet the paper with a sponge. Use a no. 16 brush and the orange mix and paint in streaks up to about half-way up the sky, at a slight angle.

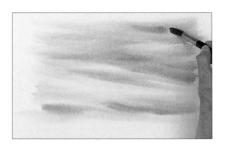

2 Add purple streaks higher up, then cobalt blue at the top right.

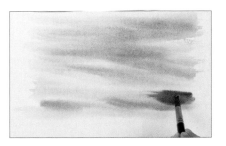

3 Paint the grey in from the bottom right of the painting.

4 Add more grey across the centre of the sky in slightly angled streaks.

5 Take a 2.5cm (1in) flat brush, dip it in clean water and dry it on a tissue, then lift out streaks.

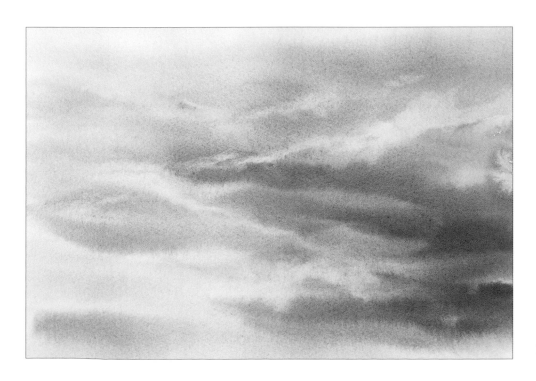

The finished sky.

Clear Sky in Winter

I came across this ruined old barn on a winter morning's walk and knew immediately I had found a potential painting subject. I went back again the following spring and it had been demolished, so I was glad I had taken some photographs and done some sketches while I had the opportunity.

I particularly liked the crisp, clear blue sky and the way these sky colours were reflected in the shadows. I considered putting a snow-covered roof on the barn but I quite liked the dilapidated look. I think it could have been painted successfully either way.

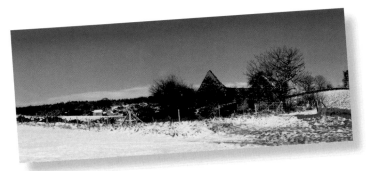

I took two photographs of the scene and taped them together to use as reference for the painting.

The preliminary sketch.

The finished painting.

124

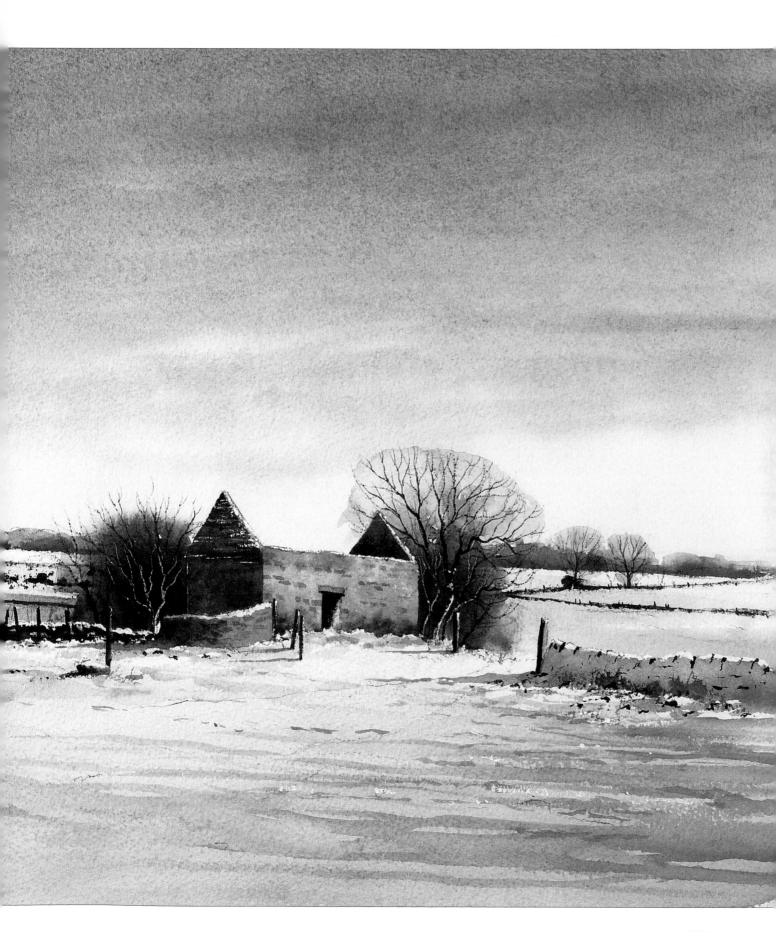

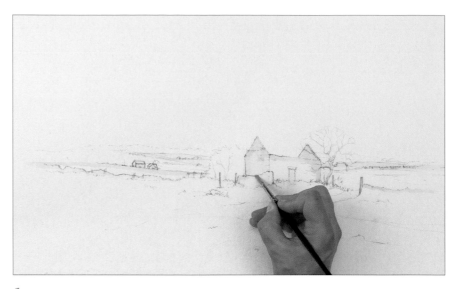

1 Draw the main outlines of the scene. Apply masking fluid to preserve the white of the paper for highlights: round the old barn, on the dry stone wall, the tree trunk, the fence, the distant fields and the snow on the left-hand building.

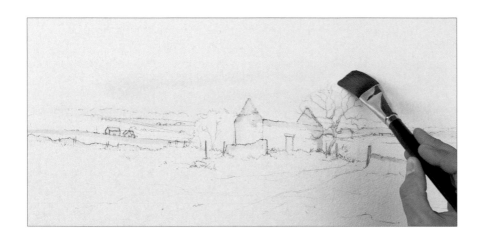

2 Always mix your sky washes first when you are going to be painting wet in wet. In this case, make washes of ultramarine blue and cobalt blue with a touch of rose madder; cerulean blue with a touch of cobalt blue; and Naples yellow with a hint of cadmium red. Wet the whole sky area, down to the horizon and the masked buildings. Start with the lightest colour, the pale pink, and paint streaks of it at the bottom of the sky, going slightly uphill towards the right, with a 2.5cm (1in) flat brush.

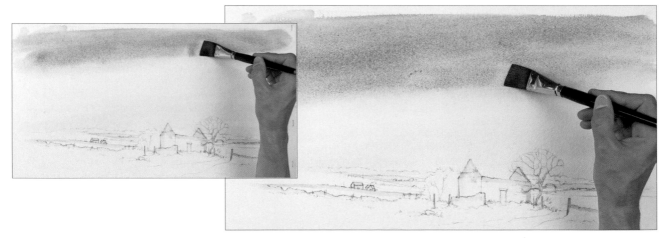

3 Wash the brush, then pick up the ultramarine, cobalt blue and rose madder wash and paint it in strokes across the paper, sloping slightly up to the right. Continue the strokes from the top downwards. Then, without washing the brush, pick up the cooler mix of cobalt and cerulean blue and paint this in the same way lower down the sky. Using a cooler blue towards the horizon helps to create aerial perspective in a sky.

4 As the blue wash reaches the pink wash near the horizon, break up your brush strokes so that the blue drifts into the pink. Allow the painting to dry.

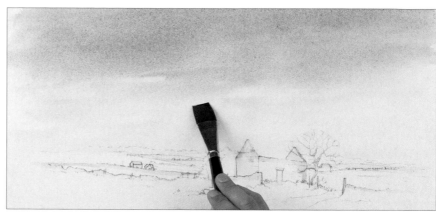

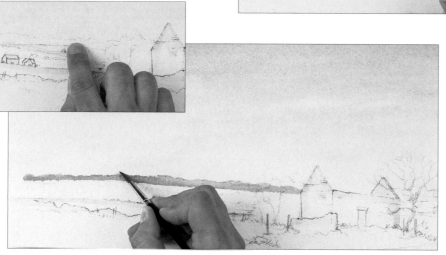

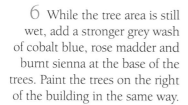

5 Once the sky has dried, use a clean finger to remove the masking fluid from the distant fields, leaving it on the buildings and the tree. Mix cerulean blue and rose madder to make a soft grey and paint the distant trees using a no. 6 round brush. Bring the colour down to the line where the trees meet the snow-covered field. Then use a damp, clean brush to soften the top edge of the tree area, to accentuate the feeling of distance.

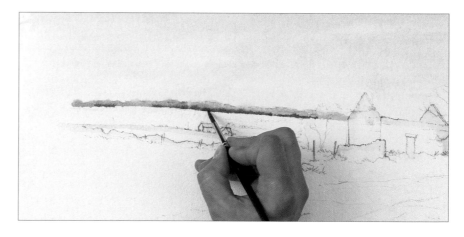

6 While the tree area is still wet, add a stronger grey wash of cobalt blue, rose madder and burnt sienna at the base of the trees. Paint the trees on the right of the building in the same way.

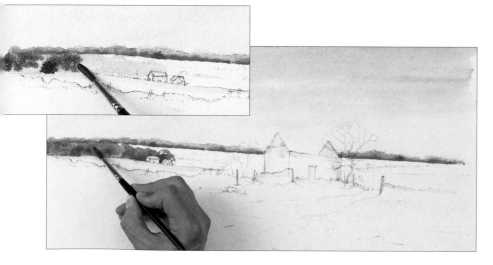

7 Wet the woodland area on the left with clean water and drop in more of the stronger grey. Mix a wash of raw sienna and burnt sienna and drop it in wet in wet to warm the woodland area.

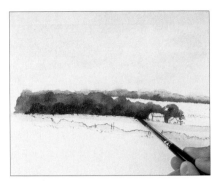

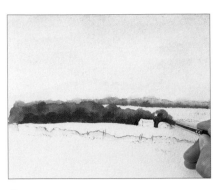

TIP

It is not easy to paint accurate shapes with masking fluid, but you can always do a bit of tidying up once you have removed it.

8 Drop in more of the cobalt blue, rose madder and burnt sienna mix wet in wet near to the masking fluid at the base of the trees.

9 Remove the masking fluid from the field's edge and the buildings on the left of the painting. If necessary, tidy up the edges of the buildings using a no. 6 brush and the same dark paint mix.

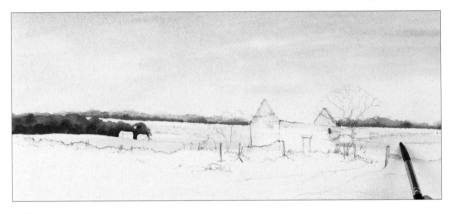

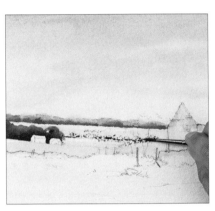

10 Mix two thin washes based on the sky colours, one of cerulean blue for cooler, distant shadows and the other of cerulean blue and rose madder for shadows nearer the foreground. Take the cooler wash and a no. 10 brush and paint the distant shadows, making sure your brush strokes follow the shape of the land, and leaving some white paper showing.

11 When the shadow washes have dried, mix a mid-brown wash of burnt sienna and cobalt blue. Take the no. 6 brush, pick up some of the wash then dry the brush a little on paper tissue. Hold the brush on its side and drag it over the surface of the paper, using the dry brush technique to suggest dark patches showing through the snow.

12 Continue working on the same area of the distance on both sides of the buildings. Still using the no. 6 brush and the same mix, paint thin lines to suggest dry stone walls. Dab in distant trees and bushes using thick paint and the dry brush technique. Suggest fence posts.

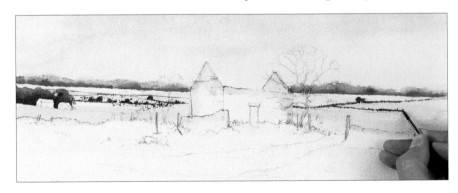

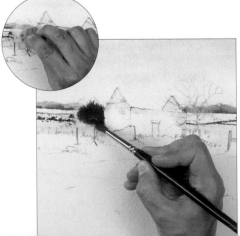

13 To paint the tree to the left of the old barn, fade the distant bushes and walls with a damp sponge. Wet the area with clean water, then drop in the mid-brown mix with a no. 8 brush and watch it spread.

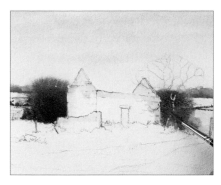

14 Mix a rich, dark brown from ultramarine blue and burnt sienna and, still using the no. 8 brush, drop it in to the tree on the left of the barn while it is still wet, near the ground. Then wet the area of the bush on the right. Drop in the dark brown first, then raw sienna and burnt sienna where the light catches the winter foliage.

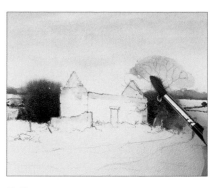

15 Water down the raw sienna and burnt sienna mix and, using the no. 8 brush, paint in the shape of the tree on the right.

16 Paint a dry stone wall on the left of the barn using the dark brown mix, and add bushes.

17 Before the paint is dry, scratch out branches in the bushes using a craft knife.

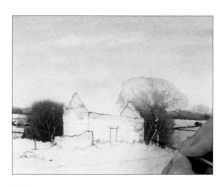

18 Remove the masking fluid from the tree on the right and drop in raw sienna and burnt sienna using the liner/writer brush.

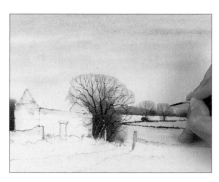

19 Continue the branches where they need to look dark against the light background, using a mix of ultramarine blue and burnt sienna. Water down the mix and paint in branches in the more distant trees.

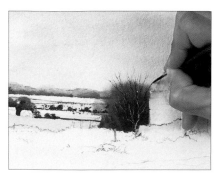

20 Add branches coming out of the bush on the left, continuing the scratched out lines, still using the liner/writer brush.

21 Paint the walls of the barns in the distance using raw sienna and burnt sienna and the no. 6 brush. Leave white paper to suggest snow on the roofs. Paint the shadows under the eaves and the shadowed walls using a mix of cerulean blue and rose madder.

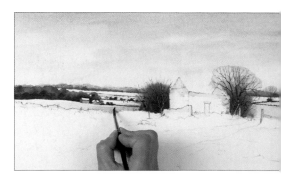

22 Shadow the field behind the barn with cerulean blue, up to the masking fluid. Allow the painting to dry.

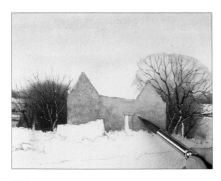

23 Rub off all the remaining masking fluid. Paint the barn with a mix of raw sienna and burnt sienna using the no. 12 round brush. While the paint is still wet, drop in a mix of aureolin and cobalt blue to suggest moss.

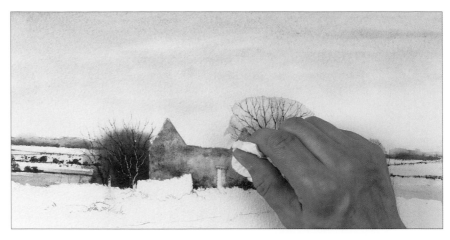

24 Drop in cerulean blue and rose madder wet in wet, then a dark mix of burnt sienna and ultramarine blue, particularly around the bottom of the barn. Use a paper tissue to dab the wet paint, suggesting the texture of stonework.

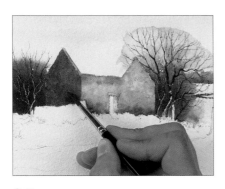

25 Make a shadow mix of cerulean blue and rose madder and paint the left-hand side of the building with the no. 6 brush. Drop in burnt sienna at the bottom, wet in wet, to suggest reflected light.

26 Shadow the gable end on the right with the same shadow mix and a no. 4 brush. Add darks to the left-hand side of the building and paint in the open doorway with ultramarine and burnt sienna.

27 Use the no. 4 brush and a watery mix of burnt sienna and cobalt blue to suggest stones on the front of the building. Then paint the little wall with a mix of raw sienna and burnt sienna and the no. 6 brush. Drop in the shadow colour on the left and blend it in to suggest the curved shape.

28 At the furthest point of the curved wall, add burnt sienna and ultramarine blue. Then paint a cast shadow from the wall using the shadow mix of cerulean blue and rose madder.

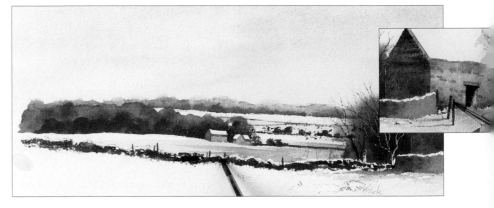

29 Make two strong, thick washes, of raw sienna with burnt sienna and burnt sienna with ultramarine blue. Use the no. 4 round brush to paint the dry stone wall with the lighter wash, leaving white at the top to suggest snow. Then with the no. 6 brush paint in the darks with the darker mix. Add fence posts and cast shadows with the no. 4 brush.

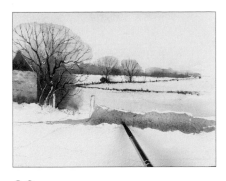

30 Use the no. 6 brush to paint the snow-covered wall on the right with cerulean blue and cobalt blue. Then drop in a touch of cerulean blue and rose madder.

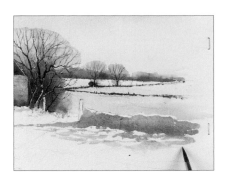

31 Add touches of shadow in front of the wall to suggest uneven snow. Soften the shadows in places with clean water. Leave some harder lines for variety.

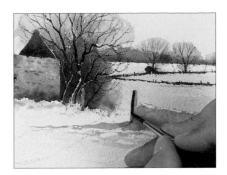

32 Paint the fence post using raw sienna mixed with burnt sienna. When it is dry, shadow it with burnt sienna and ultramarine blue.

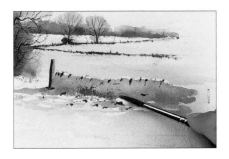

33 When the shadows are dry, use burnt sienna and ultramarine blue to add marks suggesting stones showing in the snowy wall and beneath it in the snow. Then suggest grass at the foot of the wall using burnt sienna and raw sienna.

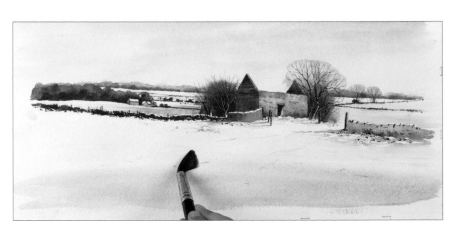

34 Wet the whole foreground with clean water. Paint in the colour of shadowed snow using cerulean blue and rose madder and the no. 16 brush. Allow to dry.

35 Use the no. 8 brush and cobalt blue mixed with cerulean blue to paint shadows cast into the painting from the right-hand side.

36 Paint smaller, slightly stronger marks in the snow on the right, suggesting uneven ground.

37 Finally add touches of white gouache on the tops of walls and posts and in trees. Also add dark fence posts and stones for contrast.

TIP

Use white gouache neat. If you dilute it, it is not sufficiently opaque.

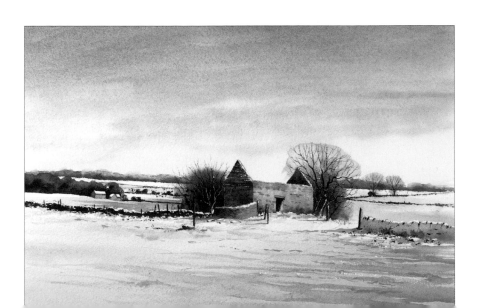

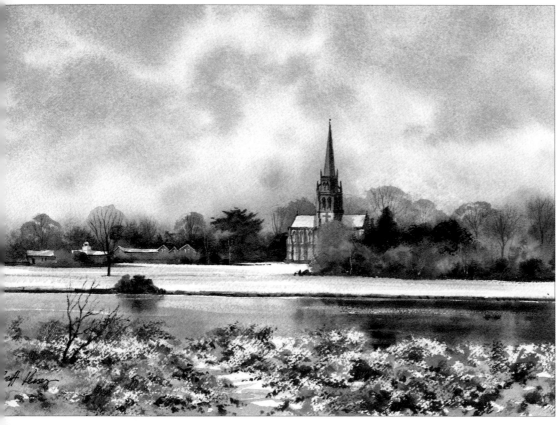

Clumber Park, Nottinghamshire
31 x 23cm (12¼ x 9in)
For the sky in this scene I mixed cerulean blue and rose madder. When these two are mixed, they tend to separate on the paper, which I think has been quite effective here, as it gives a pink/purple glow in the middle and lower part of the sky. I repeated the sky and foliage colours by dropping them into previously wet paper to create the reflections in the river. When the river had dried I lightly brushed some white gouache over it to indicate movement and slight ripples.

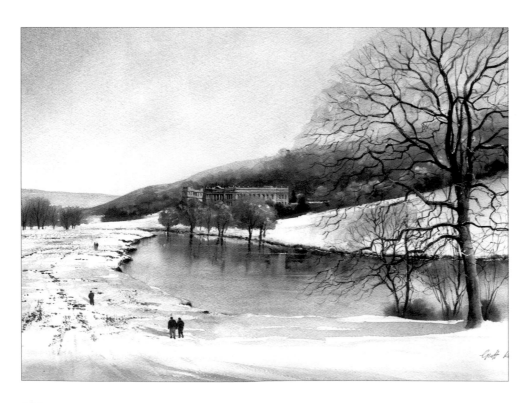

Chatsworth in Winter
38 x 29cm (15 x 11½in)
In this painting the clear blue from the sky is echoed not only in the shadows on the snow but also in the reflections in the water. I used a mixture of cobalt blue and cerulean blue to create a crisp, clean look. Note the area to the right of the house where I have left stark, white paper next to the dark grey/brown background to create an area of maximum contrast.

132

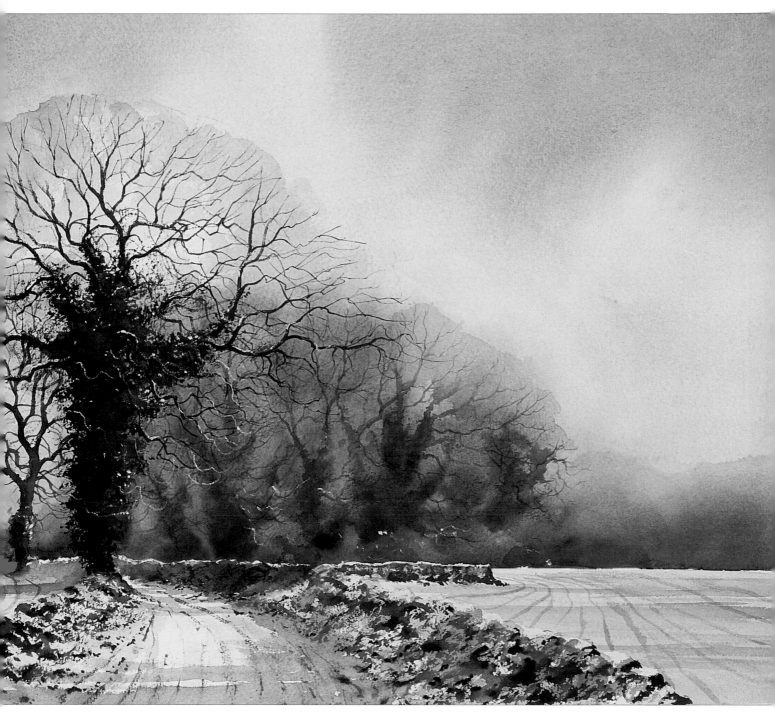

Lane in Winter

65 x 42.5cm (25½ x 16¾in)

I painted this simple but atmospheric scene from the sketch shown on page 107, bottom left. The distant and middle distance trees were indicated wet-into-wet to give them a misty, indistinct look, which helps to push them into the background, creating the illusion of depth. The sky was painted with four separate washes: cobalt blue; cobalt blue mixed with light red; Naples yellow with Indian yellow; and a light wash of neutral tint. These were then floated into a wet background using a 3.8cm (1½in) flat brush. Note how the cobalt blue and light red washes are repeated in the shadows, to give the finished work harmony.

133

Cloud Shadows

I live just a few miles from Chatsworth Park in Derbyshire, the setting for this painting. It is a very popular subject with both painting buyers and artists, so it is a challenge to find new angles and views. When I chose this composition, I was attracted to the three trees on the right. I liked the way these got progressively smaller, leading the viewer's eye into the scene. I have used the same purple/grey mixes from the sky to place shadows across the land. This not only gives the painting some continuity, but the directions of the shadow brush strokes desribe the contours of the land.

The reference photographs for this painting.

The preliminary sketch.

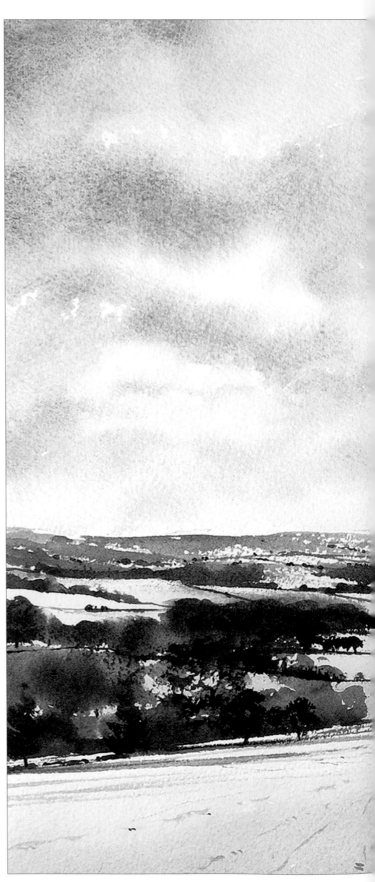

The finished painting.

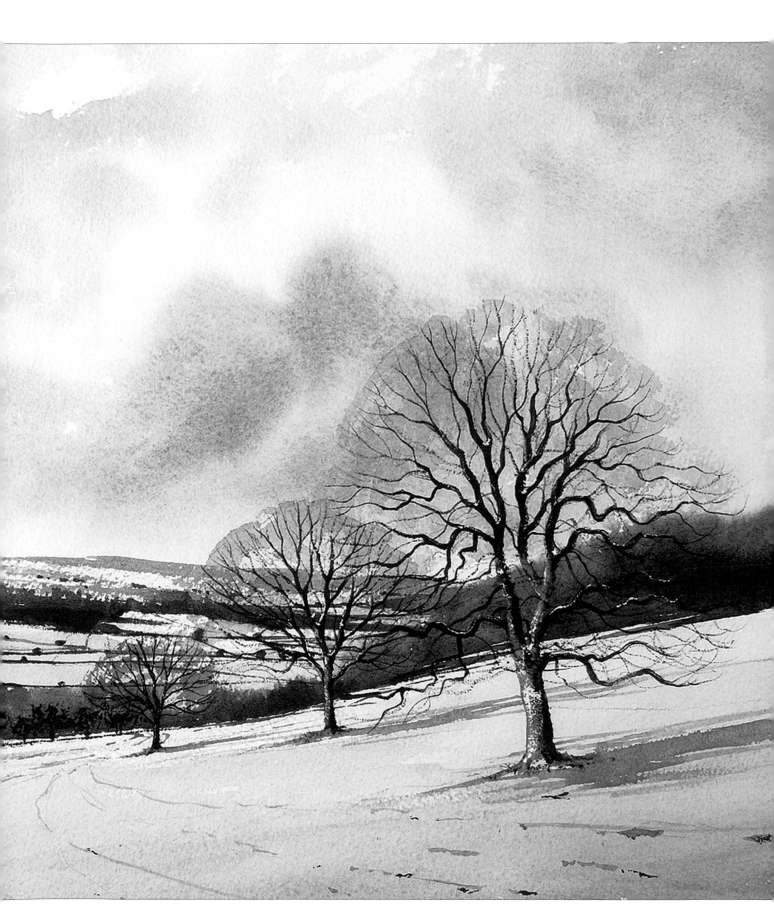

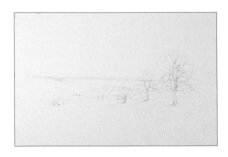

1 Draw the scene. Apply masking fluid to preserve a crisp, white edge where the snow meets the skyline, and also half-way up the largest tree and a little on the middle tree.

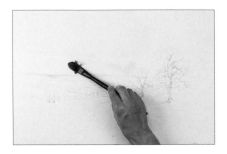

2 Mix three sky washes: Naples yellow with cadmium red; cobalt blue; then cobalt blue, cobalt violet and burnt sienna to create a grey/purple. Wet the sky area with a sponge, leaving roughly cloud-shaped patches dry. Pick up the Naples yellow and cadmium red mix on a filbert brush and drop it in at the bottom of the sky.

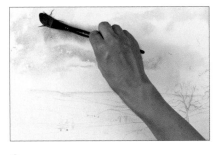

3 Next paint ragged-edged shapes with the cobalt blue wash. Soften any hard edges with clear water.

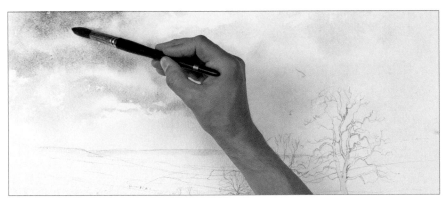

4 Add the purple-grey wash at the top of the sky using the no. 16 round brush. Then paint more of the Naples yellow and cadmium red mix at the top of the sky.

5 Add more of the same pinkish mix near the horizon.

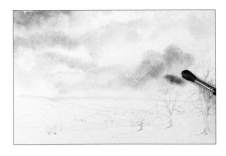

6 Dab in the shape of a dark cloud on the right of the sky with the purple/grey wash.

7 Drop the same wash into the wet pinkish paint at the bottom left of the sky.

8 Drop more cobalt blue into the top left of the painting. Allow to dry.

TIP

Do not spend too long working on the sky. If you brush the colours around too much, it can become muddy.

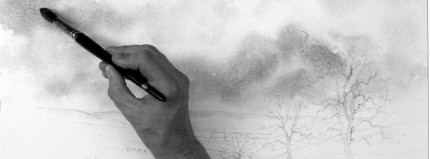

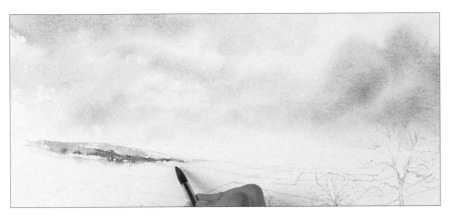
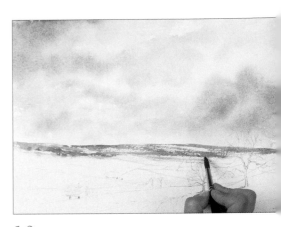

9 Remove the masking fluid from the distant hills. Prepare washes of raw sienna with burnt sienna for the bracken on the hills; cobalt blue and cobalt violet with burnt sienna to make grey; cobalt blue, burnt sienna and cobalt violet for a strong brown. Using the no. 10 brush and the dry brush technique, use the first wash to suggest bracken on the distant hills, then drop in grey while the first colour is wet.

10 Use the grey mix and the dry brush technique to paint texture on the furthest hills. Mix the sky colours, cobalt blue and cobalt violet to paint cloud shadows.

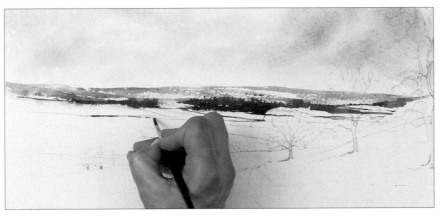

11 Using the strong brown mix, suggest dark patches of forest on the hillsides, and with the point of the no. 4 brush, paint dry stone walls and bushes in the distance.

12 With the same mix, paint shadowed woodland on the left of the painting. Soften the tops with clear water to create a distant, misty look. Pick out shapes in the far distance using the dark grey. Allow to dry.

13 Make two shadow washes: cobalt blue; and a weak, transparent mix of cobalt blue and cobalt violet. Use the no. 16 brush to paint the cooler cobalt blue wash across the middle ground and soften it in with clear water.

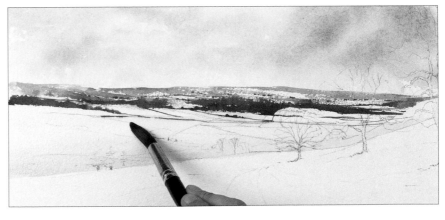

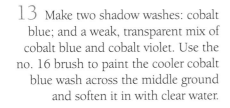

14 Blend in the thin, warmer shadow wash as shown.

137

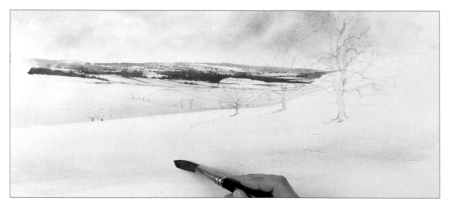

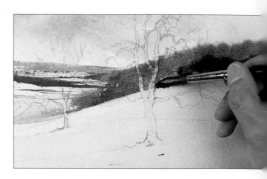

15 Next paint the foreground shadows. Wet the area with clean water and paint the cobalt blue wash across it. Paint in the cobalt blue and cobalt violet mix, making sure your brush strokes follow the contours of the land.

16 Wet the area of the trees on the right, and drop in a mix of cobalt blue, cobalt violet and burnt sienna. Then drop in a darker mix of cobalt blue and burnt sienna at the base of the trees.

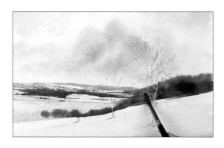

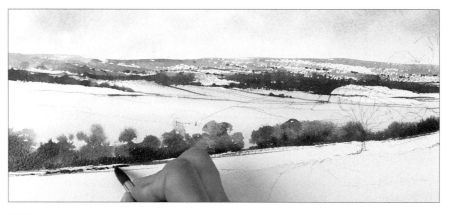

17 Paint soft shapes towards the middle of the painting, then drop in a touch of raw sienna and burnt sienna wet in wet to add warmth.

18 Work on the left-hand side in the same way. Wet it first, then drop in raw sienna and burnt sienna. Then drop in dark shapes using the darker mix. Add a thicker mix of the dark colour at the base and break up the edge against the white as shown.

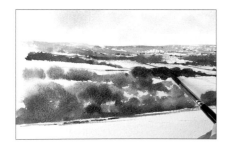

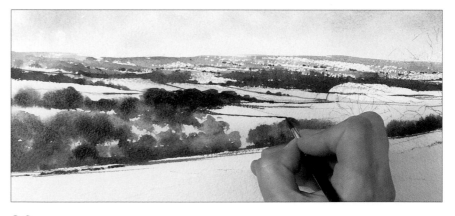

19 Dampen the background on the left and drop in tree shapes using a weak mix of cobalt blue and burnt sienna. Then use a stronger wash of the same colours to paint darker details, and the dense woodland in the middle.

20 Drop a little burnt sienna into the dark areas, wet in wet. Then use the no. 6 brush to suggest dry stone walls across the middle of the area.

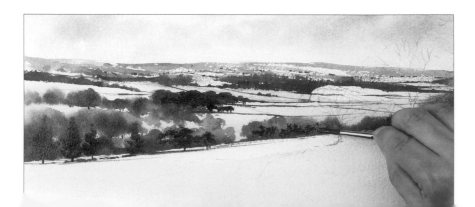

21 Mix a dark brown from ultramarine blue and burnt sienna and suggest fir trees against the soft background. Paint glimpses of trunks and other tree shapes. Use dry brush work to suggest the texture of the trees in the middle.

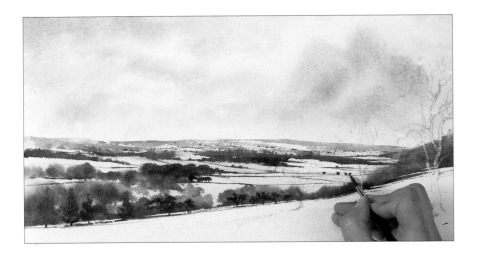

22 Mix cobalt blue, cobalt violet and burnt sienna and suggest distant trees along the dry stone walls with the no. 4 brush.

TIP

When suggesting the shape of the trees, use a very thin wash, leaving gaps through which the sky can be seen.

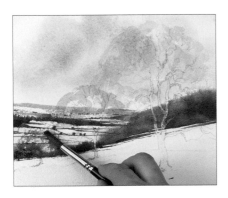

23 Use the side of the no. 10 brush and a thin mix of raw sienna and burnt sienna to paint in a shape for the biggest tree. Allow it to dry, then add cobalt blue and cobalt violet to the mix to cool it and paint the middle tree in the same way. Allow this to dry, then paint the third tree.

24 Rub off the masking fluid from the trees. Mix a strong, dark brown from burnt sienna and ultramarine blue and use the no. 4 brush to paint the trunk and branches of the smallest tree. Then use the liner/writer brush to paint the finest branches, reaching to the edge of the tree shape you put in earlier.

25 Paint the light on the middle tree using raw sienna and burnt sienna and the no. 4 brush. Then drop in burnt sienna and ultramarine blue to shadow the right-hand side before the first colour has dried. Complete the tree by extending the branches to the edge using the liner/writer brush (see inset picture).

26 Paint the right-hand tree in the same way, starting with raw sienna and burnt sienna. Then drop in the dark shadow mix wet in wet.

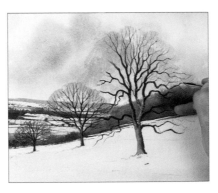

27 Continue developing the branches using the dark brown and the no. 4 brush. Paint in the direction the tree grows, from the ground upwards. Then take the liner/writer brush and follow the branches to the edge of the tree shape. Some should cut across the trunk.

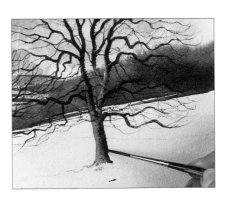

28 Use the liner/writer brush to texture the trunk bark with the dark mixture of burnt sienna and ultramarine.

139

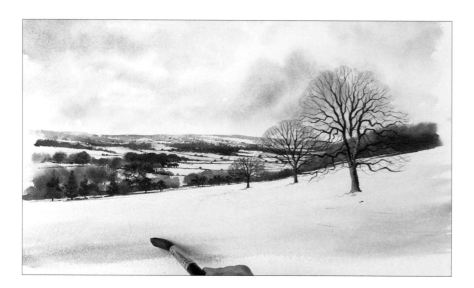

29 Wet the foreground with clean water and a no. 16 brush. Mix a wash from the sky colours cobalt blue and cobalt violet, to create shadows to bring the foreground forwards. Paint shadows in the snow coming from the left.

TIP

Use the angle of your brush strokes to describe the contours of the land.

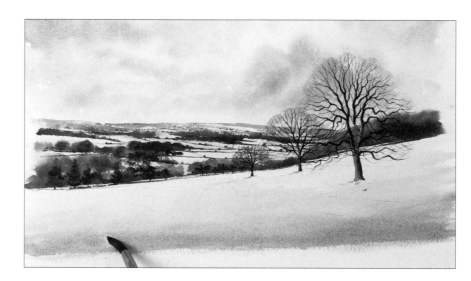

30 Add burnt sienna to the mix and paint it across the extreme foreground to warm the shadows.

31 Use a no. 6 brush and the mix of cobalt blue and cobalt violet to paint cast shadows coming from the trees on the left.

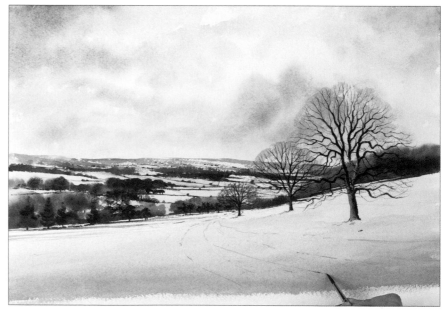

32 When the shadows have dried, use the same mix to suggest tracks through the snow with curved, disjointed lines. These will lead the viewer's eye into the picture. Soften the tracks in places using clean water.

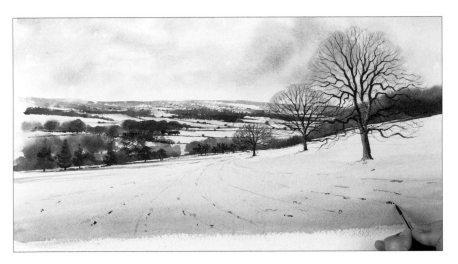

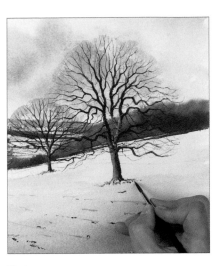

33 Paint dark patches showing through the snow in the foreground using the same brush and a mix of burnt sienna and ultramarine blue. These are also useful to create perspective and lead the viewer in to the scene.

34 Add dark patches around the base of the tree trunks in the same way.

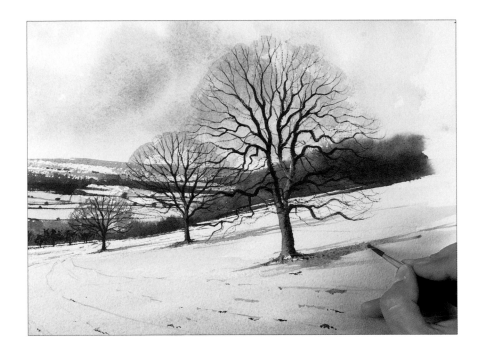

TIP

You can put a little arrow mark in the margin of your painting to remind you of the direction of the light.

35 Paint cobalt blue and cobalt violet shadows from the trees. The light is coming mainly from the left, so although there should be some shadow on the left, long cast shadows should fall to the right of the trees, slanting slightly upwards with the hill.

36 Finally use white gouache to add snowy details to some tree branches, and add a dusting of snow to the largest tree's trunk.

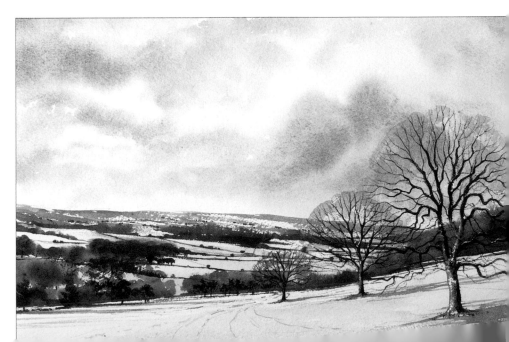

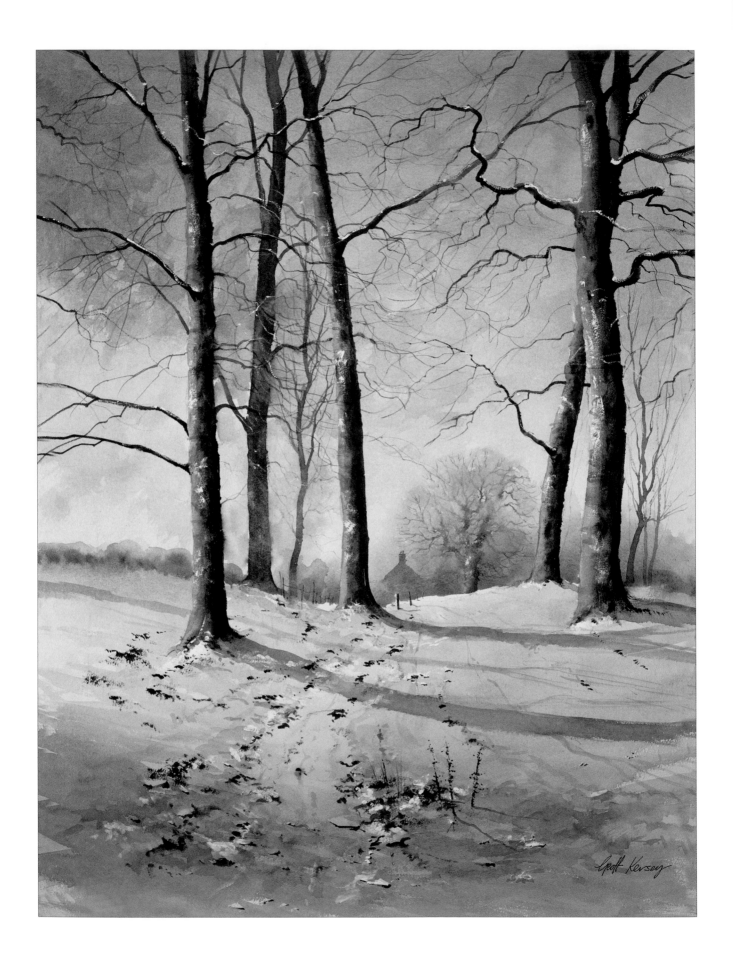

142

Opposite
Afternoon Light, Calton Lees
68 x 48cm (27 x 19in)

*This is another scene in Chatsworth Park, quite near my home in Derbyshire.
I have tried to capture the feeling that the whole subject is bathed in a warm,
afternoon glow by mixing a rich orange colour from aureolin and burnt sienna for
the middle and lower part of the sky, followed by a mixture of cobalt blue and rose
madder for the top. Both the blue and orange colours were quite strong mixtures,
so that the sky – as well as having a bright glow – gave the impression it was
darkening towards early evening. I have carried these sky colours through into the
snow, only leaving a small amount of white paper showing. I think the little house
in the distance, glimpsed through the trees is quite important as the eye follows the
path and settles on this feature. Finally, note how the tree to the right of the house
is rendered with soft colours, slightly out of focus, to give it a distant look.*

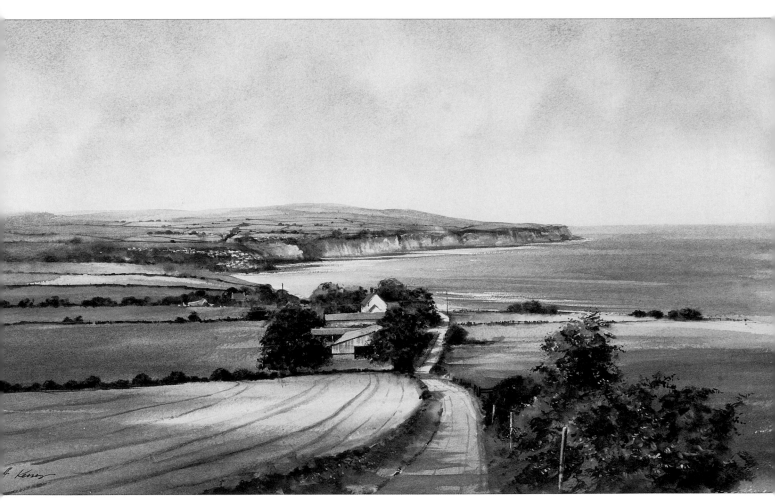

Looking Towards Robin Hood's Bay From Ravenscar
75 x 43cm (29½ x 17in)

*In this scene on the Yorkshire coast, I have created a soft, dull sky to give the impression of diffused
light, complemented by some bright colours on the land. The land was glazed over with various washes
to indicate cloud shadow, which gives the impression that even though it is a dull day, the sun is just
breaking through, illuminating areas of the landscape. In the sky I used a pink colour mixed from rose
madder and Naples yellow and a soft grey from cobalt blue with rose madder. I used cobalt blue with
rose madder for the shadows on the distant hills and the road. For the shadows glazed across the fields
I used a darker version of the colour underneath, for instance the large field in the left-hand foreground
is a bright green mixed from aureolin and cobalt blue, and the shadow glaze is mixed from the same
two colours but with more blue to make it darker.*

143

Sky and Water

At the southern end of Derwentwater in the Lake District, there is a marshy area with a long boarded walkway that affords some marvellous views towards the lake and distant hills.

I liked the bright yellow/browns of the reeds and the way the sky was mirrored in the almost still water, the direction of which leads the viewer through the marshes towards the distant hills.

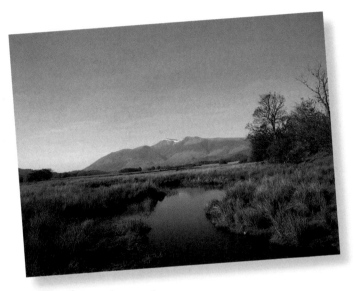

The reference photograph.

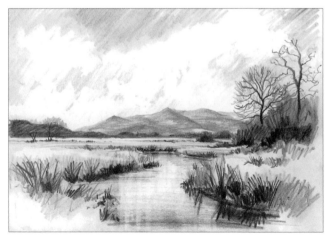

The preliminary sketch.

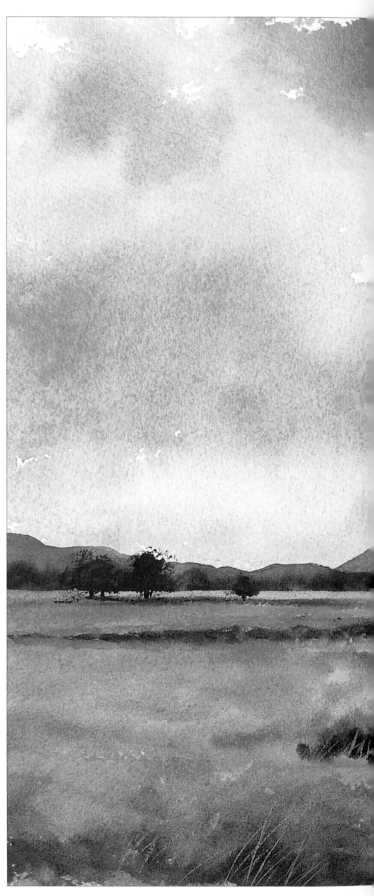

The finished painting.

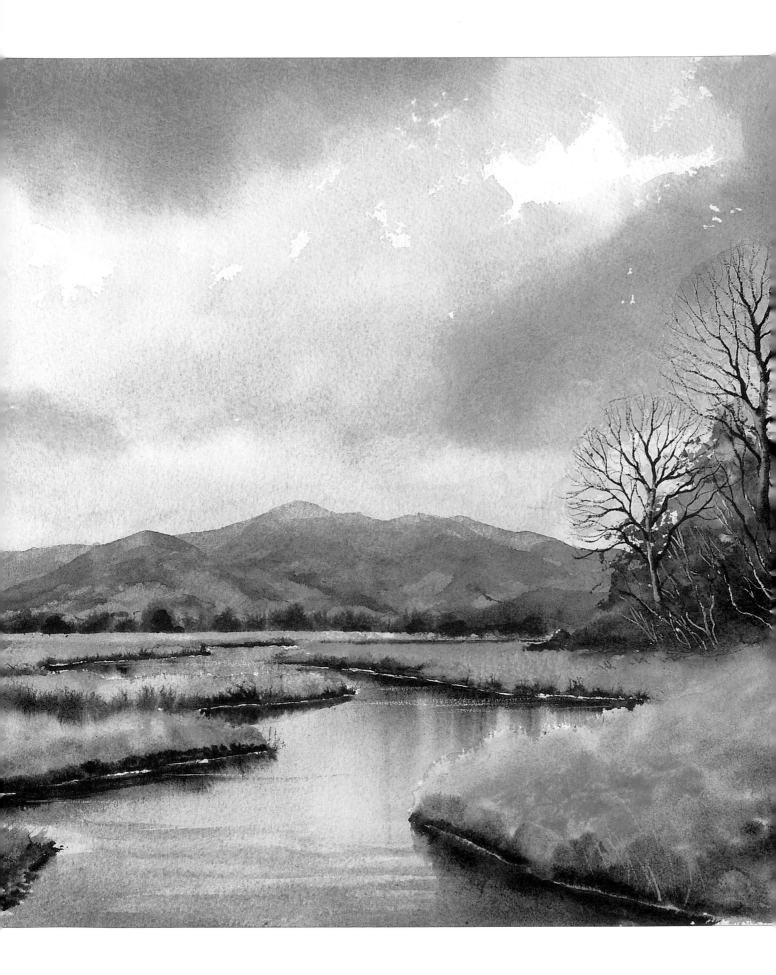

1 Draw the scene. Paint masking fluid on to the tree trunks on the right and where the land meets the bottom of the hill, to preserve the horizontal line.

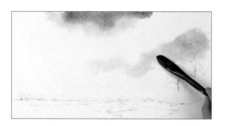

2 Mix plenty of each sky wash first: ultramarine blue and cobalt blue; a thinner mix of cobalt blue alone; cobalt blue and light red to make a warm grey; and light red on its own. Take a filbert wash brush and wet some areas of the sky, leaving others dry to suggest cloud formations. Drop the ultramarine and cobalt blue mix in to the wet paper.

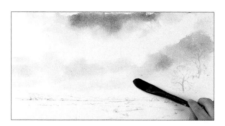

3 Drop in the paler wash of cobalt blue lower down, brushing over the tops of the hills.

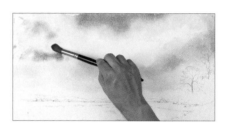

4 Change to the no. 16 brush, pick up the grey mix and paint shadows into the cloud shapes. Soften the shapes with clean water.

5 Drop in some of the light red wash wet in wet to add warmth to the clouds. Soften it in with clear water.

6 Drop in more grey to strengthen the clouds.

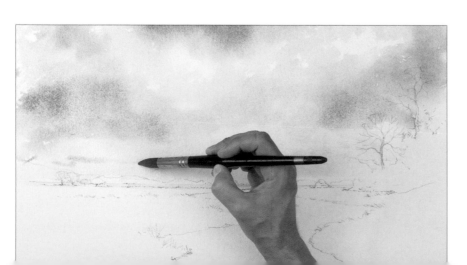

7 Add grey streaks in the lower part of the sky. These should give the impression of clouds a long way in the distance, which helps with perspective. Leave the painting to dry.

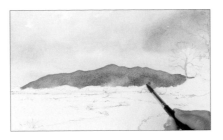

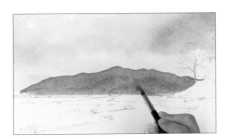

8 Mix a warm grey wash from light red and cobalt blue; an orange wash from raw sienna and light red; and green from aureolin and cobalt blue. Paint the distant hill with the warm grey and a no. 10 brush.

9 Brush in the orange wash wet in wet across the middle, then drop in more grey lower down.

10 Paint more of the orange mix down to the level ground, and drop in touches of the green wash.

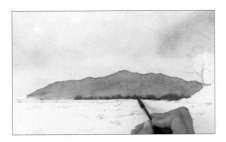

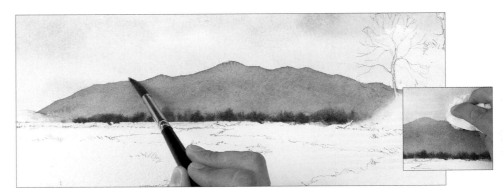

11 While the paint is wet, mix aureolin and ultramarine blue and add burnt sienna to make a rich olive green and touch this in to suggest trees where the hill meets the ground. Drop in a darker mix of burnt sienna and ultramarine blue at the bottom.

12 When the hill area has dried, soften the hard lines at the right and left-hand sides of the hill using clean water. Use the no. 10 brush and clean water to wet the top of the hill, then dab it with a paper tissue, a small area at a time. Take care not to remove too much colour. A soft edge will make the hill appear more distant.

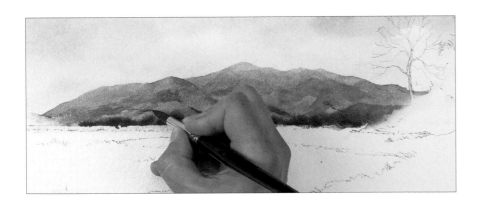

13 Paint shadows on the right of the hill using the no. 10 brush and cobalt blue and light red. Soften the shadows with a damp, clean brush. Continue painting shadows to create form. Use a stronger wash of the same mix to paint in details such as crevices and fissures in the rock.

14 Mix a stronger wash of cobalt blue and light red; and aureolin, cobalt blue and burnt sienna for an olive green. Using the no. 7 brush, paint the shape of the hill on the left with the cobalt blue and light red. The stronger colour will make this hill look nearer than the hill on the right. Add warmth using the orange mixed from raw sienna and light red.

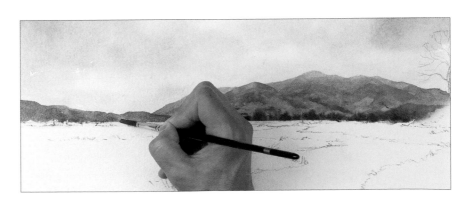

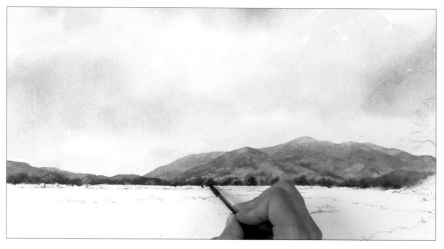

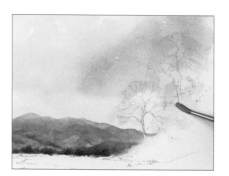

15 Paint trees from the left-hand side using the olive green mix, then drop in undiluted aureolin to create highlights. Brush in more aureolin. Then mix a very dark green from aureolin, ultramarine blue and a little burnt sienna to paint the middle trees. The colour of the trees should gradually get stronger as they get nearer.

16 Mix the washes for the right-hand side of the painting: a brown from burnt sienna and cobalt blue; a mid-green from aureolin and cobalt blue; a dark green from ultramarine blue, aureolin and burnt sienna; and a beige from Naples yellow and light red. Use the no. 8 brush and beige to paint the shape of the trees, leaving gaps through which the sky will show.

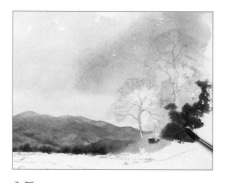

17 Drop in the mid-green wash, then the brown wash.

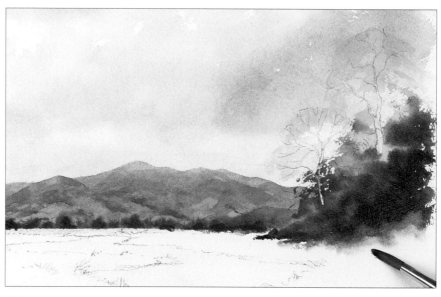

18 Add the dark green wash using the side of the brush, then float the mid-green into the wet colour so that it blends in. Soften with clear water at the bottom.

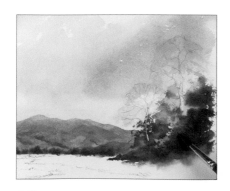

19 Lay the slightly opaque mix of Naples yellow and light red into the dark colours and soften it in with a clean, damp brush.

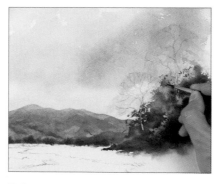

20 Using the no. 4 brush and the dark green, suggest a few leaves.

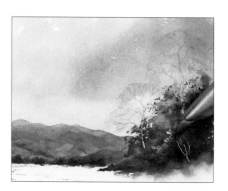

21 Just before the paint dries, as the shine goes off the paper, scratch out lines using a craft knife to suggest branches and twigs.

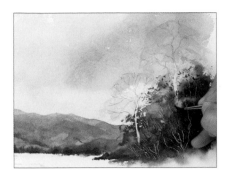

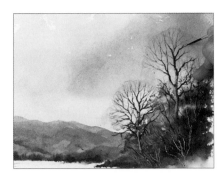

22 Remove the masking fluid. Use clean water to soften the tree trunks into the surrounding undergrowth.

23 Paint the left-hand side of the trunks and branches with Naples yellow and light red, and the right-hand side with ultramarine blue and burnt sienna. Start with a no. 4 brush, then change to a liner/writer as you move out to the edges of the wash. Complete the second tree in the same way.

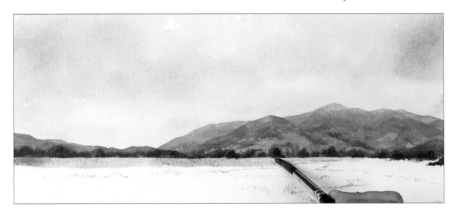

24 Mix washes for the middle ground: Naples yellow and light red; raw sienna and light red; a mid-green from aureolin and cobalt blue; aureolin, ultramarine and burnt sienna for a dark green. First paint on raw sienna and light red for the light catching the marshes, using a no. 10 brush.

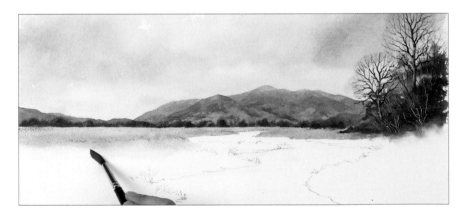

25 Next add Naples yellow and light red with the no. 10 brush. Then add the green wash coming forwards, wet in wet. Soften it using clean water.

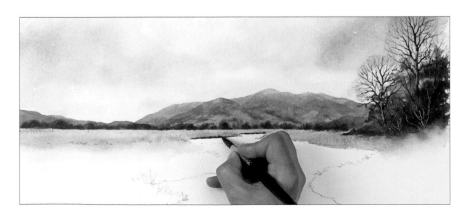

26 Paint more of the orange mix around to the bottom right and fade it out using clean water. Paint the dark brown to suggest peat where the marsh meets the water. The brown should spread into the orange wet in wet.

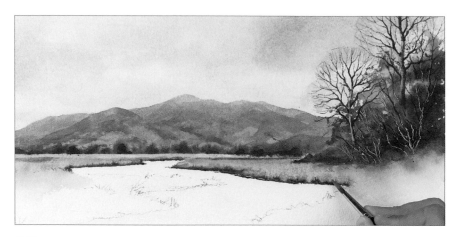

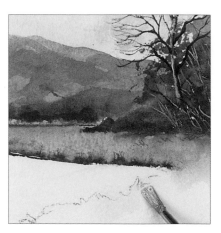

27 Add streaks of the same brown using the point of the brush, to show variations in the colour of the grass. Add more green along the dark peat at the water's edge.

28 Wet the area along the water's edge with clean water. When the shine starts to go, drop in masking fluid. It will make feathery shapes. This can be tricky and is worth practising first on a separate piece of paper. Allow to dry.

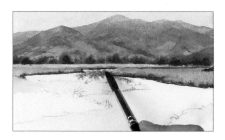

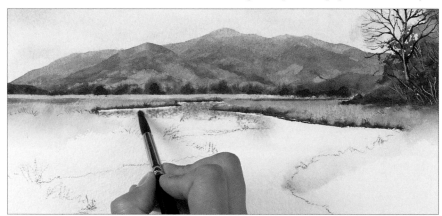

29 Water, especially still water, should not just be blue, but should reflect the sky and the landscape. Mix all the colours you will need to paint the reflections. Wet the paper over the whole water area, leaving a tiny dry line at the very edge, then paint the reflection of the hill using cobalt blue and light red.

30 Drop in raw sienna and light red for the orange of the hill; and green mixed from aureolin and cobalt blue. Then add a weaker wash of the dark brown mix to paint the reflection of the peat at the water's edge.

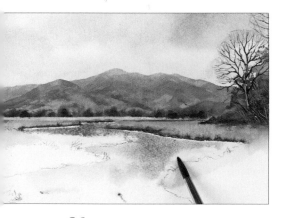

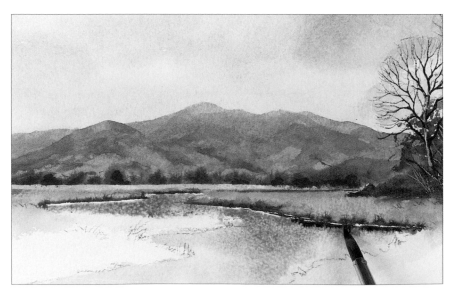

31 Drop in cobalt blue and then light red wet in wet to reflect the sky colours.

32 Paint raw sienna and light red where the grasses are reflected in the water, then add a reflection of the peat colour.

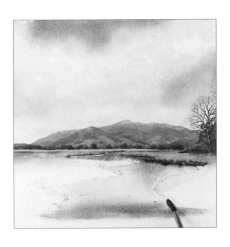

33 Paint the ultramarine blue and cobalt blue mix that appears at the top of the sky at the bottom of the water.

34 Add cobalt blue in the middle of the water, then use the tip of the brush to paint the reflection of the peat under the far bank.

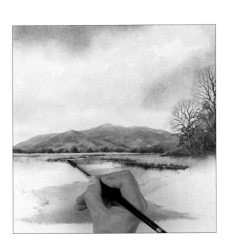

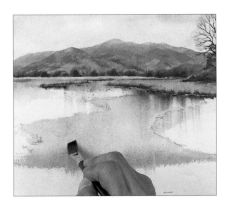

35 Working quickly while the washes are still wet, take a clean, damp 1.5cm (½in) flat brush and stroke it down to suggest vertical reflections.

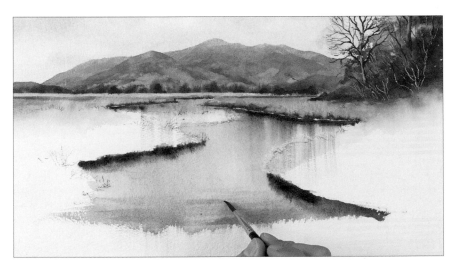

36 Use the no. 10 brush to paint the peat on the left and right banks. Paint raw sienna and light red underneath. Take the no. 6 brush and cobalt blue mixed with ultramarine blue and suggest ripples in the foreground.

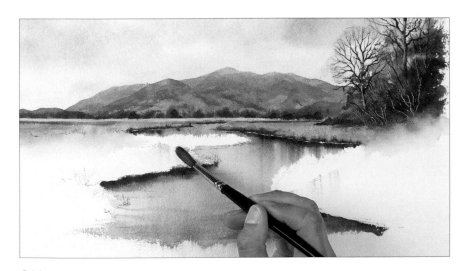

37 Once all this has dried, rub the masking fluid off the banks and clean up any stray marks. Prepare washes: raw sienna and light red; aureolin and cobalt blue; aureolin, ultramarine blue and burnt sienna for a dark green; burnt sienna and ultramarine blue; and Naples yellow and light red.

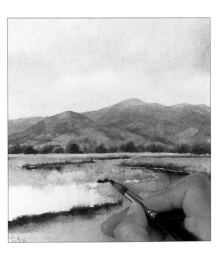

38 Use the no. 10 brush to paint raw sienna and light red on the left-hand bank. Drop in the mid-green mix of aureolin and cobalt blue wet in wet, then the dark peat colour.

151

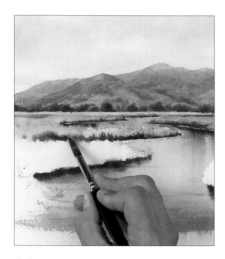

39 Add the dark green mix to the peat at the water's edge.

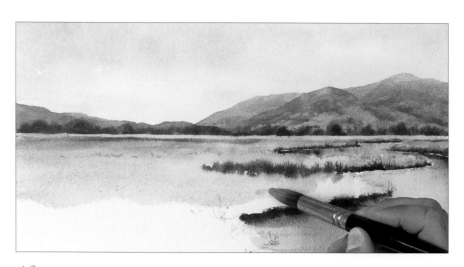

40 Take the no. 16 brush and sweep the Naples yellow and light red wash across the land on the left, then add raw sienna and light red, working down the middle ground.

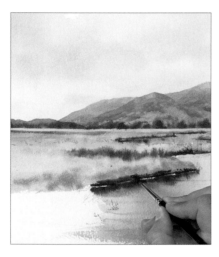

41 Drop in mid-green on the left-hand bank, then add peat above the water line.

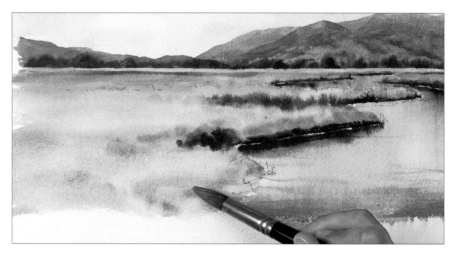

42 Add dark green to accentuate the bend in the water's edge, then paint raw sienna and light red down to the foreground. Drop in mid-green wet in wet.

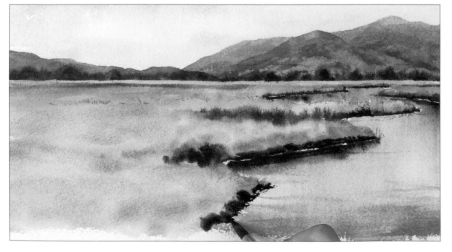

43 Use the same green to accentuate the point at the water's edge, then add the dark peat with the tip of the no. 10 brush.

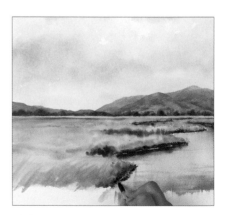

44 Add more green to suggest grasses. Wet the water area just beyond the left-hand bank and drop in the dark peat colour. Soften it in with clean water to suggest rippled reflections.

152

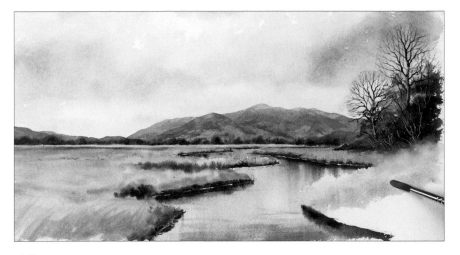

45 Paint the right-hand bank in the same way. Start by applying a wash of light red and Naples yellow, then blend in raw sienna and light red. Add a little mid-green.

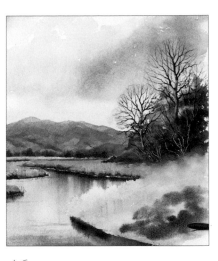

46 Paint the same progression of washes wet in wet down to the water's edge, then float in dark green.

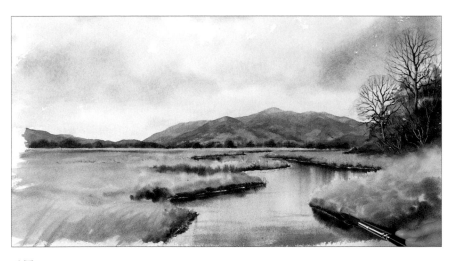

47 Add more raw sienna and light red to soften in the green. Before it dries, paint the rick dark brown for the peat at the water's edge and soften this in with green.

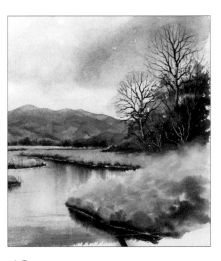

48 Paint the reflection of the dark peat in the water.

TIP

Before wetting the water area, make sure you have all your colours mixed and you are ready to go.

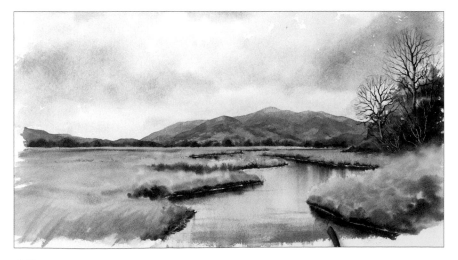

49 Paint the reflections of the other colours from the bank in the water, by wetting the area first, then dropping the colours in.

50 Paint the dark green mix in the left-hand side of the foreground, dampening the background to blend it as required. This rich, dark green should help bring the foreground forward.

51 Blend in the dark green using the raw sienna and light red mix. Add more green, and allow the painting to dry.

52 After standing back to have a look at the painting, I used dark brown paint and the dry brush technique to paint in some tree shapes and trunks. I then painted some ripples in the water using white gouache on a no. 4 brush. I mixed white gouache with a little raw sienna and painted in some grasses and reeds against darker areas in order to establish the foreground of the painting.

Kippford, Scotland
42.5 x 25.3cm (16¾ x 10in)

In this painting, I liked the way the yellow glow in the sky and the muted greys in the distant hills were reflected in the sea. For the sky glow I used quinacridone gold, cobalt blue with cobalt violet and a grey mixed from cobalt blue, cobalt violet and burnt sienna. When I got to the water area these colours were repeated with horizontal brush-strokes to give the impression of lapping waves.

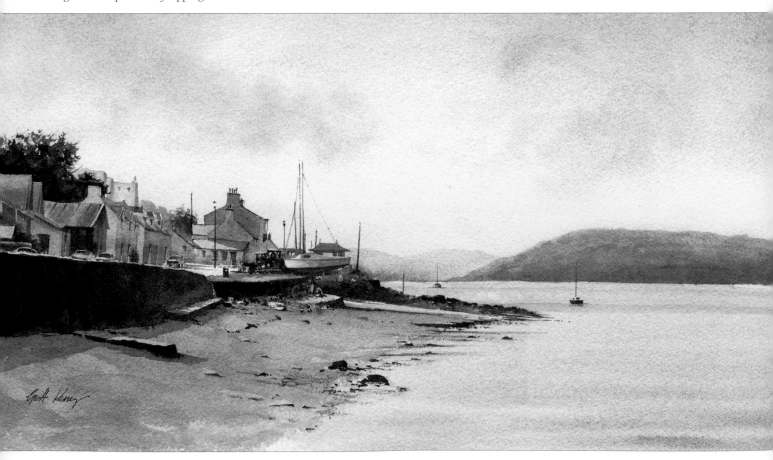

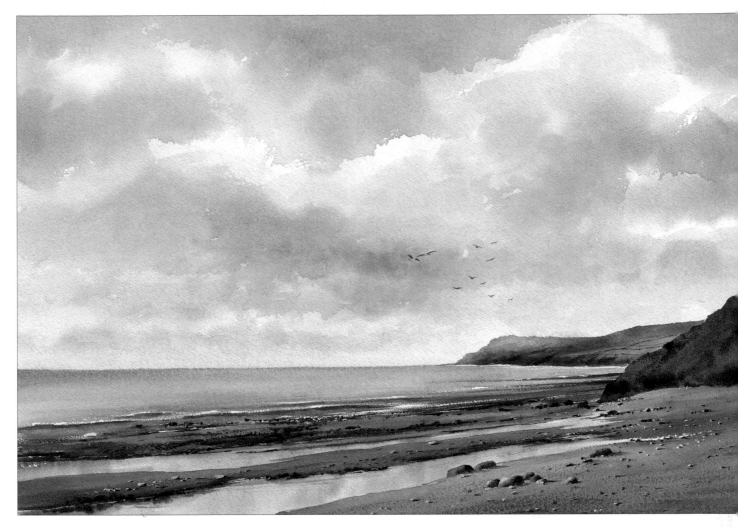

Boggle Hole, Robin Hood's Bay

54 x 36.5cm (21¼ x 14⅜in)

In a scene like this one on the Yorkshire coast, you get the opportunity to suggest the breaking waves of the sea, contrasted with the reflections in the still water of the various rock pools. I coated the sky area with clear water, leaving a few dry edges roughly in the shape of clouds. Then I laid in a wash of cobalt blue followed by a wash of cobalt blue mixed with a touch of rose madder. While the background was still wet I dropped in a hint of Naples yellow with burnt sienna to warm the sky area just above the horizon, and allowed it to dry. For the next stage I added burnt sienna to the cobalt blue and rose madder mix, to create a thin grey glaze. I now indicated the cloud shadows using this grey wash, deliberately leaving some hard edges in some places and softening some others using a damp clean brush. It's this variety of "lost and found" edges and the transparency of the thin glazes that make this type of sky work. To indicate the sea I used the same blue and grey mixes from the sky, adding just a touch of viridian in the area where the sea meets the shore. When this was dry I indicated the waves with a touch of white gouache. The sky reflections in the still water were indicated in the same way as described in the main demonstration in this chapter.

Stormy Sky

In this painting I wanted it to appear as though sunlight breaking through a gap in the heavy clouds was illuminating the little cluster of buildings on the cliff-top. I really liked the sky in the first reference photograph (below, top) and the way it created a sparkling effect on the sea, but the buildings were silhouetted and looking a little flat. I had in mind for this scene a definite light and dark side to the buildings and I wanted to use some colour to make them appear sunlit, so I used a photograph I had taken a day or two earlier to supply me with this information (see below, bottom). I realise to some this may seem a bit contrived or over-complicated, but it gave me a working method to try and achieve the picture I envisaged at the outset.

The reference photographs.

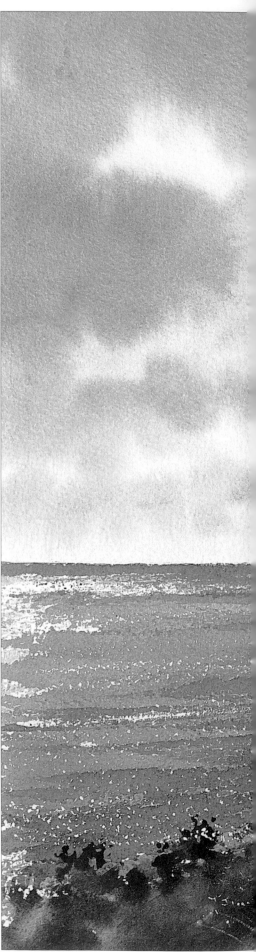

The finished painting.

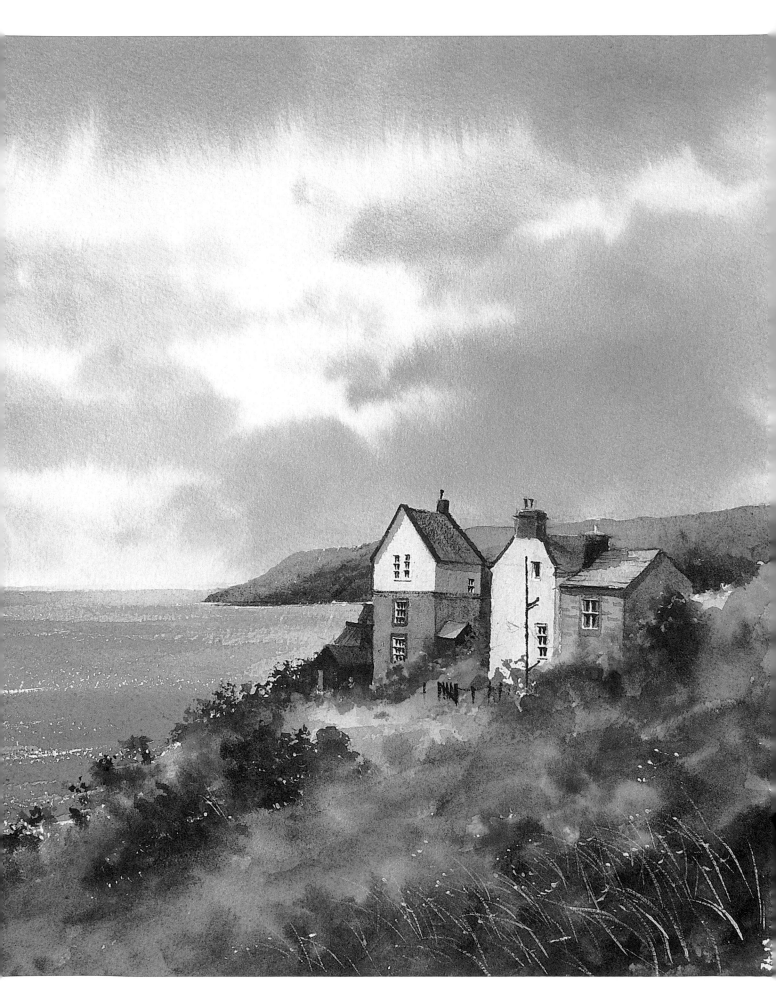

1 Draw the scene, then use a piece of white candle to create wax resist where you want to imply sparkles on the water.

TIP

Do not overdo the wax resist as it is not easy to see what you are going to get when you add paint.

2 Next use masking fluid to mask out the areas you want to keep white: the tall whitewashed buildings that are the focal point of the painting; the rooftops on the left, and part of the horizon.

3 Mix your sky washes before beginning to paint: cadmium red; cadmium red and cobalt blue; neutral tint; sepia; and cobalt blue. Sponge the sky area with clean water, going over the tops of the buildings and the cliff. Take a no. 16 brush and paint a very thin wash of cadmium red to tint the lower sky.

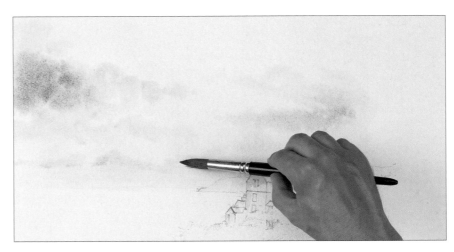

4 Pick up the cadmium red and cobalt blue mix and paint cloud shapes wet in wet on the left and right of the sky with the side of the brush. Then use the point of the brush to paint smaller clouds lower down.

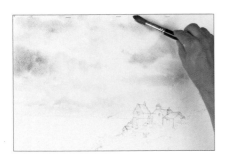

5 Drop in some cobalt blue at the top of the sky, leaving some white paper showing.

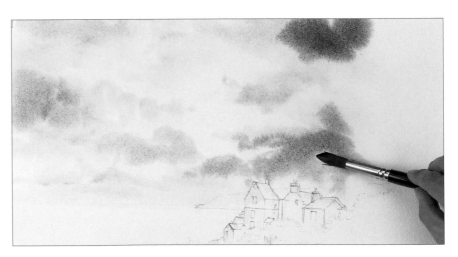

6 Paint dark clouds using neutral tint, to create a dramatic, stormy look to the sky, especially behind the houses, where it will contrast with the brightness of the buildings.

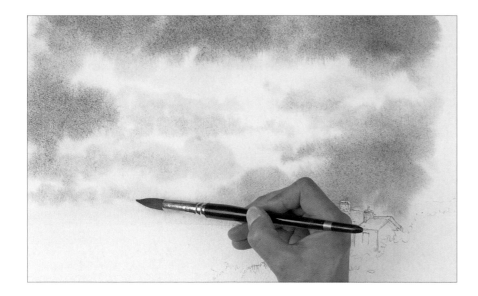

7 Drop in a brush full of sepia from the top of the painting, allowing the colours to mix on the paper. Add more sepia behind the houses and still more at the top of the sky. Then paint small cloud shapes in the pink near the horizon with a weaker mix of sepia.

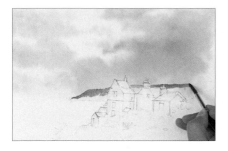

8 Rub the masking fluid from the horizon, and prepare the paint mixes for the next section of the painting: cobalt blue and cadmium red; lemon yellow and raw sienna; neutral tint; and burnt sienna and cobalt blue. Take a no. 8 brush and paint the cliff with the cobalt blue and cadmium red mix.

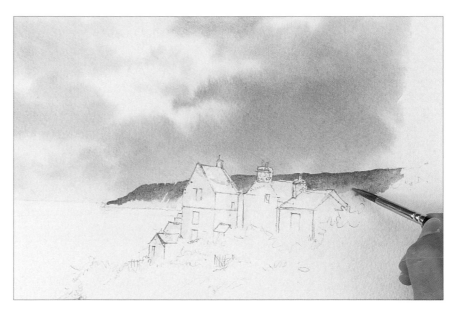

9 While the paint is wet, drop in the lemon yellow and raw sienna mix lower down, allowing the colours to blend on the paper.

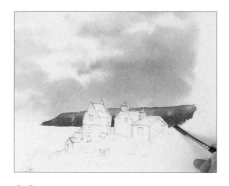

10 Bring the edge of the cliff to a fine point using a no. 4 brush and the burnt sienna and cobalt blue mix. Soften the hard edge at the right of the cliff using clean water and allow the painting to dry.

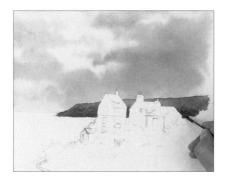

11 Remove the masking fluid from the larger buildings and tidy up the edges using the colours from the background.

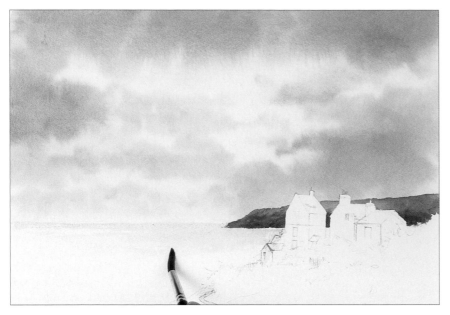

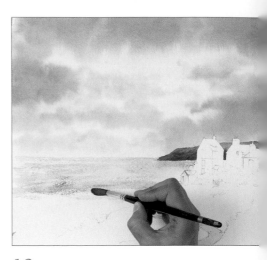

13 Next brush in the cobalt blue and cadmium red mix, painting over the wax resist to create a sparkling effect.

12 Prepare the washes for the sea, which should contain the same colours as the sky: cadmium red; neutral tint; cobalt blue and cadmium red; and sepia. Use the no. 10 brush and paint a hint of cadmium red with water up to the horizon. Brush water in to soften it.

14 Paint with neutral tint at the lower edge of the water area, and add a little on the horizon.

15 Next add streaks of sepia to reflect the dark clouds, making the colour darker near the foreground. Allow to dry.

16 Working wet on dry, develop the sea, adding streaks of cobalt blue and cadmium red.

17 Add streaks of neutral tint and then a touch of sepia at the lower edge of the water area.

18 Paint a little neutral tint on the horizon, suggesting a dark cloud shadow on the sea.

19 Brush the horizon with clean water and dab it with a paper tissue to fade out the hard line. Then use the liner/ writer brush and white gouache to suggest waves in the far distance.

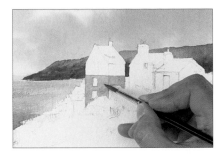

20 Use the no. 6 brush and a mix of raw sienna and a little burnt sienna to paint the stone colour on the lower part of the house on the left.

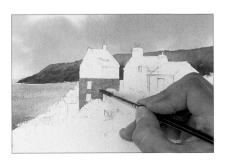

21 Drop in sepia wet in wet.

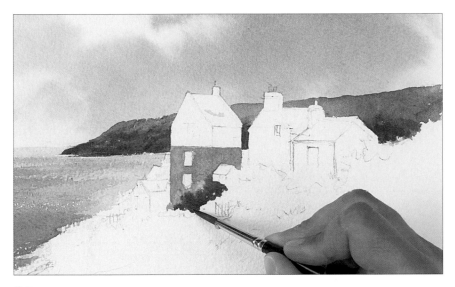

22 While it is still wet, touch in a little lemon yellow around the bottom of the house, then mix aureolin and neutral tint to make a dark green, and drop this in to the wet lemon yellow.

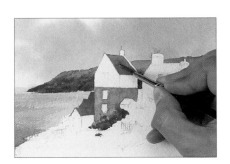

23 Mix a red from aureolin and burnt sienna and paint the roofs to the left of the big house, and the main roof.

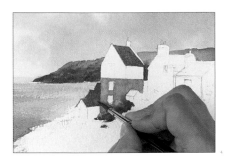

24 Tone down the brightness of the roofs by dropping in a mix of cobalt blue and cadmium red wet in wet. Leave the painting to dry.

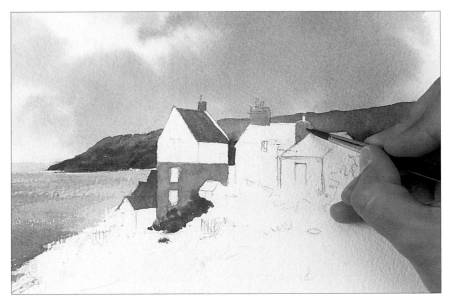

25 Paint all the chimneys with the same raw sienna and burnt sienna mix used on the walls.

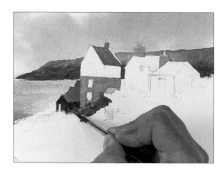

26 Use a mix of neutral tint and burnt sienna to paint the dark building on the left. Before it dries, drop in lemon yellow around the bottom and let it seep into the darker colour, suggesting bushes in front of the house.

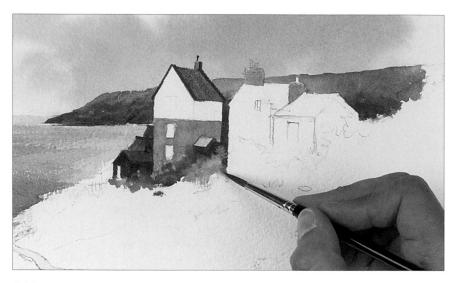

27 Shadow the roofs facing away from the light with cobalt blue and cadmium red. Use burnt sienna and neutral tint with a no. 6 brush to paint the roof ridges. Use dry brush work and the same colour to paint the dark shades of the shed and between the buildings. Add more lemon yellow to the bushes.

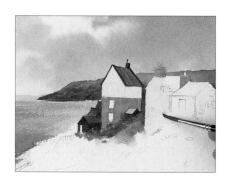

28 The white of the paper is too stark, so apply a faint tint of cobalt blue to the houses. Allow it to dry.

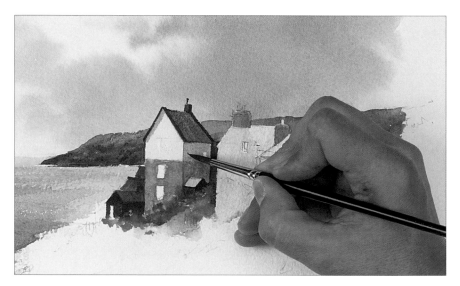

29 Use cobalt blue and cadmium red to shadow the right-hand side. Glaze over the whole side of the building and under the eaves.

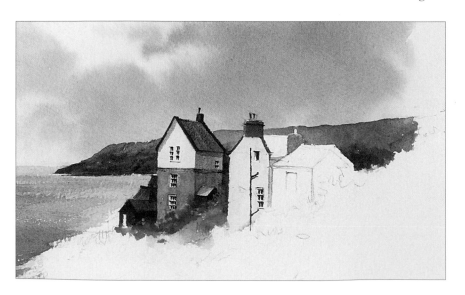

TIP

Make sure the brush you use for detail has a good, fine point.

30 Paint a line where the whitewash joins the stone. Use the same dark mix and a no. 4 brush to paint architectural details and windows.

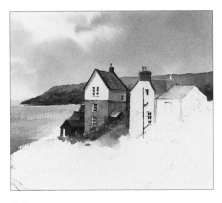

31 Paint the second roof with aureolin and burnt sienna, then drop in cobalt blue and cadmium red wet in wet. Dab off some of the colour with a paper tissue to create texture.

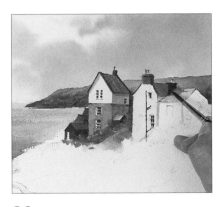

32 Darken the chimney of the third building with neutral tint and burnt sienna. Then paint the shadow on the roof, the shadow side of the chimney and the cast shadow from the chimney using the cobalt blue and cadmium red mix.

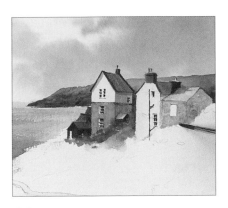

33 Paint the walls of the third building using the no. 6 brush with raw sienna and burnt sienna, then drop in the cobalt blue and cadmium red shadow colour wet in wet.

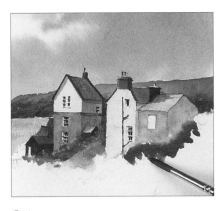

34 Paint the bushes round the bottom of the third building using lemon yellow, then use the no. 8 brush to drop in a dark green mixed from neutral tint, aureolin and burnt sienna to suggest foliage.

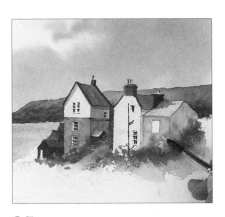

35 Develop the foliage around the front of the middle house using dry brush work. Then drop in a little burnt sienna and lemon yellow and allow the painting to dry.

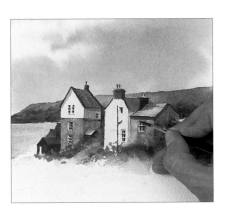

36 Paint shadow on the third building using the cobalt blue and cadmium red mix. Then take the no. 4 brush and paint the window using a strong mix of the same colour.

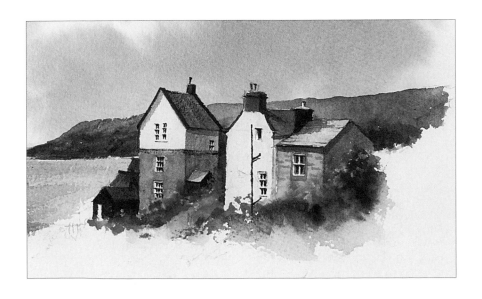

TIP

Burnt sienna always looks brighter if you add a touch of yellow.

37 Indicate stones on the building on the right using raw sienna and burnt sienna. Using the no. 4 brush, paint a shadow cast down the roof from the middle chimney.

163

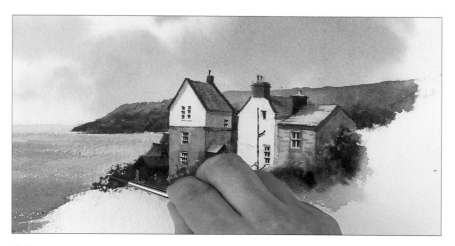

38 Paint the door of the shed in burnt sienna and cobalt blue. Next mix the colours for the hillside: light green mixed from aureolin and a touch of cobalt blue; raw sienna and burnt sienna; lemon yellow; lemon yellow and raw sienna; and a dark olive green from aureolin and neutral tint with a hint of burnt sienna. Take the no. 4 brush and use the dark olive green and dry brush work to paint bushes to the left of the buildings.

39 Wet the area of the hillside in front of the buildings to help the colours flow. Drop in the light green and then some of the dark olive green, wet in wet. Drop in lemon yellow and raw sienna to suggest the bright colour where light catches the grasses.

40 Float in raw sienna and allow the colours to merge. Add clean water and drop in light green. Drop in dark green at the edge of the sea and over the lighter green, letting the colours blend wet in wet.

41 Paint raw sienna and burnt sienna on the left-hand edge of the hillside. Drop in the darker green, then add more neutral tint to the dark olive green mix and drop it in at the water's edge.

42 Drop in lemon yellow to merge with the green.

43 Re-wet the foreground so that the colours continue to merge. Drop in raw sienna and burnt sienna and add a little cadmium red.

44 Take the no. 16 brush and paint the aureolin and cobalt blue mix up to the right and the foreground of the painting. Drop in burnt sienna, then lemon yellow.

45 Mix aureolin, neutral tint and burnt sienna to make a very dark green and paint it in from the bottom right.

46 Add more dark green, especially around the lighter area of the lawn in front of the buildings.

47 Drop burnt sienna into the foreground to add warmth, and add more dark green at the top right. Allow the painting to dry.

TIP

A few touches of extra detail in the foreground can help bring it forward.

48 Paint the edges of the windows using netural tint and raw sienna. Then pick up the shadow colour, cadmium red and cobalt blue and glaze cloud shadows over the foliage. This will help to unify the painting by echoing the sky colours and the shadows on the buildings.

49 Paint the garden gate and fence posts with neutral tint and burnt sienna using a no. 4 brush. Mix white gouache with aureolin and use a liner/writer brush to suggest highlights, weeds and flowers. Paint grasses with white gouache mixed with a little lemon yellow and cobalt blue.

50 Having stepped back to look at the painting, I decided to add a few flower heads in the foreground using white gouache and lemon yellow. I also faded out the hill behind the house with clean water and a paper tissue.

Woodbridge Tidal Mill, Suffolk

45.7 x 30.5cm (18 x 12in)
Here I have painted weatherboarded buildings with brightly lit, orange rooftops under
a dramatic cloudy sky. I painted the sky by mixing four separate washes: Naples yellow,
cobalt blue, neutral tint and sepia. Then it was simply a case of wetting the top three-
quarters of the paper with clean water and laying these colours in, concentrating the sepia
at the top so the sky is darker there and gradually lightening towards the horizon.

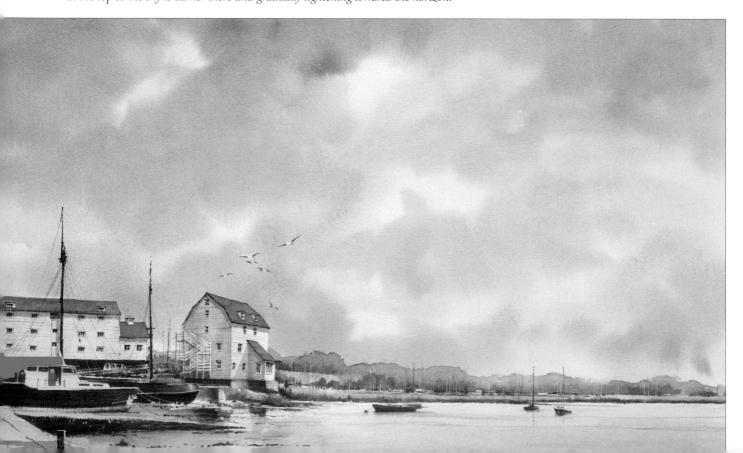

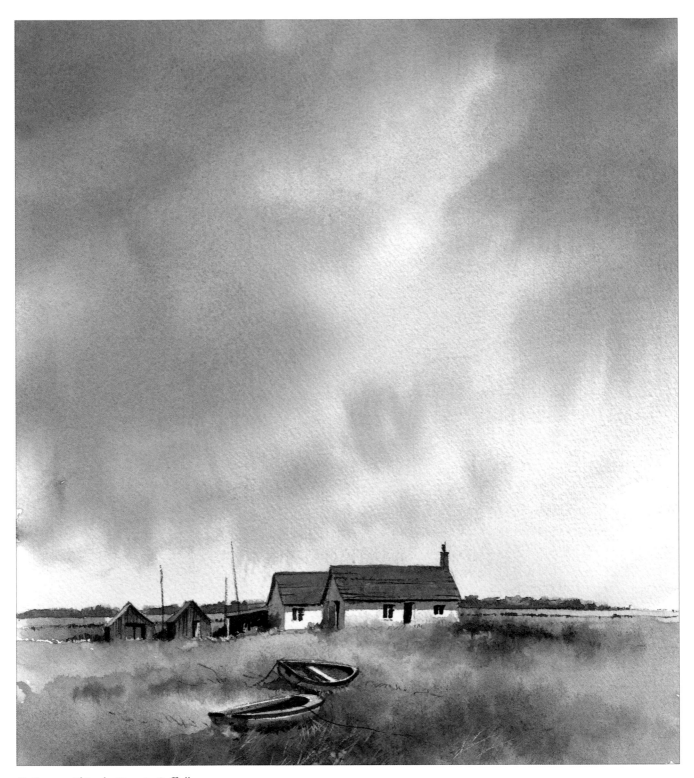

Cottages, Shingle Street, Suffolk

23 x 31cm (9 x 12¼in)

*This couple of whitewashed cottages with old weathered huts on the Suffolk coast gave me an
excellent opportunity to contrast clean white paper with an atmospheric, heavy sky. I used
a thin wash of Naples yellow to take the whiteness off the paper in the lower part of the sky,
immediately followed by a thin wash of cobalt blue in the top two-thirds of the sky, then a much
stronger wash of Payne's gray, also in the middle and top of the sky. Concentrate the heavier
wash at the top and do not cover all the sky area with colour, as the odd glimpse of white and
Naples yellow looks more convincing. I propped the drawing board up at a slight angle to
encourage a running down effect to suggest distant rain, and then left the painting to dry.*

Light and Atmosphere

In this chapter I want us to consider the sky mainly as a source of light, and as a backdrop to the painting. In a painting like the one on the right, depicting sky detail and cloud formations is not as important as seeing the sky colours as a continuous theme throughout the whole scene. It is a good opportunity to practise using a bit of imagination – just think of a set of colours, mix them and lay in some washes, then use this to suggest a painting, rather than starting off with a specific place in mind.

This view from the shore of Lake Garda is quite uncomplicated, relying on a limited palette of colours and simple shapes. Often if you add too much detail, it detracts from the main theme of light and atmosphere and you can lose the very essence of the subject that attracted you in the first place.

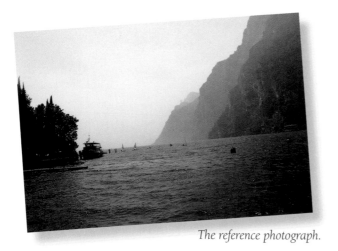

The reference photograph.

The preliminary sketch.

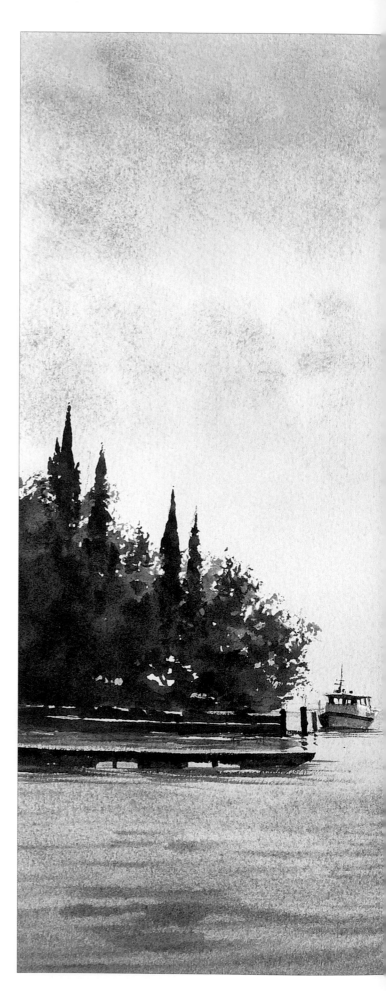

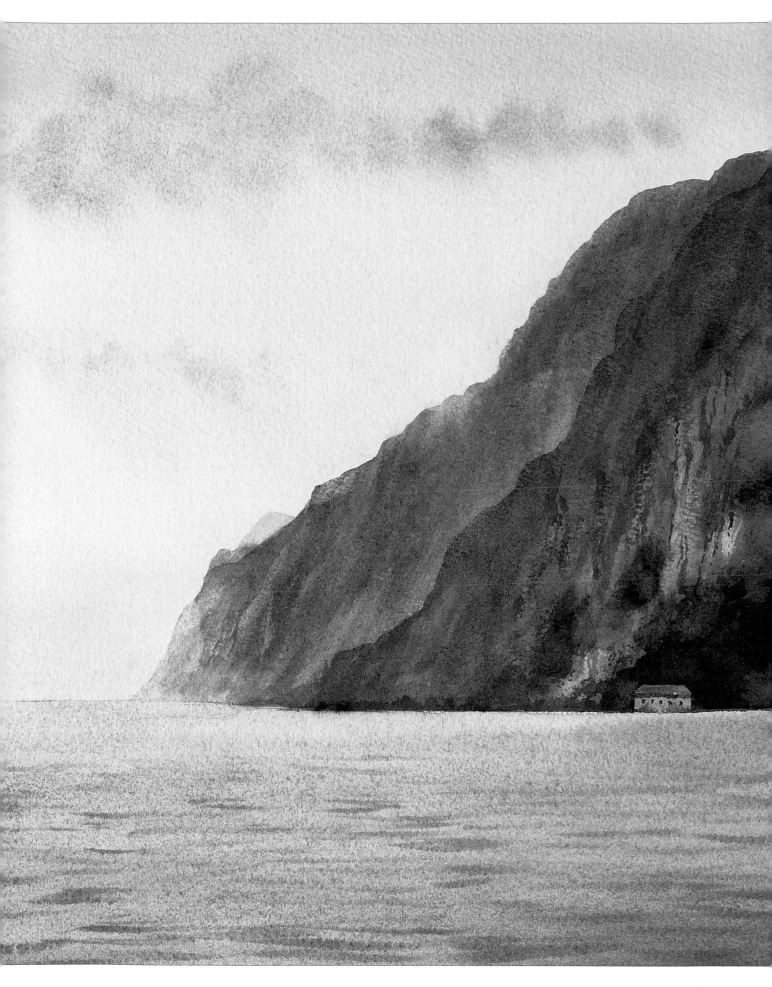

1 Draw the scene. Paint masking fluid where the lake meets the sky and on the boat, jetties and building.

TIP

Keep the sky washes light to achieve a bright glow.

2 Make two very thin washes, one of quinacridone gold and one of burnt sienna. Then mix washes of cerulean blue with a touch of cobalt blue; and cerulean blue with cobalt violet. Sponge over the whole area above the horizon with clean water and use a 2.5cm (1in) flat brush to lay in the quinacridone gold wash from the horizon upwards.

3 Half-way up the sky, blend in the burnt sienna wash. Then paint the cerulean blue and cobalt violet wash from the top, wet in wet.

4 Change to the no. 16 round brush, pick up the cerulean blue and cobalt violet mix and drop in cloud shapes wet in wet with the side of the brush.

5 Drop in burnt sienna to add warmth to the clouds.

6 Drop in more cerulean blue and cobalt violet clouds. As the colours mix and separate on the paper, new colours will form.

7 Add burnt sienna near the horizon. You can tilt the board towards you to let the colours run downhill. Allow the painting to dry.

170

8 Mix two washes for the mountains: cerulean blue and cobalt violet; a warm grey from cobalt blue, cobalt violet and burnt sienna; and cobalt violet, burnt sienna and cerulean blue. Use a no. 10 round brush to paint the distant part of the mountain in the first colour. The brush strokes should follow the slope of the mountain.

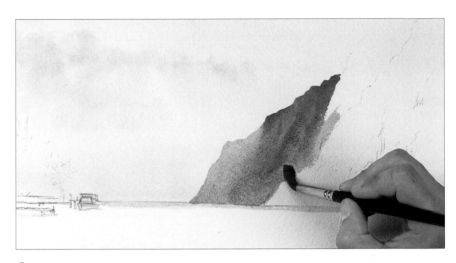

9 Paint the slightly nearer part of the mountain in the stronger warm grey. Add cobalt violet, burnt sienna and cerulean blue wet in wet for the lighter colour lower down. Your brush strokes should always follow the slope of the mountain.

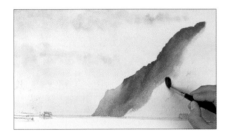

10 Continue with cobalt blue, cobalt violet and burnt sienna to the top of the mountain, and soften the edges with a clean, damp brush.

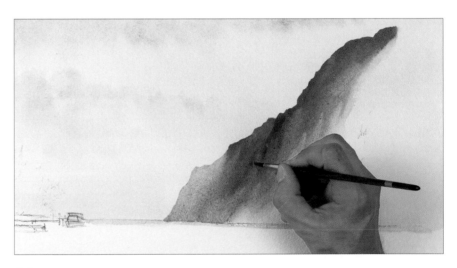

11 Take the no. 6 round brush and use the same mix to pick out crevices in the rocks, still working wet in wet for a soft effect.

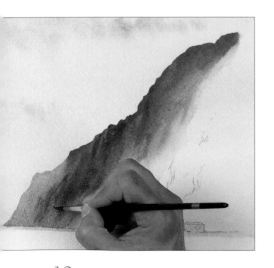

12 Paint more crevices in the more distant part of the rock, and allow the painting to dry.

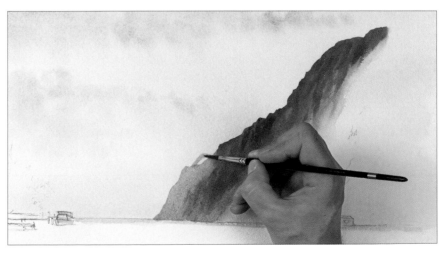

13 Use a no. 6 brush and a thin mix of cerulean blue and cobalt violet to paint in the most distant mountain, and let it dry.

 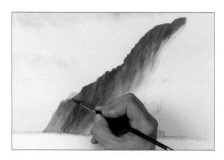 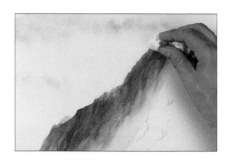

14 Use cobalt blue, cobalt violet and burnt sienna to define the nearer mountain, emphasising that it is in front of the new far-distant peak.

15 Define the distant mountain a little more and allow the painting to dry.

16 Soften the edge of the main mountain using clean water, then blot it with paper tissue.

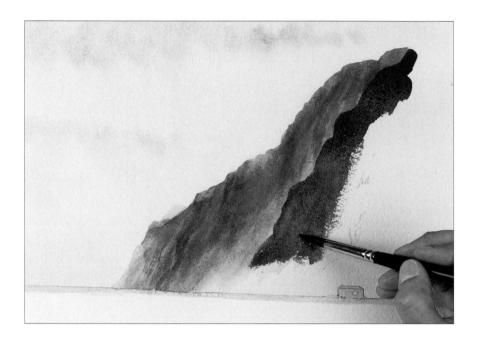

17 Mix the washes for the nearer hillside: cobalt blue, cobalt violet with more burnt sienna; raw sienna and cobalt violet; quinacridone gold with cobalt blue to create a mid-green; quinacridone gold with ultramarine blue to make a dark green; and a pink colour for rocks made from quinacridone gold with cobalt violet. Take the no. 16 brush and the warmer grey and paint in the shape of the nearer mountainside.

Tip

Use a large brush to paint a large area. It will cover the paper more quickly and create a feeling of spontaneity.

18 Paint in the lighter raw sienna and cobalt violet wash wet in wet.

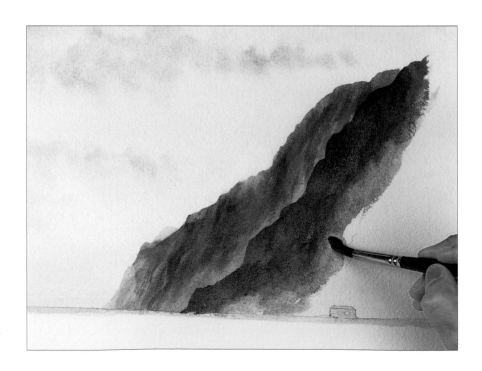

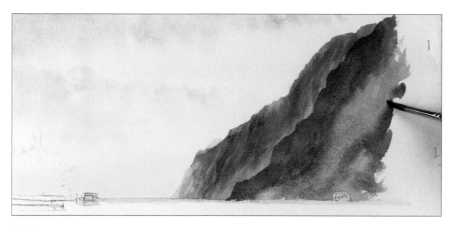

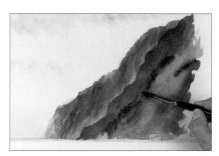

20 Mix cobalt blue and burnt sienna and paint the dark shapes in the mountainside.

19 Add the green mix of quinacridone gold and cobalt blue. Working wet in wet, drop in the darker green mix of quinacridone gold and ultramarine blue.

21 Add burnt sienna to the dark green mix and paint the rich darks behind the building. Leave lighter patches. Use a paper tissue to lift out colour, suggesting rocks catching the light.

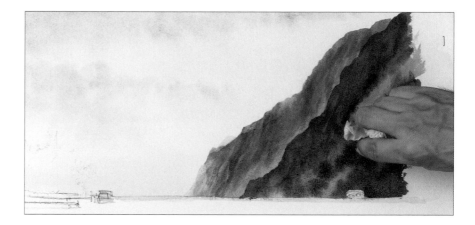

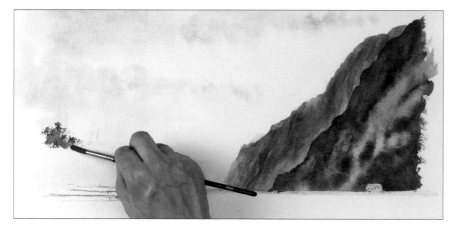

22 Use the no. 8 brush on its side with a warm grey mix of cobalt blue, cobalt violet and burnt sienna to suggest the broken edge of foliage on the left of the painting.

23 Float in the lighter green, mixed from quinacridone gold and cobalt blue wet in wet.

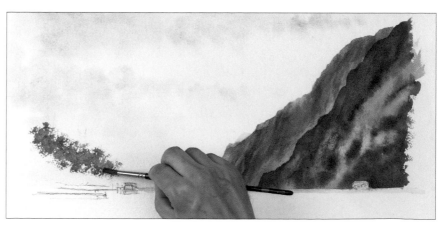

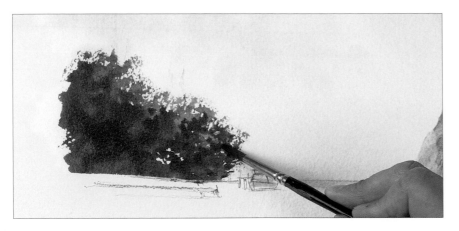

24 Add the rich, dark green mixed with quinacridone gold and ultramarine, leaving gaps to suggest light showing through the foliage. Paint more solid dark green down to the jetty.

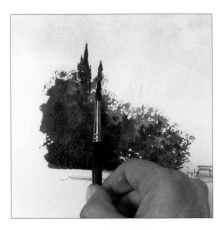

25 Use the shape of the no. 6 brush on its side to print the shape of fir trees emerging from behind the foliage.

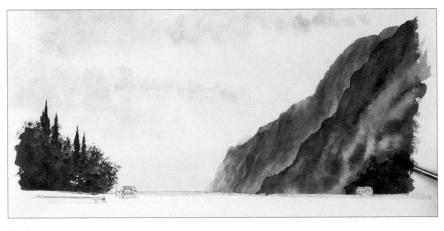

26 Develop the right-hand side of the painting, working in more dark green with the side of the no. 10 brush, then allow to dry.

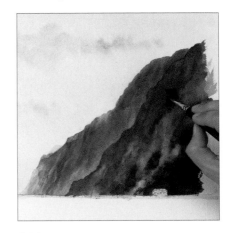

27 Take the cobalt violet, cobalt blue and burnt sienna and the 1.3cm (½in) flat brush and sweep a glaze over the crevice between hills to soften it. Add water and blend the glaze into the whole area.

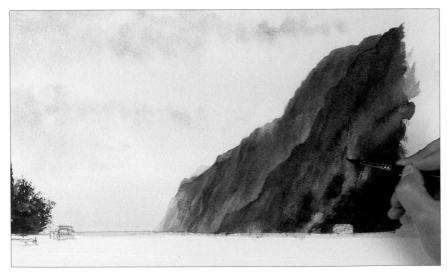

28 Use a thicker mix of the same grey and the no. 6 brush to add details such as crevices in the rocks. Allow the painting to dry.

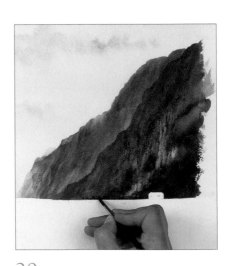

29 Rub off all the masking fluid apart from that on the boat. Neaten the edges of the house and the water's edge using dark green.

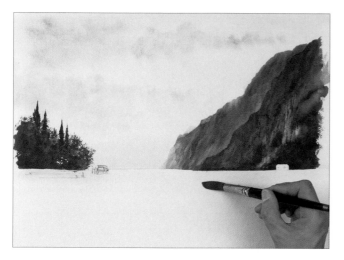

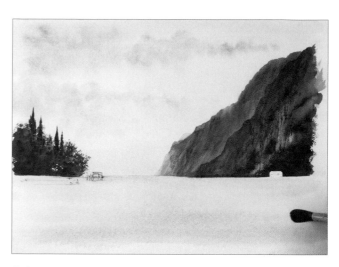

30 Mix colours for the water: very watery quinacridone gold; burnt sienna; cerulean blue; cerulean blue and cobalt violet; and quinacridone gold and cobalt blue. Wet the water area with a flat brush and clean water. Take the no. 16 brush and paint the thin quinacridone gold wash from the top down.

31 Paint the burnt sienna wash near the top, then blend in the cerulean blue wash lower down, always keeping your brush strokes horizontal.

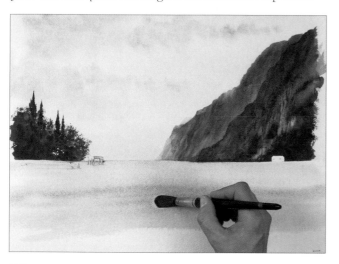

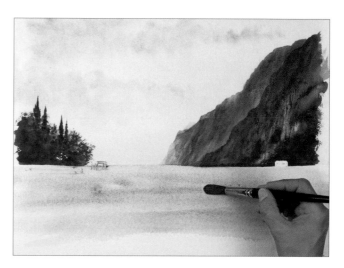

32 Add cerulean blue at the horizon, and then cobalt blue and cobalt violet in the middle.

33 Paint more of the burnt sienna wash as shown.

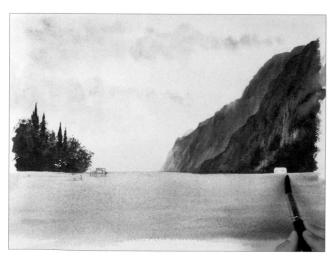

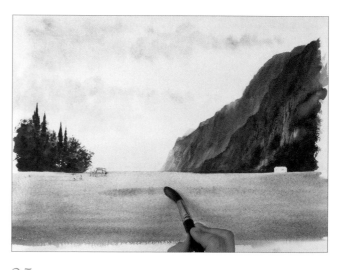

34 Darken the edges at each side with cerulean blue and cobalt violet. Paint with green mixed from quinacridone gold and cobalt blue near the horizon.

35 Add more cobalt blue to the green mix and paint it into the left-hand side. Paint streaks of cobalt violet across the middle of the water and allow the painting to dry.

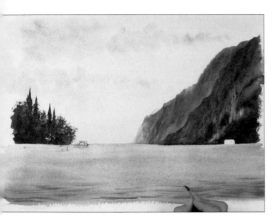

36 Use a no. 6 brush to paint grey ripples across the foreground with the cobalt blue, cobalt violet and burnt sienna mix.

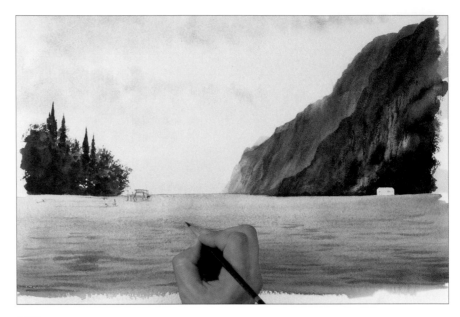

37 Paint bluey-green ripples with the tip of the brush and the quinacridone gold and cobalt blue mix. Return to the warm grey mix and change to the no. 4 brush to paint smaller ripples in the middle of the water, helping to create perspective.

TIP

Do not overdo the ripples. Keep stopping and asking yourself if you have done enough.

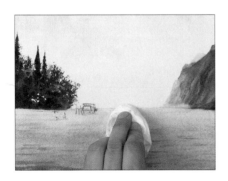

38 Soften the horizon using clean water and then blot it with a paper tissue.

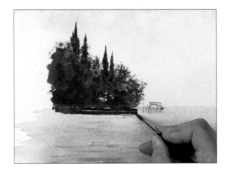

39 Use the dark green mix and a no. 10 brush to bring the green of the trees down into the water. Leave a tiny gap to suggest light on the water's edge. Then paint the dark under the jetty using a strong mix of warm grey.

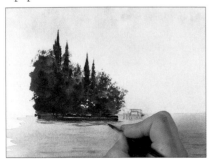

40 Paint ripples using the bluey-green mix so that the dark of the jetty appears to be reflected in the water.

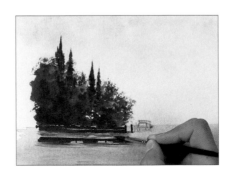

41 Use burnt sienna and ultramarine to paint a post at the end of the jetty. Paint the second jetty in the same way as the first and paint bluey-green ripples between the two.

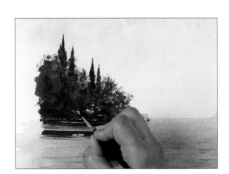

42 Mix white gouache with a little quinacridone gold and use a no. 4 brush to re-emphasise the top edge of the second jetty, and to suggest light coming through gaps in the foliage.

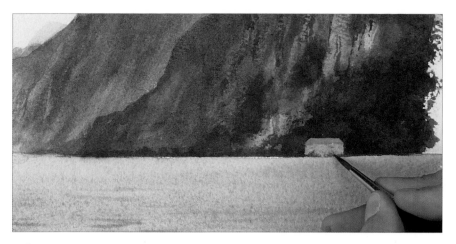

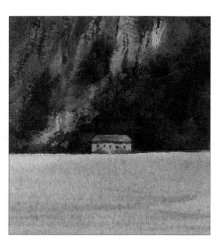

43 Paint the roof of the house on the right with a mix of burnt sienna and raw sienna and a no. 4 brush. Then mix raw sienna with some of the grey mix and paint the walls. Drop in dark green while the wall is damp to suggest bushes at the water's edge.

44 Paint the shadow under the eaves using the grey mix of cobalt blue, cobalt violet and burnt sienna. Indicate windows and add a touch of green to the roof to calm down the red.

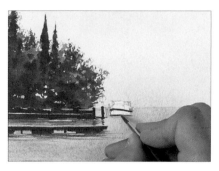

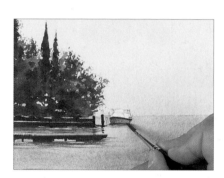

45 Rub the masking fluid off the boat. Mix a dark brown from burnt sienna and cobalt blue and paint the dark bands as shown.

46 Soften this dark colour at the bottom into the green of the water with the point of a no. 4 brush and clean water. Then paint grey along the boat's side.

47 Paint more grey at the front of the boat.

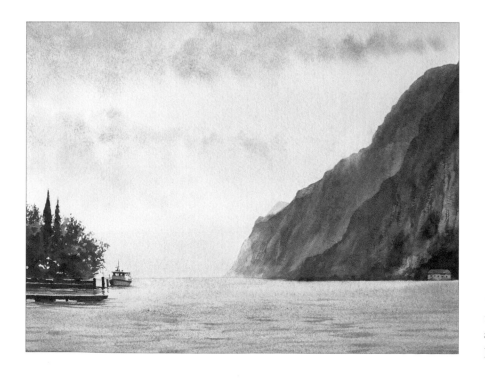

TIP

When softening a hard edge with clean water, make sure the brush is damp rather than wet.

48 Use the dark brown mix to paint the details at the top of the boat, and add an aerial. Finally, paint a mooring post by the jetty.

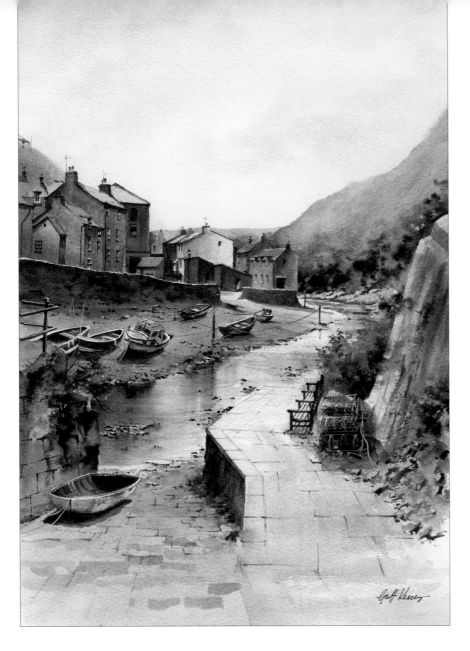

Staithes, Yorkshire

25 x 38cm (10 x 15in)

This little fishing village on the Yorkshire coast has a paintable view round every corner. I prefer to see the tide out, as it leaves the boats leaning at interesting angles with the criss-cross of ropes and assortment of posts. I painted the sky by dropping in three washes of burnt sienna, quinacridone gold and cerulean blue, allowing them to mix and merge on the paper. The distant hills were painted in using a wash of cerulean blue with rose madder, gradually introducing a hint of aureolin followed by a dark green made from viridian, ultramarine and burnt sienna. The greys and browns on the buildings were created with various mixes of the sky colours. When I got to the foreground, I echoed the sky colours once again, to create continuity and harmony.

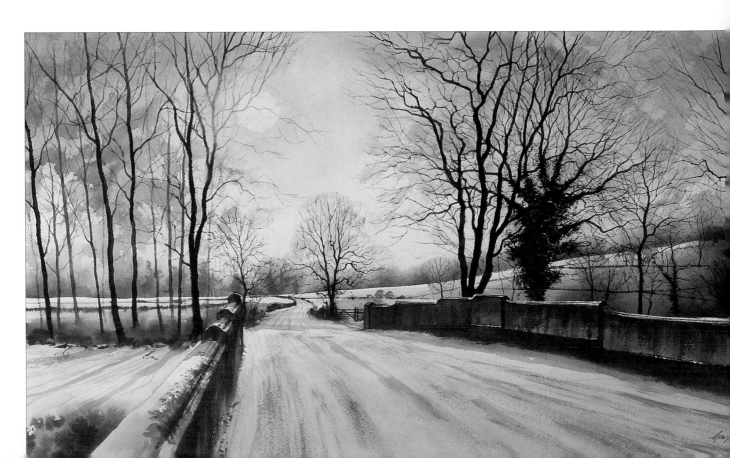

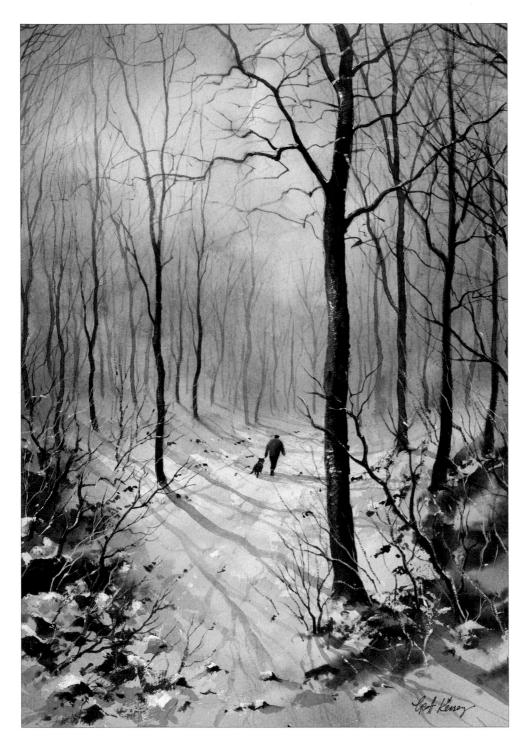

Winter in Halldale Woods

33 x 44cm (13 x 17¼in)
Because of the mass of tall trees in this scene, we do not have an uninterrupted view of the sky. Nevertheless it is the afternoon glow emanating from the sky that gives the painting light and atmosphere. The warm glow was created from a wash of aureolin and vermilion which softens into a warm grey mixed from vermilion and cobalt blue. This in turn softens into a cooler grey, containing more blue. The same grey mixtures are then used to create the all-important shadows, which steadily become warmer and redder towards the foreground. I used white gouache to indicate a light dusting of snow on the bark of the big tree on the right, on the tops of the stones in the bottom left and on some twigs and branches.

Opposite
Bridge at Rowsley

65 x 36cm (25½ x 14¼in)
In this winter scene we are looking across a road bridge into a weak, wintery sunlight, which is silhouetting the skeletal forms of a variety of trees. The whole painting was created with just four colours: cobalt blue, neutral tint, burnt sienna, and light red. To create a soft edge round the circle of the sun, I first of all wet the paper with clean water, and literally dropped a droplet of masking fluid from the end of a brush into the wet background, without touching the paper with the brush. I then mixed three thin washes: light red, cobalt blue and neutral tint, before rewetting the whole of the sky area. The light red wash was then painted in a circle around the sun, fading it out before introducing the cobalt blue and neutral tint washes. I then introduced a slightly stronger mix of cobalt blue with neutral tint and a hint of light red, to suggest the misty shapes of distant trees on the horizon. When the sky was dry, I removed the masking fluid to reveal a circle of white paper. This circle did not have as soft an edge as I would have liked, so I faded it with clean water on a damp brush.

Evening Light

On a recent day trip to Venice we were waiting by the Grand Canal at the end of the day for the return journey. The light was fading fast but the colours in the sky were inspiring, so I took advantage of the wait to take some photographs. When we are out and about, I usually have my camera with me and it is rare for me not to be looking out for potential painting subjects. I have not rendered the buildings strictly as silhouettes as I wanted to indicate some reflected light and detail, but I tried to make sure that the limited colours used for the building details were mixed from the same basic palette as the sky.

The reference photograph.

The preliminary sketch.

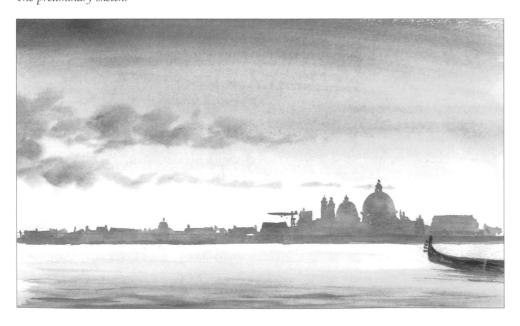

180

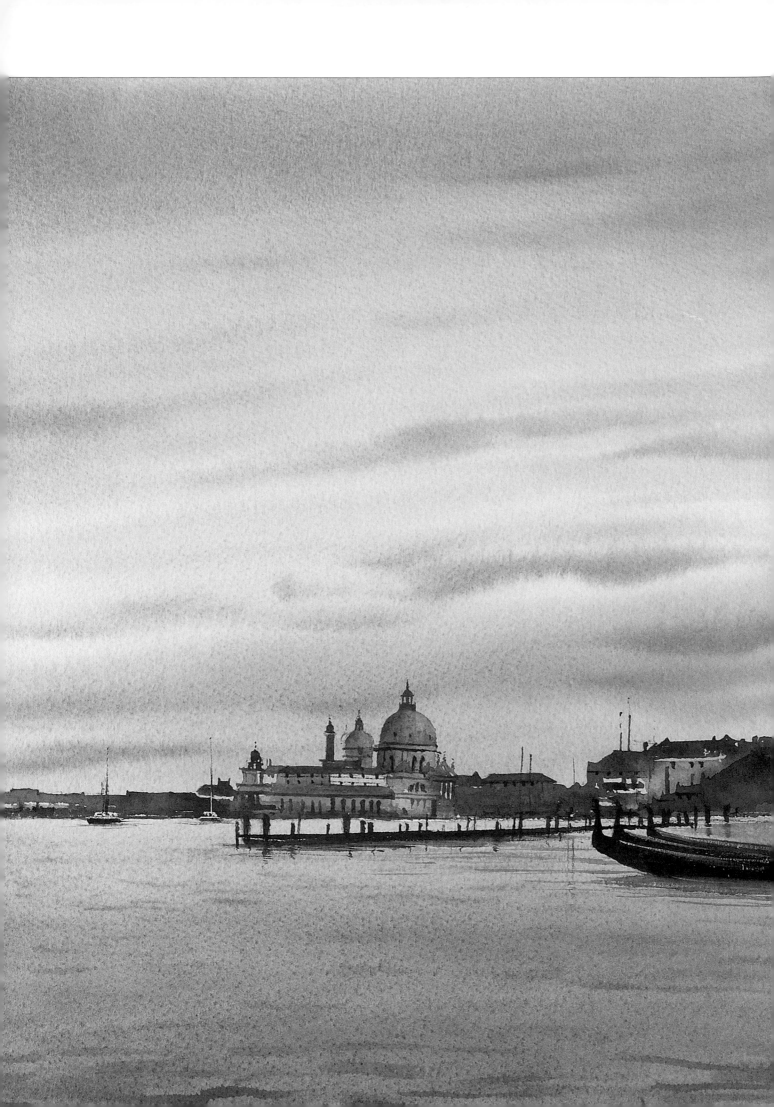

1 Draw the scene and apply masking fluid where the distant buildings meet the water. As always when working wet in wet, prepare your washes in advance: cobalt blue and rose madder for purple; aureolin; aureolin and burnt sienna for orange; rose madder; burnt sienna; and neutral tint and rose madder for cloud.

2 Wet the sky area with a clean 2.5cm (1in) flat brush, going over the buildings. Paint strokes of aureolin horizontally.

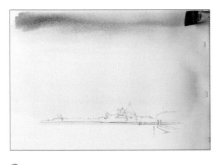

3 Clean the brush thoroughly and apply the cobalt blue and rose madder mix from the top. Do not merge it with the yellow or it will make green.

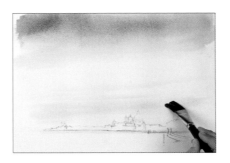

4 Pick up the orange mix and paint streaks with the flat brush on its side.

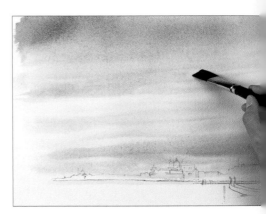

5 Paint rose madder streaks near the horizon and near the top of the sky.

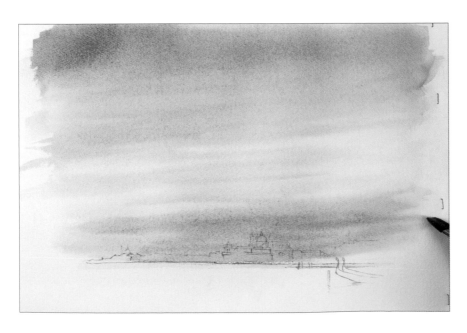

6 Add burnt sienna at the bottom of the sky near the horizon.

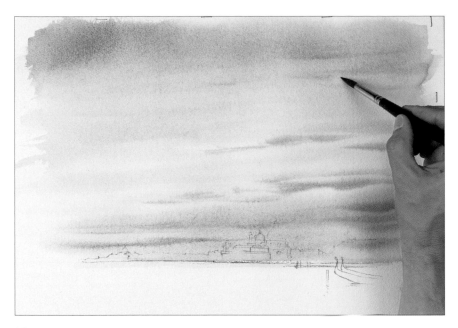

7 Pick up the neutral tint and rose madder mix with the no. 10 brush and create streaks of cloud with the very point of the brush. Allow the sky to dry.

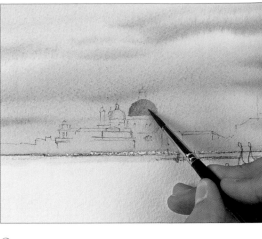

8 Some of the sky colours should be reflected in the dome. Use the no. 6 brush and cerulean blue to paint the left-hand side of the dome, then add aureolin and rose madder on the right. The colours should soften and merge on the paper.

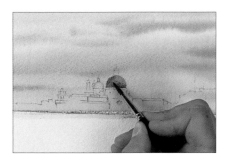

9 Drop in the purple mix from the sky washes and blend it in.

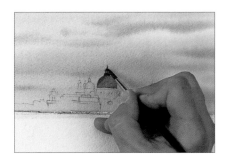

10 Mix a grey from burnt sienna, rose madder and cobalt blue and use the tip of the brush to paint the details at the top of the dome. Allow the colour to run down into the rest of the dome.

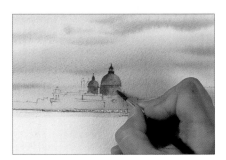

11 Paint the second dome in the same way. Add water on the right-hand side to imply highlights. Drop aureolin and rose madder in to the right-hand side of the larger dome.

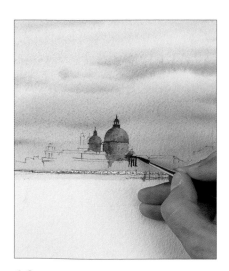

12 Change to a no. 4 brush and paint building details, leaving bright highlights.

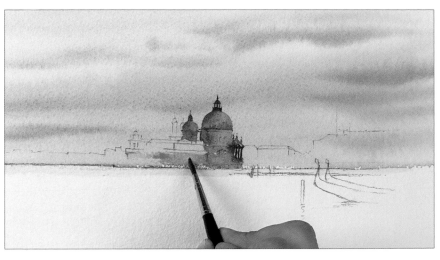

13 Drop in aureolin and rose madder so that the glow of the sky appears to be reflected in the buildings.

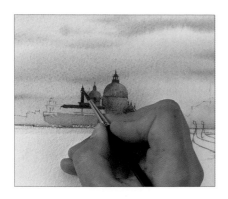

14 Paint the red roof and the tower with burnt sienna and cobalt blue.

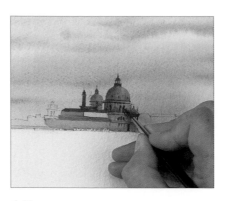

15 Use neutral tint to paint further details such as little arched windows on the dry dome.

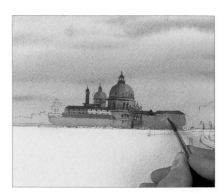

16 Paint windows on the building on the left, then paint the roofs on the right with burnt sienna and cobalt blue. Paint the walls with dilute burnt sienna.

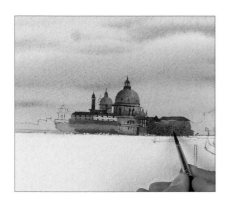

17 Drop in rose madder and then purple to reflect the sky colours.

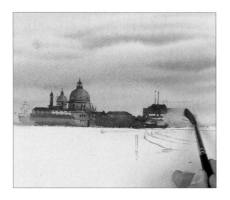

18 Work towards the right, painting roof shapes in the dark brown mix. Leave gaps to suggest rooftops catching the light. Drop in some cerulean blue to vary the colour of the highlights.

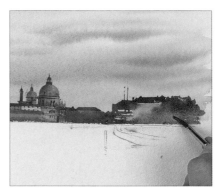

19 Use the brown mix to drop more roof shapes into the blue, then drop in rose madder and burnt sienna to warm it up.

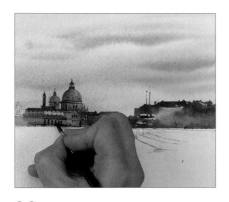

20 Drop in a little neutral tint at the bottom of the right-hand buildings. Then use the same colour to paint little arches at the base of the domed buildings.

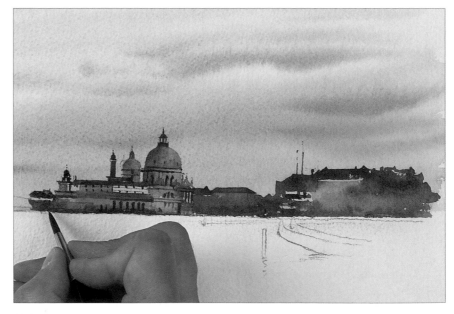

21 Paint the little dome on the left of this section with rose madder and burnt sienna. Use cobalt blue and rose madder to suggest shadow on the buildings. Paint more buildings down to the water's edge with burnt sienna and cobalt blue. Try to keep a level, neat line where the distant buildings meet the water's edge.

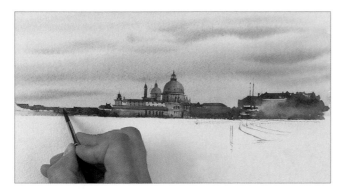

22 Paint more rooftops going towards the left-hand side using burnt sienna and rose madder, then add cobalt blue and burnt sienna lower down.

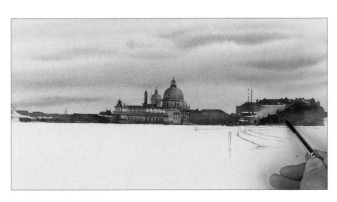

23 Paint the area on the right with a strong mix of neutral tint and rose madder.

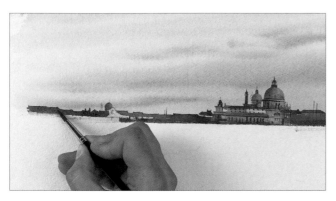

24 Use the point of the brush to paint masts. Paint the dome on the left with cerulean blue, then add grey on the shaded left-hand side and burnt sienna and rose madder lower down. Carry on to the left using burnt sienna and cobalt blue to describe the shape of rooftops.

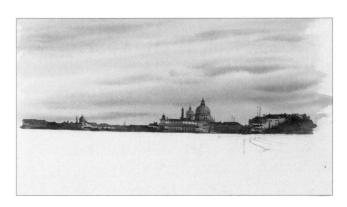

25 Paint down to the waterline with rose madder and burnt sienna. Paint the building in front of the blue dome with a thinner mix of cerulean blue. Using neutral tint and a no. 4 brush, add suggestions of architectural details such as windows and the edges of roofs.

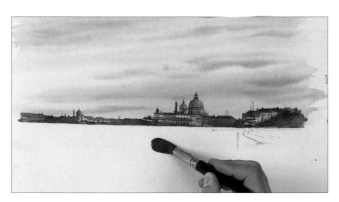

26 Take the no. 16 brush and begin to paint the water, which should reflect the sky colours but upside down. Begin with horizontal strokes of aureolin.

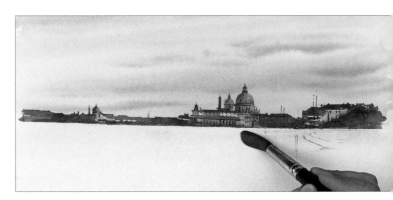

27 Next paint aureolin and burnt sienna close to the waterline.

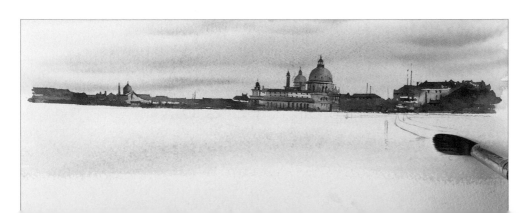

28 Working rapidly, add horizontal strokes of rose madder.

185

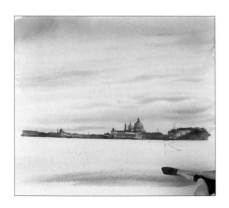

29 Add more aureolin and burnt sienna, then more purple mixed from cobalt blue and rose madder.

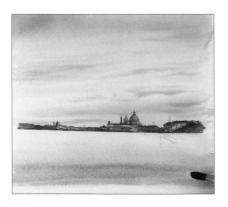

30 Add more rose madder in the foreground, working the colours together horizontally so that they merge.

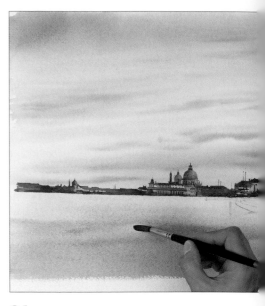

31 Paint streaks of neutral tint and rose madder with the no. 10 brush for cloud reflections.

TIP

When painting water, keep stepping back to look at the effect so that you do not overwork the area.

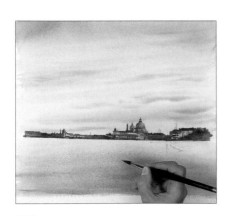

32 Mix cerulean blue and burnt sienna to create bluey-grey ripples in the foreground water. Use the tip of the brush to paint smaller ripples further back.

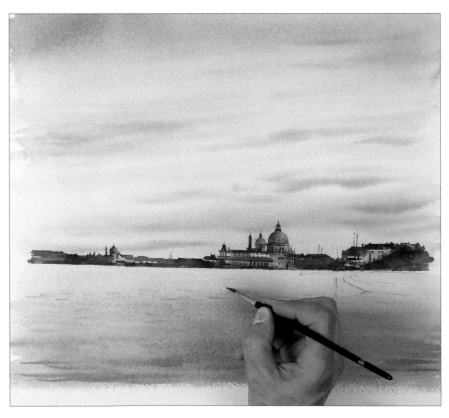

33 Paint more definite ripples on the foreground area as it begins to dry. Change to a no. 4 brush and a mix of cerulean blue and burnt sienna, and paint smaller, finer marks further back. Allow the painting to dry.

34 Draw in the jetty in front of the main dome. Mix neutral tint and burnt sienna to make a rich, dark brown and draw in the lines with a no. 4 brush.

Tip

I was not sure whether to include this jetty or not. If you want to leave your options open, do not draw any elements you are unsure of. Once you have painted over a drawing, the paint seals it and you will be unable to erase it.

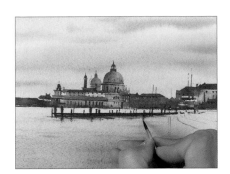

35 Paint the reflection of the jetty underneath with cerulean blue and burnt sienna, softening it in a few places with a damp, clean brush. Use the brown mix to paint posts and their rippled reflections.

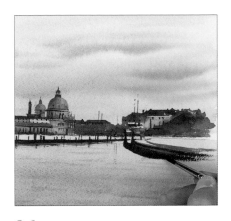

36 Mix cerulean and cobalt blue to paint the gondola covers, then use the dark brown for the gondolas themselves, allowing the brown to merge with the blue.

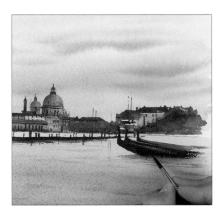

37 Use clean water and the no. 6 brush to soften the dark brown into the water, creating the gondolas' reflections.

38 Paint the jetty as it continues behind the gondolas. Add a touch of rose madder to complete the water beyond the boats.

39 Add finishing touches using white gouache. Mix a touch of rose madder with the gouache to make ripples under the gondolas and jetty. Add aureolin to paint the distant boats so that they stand out against the dark background. Complete the boats with the dark brown mix. Suggest reflections under the boats using cerulean blue and burnt sienna. Add cerulean blue to white gouache to suggest the light catching the gondola covers.

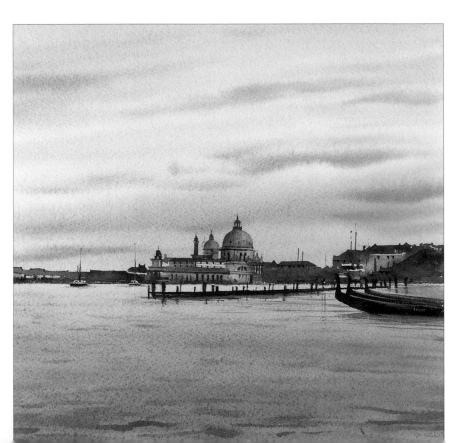

Brancaster Staithe, Norfolk

41 x 31cm (16⅛ x 12¼in)
This painting is all about light. The sky is quite simple with washes of quinacridone gold, cerulean blue and cobalt violet floated into a wet background. I have taken care to repeat these colours in the sandy foreground and middle distance, to give the painting harmony. This is not strictly accurate, as the real colours are browner and muddier, but beware of being too accurate in a situation like this, as muddy colours can look dull and flat. It is much better to create a pleasing painting with a feeling of warm light and atmosphere.

Burnham Overy Staithe

In this evening scene on the Norfolk coast, I have tried to capture the intensity of the light, using the contrasts created by almost clean white paper for the middle ground, surrounded by some quite heavy darks. I painted the sky with just three washes – quinacridone gold, burnt sienna and cerulean blue. The darks are a mixture of burnt sienna and cobalt blue, with a touch of aureolin added to make the olive green colour used for the suggestion of grass in the right-hand foreground, and at the base of the building on the left. The man-made colours on the figures and boat hulls add a touch of contrast and variation.

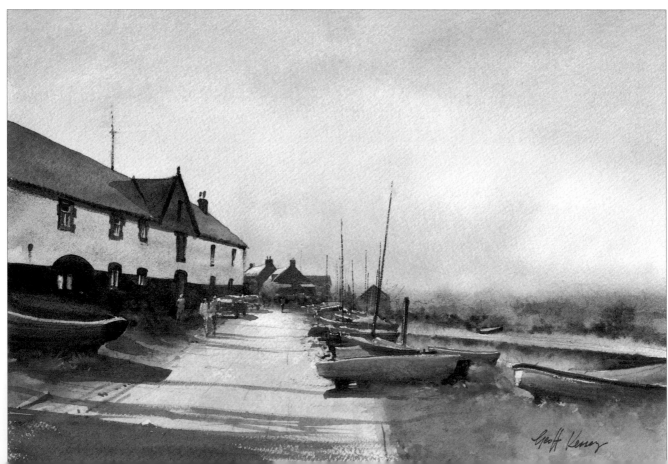

The Old West Station, Tunbridge Wells

23 x 30cm (9 x 11¾in)

This painting is all about warm light and shadows. I came across the scene crossing the road to a car park after a day in the photographer's studio, producing this book. You should always be on the lookout for potential subjects. I used quinacridone gold for the glow in the lower part of the sky, adding a touch of rose madder in the middle and finally a touch of cerulean blue with rose madder to create the grey at the top of the sky. It was very important to reintroduce these colours later in the foreground and middle distance shadows.

The rich, dark greens are also very important as they contrast with the brighter areas – note the splash of light in the bushes on the lower left. The dark green was mixed from viridian, ultramarine and burnt sienna, contrasting with the bright area created from lemon yellow and Naples yellow.

Painting Water

JOE FRANCIS DOWDEN

Learn how to paint incredibly convincing water, and how to create peaceful lakes, rippling rivers and choppy seas, in six easy-to-follow demonstrations.

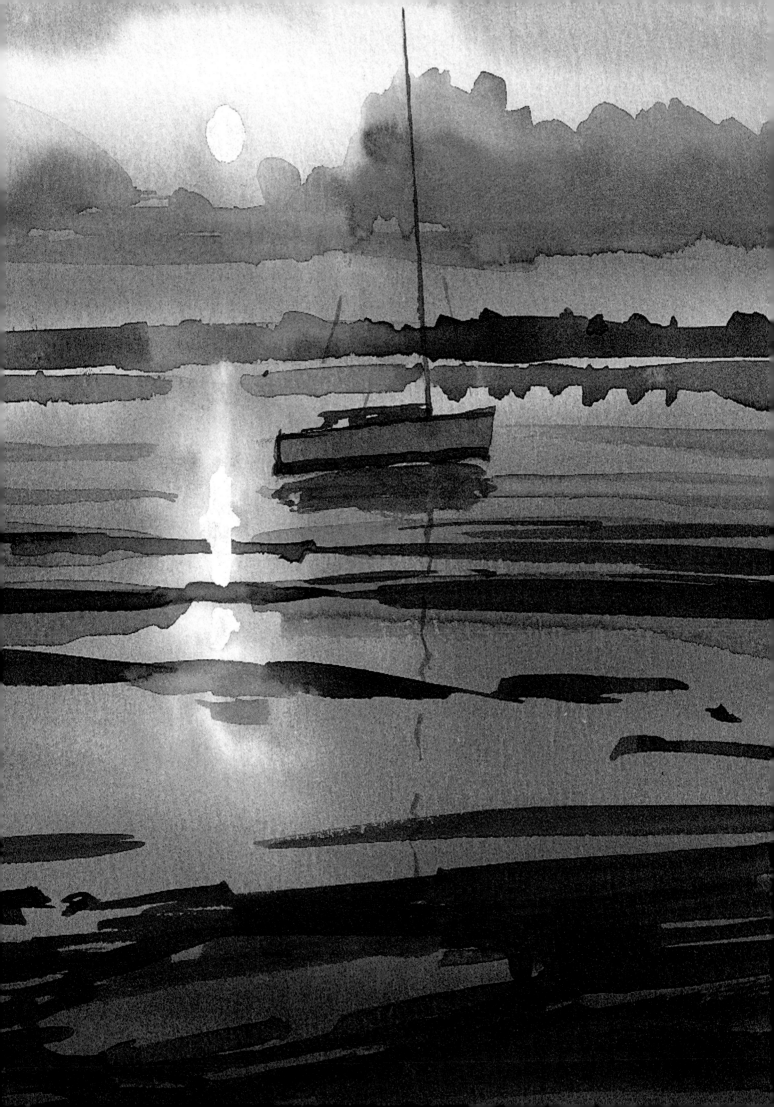

Introduction

Water forms the medium of watercolour; pigment flows naturally through it, and when the water dries that movement is frozen, perfectly capturing the movement of light on water. Its natural translucence makes it ideal for creating water itself and in this book I paint light and water, using the properties of water to achieve effective, realistic and dramatic results.

When painting a picture, I like to create powerful images that evoke the senses and draw out the mood and atmosphere of the scene in front of me. Sunlight is tremendously powerful; it cannot be looked at directly, but it lights the land with its wonderful brilliance. Perhaps there is the sound of a babbling brook, the aromatic leaf litter of a riverside forest, the crunch of shingle or the bracing cold of a sparkling stream. We can perceive and feel all these things in a three-dimensional world, because they are all around us. When working within the narrow spectrum of tone and colour it is a little different, but it is still possible to create immensely powerful mental triggers which make a painting look and feel real. They literally delude the observer – little acts of visual chicanery, deployed to trick the eye. The visual mind will say 'I know that's water, but it can't be because what I am looking at is a painting, so how did the artist achieve it?' Well, I am going to reveal my techniques to you and show you how I paint water.

Basic principles are demonstrated early on in this section with hints on capturing light, colour and texture. I include tips and techniques to help boost confidence and improve skills, and six step-by-step demonstrations which highlight particular facets of capturing water in all its moods. Many paintings are featured throughout the section, each of which was chosen to illustrate a particular point.

There are easy ways of doing most things, but you have to learn how to do them. Some of them are profoundly simple, others illustrate how to make pictures look extremely realistic. Once you know how to paint still and moving water, and how to create reflections, you will be able to enjoy the wonderful qualities of watercolour and start on your own artistic journey.

Here is how I do it. Enjoy this section and happy painting!

Opposite
Sunlit Lane
Size: 25.5 x 38cm (10 x 15in)
A large loose wash was painted virtually all at once with many colours run in, leaving the puddles as white paper. When this was dry, the puddles were rewetted, then an upside-down sky was painted, wet in wet, in each – miniature washes of phthalo blue and indigo, dark at the bottom, light at the top, getting progressively lighter for the more distant puddles. The landscape and road colours were light red and indigo. Phthalo blue, cadmium lemon and burnt sienna were also used in the landscape. The puddles were enhanced by painting contrasting darks around them.

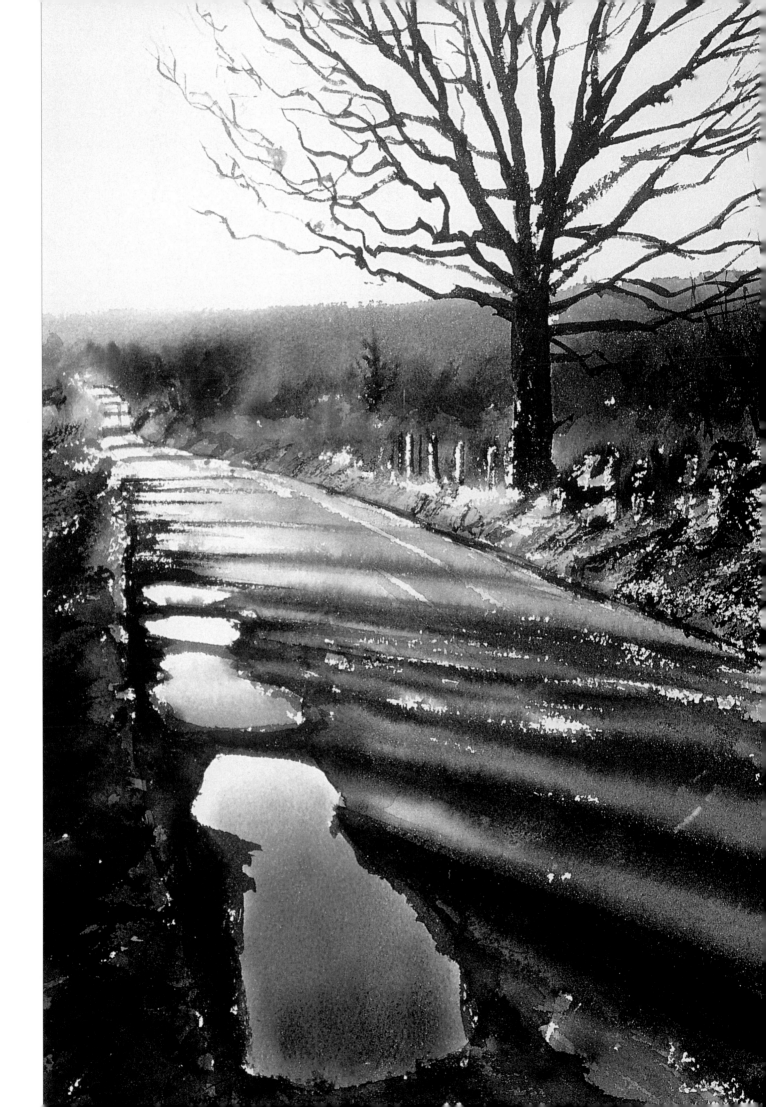

Materials

It is not the materials themselves that matter but what you do with them. The greatest triumphs can often occur in the face of adversity, especially when painting in the open air without the comfort of the studio or a set of ideal materials to hand. For me, materials are part of the enjoyment of watercolour, so, apart from the essentials (colours, brushes and paper), I have a few *extra* items in my workbox which help make painting with watercolour more enjoyable!

Phthalo blue is a near-primary blue. It is useful in skies where I often mix it with a little green. It also forms the basis for blue sky reflections in water.

Ultramarine blue (or French ultramarine) is a warm blue from which good violets can be made. It is useful on its own for distant landscape blues. Mix with burnt sienna for a range of greys.

Cobalt blue is a cool blue. It is a traditional sky blue, and, sometimes, I mix it with phthalo blue. Also used as the base for subtle greys.

Phthalo green added to cadmium lemon makes the range of intense greens that I use. Start with a lot of cadmium lemon and add a little phthalo green. You can also warm it with burnt sienna. You could mix greens from phthalo blue and cadmium lemon, but a tube of ready-mixed colour is easier.

Cadmium lemon makes all the other yellows, but you cannot mix a lemon yellow from any other. Cadmium lemon lacks transparency, but it does have mixing power, and you do not get both qualities in one pigment. In any case it will still behave transparently in practice. Mix it with touches of quinacridone red to make lovely oranges.

Quinacridone red is a crimson red which will make good violets when mixed with blue, and a fire-truck red when mixed with touches of cadmium lemon. Cadmium red could be a later addition to your palette, but it is not such a versatile colour for mixes.

Burnt sienna is a lovely transparent oxide brown – wonderful with the blues in a range of mixes for endless subtle warm and cool greys, and brilliant on its own.

Payne's gray can be used as a darkening agent. I use it as a virtual black, sometimes mixing it with phthalo blue for intense dark.

COLOURS

Sometimes, I paint with a very limited palette, or deliberately avoid using my favourite colours, so that I have to try new ones. This practice helps continue the learning process and prevents me from feeling stale. Always try to be open minded and experiment with new colours.

It is surprising how much you could paint with just three near-primary colours (cadmium lemon, quinacridone red and phthalo blue), but, more realistically, the eight colours shown left would make an immensely versatile palette. Buy them in larger tubes as it is less expensive in the long run. There are three blues, one green, one yellow (but no orange), a crimson, an earthy golden brown, and a heavy duty grey which can be used as a black. I have included three blues because it is hard to do without them and it is difficult to duplicate them by mixing.

The colours I use most are cadmium lemon, burnt sienna, and to a lesser extent ultramarine blue.

The next colours to add to your palette could be those shown opposite.

TIP USEFUL GREYS

Useful greys can be mixed with phthalo green and quinacridone red. A touch of the red in the green makes a great pine-tree colour. Gradually add more red to create a fascinating range of complementary greys. Beautiful greys for skies can be obtained with cobalt blue or ultramarine blue mixed with burnt sienna and quinacridone red.

Yellow ochre is a summer meadow yellow – the colour of a field of ripe barley.

Cerulean blue granulates beautifully and is an opaque, slightly greenish blue, sometimes used in skies.

Naples yellow is a creamy yellow mixture of several pigments in one package. It can be used as a medium for mixing other colours into an evening sky.

Cadmium red (light or middle) is a tertiary red, on the border between red and orange. A beautiful colour on its own.

Cobalt turquoise light is another tertiary colour. It is an almost iridescent turquoise made of several pigments. It can be used as a body colour over darker colour. I use it to get distance and depth in my woodland landscapes.

Light red is a brick red which is the perfect colour for roofs and walls of old houses.

New gamboge is a luminous transparent colour that creates the sunlight on a hillside better than anything else. It allows the whiteness of the paper to provide the light and is a modern, permanent version of gamboge.

TIP COMPLEMENTARY COLOURS

If you do not know what colours to use to get a good result and make something really beautiful, try constructing a painting in which two complementary colours predominate. Complementary colours look great together; each provides the after-image of the other within the eye, making them zing and spark off each other. For example, try using violet and yellow for the sky and water in an evening scene, crimson poppies in a green field, or orange autumn leaves against blue sky and water. Mixes of each pair of colours will make greys that can be used for the darks in the same painting –a partial guarantee that you will achieve colour harmony. The painting at the bottom of page 202 is a good example of using complementary colours.

195

BRUSHES, WATER JARS AND PALETTES

Using good-quality brushes can help improve your painting skills. I like to paint with sable brushes as their hairs return easily to a point, they hold a good quantity of colour and they have the capacity to release it steadily. Less expensive, synthetic and mixed-fibre brushes also point well and I have used them extensively even though they do not perfectly mimic the qualities of sable. The larger sizes, however, do not clean as quickly as sable, so take this into account when changing colours while working rapidly.

Although I own a wide selection of brushes, most of my work is painted with a No. 8 or a No. 12 round brush, but a No. 16 is useful for large washes. A fan blender is the best brush for softening multicoloured washes.

Try to avoid mixing paint with your best sable brushes. Wash all brushes gently in cold water. You could use a little vegetable-based, artists' brush-cleaning soap. Never use ordinary soap or detergent.

My water supply consists of a glass jam jar in a paint kettle. I fill both with water, then use the water in the kettle for cleaning brushes and that in the jar for mixing colours.

There is a wide range of palettes available for artists, but I prefer to use old plates and saucers.

It is always worthwhile to have more than one brush of each size.

My water supply.

Old saucers and plates make excellent palettes.

PAPER

There are four basic characteristics associated with watercolour paper: surface texture (or tooth); weight (or thickness); whiteness; and hardness. They react differently to watercolour, and it is well worth experimenting with different types of paper.

Surface texture

There are three types of surface finish – Hot pressed, Not (or cold pressed) and Rough.

Hot pressed paper is pressed between hot rollers to give a smooth surface. It is fine for some artists, but I hardly ever use it.

Not paper is pressed through rollers and felt mats. It has a subtle surface texture between moderately smooth and slightly rough which does not leave its *signature* in a painting, and I use it for most of my paintings. The term *Not* is another way of saying 'not hot pressed'.

Rough paper is not pressed at all, and the texture can be *very* rough on heavier papers. However, by controlling water and colour, you can get a smooth sky wash or a grainy/broken effect.

Weight

The imperial method of paper weight (in pounds) refers to the total weight of a ream of paper. A 90lb sheet is thin and papery, whereas a 300lb paper is heavy and thick. Nowadays, most paper weights are given in gsm (grams per square metre) units, from 150gsm to 640gsm. Watercolour paper cockles when wet, so I always stretch it. Heavy papers will take more colour and give a more intense finish than lightweight papers.

Whiteness

The 'whiteness' of paper varies considerably, but the mellower-toned papers still read as white when whites are saved. I seek out the whiter papers for river scenes.

Hardness

The hardness of papers also varies. Masking fluid, for example, can rip softer papers when it is removed. It will not harm harder papers but it can lift some of the underlying colour when laid over it. Soft-surfaced papers are sensitive and can be used for building up subtle textures. Some tearing caused by removing masking fluid can enhance the final image, as with jagged sky holes in a woodland. For detailed masking, I use a harder surfaced rag paper.

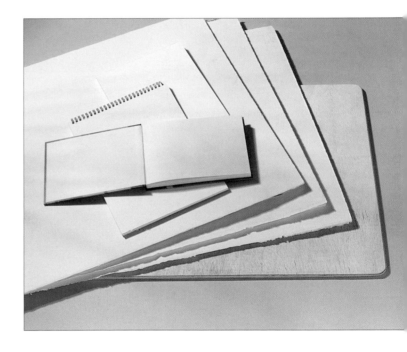

Stretching paper

I stretch all my paper before starting to paint. I thoroughly soak the paper in water, lay it on a wooden board for a few minutes to let it expand more, then staple it to the board. I keep the staples close together on papers below 425gsm (200lb) and set the line of staples just in from the edge of the paper – if they are too close to the edge the paper will rip. Leave until the paper is thoroughly dry and taut. I cut the finished painting off the board, then use a tack lifter and a pair of pliers to pull the staples from the remaining strip of paper.

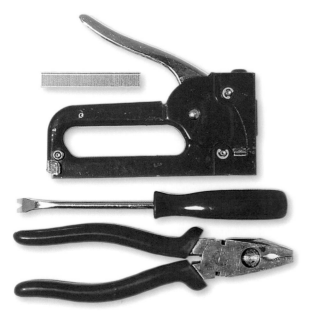

HAIR DRYER

I use a **hair dryer** to save drying time – in fact, I have two of them in my work box. However, you must dry work evenly to avoid still-wet colour running back into drying areas.

RESISTS AND MEDIUMS

Masking fluid can be used to protect the paper surface from layers of colour and left to dry. When peeled off, the underlying paper or pigment appears. Use old or cheap brushes to apply the fluid because it ruins them. Colour shapers, ink nibs and toothbrushes can also be used to create different marks with the masking fluid.

Wax candles rubbed over the paper or a dry wash will resist overlying washes to create a subtle grainy texture.

Gum arabic and **watercolour medium** added to a wet wash will slow the passage of paint through the water and allow you to get the wet, soft focus look of reflections. Use sparingly.

Granulation medium can be used to enhance the granulation of some colours.

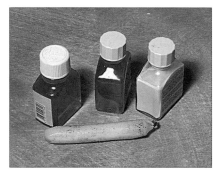

Gum arabic, watercolour medium, masking fluid and a candle can all be used to help make water look wet.

TIP GRANULATION

The granulation effect of some colours can be used to create a beautiful grainy texture. It works best with the board tilted away from you, and the painting left to dry naturally – the pigments settle into the undulations in the surface of the paper. Cerulean blue, ultramarine blue, cobalt blue, manganese blue, viridian, cobalt violet, ultramarine violet and raw umber are usually good granulating colours, but the characteristic does vary with different brands. Granulation medium can be used to enhance the effect.

This enlarged detail, taken from the Seascape demonstration (see page 250), shows the granulation of ultramarine blue mixed with granulation fluid and touches of burnt sienna and quinacridone red.

*A **colour shaper** is my favourite masking fluid applicator. It can be used to create many shapes and is easy to clean. An Indian **ink nib** is good for fine detail. Ruling pens do flow better and you can adjust the line thickness, but they can leave blobs. You can flick specks of masking fluid from a **toothbrush**, either by dragging your thumb across the bristles to create a spray of fine dots, or by banging the brush down against the palm of the hand for droplets. Clean toothbrushes by immersing them in a cup of hot water, then combing the bristles with a strong needle. A **ruined brush** covered with dried masking fluid is great for masking rough natural shapes, such as leaves and woodland sky-holes.*

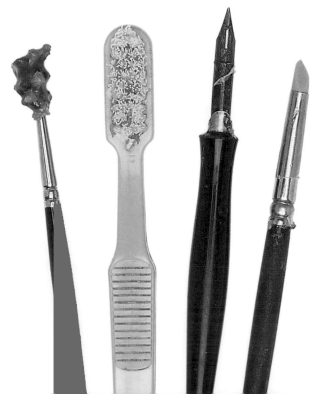

OTHER EQUIPMENT

Apart from sharpening pencils and cutting stencils, a **craft knife** can be used to scratch tiny marks on the paper (perfect for sparkles on a river). You can also incise the surface and peel off slivers of paper to give extremely sharp whites, but, take care, as this may spoil the image. I use **scissors** for cutting paper masks and stencils.

I use lengths of **masking tape** to mask the borders around my paintings for a neat finish. It can also be cut to shape with a craft knife and used as a resist.

I make stencils with ripped up pieces of **scrap paper** when spattering colour. The natural look of torn edges is ideal for masking a river-bank. Stick torn edges together to make a complete river bank shape. You can also cut shaped apertures in scrap paper and scrub through these with a damp brush to lift out colour to that shape – a good technique for underwater stones and branches in trees.

I draw final compositions on **tracing paper** then transfer them on to the watercolour paper.

I use pieces of **paper towel** to dab off excess colour. Use it damp or dry to lift out clouds from wet skies, and for other effects. Try twisting it into coils to create mares-tail clouds. Always use a clean part of the paper for each dab. Dabbing twice with the same piece will just imprint paint from the previous dab!

I use a B grade **pencil** and an eraser for sketching. I do not use an eraser on watercolour paper as it can damage the surface.

Use artists' **brush-cleaning soap** sparingly with cold water to extend the life of sable brushes.

A pencil and eraser, a craft knife, a roll of masking tape, a pair of scissors, scrap paper, tracing paper, paper towel and a bar of artists' brush-cleaning soap complete my essential set of equipment.

TIP COLLECT UNUSUAL ITEMS FOR YOUR WORK BOX

Expand your repertoire of techniques and your ability to express the world around you by experimenting with unusual items. I blow through a drinking straw to control washes and fine tune an image. I use small pieces torn from a sponge to create a variety of textures. Sometimes, I use a small bristle (bright) brush to gently scrub out highlights on fence posts, trees, etc., but take care not to damage the paper fibres because they will then absorb colour deep into the paper. Tiny woodcock's pinfeathers, taped to an old brush handle, can produce amazingly long fine lines. I have even used a seed head of grass, a toothpick, the edge of a piece of card, and a coiled-up piece of typing paper to create particular textures.

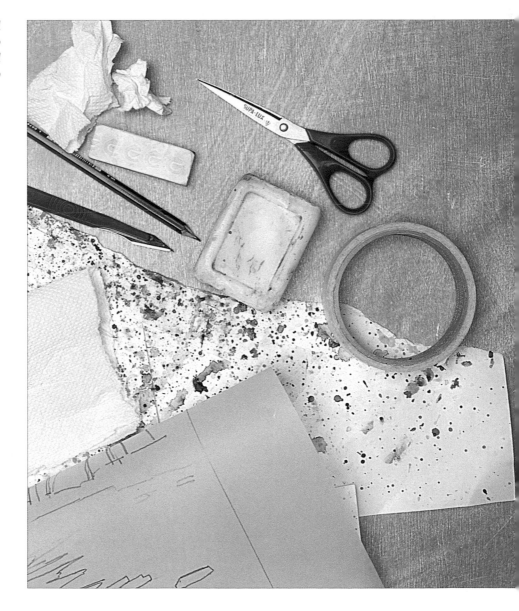

Making water look wet

Whether it is a splash of water on the edge of a quiet lane, or a deep river gliding smoothly towards the ocean, water has the same basic quality; it is colourless and transparent – effectively invisible. You cannot paint the invisible, so what do you paint?

Well, water has another quality in that its surface moves, diffuses and breaks up light: mirroring it in reflections; distorting it in ripples; and bending it in refraction.

Painting is all about recreating surface colours and textures. Although water has a surface, the colours we see on that surface are those reflected on to it. So, do not paint the surface of water, paint what it reflects, because that is what you see – reflections.

Most land-based objects head skywards; buildings, fence posts, trees, plants, people, all are upright, but their reflections go in the opposite direction. So that is what you can paint – things going down.

Water also tends to elongate texture vertically because of movement. It moves light up and down in a kind of reciprocating motion. Painting vertical texture implies a small amount of this up and down rippling movement. Perfectly smooth water will give perfect, pinpoint reflections, but such smooth water is rare. All reflections tend to be blurred. Smooth shining water is nearly always covered in tiny ripples and these soften the light and blur the reflections. So, if you paint blurred and vertical reflections, water will look wet.

Except for bright lights, reflections mirror the dimension of the subject reflected. To be a bit technical (for which I apologise), reflections mirror the subject about the point at which the horizontal plane of the water intersects the subject. But, do not worry about rules. It is much easier to get the feel of water – just look at your reference material or the view in front of you to see what is happening.

On these and the following pages, I have included coloured sketches of different types of water with captions about how I painted them.

Rapid application of lots of colour wet in wet

This stretch of water was started as an upside-down sky – a wash of phthalo blue and indigo painted wet in wet. The blue in the foreground is darker than that of the visible sky for two reasons: it is the reflection from high overhead (the sky is often darker up there); and it also takes some colour from the river bed. When the first wash was dry, I dashed clean water all over the area of tree reflection leaving a few dry patches, then brushed in a base layer of cadmium lemon. Keeping the saved whites, I dragged touches of phthalo green, burnt sienna and Payne's gray downwards into the wet wash. I added a little cobalt turquoise light in the distance, and teased a few rough marks out of the wet area on to the dry sky reflection to create a slightly rippled edge.

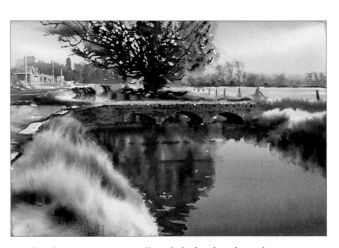

Mud colour contrasts well with light, bright colours

After building the strong tones around this image, I painted the upside-down sky wash in the water with phthalo blue, indigo and a little quinacridone magenta. The dark reflection was a single wash of burnt sienna and cadmium lemon painted separately on to a wash of water, and added to with Payne's gray and phthalo green. The rich brown comes from the mud on the river bed. Rivers often have this colour in their reflections - think of varnished teak instead of dirty mud.

Leave puddles as white paper and paint them last

Water is a small but important feature in this composition. The surrounding tones provide contrast and were completed before any work was carried out on the puddle. I used burnt sienna and ultramarine blue as a grey undertone of the puddle, leaving some white areas in the distance to give it light, and pulling some of the landscape colours down into it to form the reflections. When this was dry, I brushed on the dark, hard-edged reflections. Note how the area of dark mud contrasts with the bright reflections

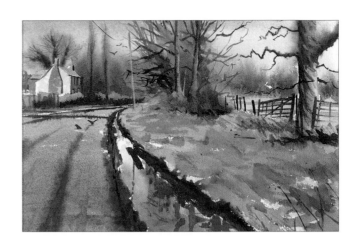

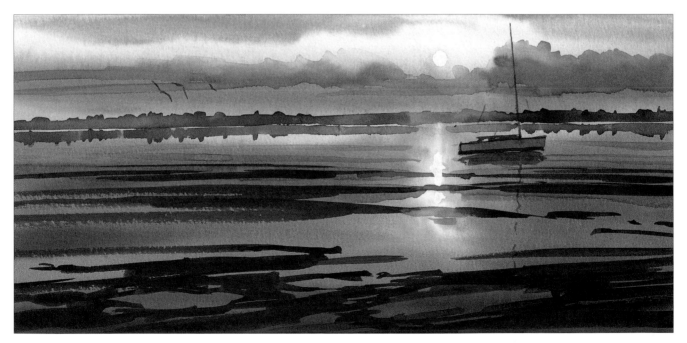

Many colours blended together make rich, deep water

The foliage was spattered over a dry glaze of cadmium lemon, using a similar technique to that shown on page 236. After the upside-down sky and reflection washes were dry, I brushed loose, angled tree reflections down into the water, giving them a few vertical squiggles of the brush on the way down. Look carefully at the trunk reflections; they are not straight diagonals, they go straight for a while, and then give a little kick.

Masked out whites and strong contrasts create impact

The sun and its longer reflection were masked out, then a wash of Naples yellow was painted over most of the image, diluting it around the brightest areas. Into this was worked quinacridone red and phthalo green mixed on the palette. These colours give anything from a grey green through black to grey crimson. I put more dark colour into the water than the sky. When dry, I painted the clouds wet in wet and the dark streaks wet on dry, reddening them near the bright area with quinacridone red and Naples yellow, before painting the boat and the gulls. These muddy colours work because they are set against strong lights and darks.

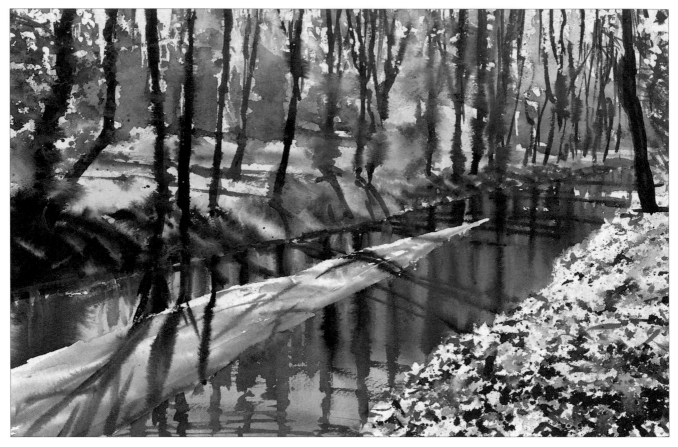

Vertical reflections, both sharp and soft focus, read as wet

Vertical reflections contrast with angled shadows across this river. The jagged-edged mud bank was masked out, and the river painted as an upside-down sky. This was then glazed over with reflected colours. The dark reflections were worked wet in wet, then the colours were dragged out of the wet area on to dry paper. The shadows give a deep sense of perspective. Starting from closely-spaced horizontal lines in the distance, they widen out and change to diagonal lines in the foreground.

Complementary blue and orange washes work together

When painting the intense blue and orange washes for sky, water and woodland, I left the boat and its reflection white, and added various darks into the river reflection wet in wet. When these washes were dry, I used the point of a brush to paint simple horizontal streaks across the river to indicate movement on the surface. These diminish in width and spacing as they get further away, giving perspective to the composition.

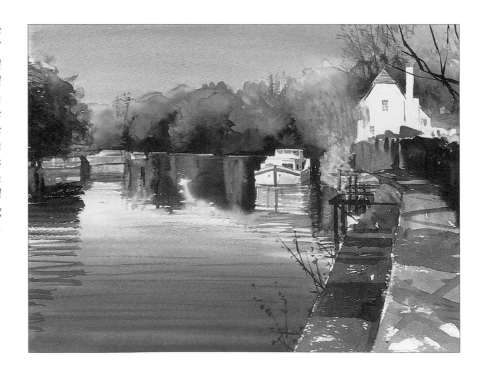

Build tone with several glazes

A disappointing grey day for an on site painting led me to use the red of this dredging rig to provide a contrast to the grey. Several grey washes were laid one over the other, and the foaming sea was left white. The distant whites are breakers on submerged reefs and these were scratched out with a knife. The water diffuses light, with few distinct reflections, but there are still a few reflections from the rig. The lines of waves were painted wet on dry – making them narrower and closer together as they get further way enhances the perspective.

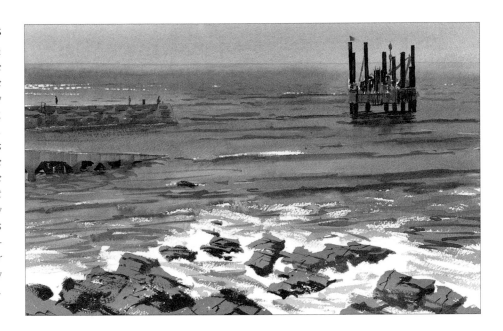

Mask the bridge and paint water with a single wash

Once the perspective lines for the river and path were established, I loosely masked the bridge, some of the distant trees, some sky holes, and some foreground leaves. When all the foliage had been painted, I wet the river and brushed in a wash of phthalo blue and indigo from the bottom up and let this dry. I then brushed a lot of water on to the river behind the bridge, added a little gum arabic in the middle distance area, then applied a base layer of Naples yellow. Working wet in wet, I then added the other river colours – burnt sienna, cadmium lemon, phthalo green and Payne's gray. Before these colours dried, I brushed some darks from the palette to indicate the shadows across the water. I also used the darks to brush in the foreground reflections very wet and loose.

TIP LIGHT SOURCES

Choosing lighting conditions is as important as the choice of subject matter, and the location of the light source is as important as that of the scene. Bright light, early or late in the day, produces strong compositions. A low angled sun gives interesting definitions, shadows and colours: the sun glitters through leaves; trees are better defined with strong light and shade; and patterns of tones are strong. During the summer, when I paint out of doors, I avoid painting when the sun is high overhead because it tends to flatten tones, making it difficult to create interesting compositions. I find my best times for composing light are early or late in the year.

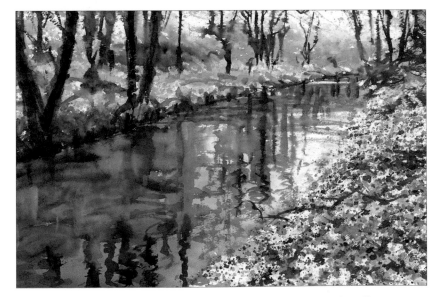

Light, opaque colours, wet in wet, on top of dark tones work well

Colour was dragged around very loosely in the reflections, leaving plenty of white paper. Darks were crisscrossed over the river bed to indicate the shadows of branches, then opaque cadmium lemon was streaked downwards, wet in wet, to give depth and colour.

Composition

No one can explain why one way of depicting a particular view is
enjoyable to look at, and another is not. We do not just see, we
enjoy the process of seeing. Fortunately for the artist, people are
widely in agreement about what looks good. They may not know
what they like, but they know when they see it. Our job as artists
is to know what people like before they see it – and paint it!
Composition is about how visual information can be presented.
On these and the following pages, I give a few guidelines to help
create good compositions.

ELEMENTS OF A COMPOSITION

Dividing a completed painting into segments shows how it was
constructed. Many compositions can be broken down into the
following segments: the foreground, the middle distance, the far
distance, the horizon and sky and linking elements.

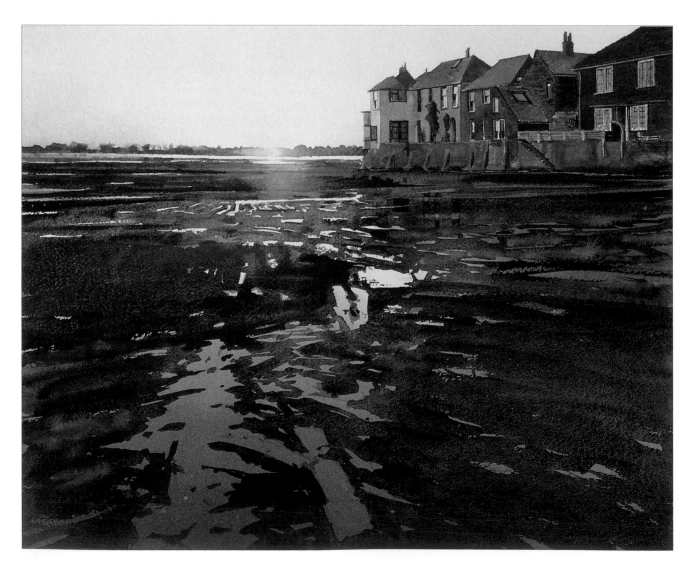

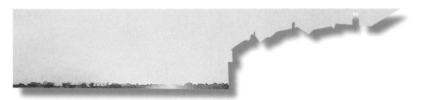

Horizon and sky area

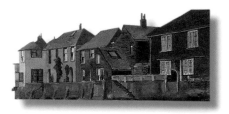

Linking element

Far distance area

Middle distance area

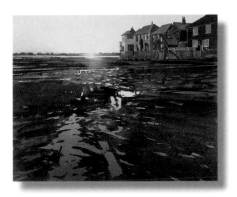

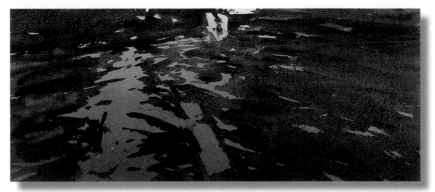

Foreground area

Here, I have broken down the painting opposite into these different segments. From standing height, half of the view extending to infinity is taken up by a few paces of foreground, where steep diagonal lines predominate. Beyond this, in the middle distance, which takes up more than half of the remaining area of flat ground, the texture flattens out quite noticeably. Even further back, the narrow segment of water in the far distance has hardly any definable texture – just a thin ribbon of light – pale grey in colour. The narrow band of sky above the horizon completes the basic structure of this composition. A high horizon, a small sky area and a large, deep foreground enhances the sense of perspective and depth. Finally, there is the linking element, the row of buildings, the shape of which leads the eye to the focal point (the sun). The fine details and vertical marks in this area contrast well with the softer diagonal and horizontal marks in the rest of the painting.

Although there are exceptions, I usually keep my horizons away from the centre. I use a high horizon and a small sky when there is plenty of interest in the foreground. On the other hand, when there is more interest above eye level and/or in the sky, a low horizon and shallow foreground can work well.

Similarly, I usually place objects of interest (focal points) away from the middle. Although the far end of the row of houses in this example is near the middle, the sun dominates the scene and moves the emphasis towards the left.

205

FORMAT

The format (shape) of a painting has a great deal to do with the composition. Formats can be used to solve problems: a panoramic view can be used to render a dramatic scene without having to paint any foreground. A long landscape can put grandeur into a scene. The proportions of a normal landscape format are roughly 6:4, and approximates to the area seen by the human eye. This can be shortened or lengthened to any shape required. I often paint to landscape-plus-a-bit, a slightly lengthened landscape. On a 760 x 560mm (30 x 22in) sheet of watercolour paper, this means using the full width, and reducing the height.

The scene in this photograph could be used to create a wide range of different-format paintings. The whole image is basic landscape format. The red rectangle is the same shape, but moving it down slightly lifts the horizon line to give more prominence to the foreground. The blue shape is proportional to the red one but smaller (you do not have to paint everything in front of you). The green rectangle is scaled to my panoramic format, while the orange rectangle shows the potential for painting a portrait shape.

Composition by selection

Choose the view, then choose the format. Instead of arranging subject matter inside a shape, arrange the shape around the subject matter.

This scene is just a few steps back up the lane from where the demonstration painting on pages 220–221 was viewed. I chose to use a portrait format here to accentuate depth and perspective. I moved my viewing position to place the tree well to the side, to put the horizon above centre, and to make the lane lead off one side of the image. The position of the distant buildings leads the eye through the composition and emphasizes the bend at the end of the lane.
This painting can also be broken down into different segments. In this case, the linking element is the tree.

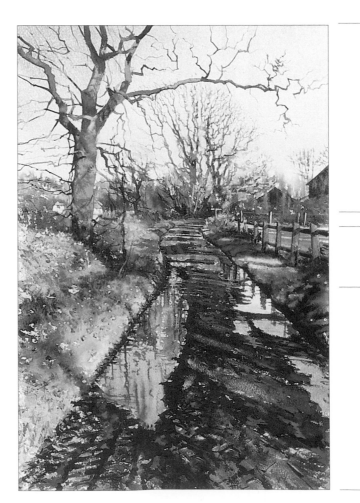

Horizon and sky

Far distance

Middle distance

Foreground

PERSPECTIVE AND COMPOSITION

The soft masses of the foreground grass and background woodland foliage conceal a sharp dynamic perspective in this image. The horizon (eye level) dictates the geometry of perspective. Here, a distinct horizon cannot be seen but its theoretical position is slightly above where the line of the land meets the distant woodland. Unlike a straight road or railway track, the perspective lines in this scene cannot be plotted with mathematical precision. The lines of river banks are especially hard to find when drawing the composition.

Nevertheless, they should ring true and not be wildly wrong. They should converge to a point (or points) along the horizon line. In this example, the edge of the left-hand bank of the river is relatively straight, so you could draw a line along this edge back to where it meets the horizon – the vanishing point. The best way to find the angle of the other bank is to draw another line from the vanishing point along which most of the bank sits. With these bones of perspective in place, you can weave the actual shape of the river around them.

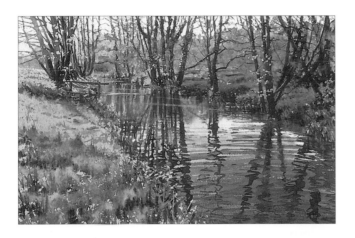

The illustration below shows this painting broken down into segments along the horizon and the significant perspective lines. The other characteristic of perspective is that images diminish in size and detail as they recede into the distance – compare the segments for each side of the river, and note how perspective affects the shapes and sizes of the ripples on the broad swathe of the river.

Flat, Still Water

The fire of a setting sun sits like a mantle on the breathtaking serenity of an upland expanse of water. Is it possible to get light to look brighter than the white of the paper, to recreate the smoothness of the sky and water and to build up the subtle tones of colour and light?

Yes, it is, and in this project I show you how saved whites, wet washes, bright colours and inky dark tones can be combined to put the fire into such water scenes. Although some credit has to go to the people who make the materials, it is the way these materials are used that gets the results – the secret is to let water do the work for you.

I used the ten colours shown on page 210 to paint this picture, but there are many other colours that can be used to get the darks, the greys and the warm glowing sky colours. It is, however, vital to keep whites saved.

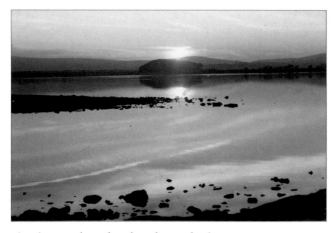

The photograph used as the reference for this painting. Notice that only three-quarters of the width of the image has been used, placing the focal point, the setting sun, off centre. I also decided to make the shapes of the foreground rocks more interesting.

The key here is to brush colours on to wet paper and let them spread and blend together and become beautifully smooth.

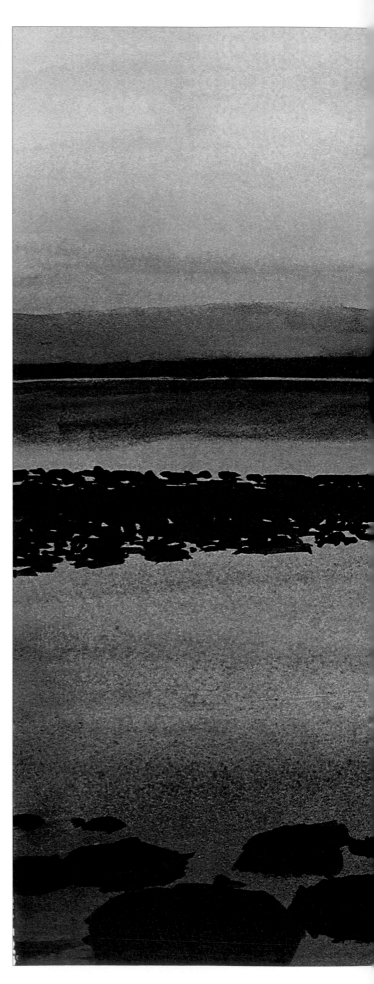

208

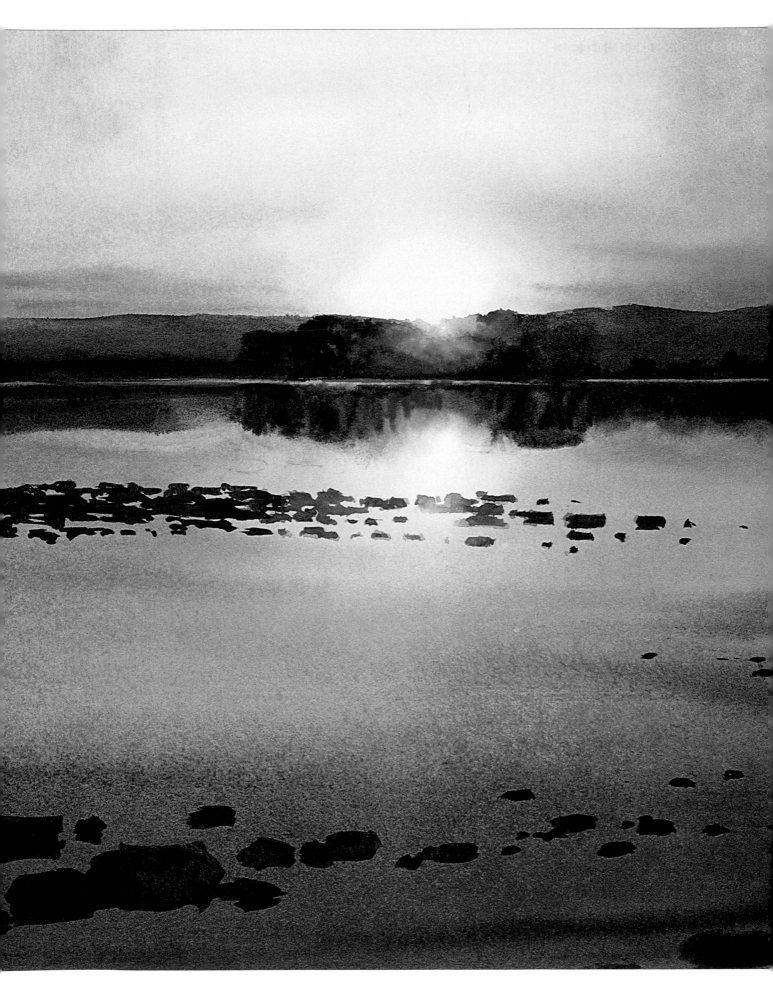

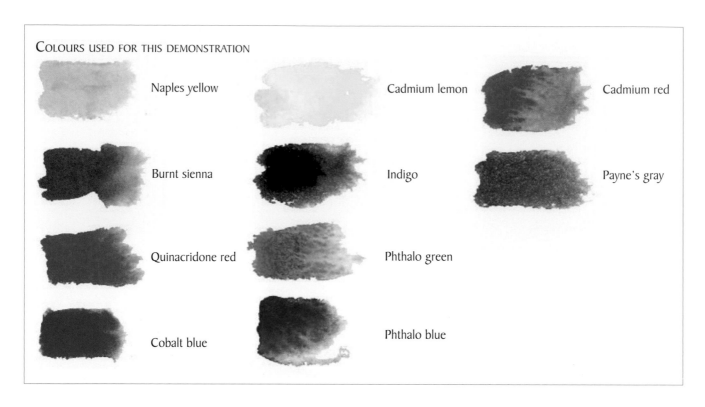

COLOURS USED FOR THIS DEMONSTRATION

Naples yellow

Cadmium lemon

Cadmium red

Burnt sienna

Indigo

Payne's gray

Quinacridone red

Phthalo green

Cobalt blue

Phthalo blue

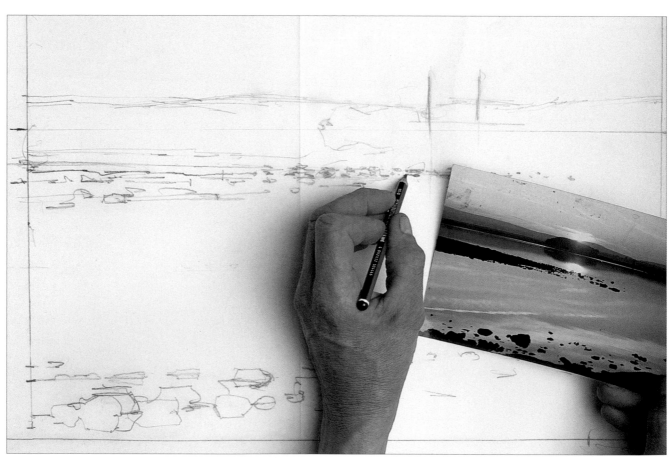

1 Using the reference photograph on page 208 and a soft pencil, make a rough sketch of the composition. Here, I have determined a relatively high horizon line and I have drawn two vertical lines to indicate the position of the sun as I do not want my pencil marks in this area.

The finished sketch drawn from the reference photograph. I changed the structure of the foreground rocks to give added interest. I also drew two vertical lines to show the location of the sun and its reflection. The space between these lines will be the lightest part of the composition, and I do not want any pencil marks in this area.

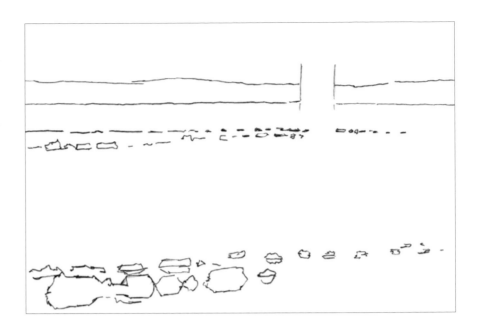

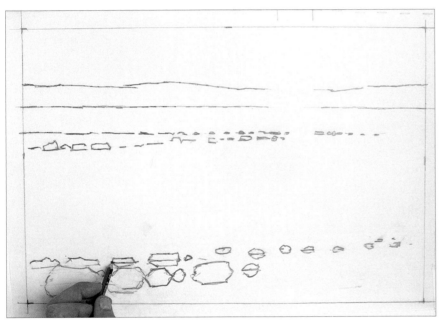

2 When you are happy with the composition, make a copy of it on tracing paper, then use this tracing to transfer the basic outlines, and the edges of the composition on to the watercolour paper.

3 Stick strips of masking tape round the outer edges of the composition.

TIP BLENDED WASHES

You need to work quickly to achieve a good blended wash, so decide on the colours you need, then set up your palettes. Here I have set up my first four colours – Naples yellow, quinacridone red, burnt sienna and cobalt blue.

In this project, it is important not to allow any colour into the areas of the sun and its reflection, which need to be kept white. This can be achieved by using the characteristic of water that causes it to flow from a very wet area into a less wet area. I achieve this by making a reservoir of water surrounded by a ring of dry paper. I wet the rest of the paper, then apply colour wet in wet, working from the edges of the paper and weakening the wash as I get closer

to the area I want to keep white. I release the clean water in the reservoir by dragging it across the dry ring. It then flows naturally into the less-wet surrounding wash, pushing colour before it and making a very soft edge. The key to this technique is to keep the reservoir wetter than the rest of the paper, and to retain it within the ring of dry paper until you are ready to use it. Repeat the process for subsequent glazes.

4 Use a clean brush to wet the whole of the paper, except for a diamond shape (for where the sun will be) and a circular shape (for its reflection, which will be just as white as the sun, but narrower)…

5 … then, leaving narrow dry gaps, thoroughly wet the diamond and circular shapes to form the reservoirs.

6 Brush a wash of Naples yellow on to the wet paper. Work inwards from the edges of the paper, and make the colour weaker as you work closer to the dry lines round the sun and its reflection. Keep all colour off the dry lines.

7 Mix Naples yellow with a little burnt sienna and a touch of quinacridone red, then, working wet in wet, drop this colour along the horizon. Work inwards from the sides of the painting, taking the colour up into the sky and down into the sea weakening the wash as you work away from the horizon. Again, keep all colour off the dry lines.

8 Mix a wash of burnt sienna and dribble it across the bottom of the painting as shown...

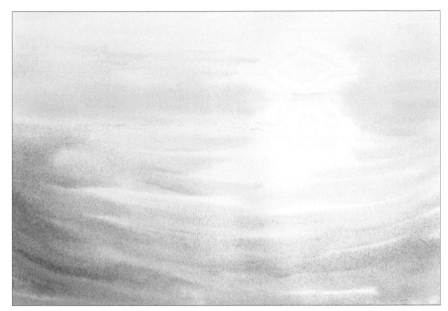

9 ... then spread it across the water area, reducing the tone as you work upwards to the horizon.

10 Use a fan blender brush to smooth all colours together.

11 Add even more water to the sun and reflection reservoirs, then breach them outwards, across the dry rings, into the less-wet surrounding colour. The water runs outwards into the surrounding wash and pushes colour away from the brightly lit areas to create the softest of edges.

12 Remove the masking tape borders, then use a hair dryer to dry the whole of the paper.

13 Replace the strips of masking tape and reinstate the reservoirs of water bounded by rings of dry paper for the sun and its reflection. Mix cadmium lemon with a little burnt sienna, then add this wet in wet to the area around the sun and reflection, keeping it slightly back from the dry rings to avoid distinct edges forming.

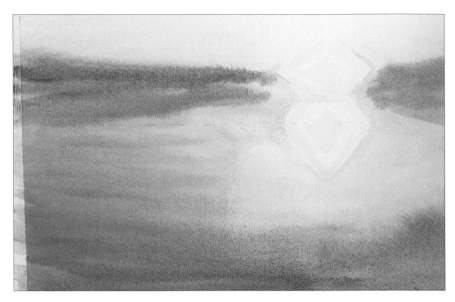

14 Lay in a wash of burnt sienna, starting at the bottom of the painting and weakening the wash slightly as you work upwards. Lay in more burnt sienna across the horizon working it up into the sky and down into the water. Brush touches of quinacridone red into the burnt sienna.

TIP CLEANING BRUSHES

You should always wash out brushes between colours. I like to have two water pots, one for washing out brushes and one for mixing colours (see page 196). Thoroughly clean all your brushes at the end of a painting session.

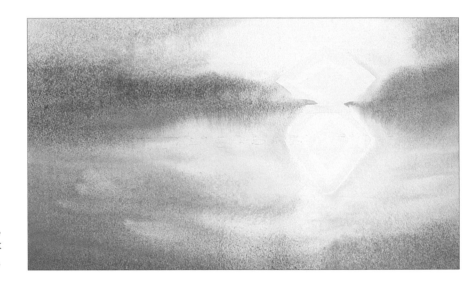

15 Introduce a wash of cobalt blue, weakening the colour as you work inwards from each side.

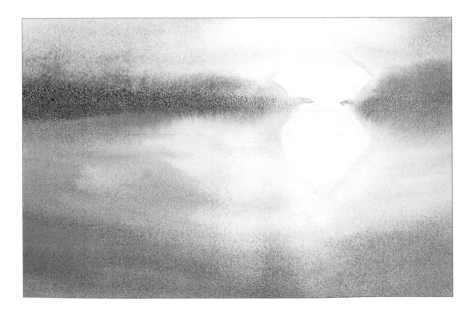

16 Add more cobalt blue in the sky, running this across the horizon and across the bottom of the water.

214

17 Add more water to the reservoirs, then breach them outwards again so that water flows into the yellow marks and softens the inner edges of these. Add streaks of cobalt blue clouds and streaks of burnt sienna across the water. Remove tape again and dry.

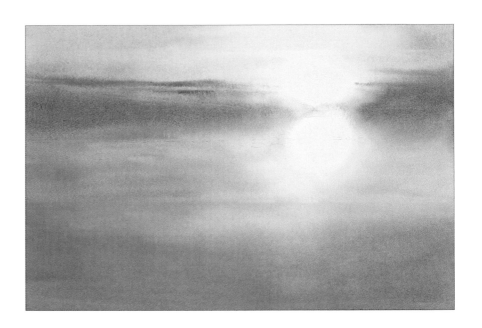

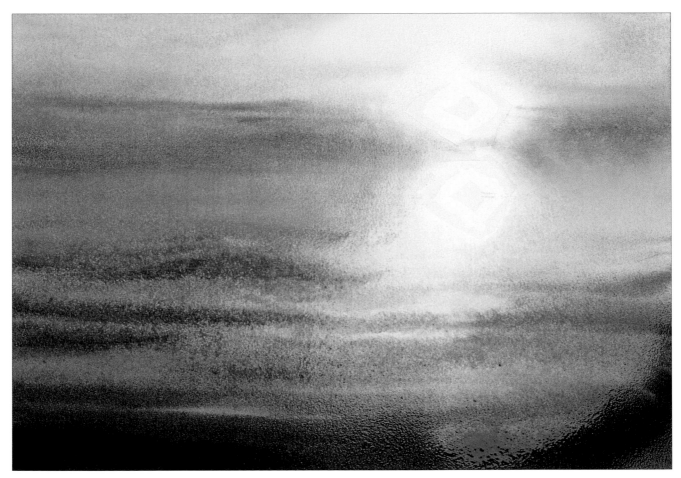

18 Reinstate the reservoirs within dry rings in the areas of the sun and its reflection. Wet the entire paper, then brush Naples yellow, quinacridone red, and burnt sienna separately into the sky and water washes, wet in wet. Glaze touches of cobalt blue over the lower part of the sky, from the horizon upwards. Add some quinacridone red and lay in horizontal streaks of this colour above and below the horizon. Strengthen this colour in the water. Using a mix of indigo with a little phthalo green, block in the foreground, streaking it across the water. Weaken the wash as you work upwards.

19 Fan blend the colour across the paper. Add horizontal streaks of cobalt blue below the horizon to define the reflections of the distant hills, then strengthen these with a mix of phthalo blue, phthalo green and indigo.

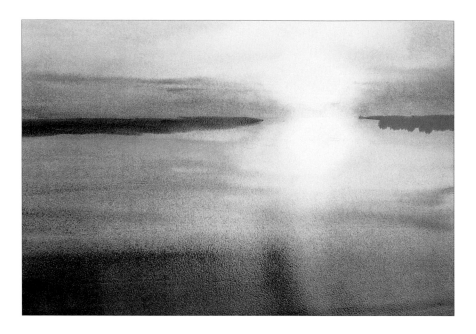

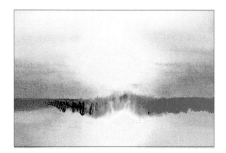

20 Add touches of cadmium lemon and cadmium red to the top part of the sun's reflection, then blend these into each other and across into the reflections of the distant hills. Add short vertical strokes of the dark mix to link the left-hand side of the dark reflection to the red and yellow.

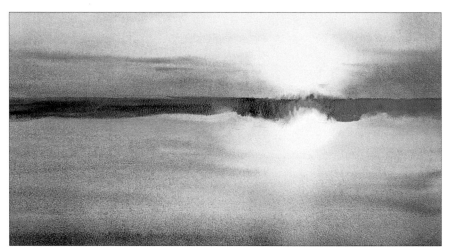

21 Use cobalt blue and the indigo mix to redefine the bottom edge of the reflection, then blend all colours together and leave to dry.

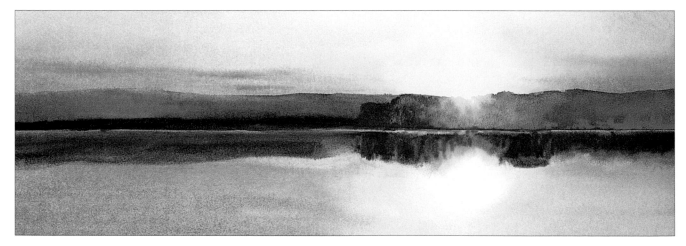

22 Wet the area of the distant hills – then brush a dark mix of phthalo green, indigo and phthalo blue into these hills, wet in wet, leaving a thin highlight between them and their reflections. Do not take this colour into the area below the sun. Mix cadmium lemon and cadmium red, then add the highlight on the hills in a similar way to that for the reflection. Darken the base of the hills, then leave to dry.

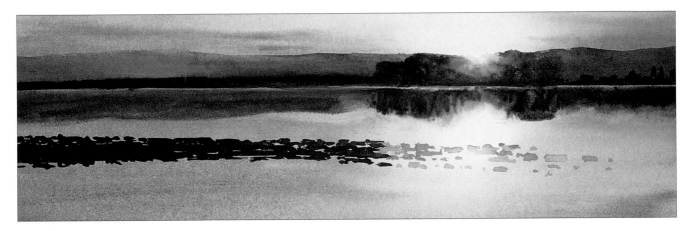

23 Use Payne's gray to block in the distant rocks. Use burnt sienna and touches of cadmium lemon to block in the those lying within the area of the sun's reflection, and darken this mix with Payne's gray.

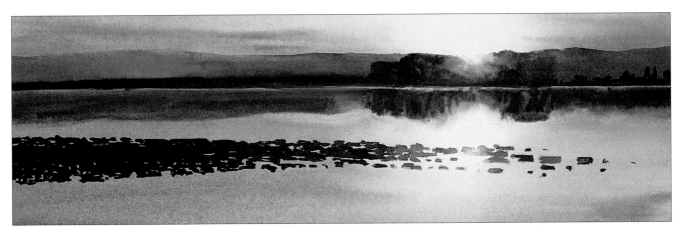

24 Darken the rocks at the extreme right-hand side and gradually reduce the colour as you work back into the bright reflection. Leave to dry.

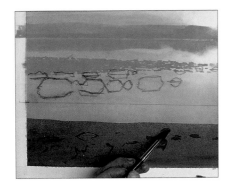

25 The dark glazes in the foreground will have obliterated the pencil marks for the rocks, so use the original tracing as a reference to redefine their shapes, then block them in with Payne's gray.

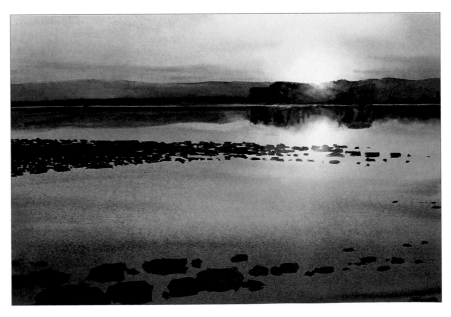

The finished painting.

217

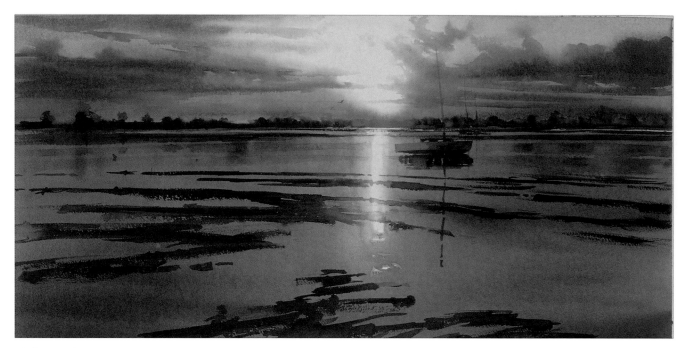

Shifting Tide

Size: 43 x 21cm (17 x 8¼in)

Deciding the overall colour of an image early on is a useful key to harmony. Burnt sienna, alizarin crimson and cadmium lemon provided the mixes for the reddish browns in this composition. The greys and intense darks are the result of adding ultramarine blue to the mixes on the palette, but I often use Payne's gray and indigo. Cadmium red provides the fiery red of the sun, and the whites were saved from the start.

Mud Flats

Size: 66 x 42cm (26 x 16½in)

Elongated landscape formats can add drama to an otherwise simple scene. Here, the long narrow sky and the deep foreground area combine to give a sense of distance, whereas the very narrow strip of water creates a wide expansive landscape and provides scale to the composition.

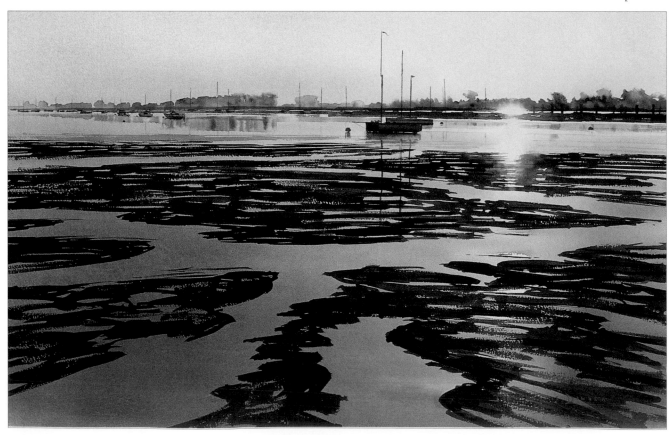

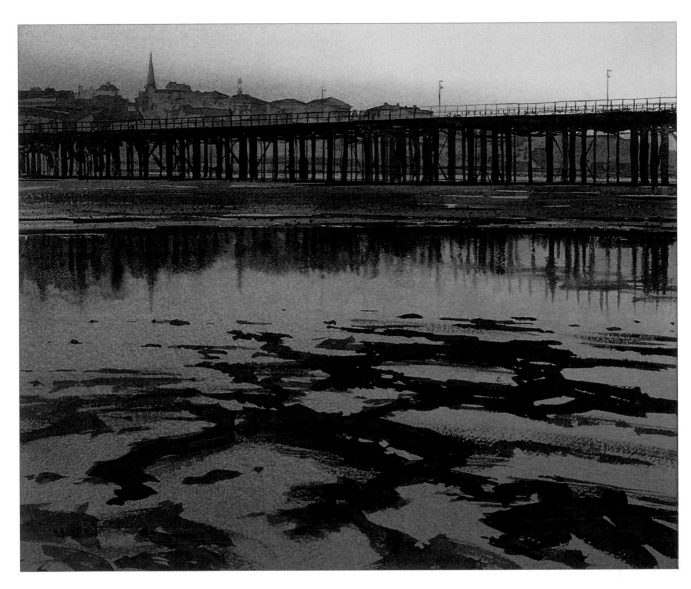

Pier on the Sands

Size: 40.5 x 34.5cm (16 x 13½in)

In this nearly-square format painting, Naples yellow was used as a base into which the other colours were worked. The subtle violets are mixes of ultramarine blue, alizarin crimson and burnt sienna. The very soft reflections of the pier were the result of gum arabic being brushed on to the paper before the colours were applied. Diagonal strokes, flattening out with distance, provide foreground perspective.

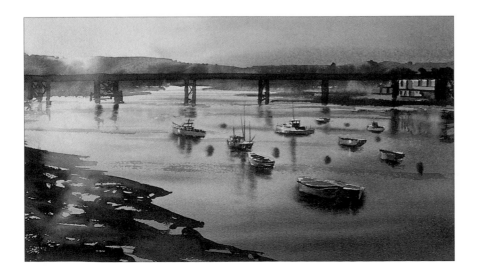

Sunset over Estuary

Size: 40.5 x 23cm (16 x 9in)

Subtle grey sky washes, fading to nothing in the vicinity of the sun, provide the brightness in this painting. The sun is not painted at all, but we know it is there because its glare is eating into the landscape below, the colours of which change from normal to red to yellow then no colour at all. Water is used to create the loose fluid shape of the glare. It would be different if I did it again, but that would not matter!

Puddles

A few puddles bring this simple scene to life; they add interest to the image and unite the other parts of the composition. The basics for painting puddles are simple. Ensure there is subject matter to be reflected. Work the reflections wet and vertical. Puddles can enhance deep sky reflections, so you can often paint them a slightly darker blue than the sky itself.

Although this is a narrow winding lane, in this composition it is very wide in the foreground where there is just sufficient detail to be convincing. The lane leads the eye into the distance and on to explore the rest of the image. There is hardly any detail in the distant, off-centre focal area, but there does not need to be.

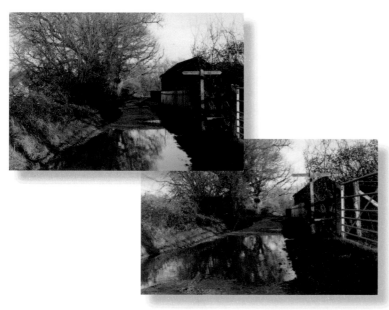

Both of these photographs were used as reference material for this demonstration. Most of the composition is taken from the top photograph, but I added the foreground detail from the other one to raise the horizon line and focal area well above the middle of the image.

Paint all puddles as a single wash, add reflections, then, when these are dry, block in the dry parts of the road.

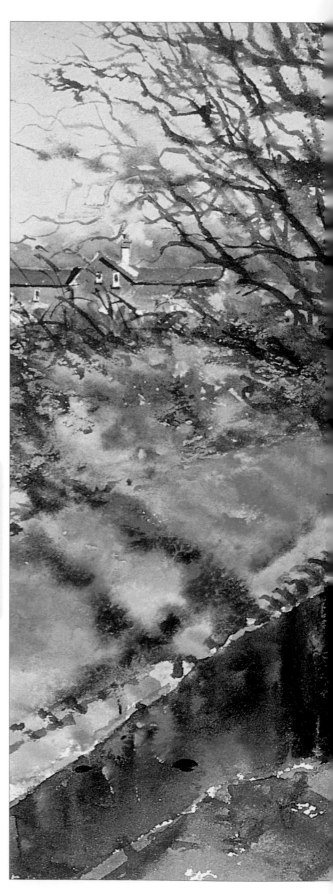

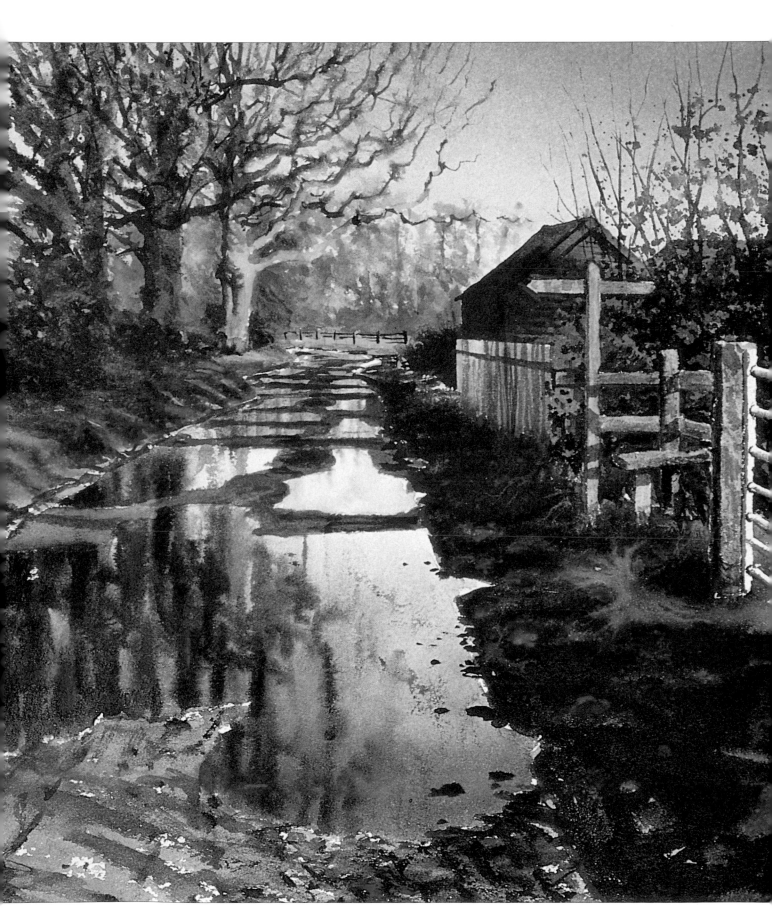

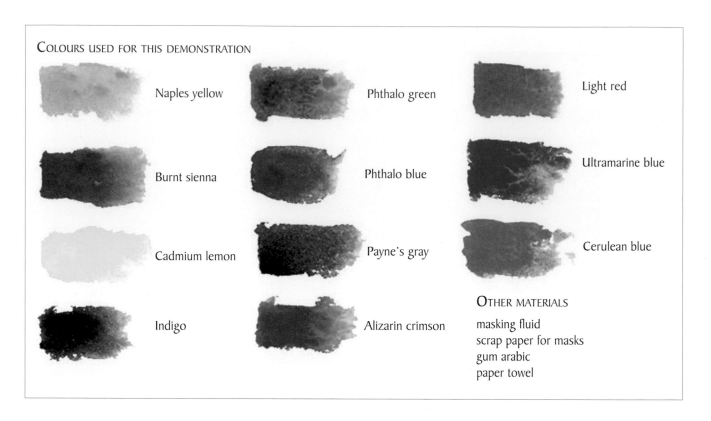

COLOURS USED FOR THIS DEMONSTRATION

Naples yellow

Phthalo green

Light red

Burnt sienna

Phthalo blue

Ultramarine blue

Cadmium lemon

Payne's gray

Cerulean blue

Indigo

Alizarin crimson

OTHER MATERIALS

masking fluid
scrap paper for masks
gum arabic
paper towel

1 Referring to pages 210–211, sketch the composition, make a tracing, then transfer
the basic outlines on to the watercolour paper. In this composition I used elements
from both of the reference photographs on page 220.

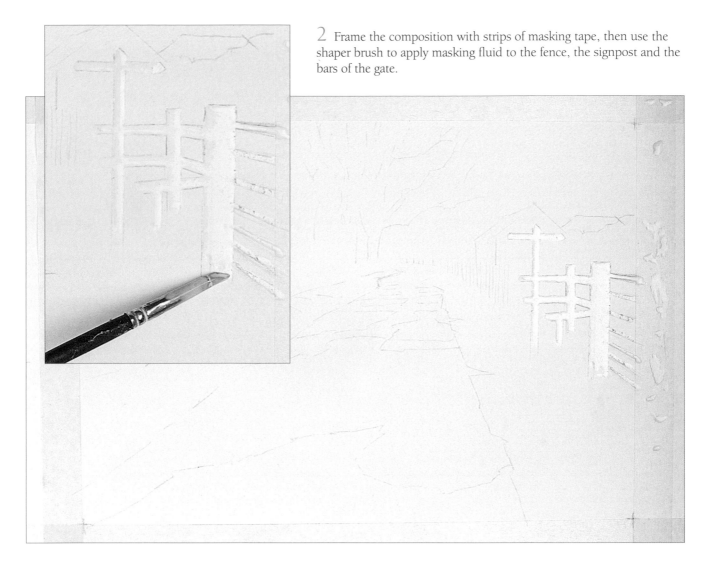

2 Frame the composition with strips of masking tape, then use the shaper brush to apply masking fluid to the fence, the signpost and the bars of the gate.

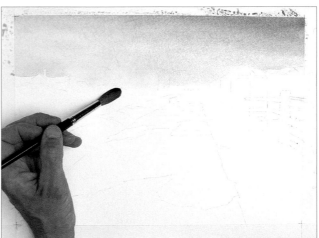

3 Wet the sky area down to the horizon, but leave the shapes of the buildings on both sides of the paper dry. Lay in a band of Naples yellow, 25mm (1in) up from the horizon, drop in a wash of alizarin crimson along the horizon, then blend this up into the Naples yellow. Soften the bottom edge of the crimson, then dry with a hair dryer.

4 Rewet the sky area as step 3, then, working from the top of the paper, lay in a pale wash of phthalo blue mixed with a touch of phthalo green, weakening the wash as you work down into the yellow and crimson. Brush a darker wash of blue into the top right-hand corner, wet in wet. Soften the bottom edges with clean water.

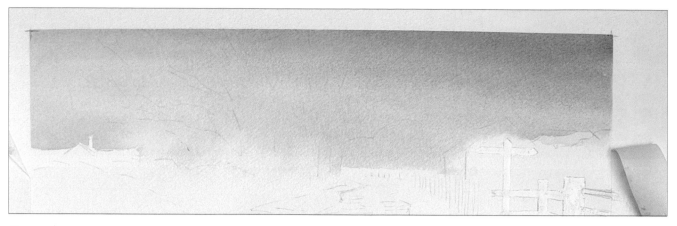

5 Remove the masking tape from around the painted area and leave to dry slowly.

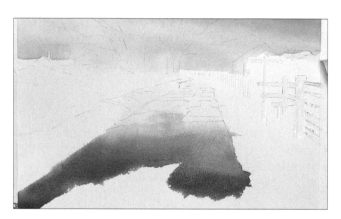

6 Wet the puddled area of the road, then lay a pale wash of burnt sienna in the middle distance. Now lay a wash of phthalo blue mixed with a touch of indigo, into the foreground, weakening the wash as you work up into the burnt sienna. Tilt the top of the painting board up to allow some colour to fall down into the foreground. Leave to dry.

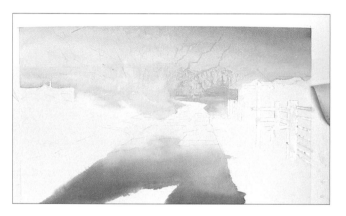

7 Using random, crisscross strokes made with the edge of the brush, gently brush (feather) clean water over the area of the foliage at the end of the road. Then, using the point of the brush, apply a mix of Naples yellow with a touch of burnt sienna through the feathered area to form the branches. Use the same mix to block in the foliage round the shapes of the left-hand buildings and the end of the fence at the right-hand side. Leave to dry.

8 Use a mix of light red with a touch of ultramarine blue to work up the darker areas of foliage. Use negative painting to start to define the form of the branches of the large tree. Leave to dry.

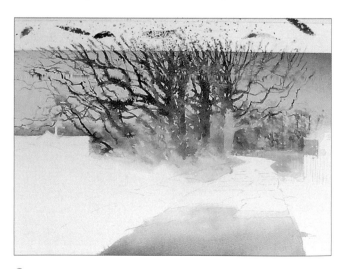

9 Darken the mix with more ultramarine blue, then develop the shapes within the foliage. Use a mix of light red and cerulean blue, and the feathering techniques, to develop the mass of branches. Start with pale tones and gradually darken them as you add finer detail. Leave to dry.

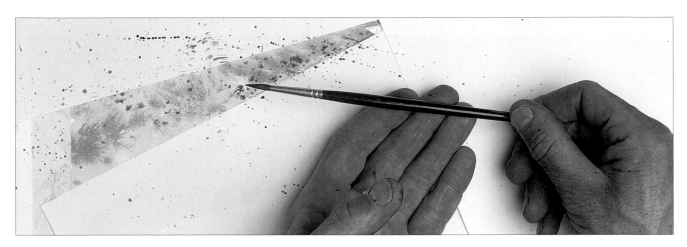

10 Use a wash of Naples yellow mixed with a touch of burnt sienna to block in the bank and hedge at the left-hand side. Add touches of burnt sienna, then blend the colours together. Leave to dry, then use pieces of scrap paper as masks above and below the area of the grassy bank. Spatter a bright green, mixed from cadmium lemon and phthalo green, followed by a darker mix of ultramarine blue and light red, spattered wet into wet. Leave to dry.

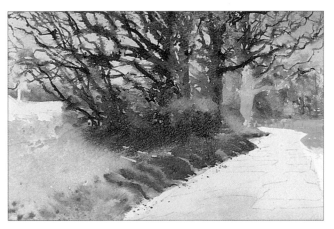

11 Using the feathering technique, wet parts of the grassy bank and hedge then use ultramarine blue mixed with light red and phthalo blue to paint dark green shadows on the bank. For the darker areas of the hedge, use a mix of light red with touches of Naples yellow, merging the colour up into the branches of the trees. Add touches of ultramarine blue, wet in wet, to form deep shadows in the hedge. Use a mix of cadmium lemon and Naples yellow to add highlights to the top of the hedge, then accentuate these with some darker marks.

12 Use the same techniques and colours to work up the rest of the grassy bank and hedge. Use the dark green mix to define the front edge of the grassy bank. Use light red to block in the walls of the building behind the hedge.

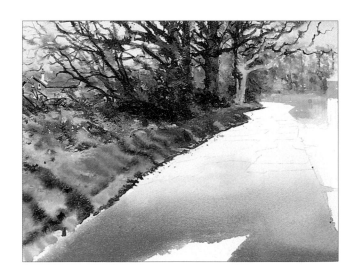

13 Use the dark colours in the palettes to build up detail in the hedge, on the trunks of the larger trees and the shadows on the distant building.

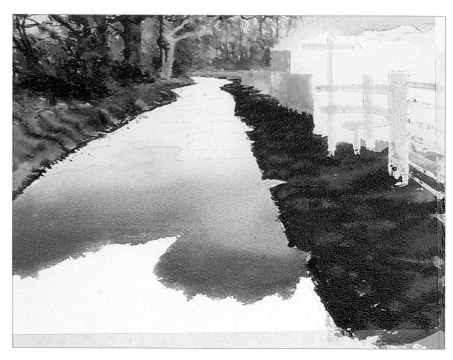

14 Wet the shape of the wooden fence, then, using a mix of Naples yellow with touches of ultramarine blue and light red, block in the fence. Use cadmium lemon with touches of phthalo green to block in the grass bank. Leave to dry.

15 Wet the grass then, using mixes of phthalo green and indigo, brush in the shadowed areas, making the strokes smaller as you work into the distance. Add more indigo to the mix, then make crisscross brush strokes across the paler lines, again making them smaller with distance. Working wet in wet, add patches of cerulean blue and allow all colours to blend together.

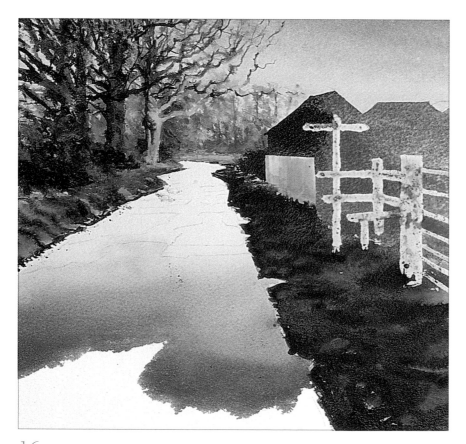

17 Glaze a mix of ultramarine blue and light red over the fence. Spatter clean water over the buildings, then spatter a mix of burnt sienna and indigo for the foliage behind the fence. Mix a touch of light red with indigo, then draw branches through the foliage, wet in wet. Use this mix to deepen the shadows on the roof and wall of the building, to add an indication of a small fence in the far distance and, when the large fence at the side of the buildings is dry, to add detail and shadows to it.

16 Use burnt sienna to block in the buildings behind the fence, then, working wet in wet, add touches of indigo for the dark tones on the sides of the buildings Leave to dry.

18 Wet the road down to the edge of the puddle, leaving a few dry patches in the area of the large tree reflection, then apply a few vertical strokes of gum arabic (see red marks on the diagram below). Working wet in wet, apply Naples yellow and burnt sienna to the distant road, and burnt sienna with touches of light red and Naples yellow to the tree reflection. Brush vertical strokes of Payne's gray into the tree reflection, then streak in touches of Naples yellow and cerulean blue. Leave some light, vertical shapes in the puddle for sky hole reflections.

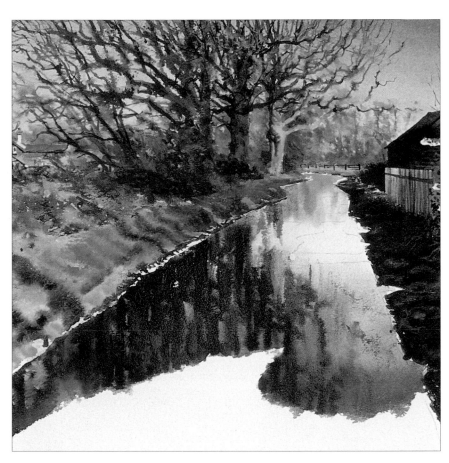

The red marks on this diagram show where I applied gum arabic.

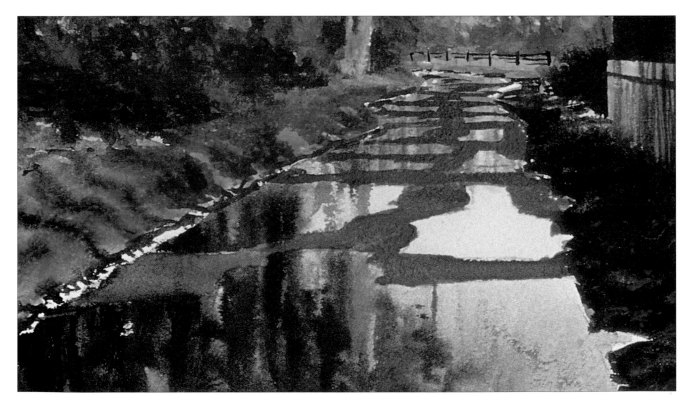

19 Use the original tracing to redefine the puddles, then use a damp brush to lift dark tones out of some of the reflections that should be dry road. Use a mix of cerulean blue and alizarin crimson to block in the dry surface of the road. Mix light red with Naples yellow for the lighter area, greying this down with cerulean blue in places. Use fine horizontal strokes of ultramarine blue to separate the distant puddles.

20 Use a mix of Naples yellow and light red to block in the foreground, leaving some of the white paper showing through as highlights.

21 Using mixes of cerulean blue and ultramarine blue, and large brush strokes, paint in a crisscross of shadows across the foreground area of dry road. Add more ultramarine blue to the mix, then make smaller marks to define the darker shadows.

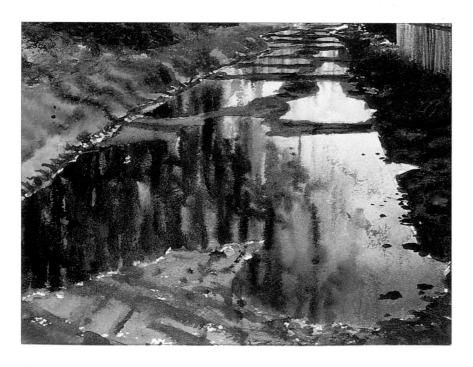

22 Wet the 'white' puddle in the middle distance, lay in a weak wash of phthalo blue, then use Naples yellow to indicate some reflections. Use indigo to add very dark shadows on the dry parts of the road, to define the hard edge of the puddles and to add debris sitting proud of the puddle surface. Make a few random marks in the front right-hand corner of the road.

23 Using a clean wet brush and a piece of paper towel, lift out a fence post behind the gate.

24 Pull the masking fluid off the fence posts.

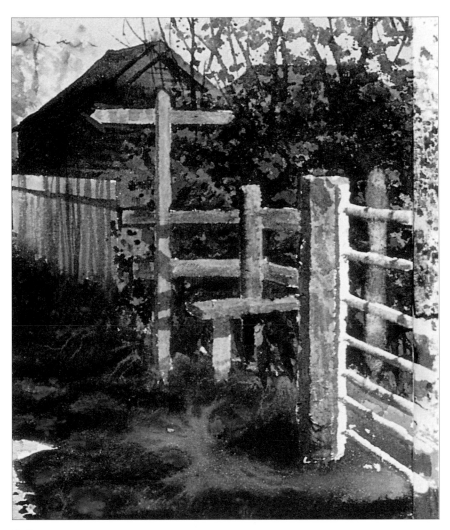

25 Use mixes of burnt sienna and cerulean blue to paint the signpost and fence. Dry them, then use the dark on the palette to define some of the edges. Brush cerulean blue down the side of the end of the steel gate. Brush water on to the bars of the gate and add cerulean blue along the bottom edge of each bar.

The finished painting.
At the end of step 25, I stood back to look at the painting and decided to add a few more fine details. I used indigo and ultramarine blue to darken the shadows on the grass at the left-hand side, to add a few more shadows in the foreground and to add more twigs and shadows at the top of the hedge.

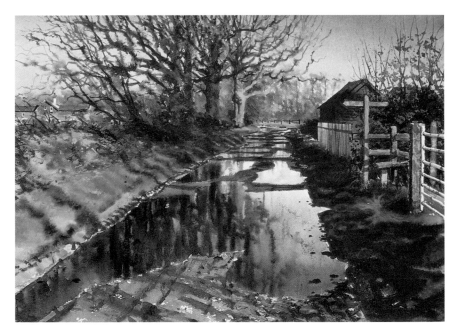

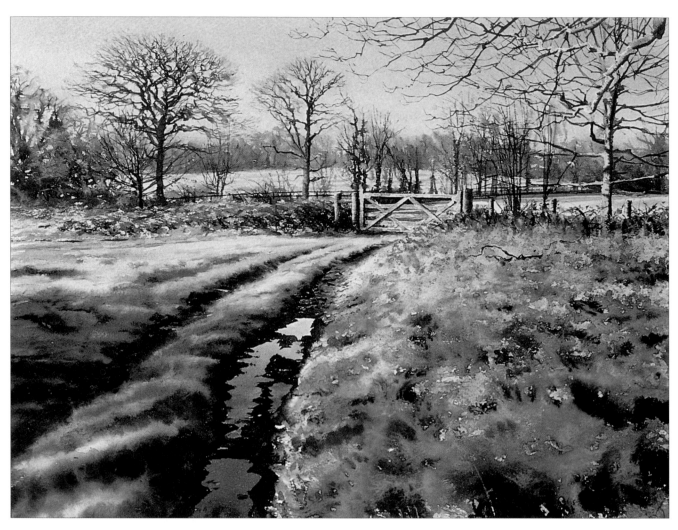

Frosty Fields

Size: 48.5 x 37cm (19 x 14½in)

In this painting, the track swings from the bottom left-hand corner into the middle; the two equally divided foreground masses may break a few rules, but they work for me. There is no distinct focal point behind the gate, but another field edge and more beyond provides space for the eye to wander. The sky is cerulean blue as is the frosty grass which also has touches of cadmium lemon and darks painted with indigo. The right-hand foreground has cobalt turquoise light brushed wet in wet over oranges mixed from burnt sienna, cadmium lemon and phthalo green. The darks in this area are Payne's gray and indigo. The water feathering technique was used to depict the canopies of the distant trees. All highlights, except the puddles, were masked before any paint was applied to the paper. The puddles were painted with a single wet in wet, upside-down-sky wash of phthalo blue and indigo. When this was dry, the dark shadowed areas around the puddles were painted loose and jagged to define their shapes; large marks in the foreground, getting smaller as they recede.

Opposite above
November Reflections

Size: 43 x 29.5cm (17 x 11¾in)

The low viewpoint of this composition creates a large expanse of beautiful water out of an ordinary roadside puddle. I started this painting by masking out some leaves in the foreground and a few, vertically elongated sky holes in the puddle. These sky holes needed protection because the reflections in the puddles were worked very wet. Lots of colour was dragged down in a wet water wash, with a little gum arabic added to give a sticky effect. When this dried, a few horizontal lights – shafts of sunlight glancing across the puddle – were lifted out by dragging the point of a damp round brush across the puddle. Finally, the masking fluid was removed to leave the dappled lights from the wooded canopy.

Opposite
Muddy Lane

Size: 38 x 26cm (15 x 10¼in)

This composition consists of two rectangles, a narrow one at the top and a broad one at the bottom, linked by the perspective lines of the lane. Notice how the puddles start as long, deep shapes in the foreground, then gradually reduce to narrow slashes in the middle distance. All the puddles were painted as a single wash of phthalo blue and Payne's gray. When this dried, the tree reflection was brushed in and other marks were made with vertical strokes of a dry brush. When these marks were dry, Payne's gray mixed with a little light red was used to define the shape of each puddle. This scene is a short distance up the lane featured in the previous demonstration and shows how a single location has the potential to yield lots of different subject matter.

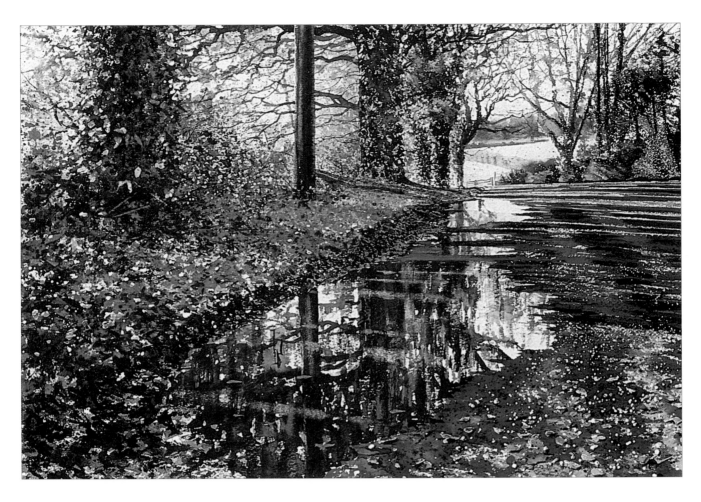

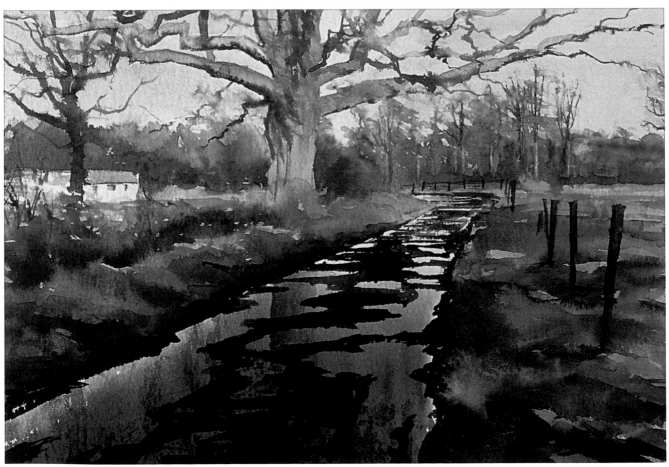

231

Rippled Water

This demonstration includes the characteristics that are typical of river scenes: the type of reflection; the colours reflected on the surface of the water and the shape of the ripples.

Lighter reflections bounce off the surface of water like a mirror. Even on a muddy river, the reflection of the sky can hide the murk below. In the foreground, the colour of the sky reflection is darker than the visible sky because it mirrors the sky high overhead (out of the image area). Further away, as the viewing angle becomes more acute, the colour becomes paler, and can often appear as white.

On the other hand, dark reflections create windows on the surface of the water through which underlying colours can be perceived. The reflections in these areas can take on a brownish tinge because of silt in the water. The viewing angle through these windows affects the visibility of the river bed. Foreground windows, for example, will allow you to see deeper into the water, making reflected colours darker than those further away.

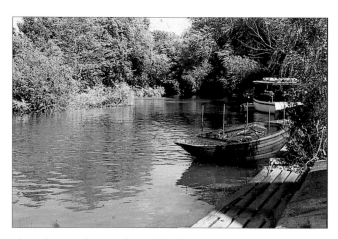

The reference photograph used for this demonstration.

The secret of painting ripples is not to try too hard. Let the ripples flow from the tip of a well-pointed brush, working back and forth in horizontal strokes.

232

233

COLOURS USED FOR THIS PAINTING

Burnt sienna

Quinacridone red

Cobalt blue

Cadmium lemon

Indigo

Phthalo green

Phthalo blue

Cadmium red

Payne's gray

Alizarin crimson

Ultramarine blue

Cerulean blue

Yellow ochre

Cobalt turquoise light

Cadmium orange

Burnt umber

OTHER MATERIALS

masking fluid
scrap paper for masks
strips of masking tape as masks
gum arabic

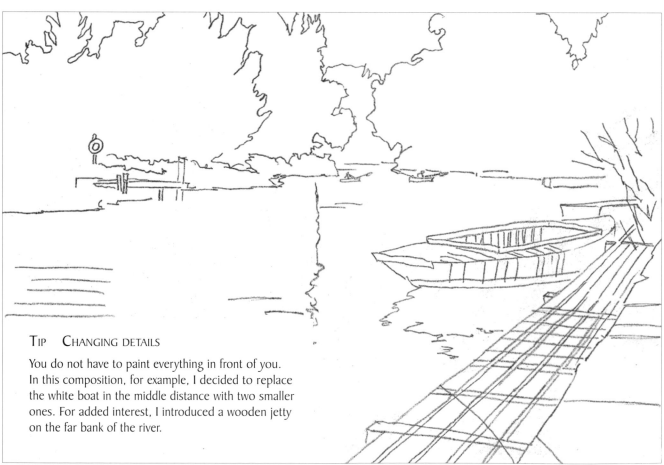

TIP CHANGING DETAILS

You do not have to paint everything in front of you.
In this composition, for example, I decided to replace
the white boat in the middle distance with two smaller
ones. For added interest, I introduced a wooden jetty
on the far bank of the river.

1 Referring to pages 210–211 and the reference photograph on page 232, make a
tracing of the composition, then transfer the basic outlines on to the watercolour paper.

2 Apply strips of masking tape round the edges of the painting, then use masking fluid to block out the jetty on the far bank and the two boats in the distance. Leave to dry.

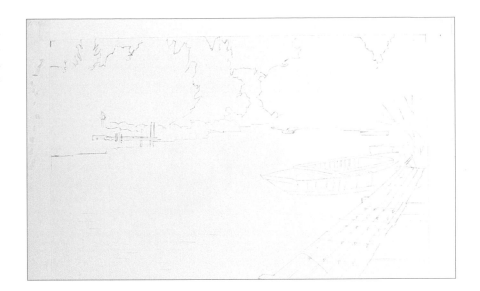

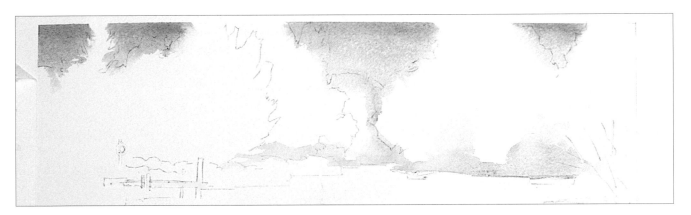

3 Wet the whole of the sky area, then lay in a wash of cobalt blue mixed with touches of alizarin crimson and burnt sienna, taking this down behind the distant trees and along the far banks of the river. Mix a wash of phthalo blue with a touch of phthalo green, then lay in a thin band of this colour along the top of the sky; make the sky darker in the top left-hand corner, and allow this blue to blend with the cobalt blue mix. Remove the masking tape from the wet edges and dry with a hair dryer.

Note At the end of step 3, I spent some time considering how to paint the backdrop of foliage. I decided to mask out a few tree trunks behind the jetty and some branches in the trees at the right-hand side before starting to paint the foliage (see steps 4 and 5).

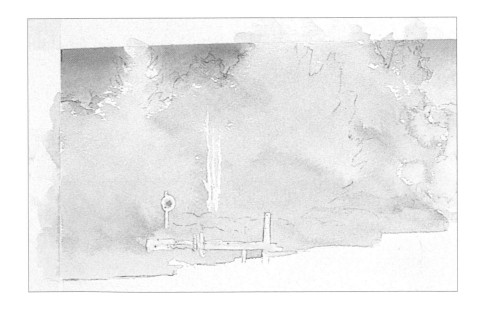

4 Prepare three washes: one from burnt sienna, cadmium lemon and a touch of phthalo green; the second from just burnt sienna and cadmium lemon; and a third from cadmium lemon with just touches of burnt sienna and phthalo green. Lay in the first wash along the bottom of the left-hand group of trees. Lay the second wash into the trees above, working a dry brush technique at the top where the tree line meets the sky. Introduce touches of the first wash at the right-hand side.

235

5 Use the third wash to block in the right-hand group of trees and those in the far distance. Add a touch more phthalo green to this wash, then block in the foreground foliage at the right-hand side.

6 Use torn pieces of paper to mask the patches of the sky and all the water, then spatter clean water all over the trees. Add ultramarine blue to the previous washes then spatter these randomly over the trees to start building up texture.

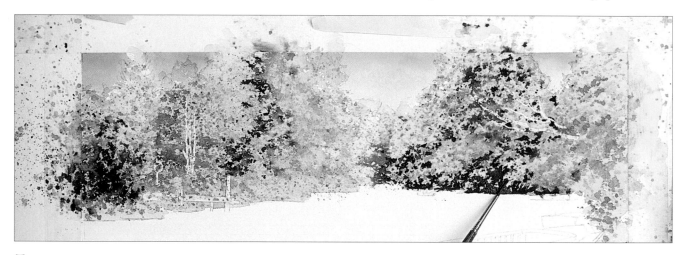

7 Build up the foliage with successive layers of spattered colour on spattered water. Dry the paper after each layer, and gradually make the tones darker and the spatters smaller. Fold back the paper masks, then use Payne's gray and the tip of a brush to model the canopies of foliage. Define their edges with areas of shadow and model the right-hand river bank.

8 Spatter water over the distant woodland in the centre of the composition, then apply cerulean blue with the point of a brush to create shadowed areas in the trees.

9 Continue building up shape and form by spattering more layers of colour and using the brush to enlarge some of the speckles. Add more paper masks as necessary. Brush touches of cerulean blue and cadmium lemon into the darks as highlights.

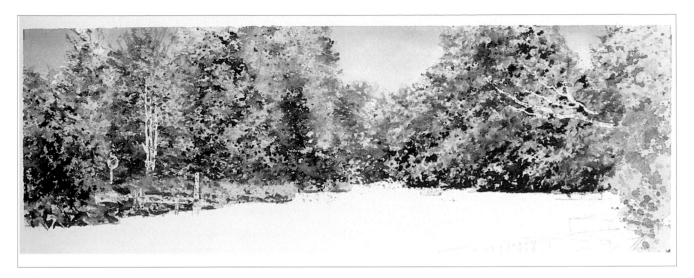

10 Complete the backdrop by tidying up the far bank, remove all masks and masking tape, then leave to dry.

11 Replace the masking tape. Wet the river, stopping short of the river bank and cutting round the boat shapes and foreground staging. Mix phthalo blue with touches of quinacridone red and indigo, then wash this in from the bottom upwards, saving a lot of light further up in the river. Take the wash up to the edge of the saved-white areas. Darken the bottom left-hand corner bottom of the river.

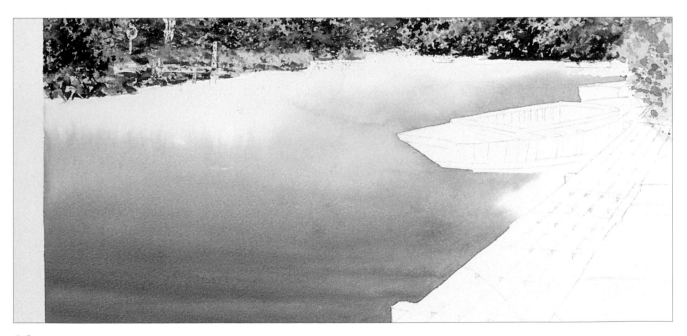

12 While the colour is still wet, brush in a few horizontal strokes of indigo in the foreground stretch of water to represent the underlying soft ripples in the water. Remove the masking tape borders and allow colour at the edges to bleed back into the river from the wet edges. Leave to dry.

13 Paint the wooden staging, wet on dry, with a mix of burnt sienna, cerulean blue and a touch of yellow ochre. Add more blue to the mix and block in the concrete path. Use a weak wash of neat cerulean blue to add texture to the concrete. Leave this to dry naturally so that the blue granulates. Paint the boat with burnt sienna, leaving a strip at the water line, the deck and the bottom of the inside of the boat white. Use the same colour to paint the small boat moored behind the large one.

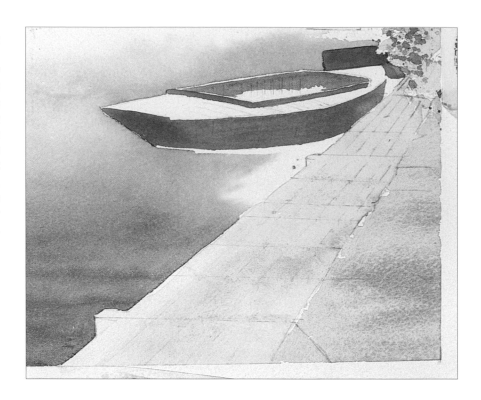

14 Using a mix of ultramarine blue and burnt sienna, paint the shadows on the staging and concrete path wet on dry. Note how these shadows dip between the boards of the wooden staging. Dry the painting, then stick thin strips of masking tape across the boards of the staging. Make the strips slightly narrower and closer together as they get further away.

15 Using a weak wash of burnt sienna and a fine brush, paint the gaps between the boards. Darken these with ultramarine blue in the shadowed areas. Make small marks of indigo in the areas of cast shadows. Dry the painting, then gently remove the strips of masking tape. Paint fine lines along the top edges of the boards in these exposed areas.

16 Use mixes of cadmium lemon and burnt sienna to give a three-dimensional shape to the hull. When this is dry, brush fine lines of ultramarine blue mixed with burnt sienna, to define the planks on the hull. Dry the painting, then paint a strip of cadmium red along the bottom of the hull. Mix a very light grey wash of ultramarine blue and burnt sienna, then block in the top of the boat. Use a light yellow-green from the palette to paint the tarpaulin in the bottom of the boat. Dry these colours, then use indigo to paint a thin shadow at the water line, the shadow at the stern, the cast shadows across the boat and the dark detail inside the boat.

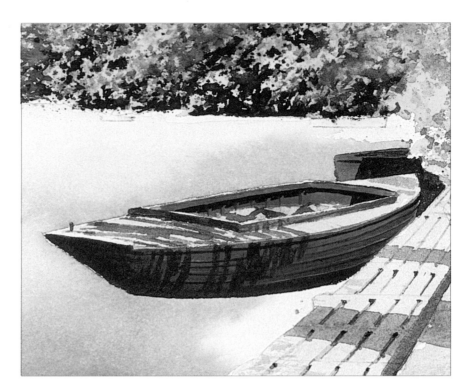

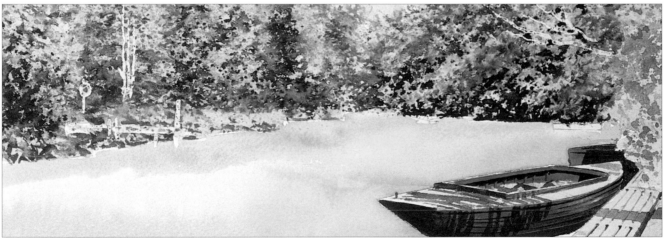

17 Rewet the distant water, then drop in a base wash of cadmium lemon mixed with burnt sienna for the soft reflections of the background trees.

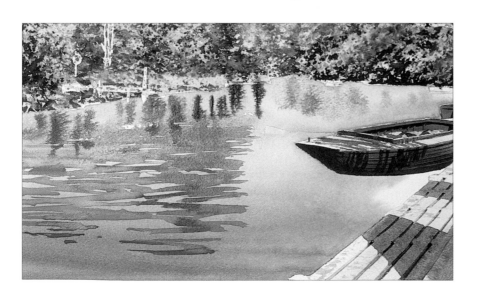

18 While the previous wash is still wet, use mixes of burnt umber and cadmium lemon, with touches of phthalo green, and horizontal brush strokes to work the hard-edged reflections, making the strokes bolder and more open as you work downwards. Gradually introduce more burnt umber and touches of ultramarine blue as the marks get closer. While the colours are still wet, paint a little gum arabic into the area of cadmium lemon (see page 227), then add vertical strokes of Payne's gray as reflections of the dark areas in the background foliage.

239

19 Continue to build up the reflections with vertical bands of Naples yellow and cadmium lemon between the Payne's gray ones, and with phthalo green behind the boat. Pull the colours down into the still-wet horizontal ripples, without disturbing their shapes. Make the strokes thinner in the distance.

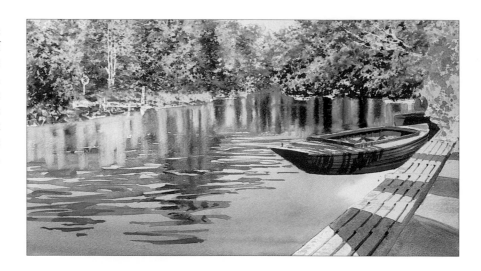

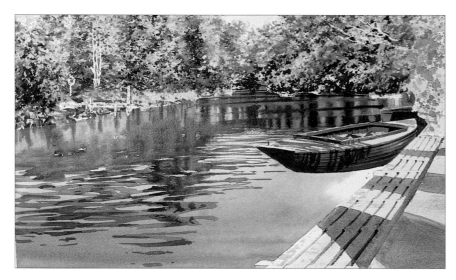

20 Lay in a few horizontal strokes of cobalt turquoise on the distant water, then darken the closer ones of these with Payne's gray. Use vertical marks of cadmium lemon to create highlights against the deep shadows, then add touches of burnt umber. Use a clean brush to soften and merge the colours in the distant water. Add darks to the now dry foreground ripples.

21 Using burnt umber and Payne's gray, work up the reflections in front of the boat.

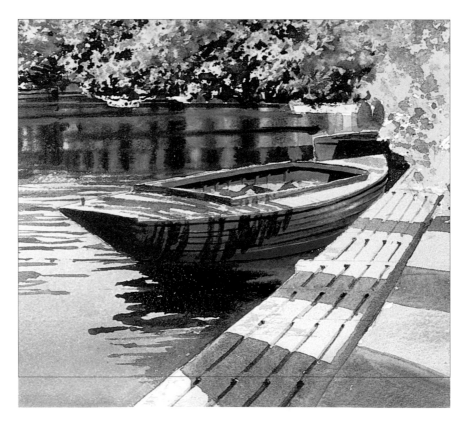

22 Mix a weak wash of cobalt blue with burnt sienna, then add touches of this to the soft foreground ripples to key these into the other reflections. Add touches of indigo and burnt sienna to the concrete path. Spatter more darks in the foreground foliage, then use a fine brush to link some of the spatters together to form dark shadows. Dry all the colours, then remove the masking fluid.

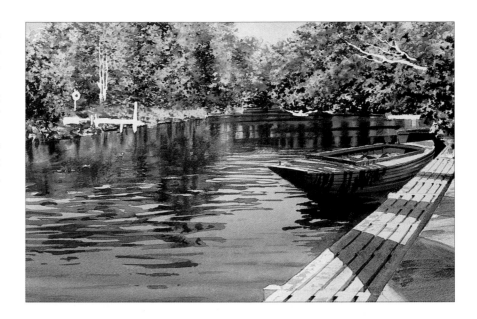

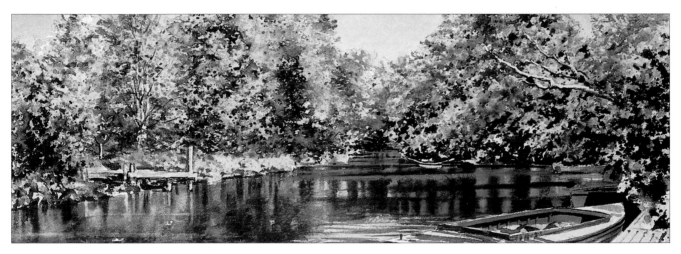

23 Finally, add the fine details. Paint the life belt using a mix of cadmium orange and cadmium red. Use burnt sienna and darks from the palette to paint the bare branches, adding touches of indigo on their undersides. Work broken strokes of browns, greens and indigo across the tree trunks on the far bank. Block in the far right-hand boat with burnt sienna. Use cadmium lemon for the distant boat with a touch of cadmium red for the rower. Lift out the reflections of the jetty, then use tones of burnt sienna and cadmium lemon, and darks from the palette to complete the jetty.

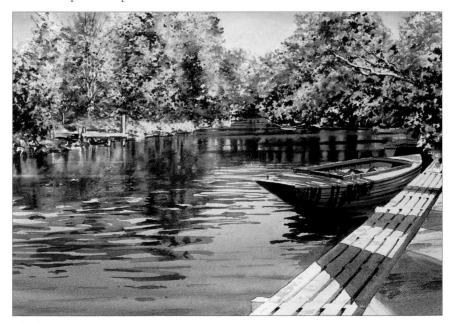

The finished painting.

241

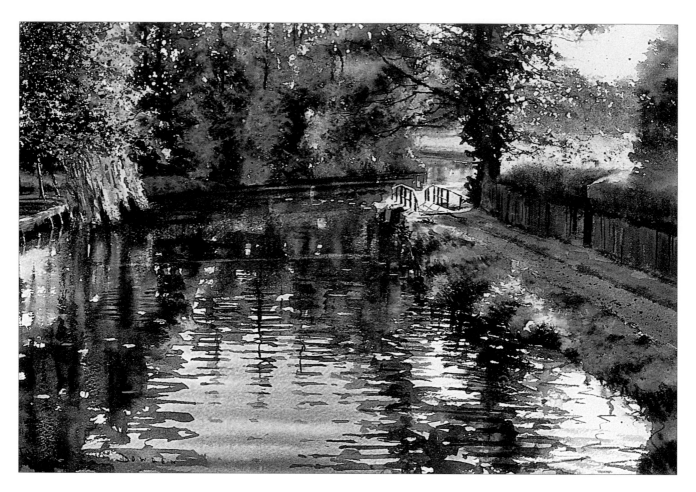

Sunlit Navigation

Size: 43 x 29.5cm (17 x 11¾in)

A wash of phthalo blue and indigo was used to paint the reflected sky. When this initial wash was dry, a large quantity of water was brushed on to the upper part of the river, then indigo, phthalo green, and cadmium lemon were run into this and allowed to blend. The ripples were dragged out of the wet area on to the dry paper below, making them larger in the foreground. These were kept wet and colourful with the addition of cadmium lemon and burnt sienna.

Opposite above
Waterborne

Size: 38 x 26.5cm (15 x 10½in)

The deep ripples left in the wake of the barge cut right across the river, so it was necessary to leave out long streaks, saving whites or the underlying colour, to produce these long light ripples. The negative sides of dark ripples were painted across the sky reflection. Notice how the lights and darks interconnect to make the surface pattern. A little masking was done around the barge, and the exhaust cloud was blurred by letting the dark colour into a clean water wash at that point. Masking fluid, spattered from a toothbrush, was used to produce the sky holes in the trees.

Opposite
December's Foggy Breath

Size: 30.5 x 21cm (12 x 8¼in)

In this winter scene, the snow was painted with light washes of cerulean blue and quinacridone red. These colours were also used in the reflection colours in the water. Long vertical marks are blurred in the mass of reflection by working them wet in wet, but, where they emerge on to the sky reflection, they are painted wet on dry. The angled lines of diagonal reflections are stepped, with short vertical segments followed by horizontal ones, to give them a wet rippled feel.

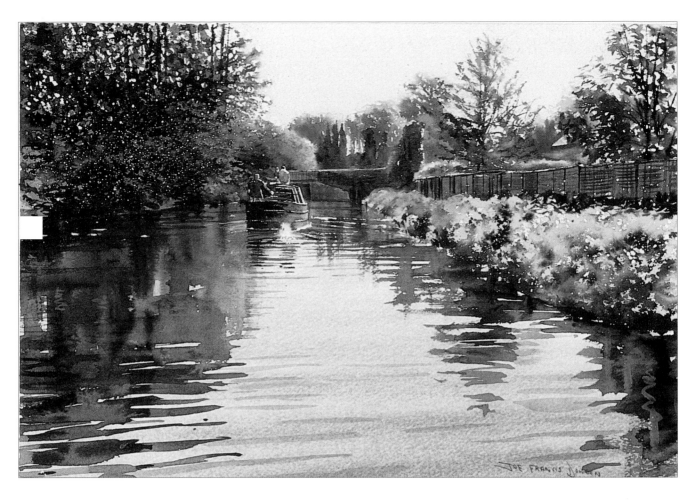

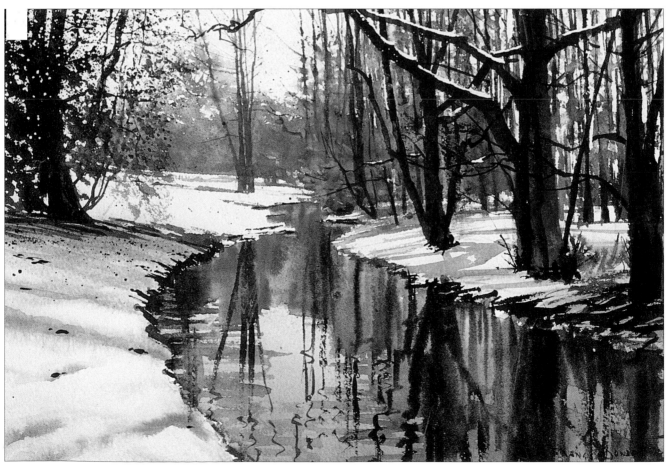

243

Seascape

I love painting seascapes such as this, where endless ranks of waves roll ashore to break on a rocky coastline. The movement in the water contrasts dramatically with the solidity of the rocks and cliffs. Light is diffused throughout the sea and there are no distinct reflections.

Strong tones, built up with a series of light and dark glazes, provide the contrast between the subdued colours of the banks of clouds, the bright whites of the foam, and the sunlit mass of rocks. The water is defined by the colour it takes from the sky, and the shapes of the ocean swells that are rendered by simple strokes of the brush.

This colour sketch, painted in situ, *was used as the reference material for this demonstration.*

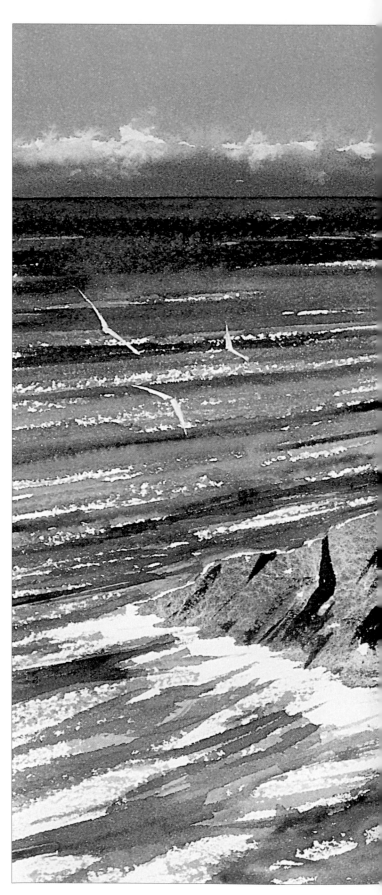

Build up tone and brush marks with a series of glazes. Saved whites add detail to this rocky coastal scene.

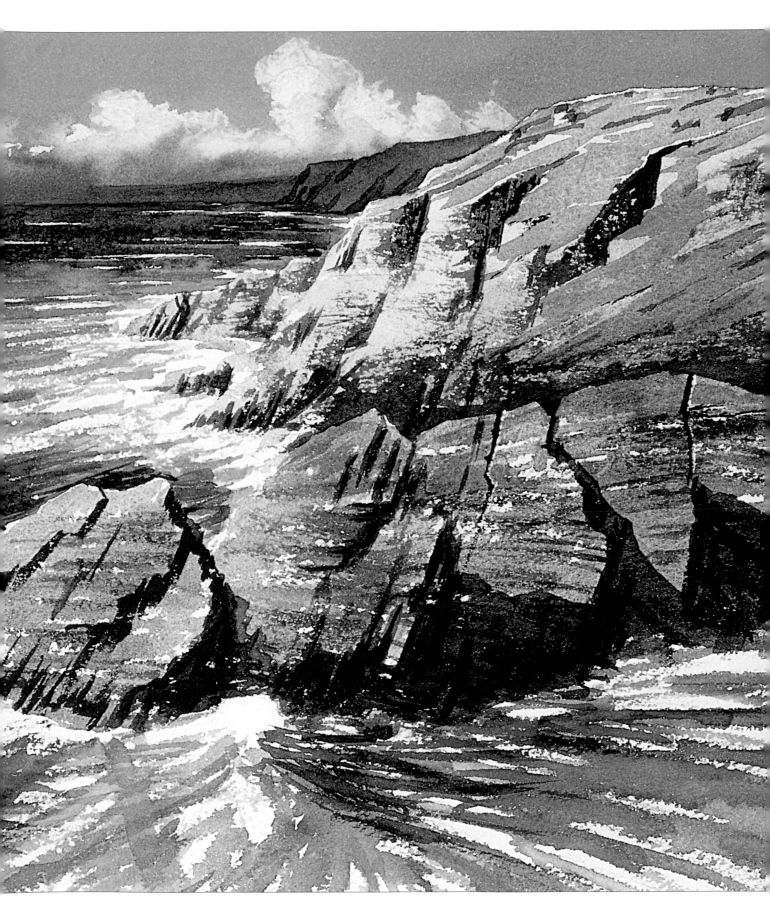

245

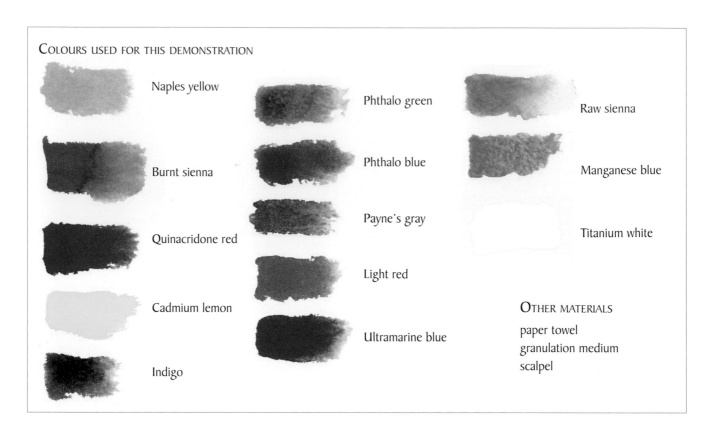

COLOURS USED FOR THIS DEMONSTRATION

Naples yellow

Burnt sienna

Quinacridone red

Cadmium lemon

Indigo

Phthalo green

Phthalo blue

Payne's gray

Light red

Ultramarine blue

Raw sienna

Manganese blue

Titanium white

OTHER MATERIALS
paper towel
granulation medium
scalpel

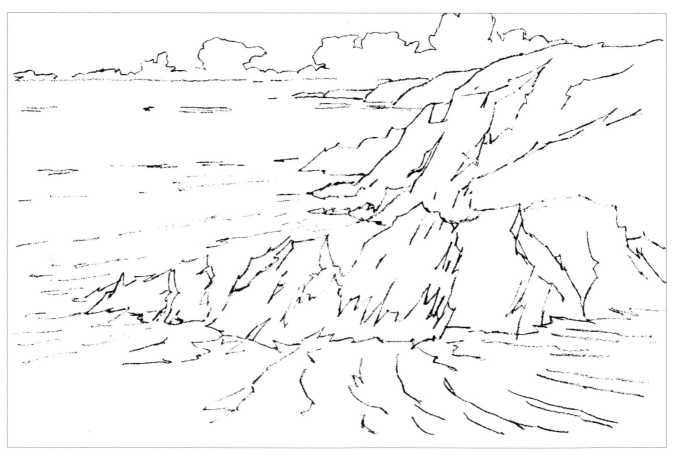

1 Referring to pages 210–211, use the reference sketch on page 244 to make a tracing of the composition, then transfer the basic outline on to the watercolour paper.

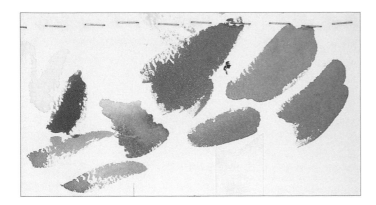

TIP BLUES FOR SKY AND WATER

I have several blues in my palette because each is unique and cannot be duplicated by mixing. I often use several blues in a sky, and I even add a little green. Building different blues into a sky or water wash can give it a vibrancy and make it seem almost iridescent. I invariably paint on oversize sheets of paper, so I can use the outer borders to try out different colours before using them on the painting.

2 Wet the sky area and the distant headlands. Lay in a wash of Naples yellow from halfway down the sky to the horizon line. Then, while the yellow is still wet, add a wash of quinacridone red along the horizon, taking it over the distant headland but leaving a dry edge along the top of the nearer headland. Leave to dry.

3 Rewet all the sky and the distant headland and wet all the sea, leaving some thin horizontal streaks of dry paper in the most distant part for the foaming crests of waves. Mix a wash of phthalo blue with a touch of phthalo green, then paint in the sky, cutting round the shape of the cliffs. Bring this colour down into the distant area of sea, leaving some white streaks.

4 Working wet in wet, paint the sea area behind the foremost rocks, leaving the dry white streaks and diluting the colour as you work downwards.

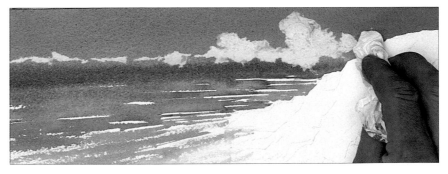

5 Use ultramarine blue to define the horizon, wet in wet, blending it into the sky and sea. While this colour is still damp, dab out some clouds with scrunched up pieces of paper towel. Use a clean part of the paper for each dab.

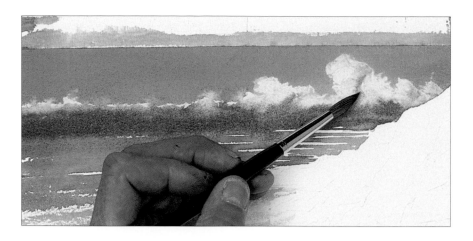

6 Use clean water to soften the bottom edges of the clouds. Brush in diluted ultramarine blue to create shadows under the clouds. Bring down some of the top sky colour to add shape and form to the clouds.

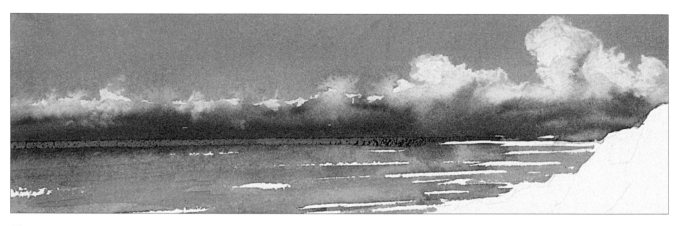

7 Use phthalo blue, mixed with a touch of phthalo green to re-establish the horizon.

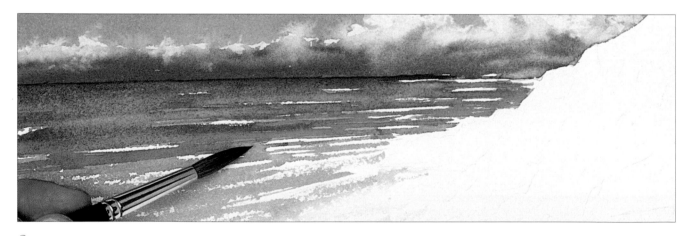

8 Use a clean damp brush to soften the bottom edge of the horizon, then work the colour on the brush downwards to darken the distant area of sea, saving the whites of the waves.

9 Overpaint the distant water with indigo, narrowing the distant white streaks of dry paper.

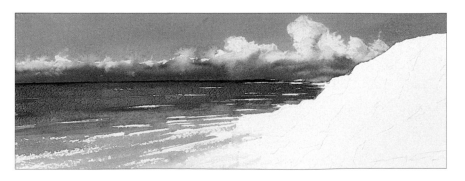

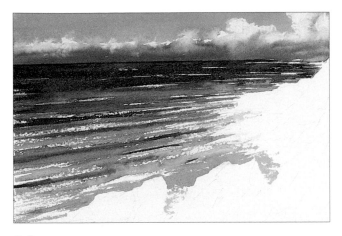

10 Using phthalo blue wet on dry, delicately pick out the wave pattern in the middle distance. Apply horizontal streaks of indigo, wet into damp, to create shadows in the waves. Use phthalo blue and negative painting to define the top edges of the rocks in the foreground. Add streaks of cadmium lemon in the middle distant stretch of water and touches of raw sienna close to the foreground rocks.

11 Start to develop the foreground waves with crisscross strokes of phthalo blue. Then, using different mixes of ultramarine blue, light red, burnt sienna and cadmium lemon, apply more random strokes of colour. Try to build up the impression of movement in the foreground water. Leave to dry.

12 Darken the bottom right-hand corner with touches of indigo and ultramarine blue, then dry thoroughly with a hair dryer. Use indigo, phthalo blue and light red to mix different greys, then develop the movement of the foreground water, adding dark tones on the right-hand side of the swelling waves.

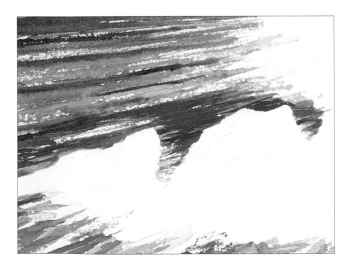

13 Use indigo and phthalo blue to darken the sea behind the foreground rocks. Use negative painting to help define the hard edges of these rocks.

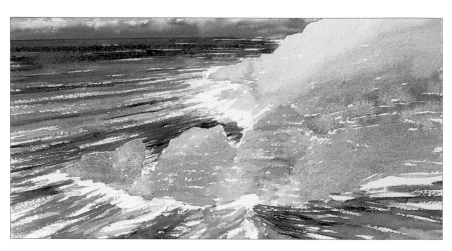

14 Use ultramarine blue and burnt sienna to mix a neutral grey. Add more ultramarine blue to this mix to make cool greys, and touches of quinacridone red to make warm greys.

15 Use touches of granulation medium (instead of water) to dilute the grey mixes on the palette, then block in the foreground rocks leaving a fine white highlight round the top edges. Soften the colours at the top of the far part of the cliffs by diluting the greys with water. Leave to dry slowly, enhancing granulation effect.

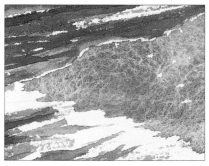

This full-size view of the left-hand rock clearly shows the pigment granulation.

16 Use burnt sienna, manganese blue and cadmium lemon to mix a dull yellowy-green, then block in the grassy areas on top of the rocks and cliffs.

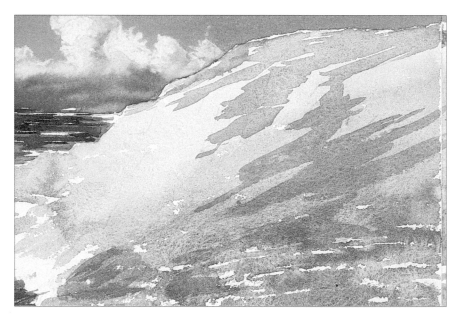

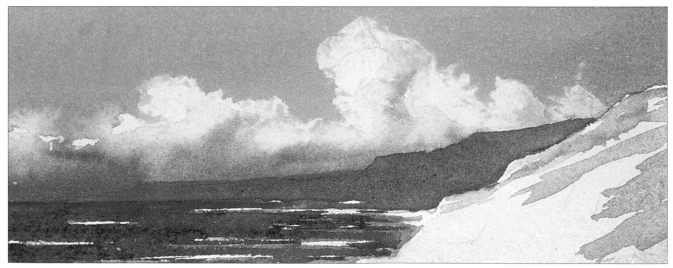

17 Wet the distant headland, add more quinacridone red to the greys on the palette, then paint the far distant headland. Soften the top edge with a clean brush, then leave to dry.

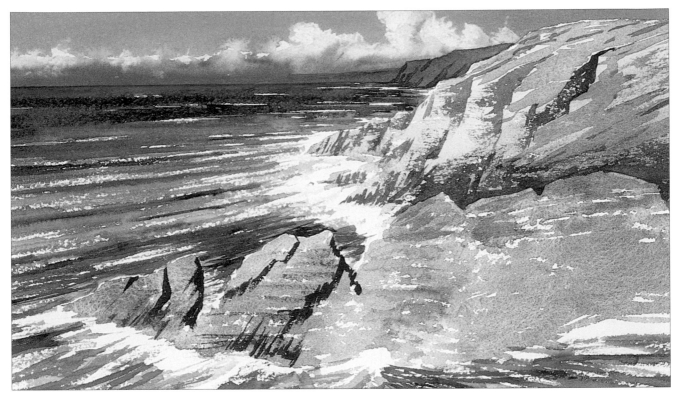

18 Mix some grey with ultramarine blue and burnt sienna, then, working from top to bottom, add the mid-tone shadows to the rocks and cliffs. Paint wet on dry to define edges, then use a dry brush to create texture and form. Darken the mixes as you move down the paper.

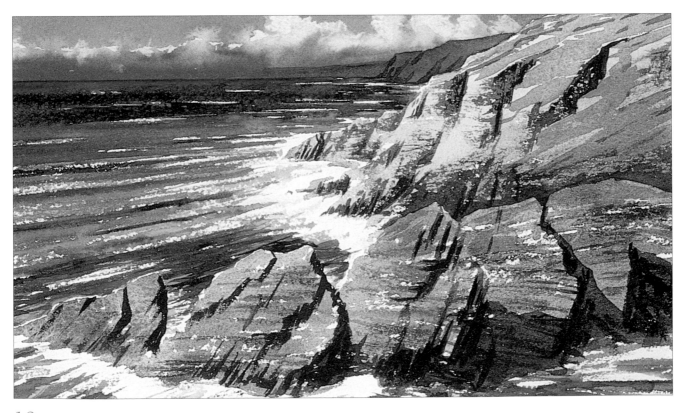

19 When you are happy with the mid-tone shadows, use Payne's gray mixed with a touch of phthalo blue to paint in the dark shadows. Work from top to bottom again, making the foreground shadows darker and more detailed than those in the distance.

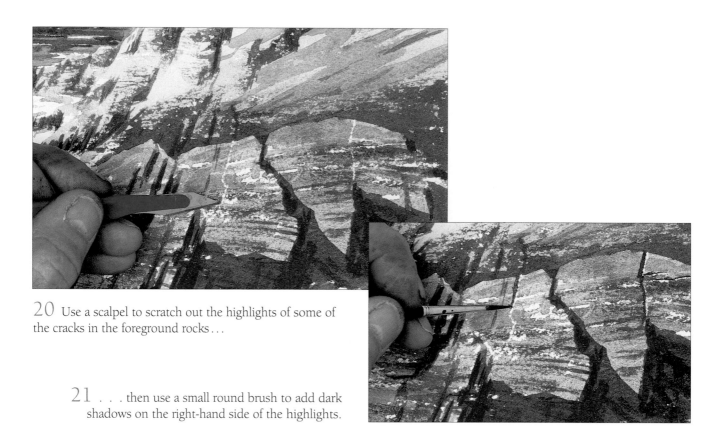

20 Use a scalpel to scratch out the highlights of some of the cracks in the foreground rocks...

21 ... then use a small round brush to add dark shadows on the right-hand side of the highlights.

The finished painting. At the end of step 21, I decided to add a few details to the shadows and to the sea beyond the foreground rocks. I also decided to add three swooping gulls which I painted with opaque, titanium white.

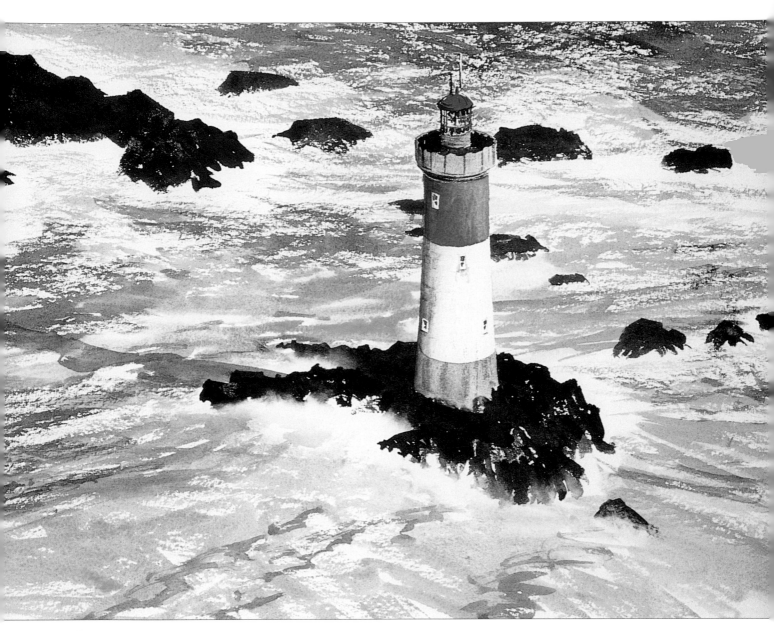

Guardian

Size: 56 x 40.5cm (22 x 16in)

I started this painting by masking out the lighthouse and dragging the sea colours rapidly across the whole expanse of paper working brush strokes wet on dry, with quite a bit of dry-brush work. Light tones of manganese blue, mixed with touches of quinacridone red and Naples yellow, were used to create the acres of foaming water being dragged across the shoals. Darker tones of this colour mixed with Payne's gray were used in places. Whites were saved around the area of each rock before these were painted with an intense Payne's gray, which was let into water brushed on the paper around their lower edges to get the soft focus spray effect of the sea. Some remaining hard edges were softened with a small flat bristle brush. When the masking fluid was removed, a wash of cadmium red light was let into a band of water around the top part of the lighthouse, then this was darkened down the left-hand side with ultramarine blue and burnt sienna. Warm grey mixes of these two colours were used for the browns on the veranda and the base of the structure.

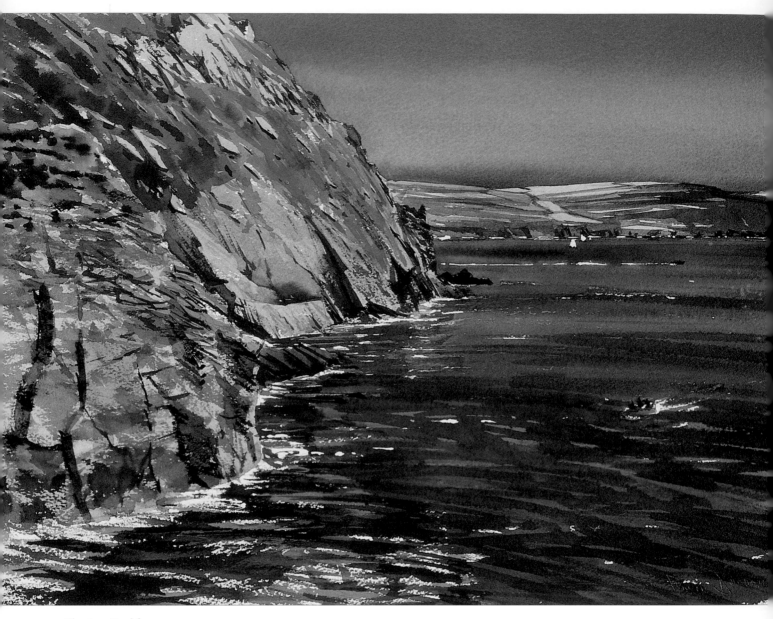

Sloping Rockface

Size: 48.5 x 34.5cm (19 x 13½in)

The three images on these two pages were painted in situ within a short distance of each other. For this composition, I laid initial washes of red and orange in the sky, then, when these were dry, I painted the sea and sky with washes of phthalo blue, avoiding the cliff face and distant hills, and saving whites for the foam and the red boat. While the sky was still wet, I added some ultramarine blue into the lower sky. When the sea was dry, I darkened it with a glaze mixed from indigo and phthalo blue, and brushed dark streaks across the wet wash, all the time saving whites.

I painted the cliffs with grey glazes mixed from burnt sienna and cobalt blue. I washed in the distant hills with Naples yellow, then followed this with washes of ultramarine blue and burnt sienna.

I touched in the boat with cadmium red, then used the tip of a knife to scratch out its wake.

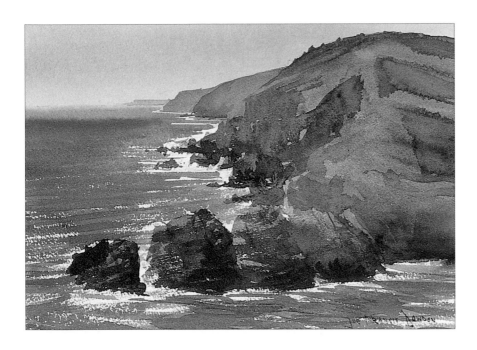

Jagged Rocks

Size: 35.5 x 25.5cm (14 x 10in)

This scene is the same subject as the seascape demonstration, but from a slightly different viewpoint, later in the day when the tide was higher. Painted more or less straight into the sun, the whole of this scene was silhouetted, with very dark foreground objects, and distant ones getting paler. This made it easier to paint, with no saving of whites or lights necessary except for the foam. The sky and sea were painted as one, then the sea was darkened with subsequent washes. I added a touch of phthalo green to phthalo blue for the sky colour. As with the demonstration painting, rhythmic brush work describes the movement of the sea.

Beach at Low Tide

Size: 40.5 x 24cm (16 x 9½in)

The groundwork for many watercolour paintings consists of colour washes. Here, I used swathes of water with added colour. The sky and sea were painted as one with phthalo blue mixed with a little phthalo green. The beach is burnt sienna and yellow ochre, greyed with touches of cobalt blue. Whites were saved at the start. The sky has enough tone to make the fields above the distant headland look light in comparison. The sea is darker than the sky. A pattern of light/dark/light was planned at the outset to capture the brightness of this sunny day. Light conditions can change completely during the progress of a painting so it helps to make a lighting plan at the start and fix it in your mind.

255

Shallow Water

Underwater objects, seen from above the surface, make a desirable subject to paint, but painting them is often regarded as an elusive skill. In this demonstration, I show you how to paint see-through water with stones 'swimming' just below the surface. The secret is not to try to paint the water on top of them, but to recreate the special effect that light has on such shallow water. Capture this effect and it will look as if water is there.

Gently lifting the rocks through a glaze gives them a slightly soft, out-of-focus appearance and makes them three-dimensional. Water refracts and bends light, and this distortion makes underwater objects appear elongated in the horizontal plane. The deep brown of burnt sienna captures the basic colour, and a few dark marks, brushed in around the lifted-out shapes, completes the effect.

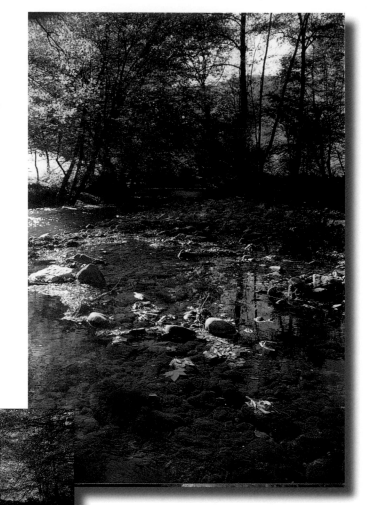

Elements from both of these photographs were used for this demonstration.

Paint the underlying colours of the water, then lift out the shapes of the submerged rocks.

256

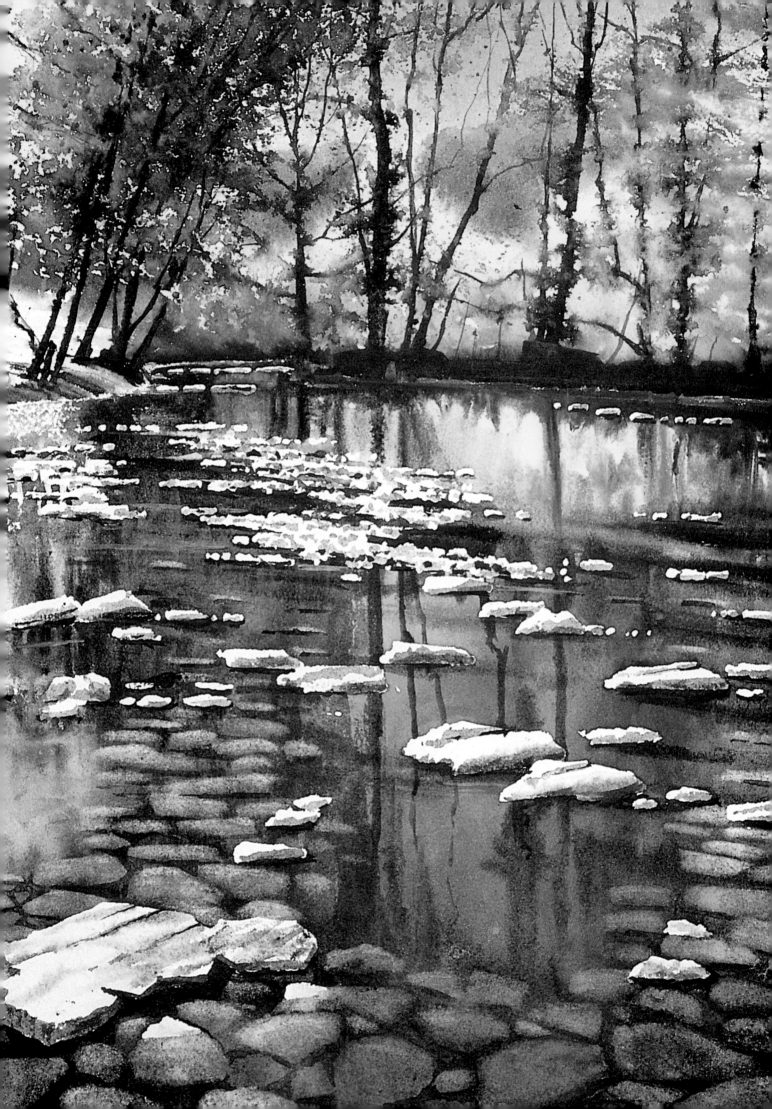

COLOURS USED IN THIS DEMONSTRATION

Burnt sienna

Phthalo blue

Manganese blue

Cadmium lemon

Payne's gray

New gamboge

Light red

Quinacridone magenta

Indigo

Ultramarine blue

Cadmium yellow pale

Phthalo green

Cerulean blue

Burnt umber

OTHER MATERIALS watercolour medium, masking fluid, wax candle, scrap paper

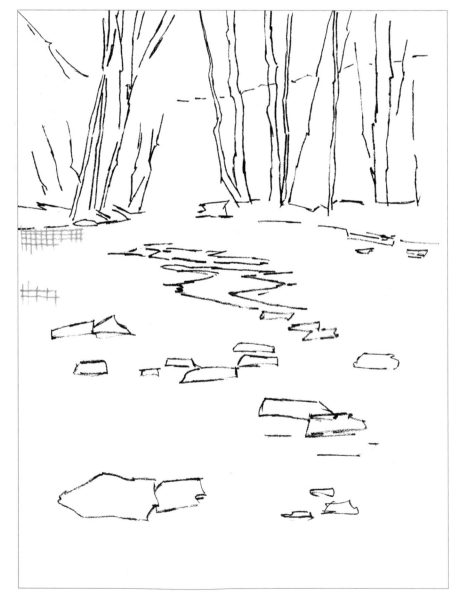

TIP WAX RESISTS

When a wax candle is rubbed gently across watercolour paper, small particles of wax are deposited on the high points or tooth of the paper, but not in the tiny dips in the surface. Wax resists water, so, when a colour is subsequently painted over it, a fine textured pattern of broken white is created. The technique can be used to depict sun sparkling on water, as in this demonstration, for the texture of masonry or to depict small leaves.

1 Referring to pages 210–211, use the reference photographs on page 256 to create the composition, make a tracing and transfer the basic outlines on to the watercolour paper. The red marks on this sketch are those made with the candle in step 3.

2 Apply masking fluid to all the parts of the rocks that sit proud of the surface of the water.

3 Using a wax candle and the straight edge of a piece of scrap paper as a guide, make some horizontal and vertical strokes on the left-hand distant stretch of water (see sketch opposite).

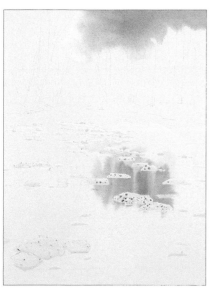

4 Wet the sky area behind the trees and its reflection in the water, then lay in a wash of phthalo blue mixed with a touch of phthalo green. Soften the outer edges with clean water.

5 Now drop in touches of phthalo blue below this reflection and a touch of quinacridone magenta at the bottom of the paper. Mix a touch of phthalo green to the phthalo blue, lay in a weak wash of this colour at the left-hand side of the painting, then leave to dry.

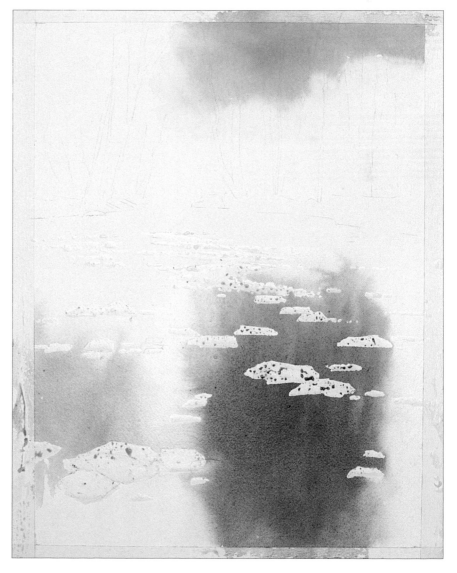

259

6 Wet the background then block in the foliage. Use cadmium yellow pale for the left-hand and central parts of the foliage and cadmium lemon for the right-hand part. Take the cadmium lemon across the bottom of the whole of the background, following the line of the banks of the stream.

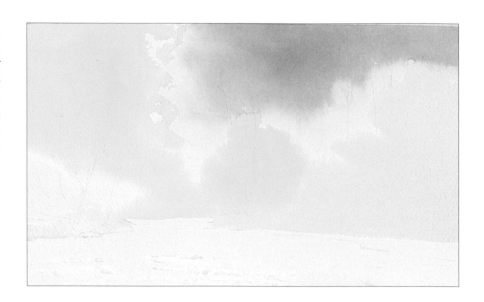

7 Wet the area of the distant hills then lay in blue wash of phthalo blue, phthalo green and quinacridone magenta. Drop in touches of orange mixed from cadmium yellow pale and quinacridone magenta. Add more cadmium yellow pale below the hill and across the central and right-hand areas of foliage. Leave to dry, allowing the colours to blend into each other.

8 Mix phthalo green with cadmium lemon, then, with pieces of scrap paper as masks, use the spattering technique (see page 236) to start adding detail to the foliage. Remember to spatter clean water and then colour. Spatter more water to spread the colours, then use a No. 3 round brush to draw some of the spatters into larger shapes. Feather water across the rest of the background then start to lay in a mix of phthalo green and indigo. Use a dry brush for smaller marks at the top of the trees. Add touches of cadmium lemon here and there.

9 Spatter water across the wooded area, then, still using the dark mix (phthalo green and indigo) brush tree trunks through the spattered water. Spatter the dark parts of the foliage. Darken the far bank of the stream. Add touches of light red to the mix for the branches in the sunlit area at the left-hand side of the painting.

10 Add two thin lines of masking fluid on the far distant stretch of water. Wet all the water area, lay in vertical strokes of watercolour medium sparingly on to this area, then lay in a wash of cadmium lemon as the base coat for the reflections of the foliage.

11 Add neat cerulean blue to the distant stretch of water. Use a mix of Payne's gray and phthalo green to add dark reflections of tree trunks and the dark parts of foliage. While this is still wet, soften the edges of all shapes with cadmium lemon. Add more touches of neat phthalo green, to define brighter reflections, and burnt sienna.

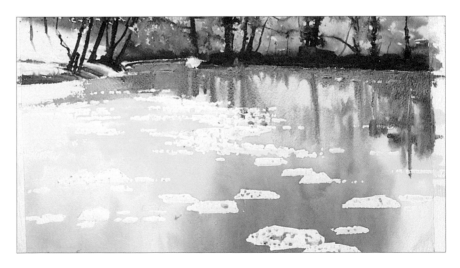

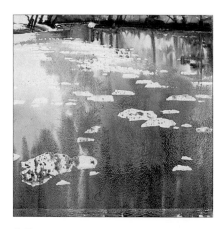

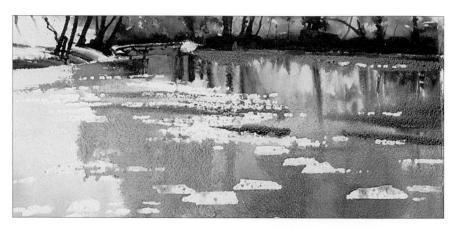

12 Mix a brown wash from burnt sienna, ultramarine blue and new gamboge, then lay in the areas of dark reflections on the water, darkening the mix as you work downwards.

13 Add more burnt sienna and some cadmium lemon to the mix and blend this into the brown in the middle distance. Soften the edges that meet the distant reflections. Lay in horizontal stripes of Payne's gray, and allow these to blend into the background colour.

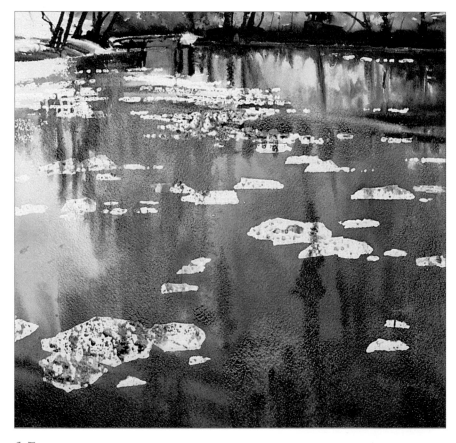

14 Working wet into wet, add random strokes of ultramarine blue to the brown at the bottom of the water to define the very dark reflections.

15 Blend touches of cadmium lemon to the edges of the brown reflections at the middle and left-hand side of the water, then use mixes of phthalo green and Payne's gray to paint in the very dark reflections of trees in the background. Note the effect of the wax resist applied in step 3. Add burnt umber to the palette, then paint in vertical strokes in middle distant stretch of water. Soften the edges of the browns with clean water and touches of cadmium lemon.

16 Mix ultramarine blue and burnt umber to make a very dark brown, then add patches of shadow at the bottom-left and bottom-right. Make smaller strokes with this colour across the whole stretch of water. Add cadmium lemon to the mix and blend paler tones into the darks. Use Payne's gray to introduce more dark shadows in the middle distance.

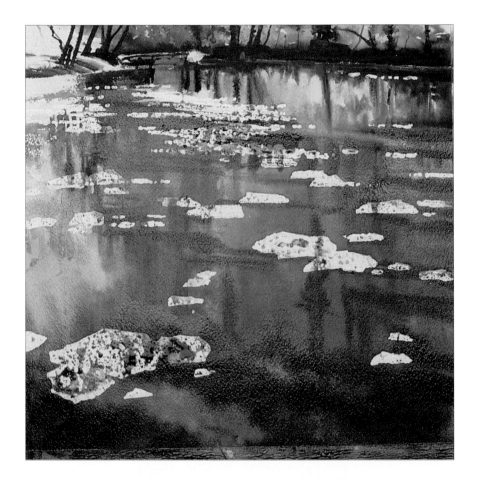

17 Working wet in wet, strengthen any weak tones with a mix of burnt sienna and phthalo green. Add a few horizontal streaks of Payne's gray as ripples and shadows under the masked-out rocks. Leave to dry, allowing all the colours to soften and blend together.

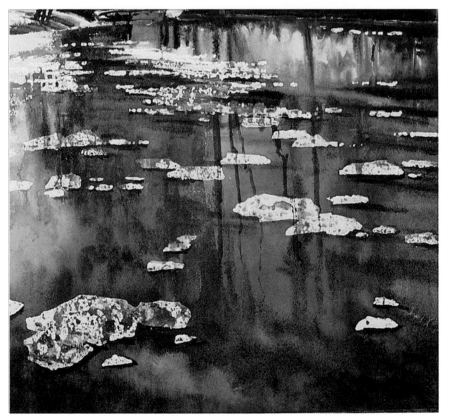

18 Use the dark mix of phthalo green and indigo, wet on dry, to redefine the vertical shadows of tree trunks and to extend them down into the foreground area. Use the same mix to emphasize the shadows below all the dry rocks. Leave to dry.

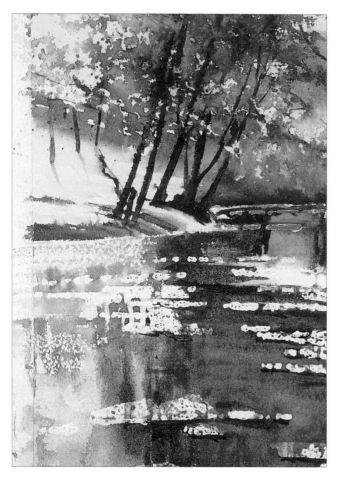

20 Wet small areas of the water with clean water...

19 Lay a weak wash of cadmium lemon across the land part of the remaining white space, and cerulean blue over the water part. Add touches of green as faint reflections.

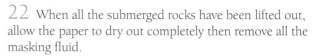

21 ... then use clean pieces of paper towel to lift off the colour in the wetted areas.

22 When all the submerged rocks have been lifted out, allow the paper to dry out completely then remove all the masking fluid.

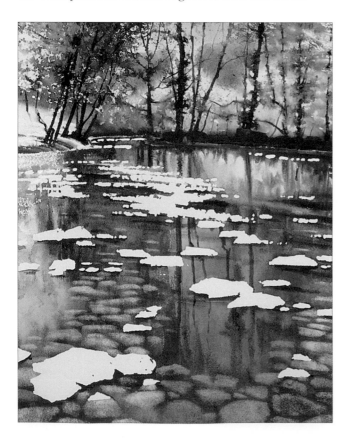

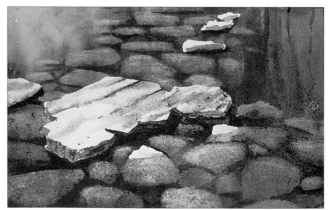

23 Mix a greeny-grey from manganese blue and burnt sienna, then paint in some texture on the dry parts of the foreground rocks. This colour mix gives very good granulation. Darken the mix slightly for the shadows on the top and sides of each rock.

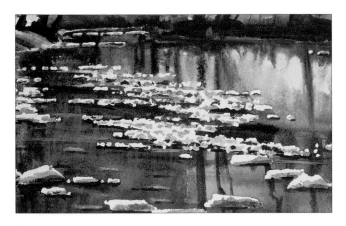

24 Use the same mix of colours to add shape and form to the smaller rocks in the middle distance.

25 Finally, use a weak mix of Payne's gray and burnt sienna to paint a latticework of shadows between the submerged rocks.

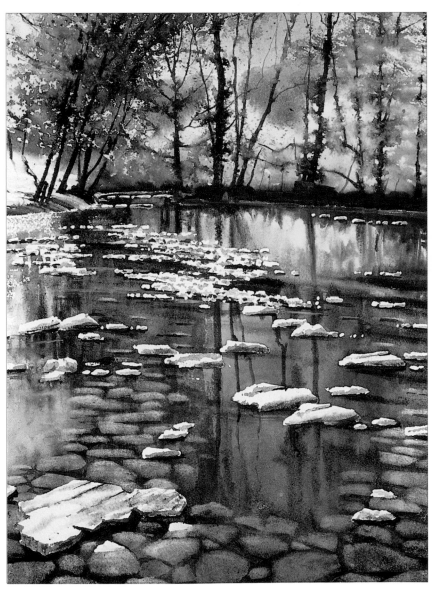

The finished painting.

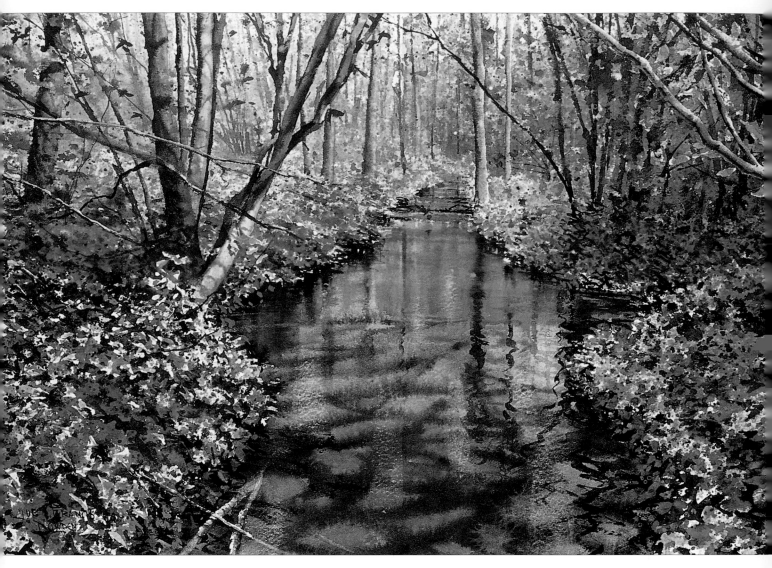

Woodland Brook

Size: 43 x 28.5cm (17 x 11¼in)

I added gum arabic sparingly to a wash of clean water on the river before painting the reflections. Gum arabic stabilises the reflections, allowing them to blur without spreading too far and being absorbed into the painting. Then, while the water was still wet, I painted the tracery of branch shadows in a diagonal pattern, flattening them out rapidly with distance. The diagonal shapes run counter to the vertical reflections, but look wet because they are blurred. The flattened look of the tracery of shapes is strongly suggestive of the effect of refraction, which seems to flatten and squash underwater shapes. The faint vertical lights on the surface depict the reflected hazy skylight coming through the wooded canopy. These marks read as wet, and are created by gently lifting out colour with vertical strokes of a damp sable brush, and leaving it to dry without dabbing with tissue.

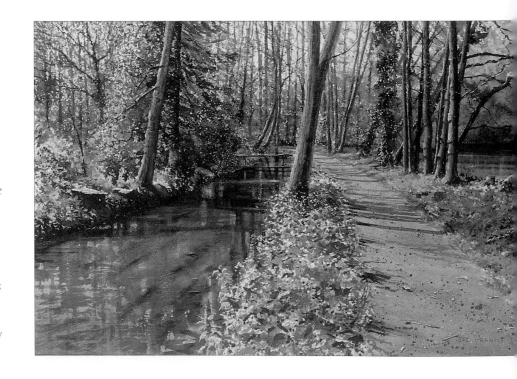

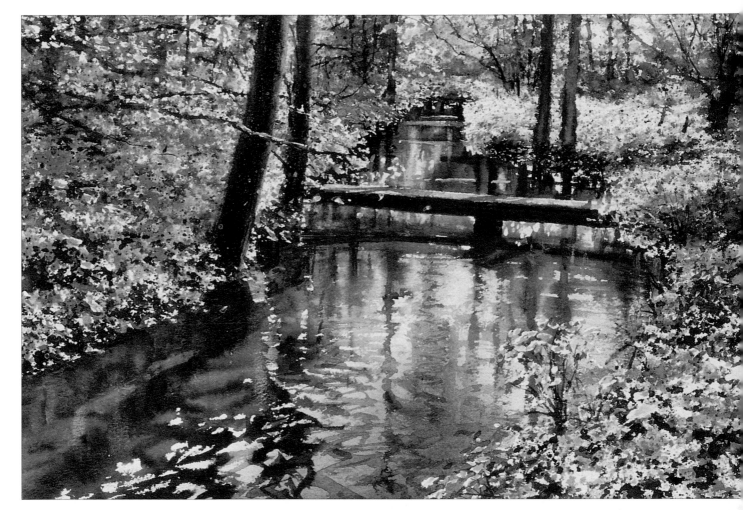

Rippling Bourne

Size: 51 x 32.5cm (20 x 13in)

Water twists and bends the light that is reflected on its surface, but it is different with light arriving from the river bed. Having been bent by refraction, it stays relatively stable – it shimmers a little, but hardly enough to paint. Compare the area of shadow at the left-hand side of the river with the sunlit areas. The shadowed area acts as a window to the bed of the river. Through this can be seen long shadows, which although blurred, are quite straight compared with the wildly fluctuating ripples in the middle of the river. The reflection colours are burnt sienna, cadmium lemon, Payne's gray, and phthalo green. Notice how the vertical scuff marks made with a damp brush on top of the water make it look like there is a glassy surface.

Opposite

Jim and Shirley's Walk

Size: 43 x 28cm (17 x 11in)

Many of the little leaves at the edge of the river bank were masked with a colour shaper before starting to paint the river. When the initial sky-reflection wash on the river was dry, a large area of the brown reflection was rapidly brushed in with a wet wash of burnt sienna and cobalt blue. A few vertical lights of the underlying sky wash were left to depict the gaps between trees. Cadmium lemon and phthalo green were added to the rich brown wash and then dark shadows on the river bed were painted across. As water travels down a shallow stream like this one, it drags mud and debris along the bottom, and this is sometimes visible as textured streaks. Painting these streaks strongly suggest the river bed seen through the surface of the water. Some more cadmium lemon was run in vertically, then a few vertical scuff marks were made with a damp brush. These marks help make the surface of the water appear transparent – like a thin veil that can be seen through.

267

Richness and Depth

How do you define the qualities of water when it is subject to so many moods and changes? Here, in this final demonstration, I have tried to capture the essence of water, bringing together most of the visual qualities discussed so far.

The river is framed like a jewel by the arch of the bridge. You can see the gentle up and down motion of the water and the way texture is dragged out vertically by the tiny ripples in the distance. A deeper swell moves along the surface of the river in the foreground, fragmenting the reflections at their tips and bending them in a rhythmical motion, projecting a sense of movement.

It is possible to paint a shining wet river on dry paper and to give it a sense of movement, even though it is static. By painting common visual effects, triggers of recognition can be activated in the mind of the observer. Water really can be made to look wet.

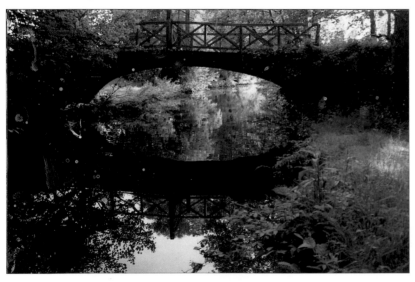

Reference photograph used for this demonstration.

Use plenty of water to make a river look wet.

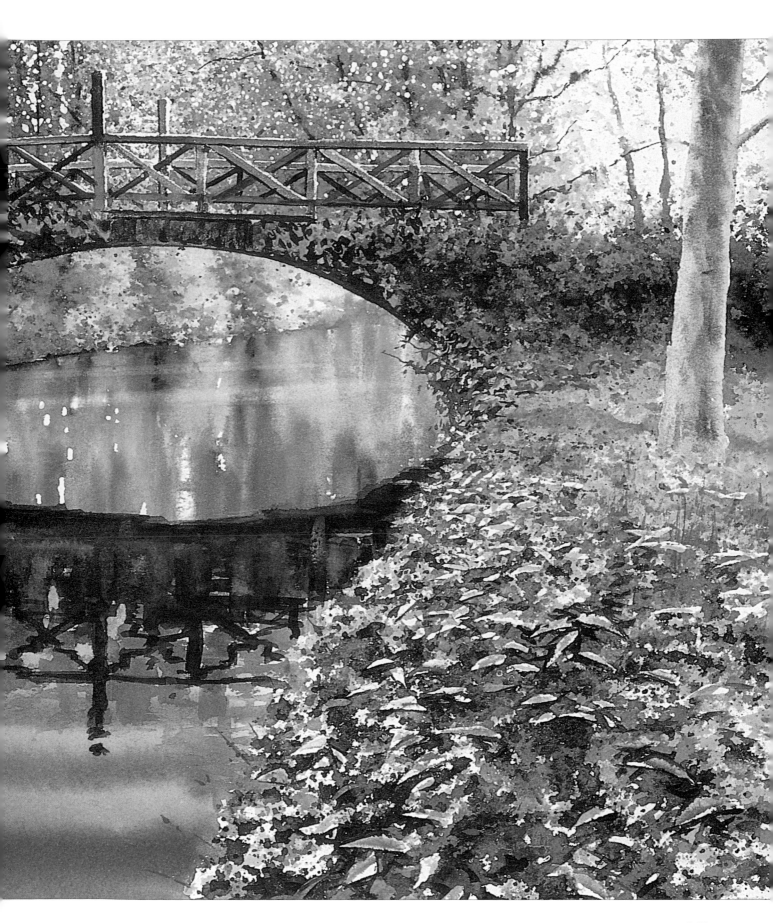

269

COLOURS USED FOR THIS DEMONSTRATION

Naples yellow

Burnt sienna

Cadmium lemon

Indigo

Phthalo green

Phthalo blue

Alizarin crimson

Cerulean blue

Cobalt turquoise light

Burnt umber

OTHER MATERIALS

scrap paper
masking fluid
watercolour medium

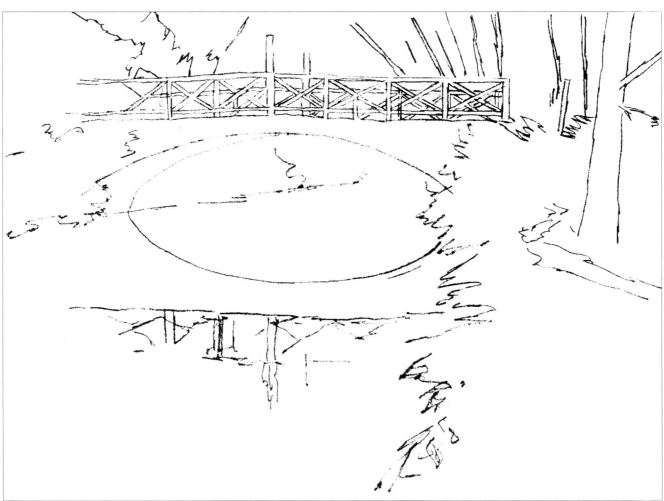

1 Referring to pages 210–211 and the reference photograph on page 268, draw a pencil sketch of the composition then transfer it on to watercolour paper.

2 Use masking fluid to block out all highlights as shown below. Use a shaper brush to draw the lighter parts of the bridge and some vertical highlights in the water. Use the shaper brush and then the drawing pen to create fine-pointed leaf shapes in the foreground. Use an old toothbrush to spatter small speckled highlights in the area of foliage behind the bridge. Use an old paint brush, with a blob of dry masking fluid on the bristles, to dab in rough patches of light areas between the background trees.

3 Using the spattering technique described on page 236 with a No. 8 round brush and cadmium lemon, build up a layer of small leaves at the top of the painting. Use a No. 16 brush to create larger speckles in the foreground. Block in the areas of foliage at the left- and right-hand sides of the bridge and the brick part of the bridge itself. Weaken the mix then block in the foliage that is visible through the bridge. Mask out the large tree trunk at the left-hand side and a couple of gaps between the trees at top centre left. Leave to dry.

4 Cut a paper mask for the shape of the arch of the bridge and mask this area and all the water area. Start to build up the texture of the foliage with spattered glazes. Begin with cobalt turquoise light…

5 … then spatter glazes of different greens made with cerulean blue, cobalt turquoise light and cadmium lemon. Remove the scrap paper masks, then leave to dry.

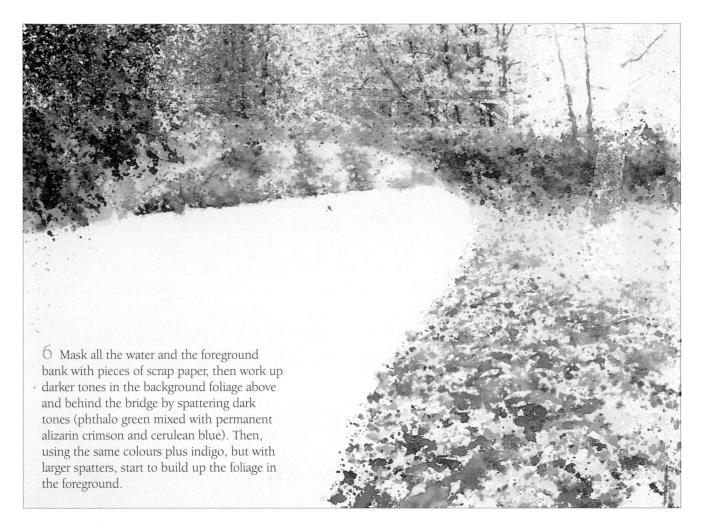

6 Mask all the water and the foreground bank with pieces of scrap paper, then work up darker tones in the background foliage above and behind the bridge by spattering dark tones (phthalo green mixed with permanent alizarin crimson and cerulean blue). Then, using the same colours plus indigo, but with larger spatters, start to build up the foliage in the foreground.

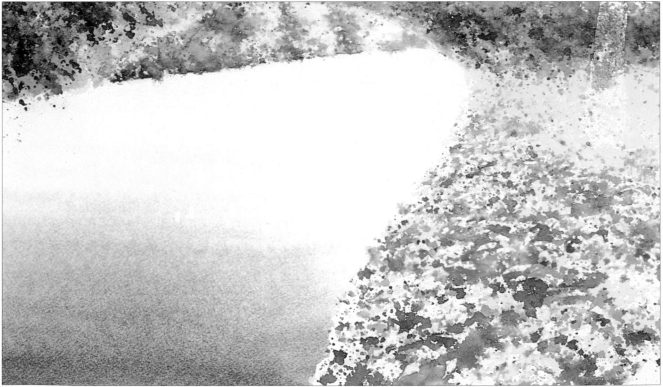

7 Wet all of the water area, then, using a wash of phthalo blue with a touch of indigo, lay in the water. Weaken the colour as you work up towards the bridge.

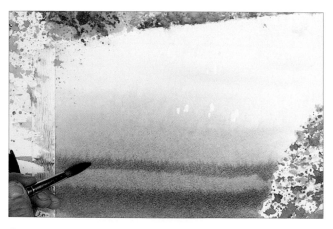

8 Mix a wash of indigo and phthalo blue, then, using a No. 16 round brush, lay in two horizontal strokes across the bottom of the water.

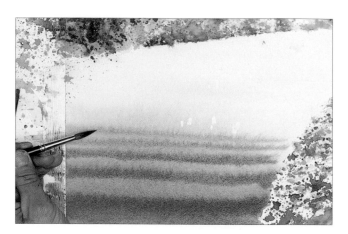

9 Change to a No. 8 brush, then lay in more horizontal strokes, making these narrower as you work upwards.

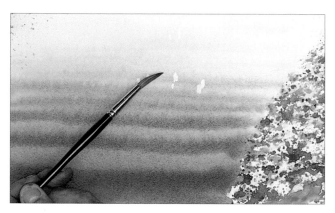

10 Soften the edges of the narrow streaks with clear water.

11 Then, using small, random, crosscross strokes, link the water to the edge of the foreground foliage.

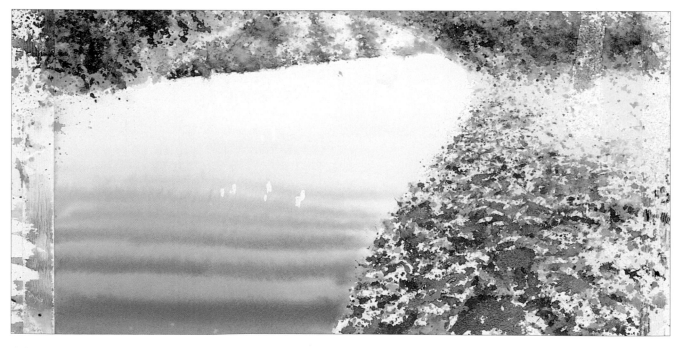

12 Add more detail to the foreground foliage by spattering water followed by a mix of indigo and phthalo green – make large marks at the bottom of this area and smaller ones as you work backwards.

13 While the spattered paint is still wet use the No. 8 round brush to draw some of the spatters together to create larger, more defined shapes.

14 Work up the right-hand middle distance area of foliage, by spattering in darks from the palette.

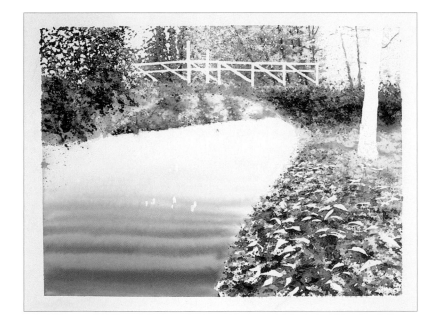

15 Remove the masking tape from round the edges of the painting, then, when the paint is completely dry, peel off all the masking fluid except those parts in the water.

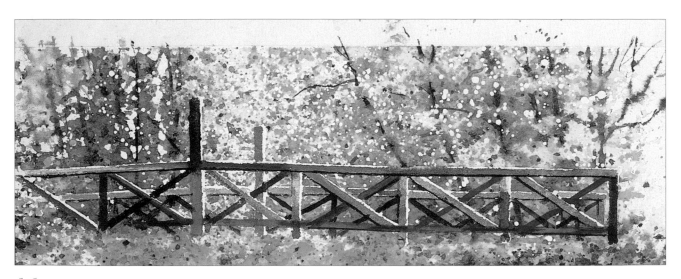

16 Replace the masking tape border. Use mixes of cerulean blue, burnt umber and phthalo green and a No. 2 round brush to block in the wooden railings, leaving white highlights along the top edges of each strut. Add a touch of indigo to the mix for the darker parts and the shadows.

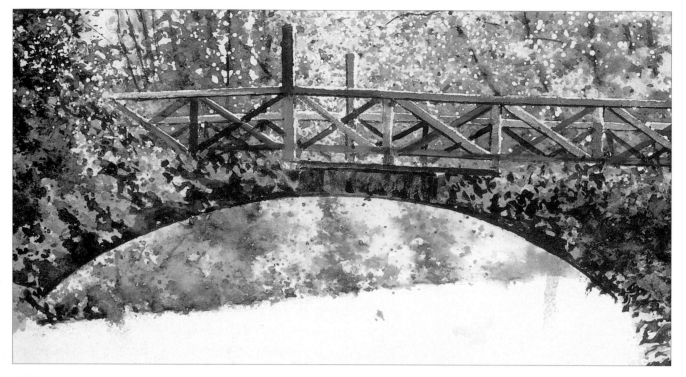

17 Mask the curve of the arch and the water below, spatter clean water over the front face of the bridge then, using burnt umber mixed with a touch of the dark on the palette and a No. 3 round brush, start to define the bridge structure. Add more indigo to the mix for those parts in the shadow of the foliage – use negative painting round individual leaf shapes. Remove the masks and leave to dry.

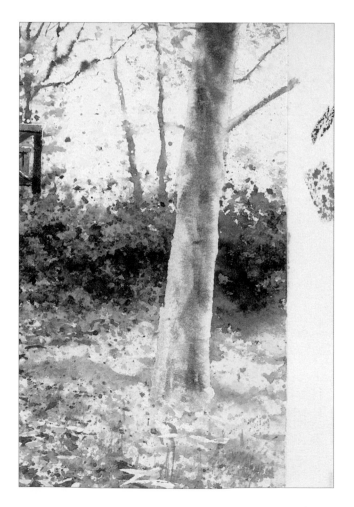

18 Build up shape and form on the large tree trunk. Block it in with a mix of Naples yellow and cadmium lemon, then, while this is still wet, add touches of cerulean blue, burnt umber and indigo. Soften all edges and blend the colours into each other.

19 Use cadmium lemon, then cobalt turquoise light and indigo to paint in the remaining leaves in the foreground leaving small white highlights.

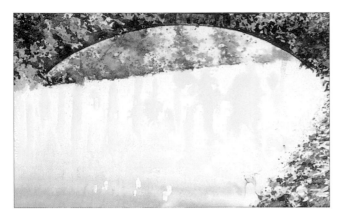

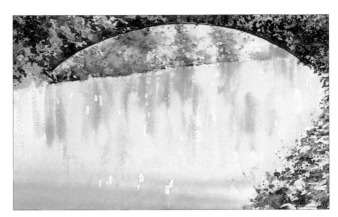

20 Wet the reflection areas of the foliage and bridge, but leave a few vertical lines dry. Overpaint some parts of the wetted area with watercolour medium, then lay in rough vertical streaks of cadmium lemon.

21 While these yellow marks are still wet, lay in a patch of cobalt turquoise light on the distant bank under the bridge then pull down a few short vertical streaks. Working quickly, lay in rough vertical streaks of burnt sienna, cadmium lemon and phthalo green between the cadmium lemon ones. Allow the colours to blend together.

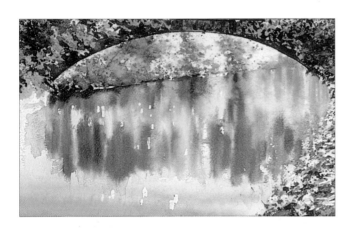

22 Mix indigo with touches of phthalo green, then, still working wet into wet, add dark green reflections. Mingle streaks of cadmium lemon and burnt sienna between the darks. If necessary, reinstate the cobalt turquoise light marks. Soften any hard edges that start to form. Define the edge of the far bank of the river with indigo, then pull this colour down into the reflections. Leave to dry.

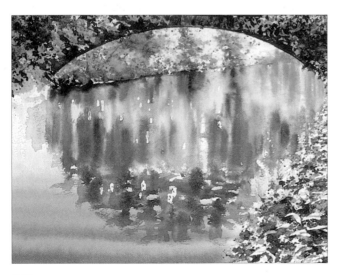

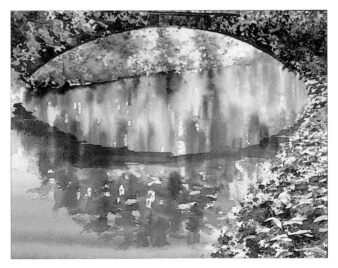

23 Now, working wet on dry, with mixes of phthalo green, cadmium lemon and burnt sienna, start to work the rippled reflections in the foreground water. Add indigo to the mix and lay in some darks among the rippled reflections, then leave to dry.

24 Use the original tracing to redefine the shape of the bridge's reflection. Mix a dark from burnt sienna and indigo then, using a series of roughly horizontal strokes, block in the reflection of the curve of the arch. Soften the bottom edge with water.

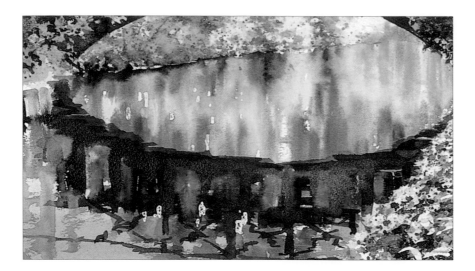

25 Using the dark tones on the palette, continue to develop the reflection of the bridge. Add some vertical strokes of cadmium lemon overpainted with burnt sienna. Note that the reflection of the bridge is larger than the bridge itself as it includes the underside of the arch. Use cadmium lemon to lay in a base coat of the reflection of the foliage at the left-hand side of the painting.

26 Develop the reflections at the left-hand side, using vertical and horizontal strokes and the colours of the foliage above. Make the brush strokes larger and harder-edged as you work down the painting.

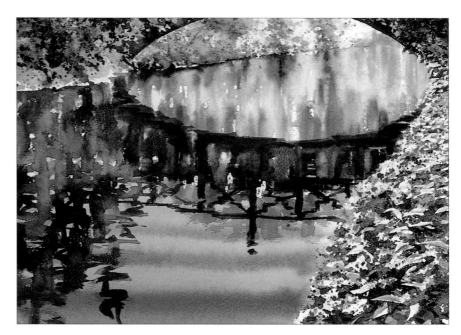

27 Continue to develop all the reflections using both dark and light tones from the palette.

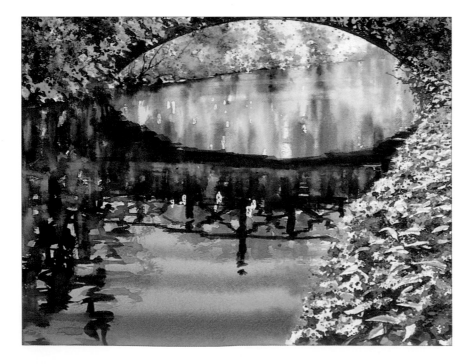

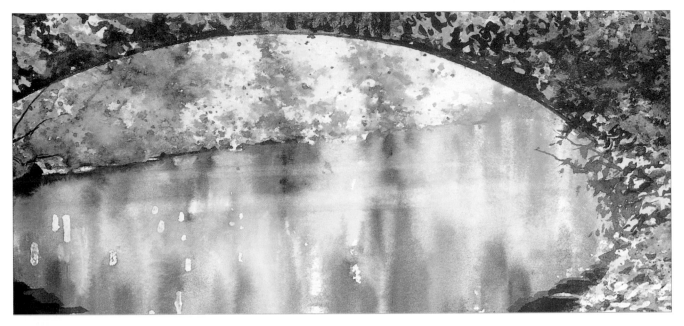

28 Use a bristle brush and clean water to scrub out two horizontal lines. Dab off water (and colour) to leave pale horizontal streaks.

29 Remove the masking fluid from the water then use the colours in the palette to block in some of these.

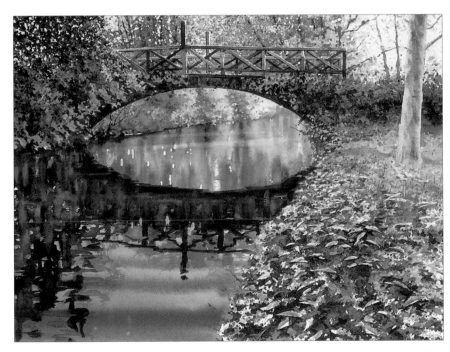

The finished painting. Having stood back and looked at the whole composition I decided to add touches of cadmium lemon in the right-hand area of the sky, to redefine some of the foreground leaf shapes and to add the indication of grassy spikes in the middle distance.

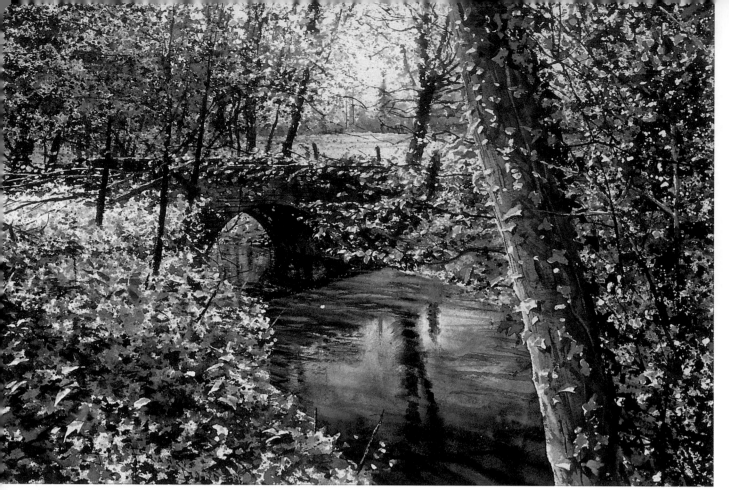

Old Masonry Bridge

Size: 35.5 x 24cm (14 x 9½in)

Sharp-focus detail around this river puts it in a convincing setting. Many of the leaves were individually masked before the foliage texture was spattered on. A rich violet of phthalo blue and alizarin crimson was used for the sky reflection in the water. When this was dry, a warm brown wash, mixed from burnt sienna, cadmium lemon and Naples yellow, was glazed on top, to which touches of phthalo green were added. The bridge reflection forms a large 'window' through which the river bottom colour can be seen. Here a pattern of darks was dragged through the wet wash using Payne's gray. The arch is only hinted at, and painted wet in wet, and the reflection below it is in shadow from the bridge, with a pronounced edge to the shadow running across the river. Reflections and details are just visible through the arch. A high concentration of colour was used – watercolour is well suited to intense images, it can rival any other medium in strength. Foliage colours are cadmium lemon, phthalo green, and burnt sienna or burnt umber mixed, with a mixture of Payne's gray and phthalo green for the darks.

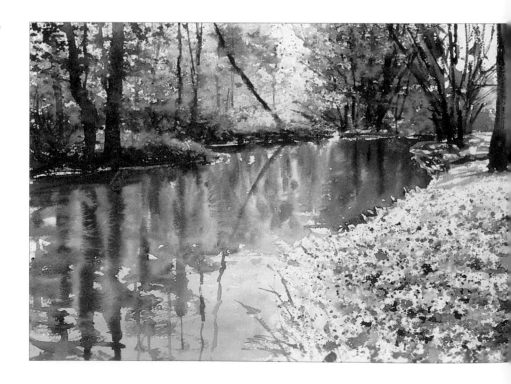

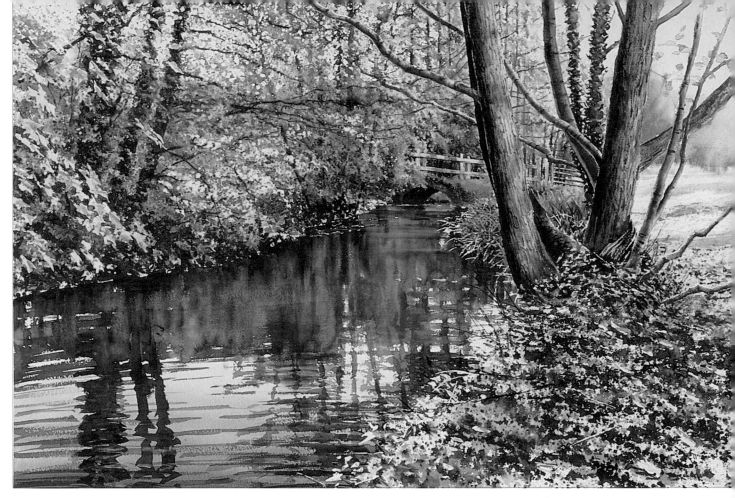

Weston Reach

Size: 66 x 51cm (26 x 20in)
I used so much water in this painting
that I almost poured this river rather
than painted it. Water can be painted
with water. In some ways it behaves in the
same way on the paper as in the river. A
river can be painted wet in wet, or the wet
colour can be brushed on to dry paper.
Colour can be mixed in the palette, or
on the paper. In this scene many colours
were brushed into the water separately
and allowed to blend. Genuine cotton rag
watercolour paper, 300gsm (140lb) or
heavier, will sustain the large quantities
of wet colour required. The foreground
tree on the right was masked so that paint
could be applied loosely all around it. Its
form helped make this composition – try
and imagine how featureless the painting
would be without it.

Opposite
Parkland River

Size: 43 x 28cm (17 x 11in)
This scene was painted facing a low late-afternoon sun, and the strong yellows from backlit
foliage provide a stark contrast with the deep shadows. Scrap paper stencils were used to mask
the ragged river-bank, then the foliage was spattered vigorously using a wet spattered colour
into spattered water technique. The dark trunks, brushed through the woodland while the
spatter was still wet, alternate between sharp focus and diffused patterns as they pass through
wet and dry patches on the paper. The water was painted in two washes. First, an upside-
down sky wash of phthalo blue, quinacridone red, and indigo was applied. When this was dry,
a very wet and loose wash of lots of colours – cobalt turquoise light, cadmium lemon, burnt
sienna, phthalo green, Payne's gray – were added separately into the top half of the river and
brushed down vertically. The tree was painted by wetting the trunk and adding colour to one
side, then repeating the process later with a darker tone. Long tree reflections were dragged
out of the bottom of this wash and painted wet on the dry paper.

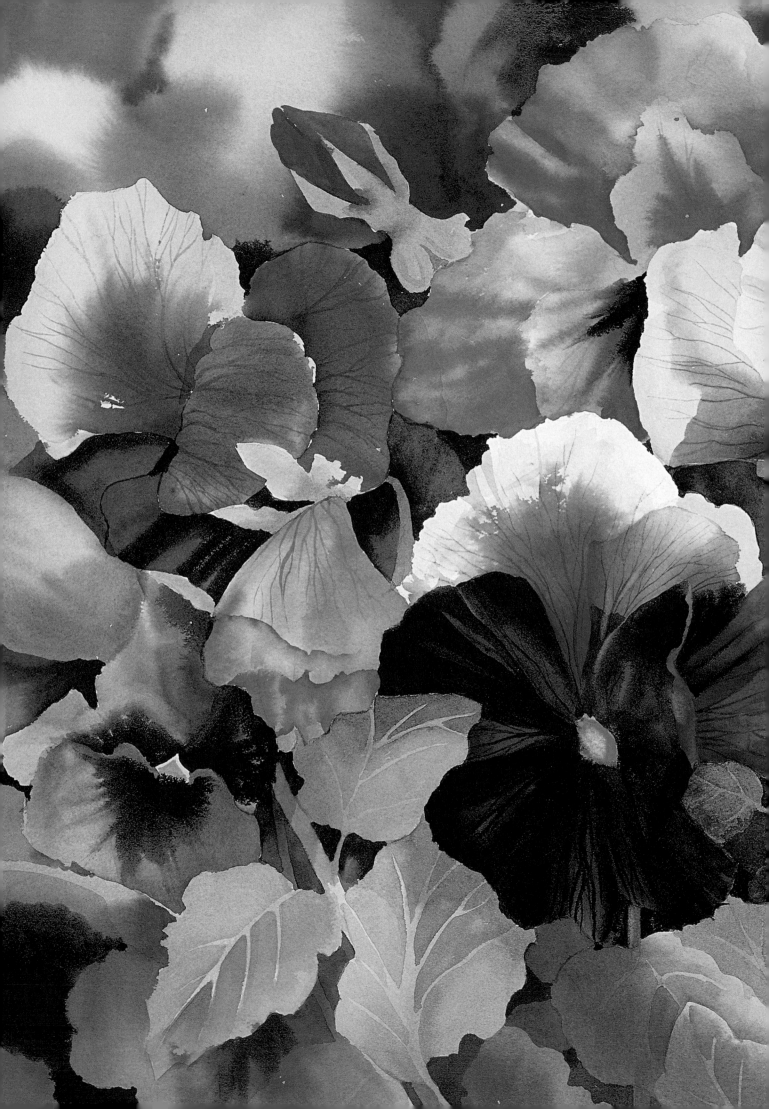

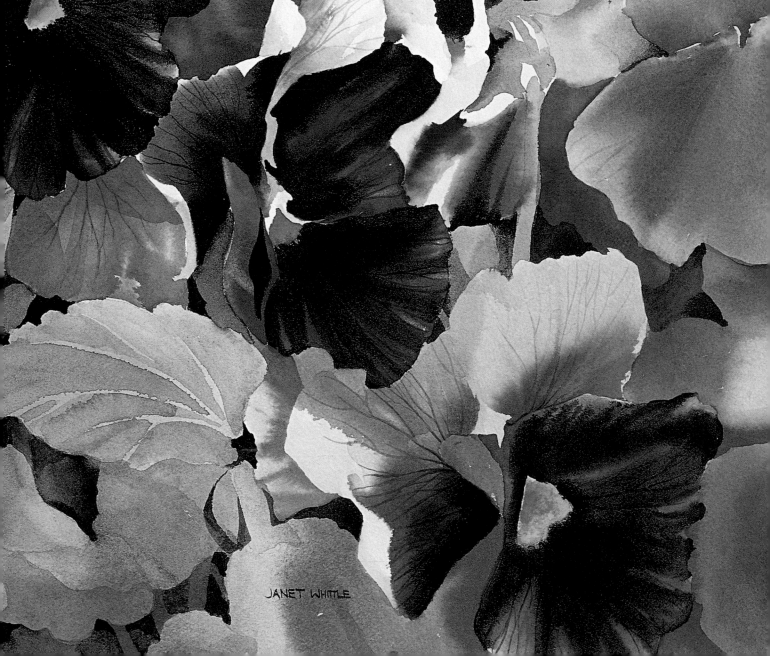

Painting Flowers & Plants

JANET WHITTLE

Learn to paint flowers that glow with vibrant colour. Janet Whittle shows how to achieve effective washes, masking, negative painting, veining, shadows and much more. Five beautiful step-by-step demonstrations show you all you need to know about painting flowers.

Introduction

Painting is like a journey which never brings you to a final destination. There is always something you have not yet painted, or a different colour or medium to try. The possible variations are endless, which is why I find it so exciting: it has kept me enthralled for twenty years.

Throughout my painting career, flowers have been one of my main inspirations. I never fail to be enchanted by the variety of colours and shapes, and the sheer perfection as the bud slowly unfolds to reveal the flower. As a painter, I have the freedom to portray them as I wish, using my imagination to change or combine colours and background tones.

I find the effects of sunlight and shadow magical. They can add an extra dimension to any painting, bringing out the colours, form and depth. I believe that it is only when you paint that you learn to observe closely enough to discover the significance of different light effects.

Every flower or plant is unique, and will respond to different techniques in different ways. Work through the exercises and practise any techniques you have not yet tried. Experiment with different approaches.

I have included some of my favourite techniques in this section. I hope you will find them useful and that, above all, you will enjoy trying them. It would take more than one lifetime to carry out every one on every flower, but I hope it will help you on your journey to improve your paintings.

Janet.

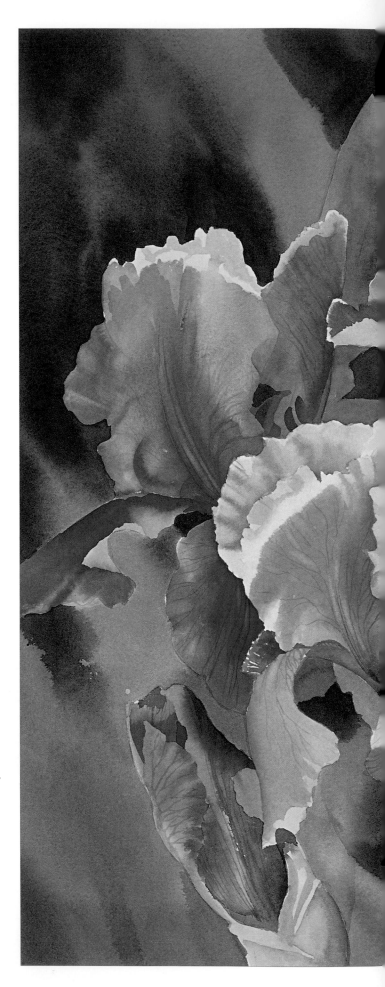

Irises
Size: 51 x 33cm (20 x 13in)
These irises do not flower for very long, so you have to watch the weather and take care not to miss the best of them.

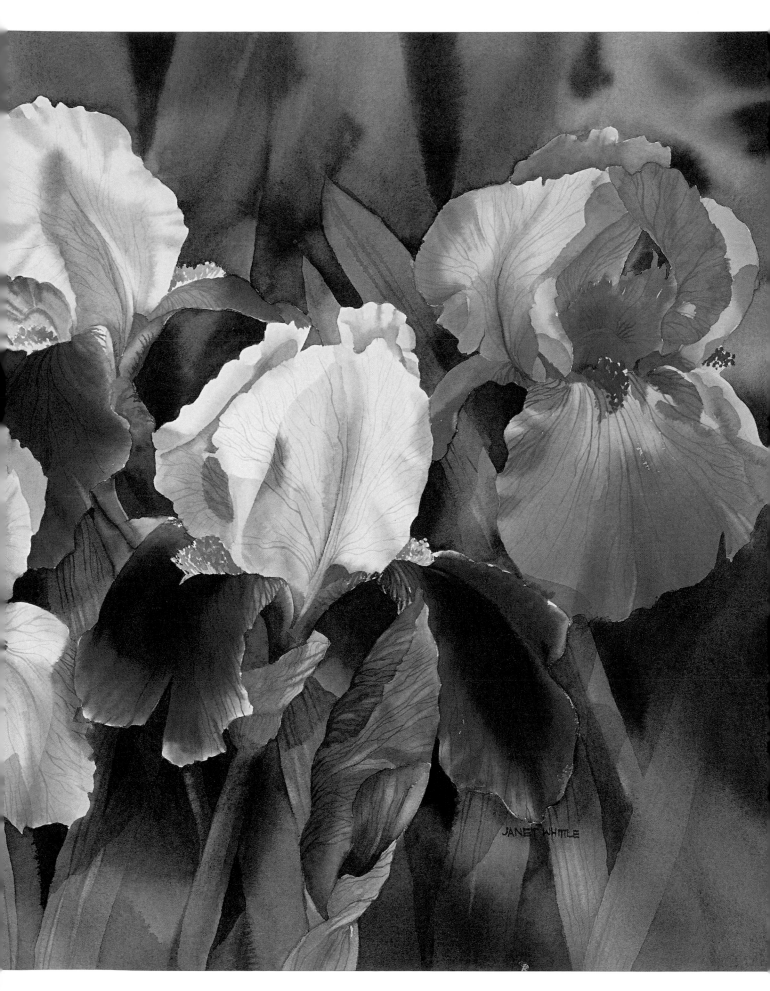

JANET WHITTLE

Materials

It is not necessary to collect all the items on these pages before you begin to paint: start with a few and add more as you go along. Starting out can be expensive: generally, the better the materials you buy, the longer they will last, and the easier it will be to master painting in the way you want. After all, you would not buy sandals if you wanted to take up jogging!

The essentials, obviously, are paper, brushes and paint. The colours and paper I use now are not necessarily the ones I shall be using next year. I am always trying to improve my painting and know I always will be. It is part of the excitement that keeps me painting, and I hope it will be the same for you.

PAPER

They say a workman is only as good as his tools, and this is a good rule to follow when choosing paper. Do not buy job lots of cheap paper, or something left over from school, or bits of unidentifiable paper that you have had given to you or have found in a drawer.

Different papers have very different properties, and it is important to understand what your paper will or will not do as this will dictate the techniques you use for a painting. The most obvious distinction is the smoothness or roughness of the paper, which will affect the appearance of your painting. Some papers will take masking fluid, but it will lift the surface of others when you try to remove it. It is more difficult to work wet-in-wet with the more absorbent papers.

I have indicated the paper I have used for each demonstration. This is the one I enjoy working with, but it may not be the case for you. It pays to experiment, and it is also fun! I use 300gsm (140lb) or 640gsm (300lb) Not. If you use the lighter weight paper it should be stretched on a drawing board about 20cm (4in) larger than the size of the paper. Do not forget you will lose at least 5cm (1in) all round underneath the tape. For composition sketches, I use ordinary cartridge paper.

PENCILS

I use HB pencils for initial line drawings as they do not need to be too heavy. To draw in extra flowers after the initial washes, I use a 3B pencil, as this shows up over the colour and will not dent the paper like a harder pencil. For darks, or for transferring carbon to the back of a tracing, I use a 9B pencil.

FOUNTAIN PEN

I use a fountain pen to trace off an image, as pencil lines cannot be seen through carbon placed on a design. I use a ballpoint pen (not shown) when I am tracing off a design from carbon paper – see page 295.

SCALPEL

I use a scalpel or a penknife to sharpen lead pencils. For pure graphite pencils, I use a pencil sharpener.

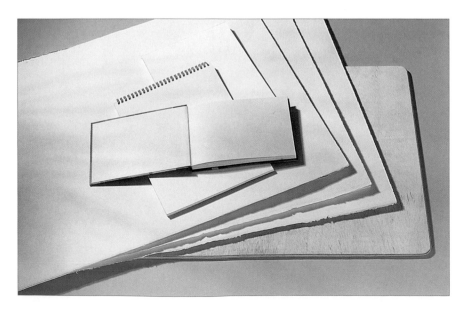

A selection of watercolour papers, sketch books and a drawing board.

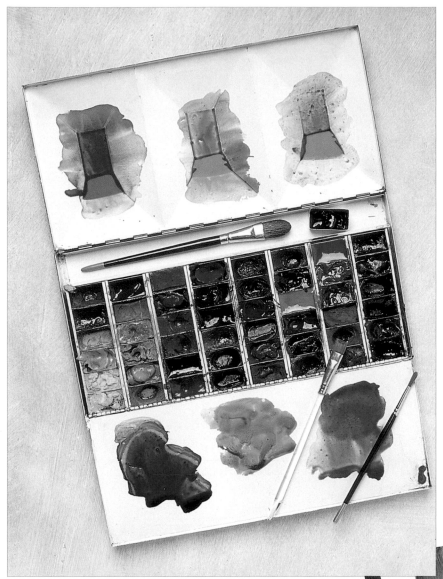

PAINTS

I use a variety of different makes and colours of paint, but I always choose artists' quality. These are brighter and soften easily, and though they are more expensive the effect is well worth it. Buy just a few colours to begin with, rather than starting with dozens of tubes or pans. This will help you to get to know the colour mixes well.

I am continually discovering new colours and mixes; it is part of the joy of painting. I fill up empty pans with paint straight from the tube.

BRUSHES

These are just a few from my collection of brushes, which are made from both natural and man-made fibre. I have no particular preference, though I like a firm brush and synthetic fibre does tend to be firmer as well as less expensive.

You will need a small (No. 00) round brush for details such as veining on petals and leaves, and Nos. 4, 6, and 8 round brushes for painting flowers. A small rigger (No. 3) is good for veining on larger paintings as it holds a lot of paint and does not need loading so often. I use a 13mm (½in) or 6mm (¼in) flat acrylic brush, which is a little firmer than a watercolour brush, for softening outlines and lifting out painted areas. The largest brush shown is a No. 6 wash brush. To wet backgrounds, I use a larger brush (not shown) – up to a No. 16.

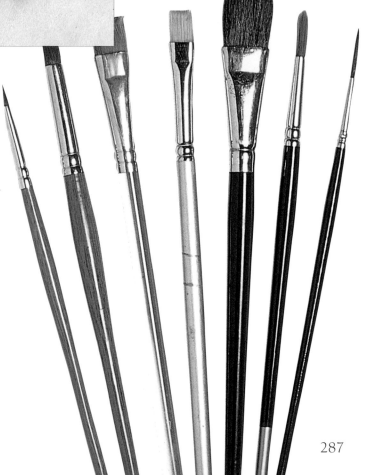

OTHER EQUIPMENT

Water container I use ordinary jam jars to hold water.

Scissors You will need a good sharp pair of scissors.

Pipette This is useful when mixing the larger first washes. They cost very little and make it easier to dilute a colour to the shade you require.

Pencil sharpener Use this to sharpen pure graphite pencils.

Masking fluid Use this to mask off areas of your painting – see page 308.

Old paintbrush Useful for applying masking fluid.

Dip pen Use this to apply masking fluid when you want fine detail.

Drawing pins I find these useful for attaching paper to a drawing board.

Rule or straight-edge Use this for measuring paper and for drawing a border for your painting.

Large soft brush Use this to brush away rubbed-off particles of masking fluid.

Plastic eraser I prefer this to a putty eraser as it is a little firmer, and never takes the surface off the paper. To erase small or fiddly areas, cut a small slice off the end of your eraser.

Paper towels Use these to adjust the moisture on brushes or to pick up droplets of paint or water.

Gummed paper strip Use this to attach lighter weight papers to your drawing board when stretching paper.

Methylated spirit Use this with a pad or piece of cotton wool to even out carbon used for a tracing.

Palette I use a white china palette for mixing colours. White is the best choice because you will be able to see the true colours, unchanged by any colour underneath. Some artists simply use large white china dinner plates or white plastic trays which you can obtain from hardware stores.

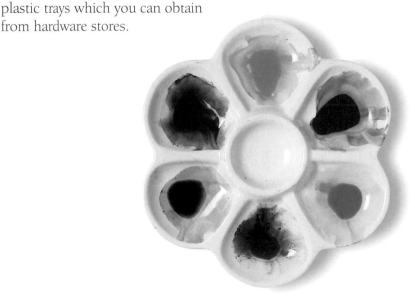

TIP

In hot weather, watercolour can be a difficult medium, especially when putting in large washes, as the heat makes them dry at different rates. Adding a few drops of ox gall fluid to your washes helps the flow and promotes even drying.

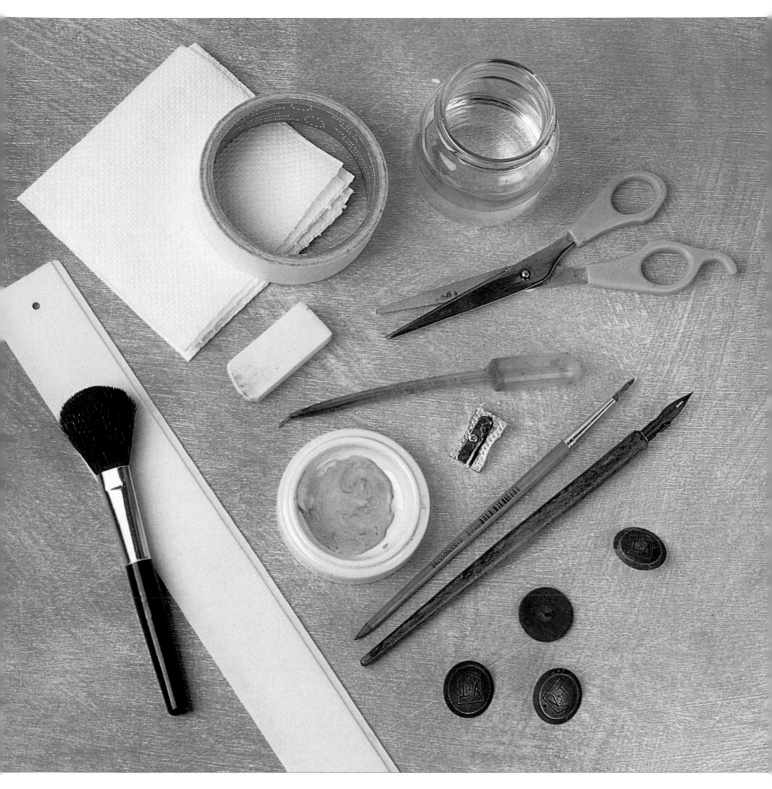

Not shown:

Hair dryer This can be used to speed up the drying process, but I feel that it can dull the colours a little, and may also make masking fluid sticky and more difficult to remove. If you do use one, make sure the shine has gone off your painting before you start or it will move the paint.

Spray mister This is ideal for softening pans of paint that have dried, or for spraying the paper to re-wet it if a wash has dried unevenly. Any empty domestic spray can be rinsed and filled with clean water (see also page 318).

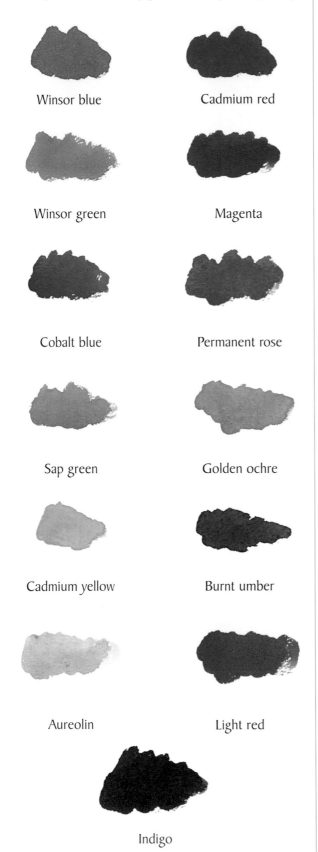

Winsor blue Cadmium red

Winsor green Magenta

Cobalt blue Permanent rose

Sap green Golden ochre

Cadmium yellow Burnt umber

Aureolin Light red

Indigo

Using colour

I have not included a colour wheel in this section because I find them deceptive. There are so many variations in makes and shades that they can bear little resemblance to those featured in a basic colour wheel. If you are a beginner, I have included a few basic mixes to start you off, which you should find useful. As you become familiar with them, you will begin to remember how they look.

When using colour, there are several stumbling blocks that students run up against. These include:

Not squirting out enough colour

Being mean with paint is a failing of which some of the most generous people I know are guilty. It is a standing joke with my students that you will not be given any sympathy if you were brought up during the war and are still suffering from 'rationing syndrome'. I regularly come across students who are desperately trying to extract the last remnants of paint from a dried-up tube, or vainly trying to moisten a hard lump of paint that has been on their palette for months. You are just going to have to brace yourself, give in gracefully and try to enjoy it.

Not mixing the colours brightly enough

When working wet-in-wet, as I do a great deal, remember that the colour will diffuse and spread, and that watercolour will dry lighter. The general rule is: 'If it's right when it's wet, then it's wrong!'

Not mixing enough paint

You will not have time to mix more paint while you are in the middle of applying a wash. Always mix more than you think you will need, and you are likely to find that you have mixed just the right amount. If there is some left over, it will not be wasted because you will need the colours throughout the painting.

Tulips
Size: 38 x 56cm (15 x 22in)
This vibrant painting uses shades from my basic palette including cadmium yellow, Winsor blue, cadmium red and permanent rose.

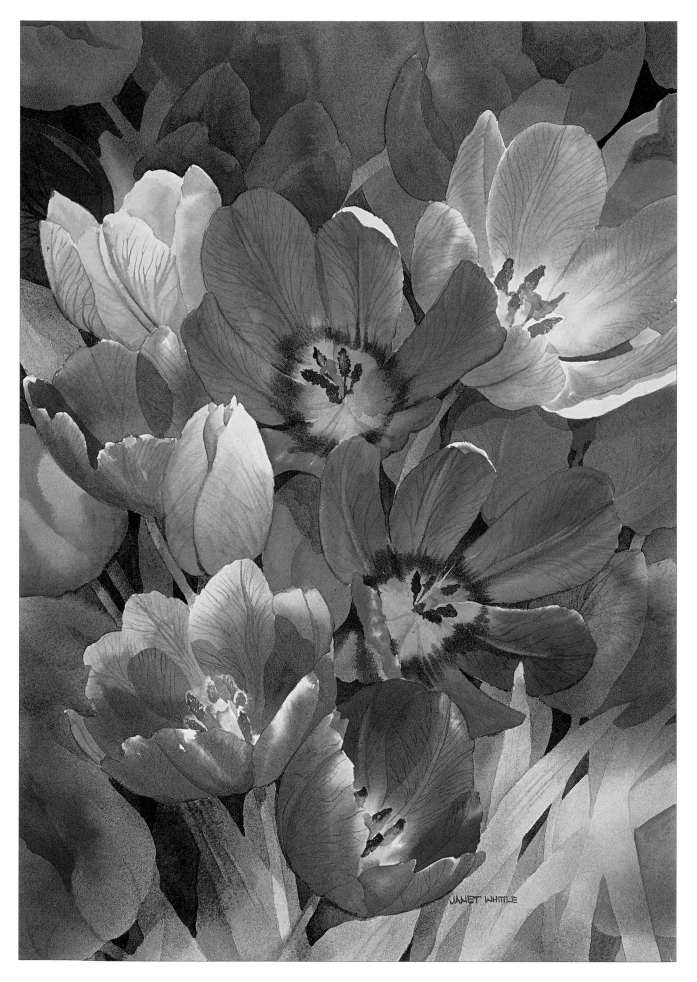

JANET WHITTLE

Colour mixes

The basic palette on page 290 and the mixes shown below are the ones I am using at the moment, but I do like to experiment with different colours and my palette changes frequently. There are so many lovely colours available that I could not bear to use the same ones year after year. Part of the joy of painting is the excitement of choosing and trying out new colours.

I prefer to use mostly transparent colours, and much of the time I feel the brighter the better – as you will see from my paintings. I hope you will find these mixes useful. Most of them have been used in the step-by-step demonstrations, but do not let that stop you experimenting. I am always discovering new mixes and I hope you will too. The selection includes warm and cool mixes which are just as important for flowers as landscapes, a fact that is often overlooked.

Basic mixes

Permanent rose/aureolin
This lovely transparent orange/ salmon colour is useful for flowers including roses.

Golden ochre/Winsor blue
Unlike many greens, this good sage green will not dry dull and cold and spoil a lively painting.

Winsor blue/permanent rose
These mix a really vibrant purple that does not dry flat, and will mix on the paper wet-in-wet.

Viridian/Winsor blue/magenta
These intense colours mix a 'wonder dark' that never dries flat and dull.

Burnt umber/viridian
This rich olive green is useful for the darks in foliage and leaves, without being dull.

Greens

Lemon yellow/viridian
This is good to retain brightness in first washes. Glazed back, it gives a glow to grasses and leaves.

Winsor blue/viridian
Many leaves are this turquoise green. It is a useful first wash where there is a shine to the leaf.

Cobalt blue/viridian
This gives a softer turquoise than the mix above, depending on the mood of your painting.

Cadmium yellow/Winsor blue
These colours mix a wide range of greens from bright to dark depending on the amounts used.

Cadmium yellow/viridian
A richer, warmer green mix than with lemon yellow. I like to vary greens from cool to warm.

Extra colours

Transparent orange
For flowers and to warm foliage: there is a surprising amount of colour in grasses and leaves.

Red gold lake
This transparent golden colour can be used as a glaze to give depth to yellow flowers.

Purple
Endless variations are mixed with this versatile colour. Blues will cool it and permanent rose brighten it.

Cerulean blue
Mixed with cobalt or Winsor blue, this extends my range of blues for flowers such as meconopsis.

Shadow mixes

Cobalt blue/permanent rose
This soft lilac is more effective for shadows than mixes with black, which can dry flat and lifeless.

Cobalt blue/light red
I tend to use this warm grey mix biased towards blue as light red can be a dominant colour.

Cabbage White on Syringa Blossom
Size: 38 x 56cm (15 x 22in)
Using a limited palette makes you explore one colour and take it to its limits without being sidetracked by different colours. I used the whole tonal range from white to darkest green to give the depth needed.

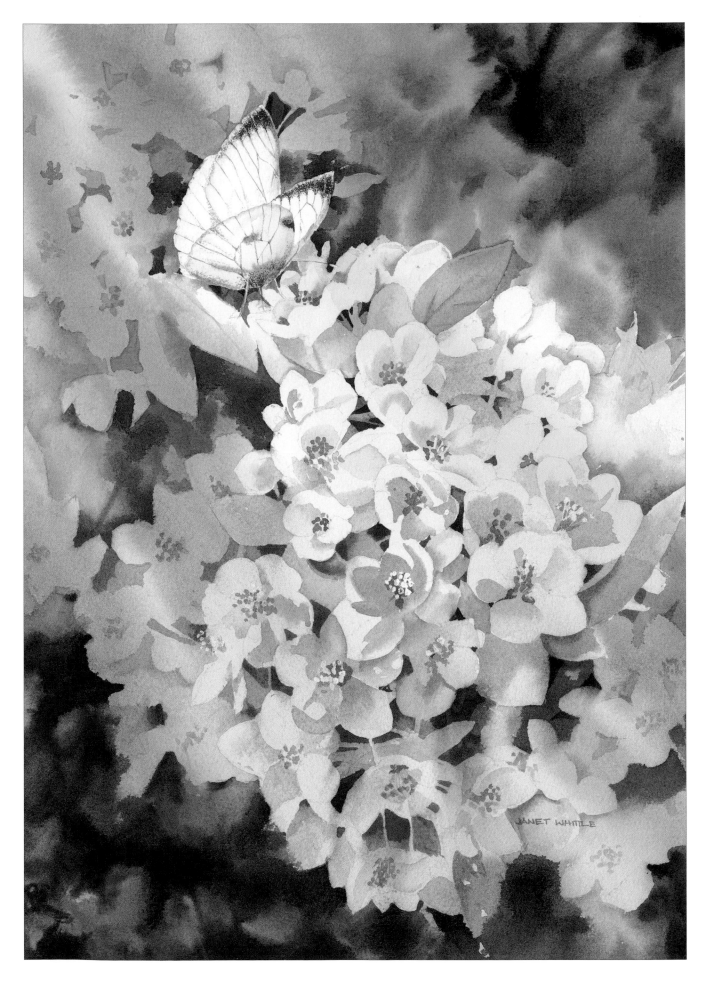

Before you begin...

I usually stretch all my paper, with the exception of 640gsm (300lb). Sometimes I even stretch this, but perhaps I was born a pessimist! The wet-in-wet washes I use can cockle the paper, and this will always show under a mount.

There are ways to flatten paper after it has been painted on, but I feel they are fraught with more problems than they are worth. The heavier the paper the less likely it is to cockle, as long as the washes are not too wet. I find that the painting which cockles the worst is *always* the best one you have done in a long while, and you will often regret not having taken the trouble to stretch the paper. The choice is yours!

STRETCHING PAPER

When you are stretching paper, the heavier the weight of paper the longer it will need to be immersed in water. For example, 190gsm (90lb) will need only around two minutes but 640gsm (300lb) will need three or four minutes. Take care not to soak the paper for too long though, as this will change the way it reacts to your washes and may cause problems.

You will need a drawing board, the paper you want to stretch and some gummed brown paper strip 38-50mm (1½–2in) wide. Make sure your drawing board is approximately 10cm (4in) larger all round than the paper. The whole sheet of paper must be immersed or it will be unevenly soaked. I find the best way is to run a shallow bath and immerse several sheets at once, but remember that you will need a drawing board for every piece of paper.

When the paper is soaked, remove it from the water and tip it to one side to allow the excess to run off. Lay it on your drawing board and pat it with absorbent paper, or a tea towel, to remove the shine. Tear off four strips of gummed tape a little longer than the sides of your paper. Draw them through the water one at a time, removing the excess water by running the strip through your fingers.

Lay the first strip half on the drawing board and half on the paper to fix it down, and smooth it lightly to remove air bubbles. Repeat on all four sides. To provide more stability when using a very large sheet of paper, drawing pins can be used over the top of the tape in each of the four corners.

Leave the board to dry flat: this is important because if you stand it up, the water will drain to the bottom and the paper will dry unevenly, increasing the chances of it pulling away from the tape.

When the painting is finished, you can remove it from the board by slitting between the paper and brown tape.

TIP
Make sure the strips of brown paper are fixed evenly to your drawing board: if one side is stronger it may pull away from the others. If you find your paper is not fixed evenly, all is not lost: soak or cut it off and start again.

TRANSFERRING DESIGNS

Making transfer paper

Making your own tracing-down paper is easy, and allows you to transfer your own designs or sketches to watercolour paper. I use a fountain pen to trace the design but a black felt-tip pen is fine too. Methylated spirit is used to 'scumble' the pencil marks, which sets the graphite and covers the back of the design evenly with carbon. The advantages of this method are that the tracing-down paper can be used many times. If you are not happy with your first painting you will not have to start completely from scratch, so I feel this will give you more confidence.

If you want to make sure your design does not slip while you are transferring it to your watercolour paper, lay the tracing-down paper on the paper you have drawn your design on and attach it to the top with 'hinges' of masking tape.

YOU WILL NEED

Tracing paper
A pen with black ink
Soft pencil (9B)
Methylated spirit
Cotton wool pad
Watercolour paper
Masking tape
Ballpoint pen

1 Lay the tracing paper over your design and trace it using a fountain pen and black ink.

2 Turn the tracing paper over and use a soft pencil (9B) to scribble evenly over the back of the design.

3 With a cotton wool pad and a small amount of methylated spirit, 'scumble' the pencil marks. Leave it to dry.

4 Turn the tracing paper over and lay it on your watercolour paper, fixing it with hinges of masking tape. Use a ballpoint pen to trace the design.

5 Check to make sure that the design has come through before removing the tape hinges. If necessary, replace them and re-trace any areas that are too faint, adding more carbon if necessary.

NOTE

1. If the tracing paper moves or the hinges of tape come off, stick the point of a pin in a recognisable place, such as the intersection of two lines. Then put the point of the pin in the same spot in your unfinished tracing and realign it. Re-attach the tape hinges.

The design shown in these steps is for the rose painting – see page 305.

Using photocopies

The simplest way of transferring a design is by using a photocopy of something you like. The advantage of this method is that it can be enlarged or reduced to suit the size of painting you wish to produce.

To transfer a design using a photocopy, scribble in soft pencil on the back of the photocopy and transfer the image (see page 295). You cannot use methylated spirit to even out and 'set' the pencil marks, so take care not to lean on your work or the graphite may rub off and make your paper grey.

You can also make a plain carbon to use between the photocopy and your watercolour paper. Do this by scribbling on tracing paper with a soft pencil (9B) and 'scumbling' with methylated spirits as on page 295.

Using a grid

A grid is another effective way to transfer a design to watercolour paper. Divide your original drawing or sketch into quarters or eighths (depending on the size) and copy one square at a time on to your paper. Erase the pencilled grid lines before you begin to paint as they can be confusing.

Irises

Size: 38 x 56cm (15 x 22in)
These irises were white, but as previously mentioned, the amount of white in apparently white flowers is often very little! I used quite a vibrant purple/ violet for the shadows and tonal values, and also dropped it into the background to unite the painting. Softer shapes of flowers have been cut out to give it depth. As purple and orange are complementary colours, these were emphasised as much as possible for effect. To give the painting vitality, the focal flowers were counterchanged towards the centre by placing the darkest darks against the lightest lights.

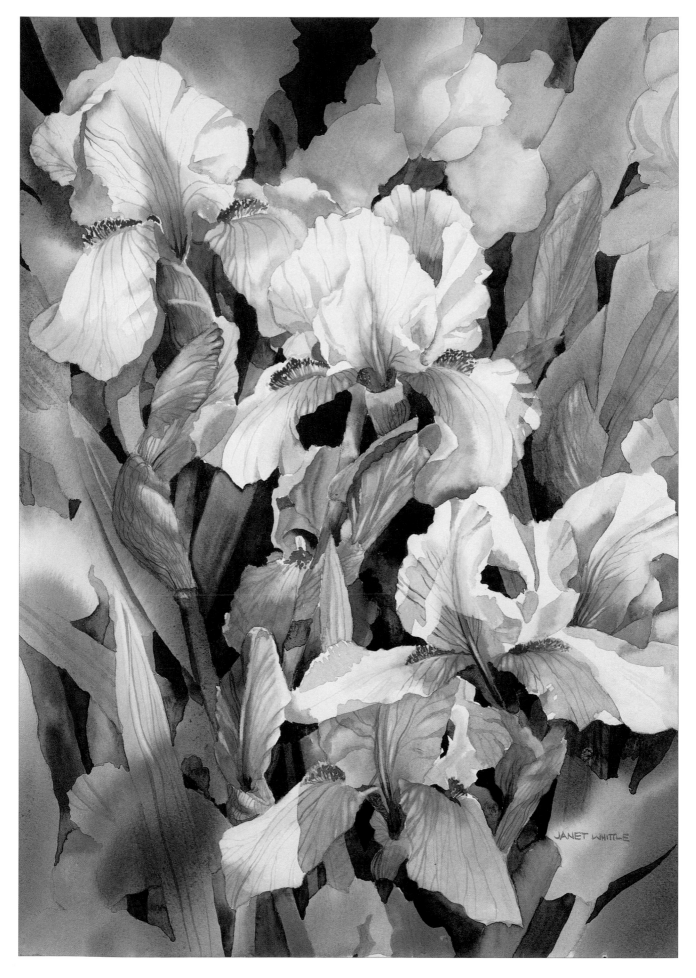

Drawing

When I have not painted a particular flower before, I always find it helpful to do a detailed drawing before I start to paint so I can familiarise myself with the flower, its form and shape, and how it grows. If, when I come to paint, the flower is no longer in bloom or there are gaps in my reference material, this information can be used to bridge any gaps. Drawing is more controllable than painting because you can erase, so it will help to build your confidence.

I usually start with a simple line drawing of the composition, like the ones shown at the beginning of the demonstrations in this book. I keep the line light and put in the first tone, leaving white for highlights. In the real world there are very few actual lines, just changes in tone, so it is important to dispense with lines and learn to shade these changes of tone as soon as possible. When I am drawing, I gradually work darker using a 3B or 4B pencil, going over some of the lighter tone and feathering it in. I prefer to work over my whole drawing rather than finishing one part and moving on to the next because I think it helps to pull everything together. I put in the darks to give depth to the composition using a 9B pencil. Make sure that you place the darkest darks against the lightest lights, a process known as counterchanging.

If you want a particular part of a drawing or painting to appear to come forward or show up, darken behind it. Beginners often outline aspects of a drawing or painting hoping to achieve this, but all it does is make the flower look heavy. In the drawing of the iris (right) I have darkened the stem beneath the front petal so the effect is that it is coming towards you.

Convolvulus

The dark leaf shapes bring the white flower forward, but do not do this all round the flower as it makes the composition heavy. Pick out one or two areas, and the eye will fill in the rest.

Tulips

Size 33 x 33cm (13 x 13in)
Drawing and painting in the same
composition is a lovely and very effective
technique. A smooth paper (cold-pressed)
has been used here as it is easier to draw
on. I make a preliminary sketch, draw
in a circle and mask out beyond it using
masking fluid. When the painting is dry,
I remove the masking fluid, then complete
the drawing with a variety of pencils.

Daffodils

Size 33 x 33cm (13 x 13in)
This painting uses the same paper
and technique as for Tulips (above).
A set of paintings using the same
technique but different subjects can
be appealing. You might also like
to try varying the shape behind the
flowers, using a square or an oval.

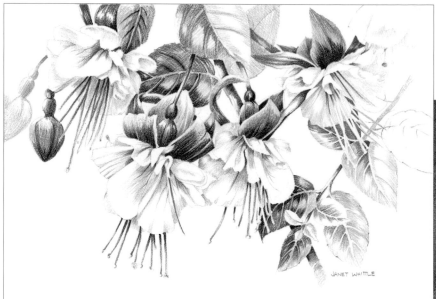

My drawing

I find that if a composition does not work in pencil it does not work in paint. Drawing a flower helps me to understand the form, and I can experiment with composition because errors can be erased easily. When I come to do the painting I am halfway there.

This drawing was done on cartridge paper using an HB pencil for the outline, then a mixture of HB, 3B, 6B and 9B pencils. I put in the darks last. The drawing was then traced, and the original drawing was used as a tonal guide for the painting.

When I have finished a drawing I usually spray it with fixative to stop any smudging. This does not prevent me from adding more pencil later if I think it is necessary.

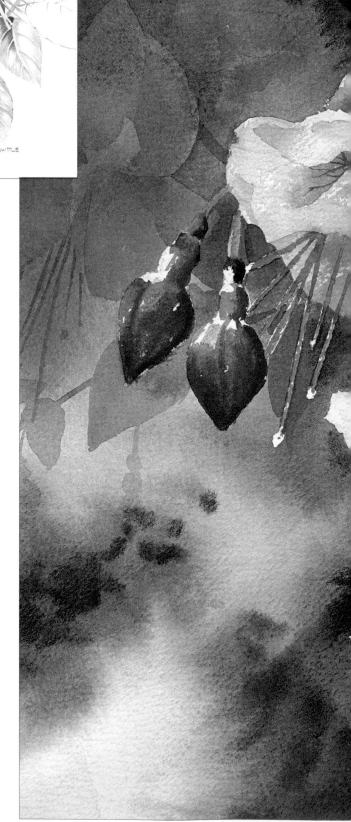

Fuchsia

Size: 38 x 56cm (15 x 22in)
This was done on 640gsm (300lb) Not paper using the drawing as a guide. The main flowers were masked and a mixture of greens, blues and pinks were dropped into the background. The leaves were brought forward with negative painting – see page 320. The flowers were painted last, using the blues from the background to shadow the white petals, and a mixture of permanent rose, cadmium red and cadmium yellow for the other petals.

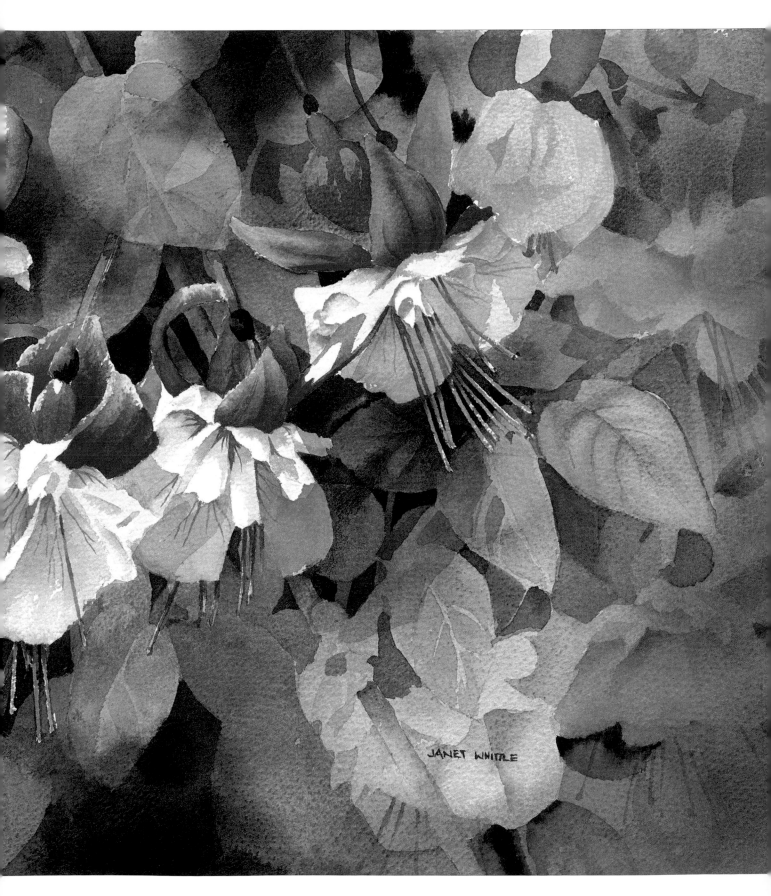

JANET WHITTLE

Composition

It is important to spend time on composition before you start to paint. The less experience you have, the more you will need to plan ahead. Not all artists draw first, but those who are brave enough not to are those with the experience to keep the basic composition in their heads and adjust elements as they go along. I find that producing one or two thumbnail sketches before I begin to paint is usually enough to inspire me.

This list may help to organise your thoughts:

1. If you are not painting from life, collect together all the reference material you have on the type of flower or flowers you wish to paint.

2. Decide what type of paper and what shape of painting – for example, portrait, landscape or letter box – suits your subject best.

3. Make thumbnail sketches to decide the position of the main flowers.

4. Draw a border to contain your composition: it makes it easier to visualise.

5. Remember to interlock some shapes to avoid a 'hole' in the middle of your composition.

6. Vary the size of different elements of your painting, taking care to include buds, half- and fully-opened flowers, and different sized leaves. If all elements are the same size the effect will be like wallpaper.

7. Draw your design, either by tracing it from cartridge paper to watercolour paper or, as your confidence grows, straight on to the paper.

8. Decide the direction of the light and stick to it throughout your painting. Your finished painting will look extremely odd if you have light coming from different directions.

9. Mask out areas where appropriate.

10. Choose your palette, and remember artistic licence means you can change the colour of the flowers and the background if you want to.

11. Think beautiful thoughts!

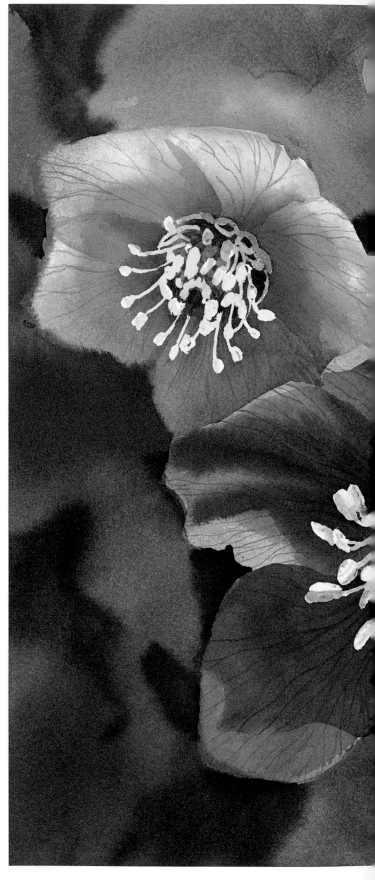

Hellebores
Size: 55 x 38cm (21½ x 15in)
Permanent rose was used underneath to give a glow to the darker colour of the flowers. The stamens were masked and painted last.

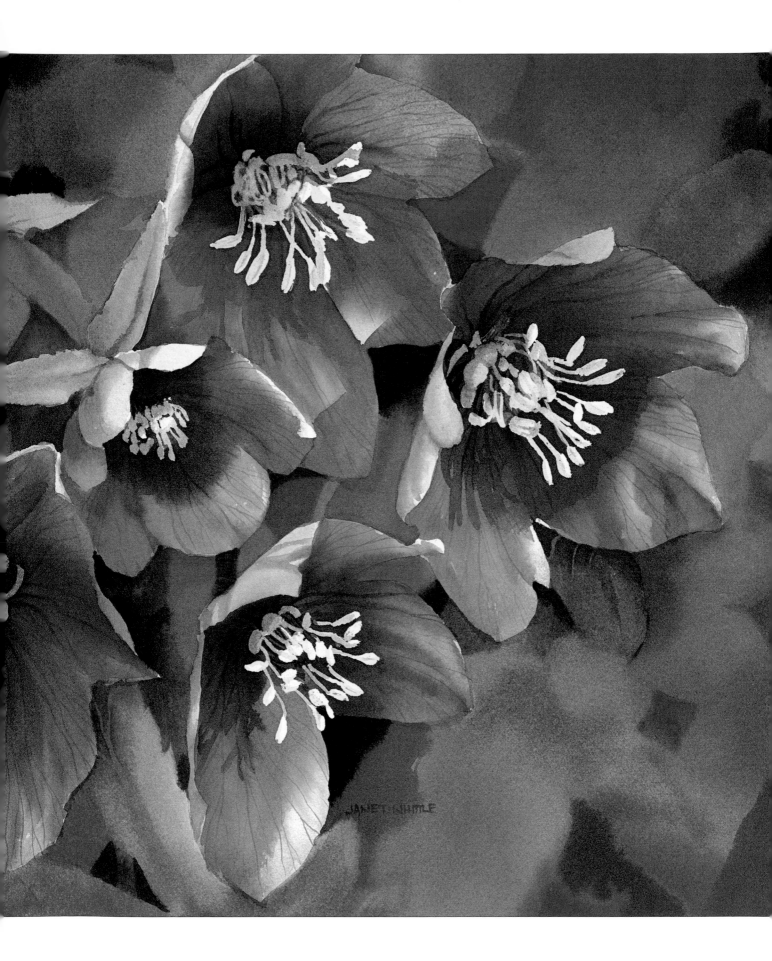

USING PHOTOGRAPHS

I paint mainly from life, but I find photographs invaluable. In an ideal world, flowers would not wilt or die until you had finished painting them, and the sun would shine all the time. As this is not the case, good reference photographs can be a real asset when you want to paint intricate flowers.

In flower painting, as with landscapes, the direction of light must be consistent or the result will be confused. When you take reference photographs, make sure the subject is lit from the same direction in each. Try to capture the flowers from all angles and at all stages of development so you have the best possible scope for your composition. To aid your memory, take a few good close-ups of details. I file my photographs in boxes in alphabetical order so they are easy to find.

The example opposite shows how the best aspects of two photographs can be used to produce a study, not a slavish copy. The background is a very simple vignette, and the leaves are painted dark against light.

My source photographs

Vignette

To do this, just wet the area of the paper where you want paint to go. You are in control because the paint will only go where you have used water. Draw your composition with an HB pencil, mask out the main flowers if you wish, and wet the background up to the masking but leaving a broken edge. Drop the paint in and tip the board so it flows into the shapes you have made with the clear water.

TIP

I try to make sure my reference photographs are taken when the sun is shining and that in each photograph the sun is coming from the same direction.

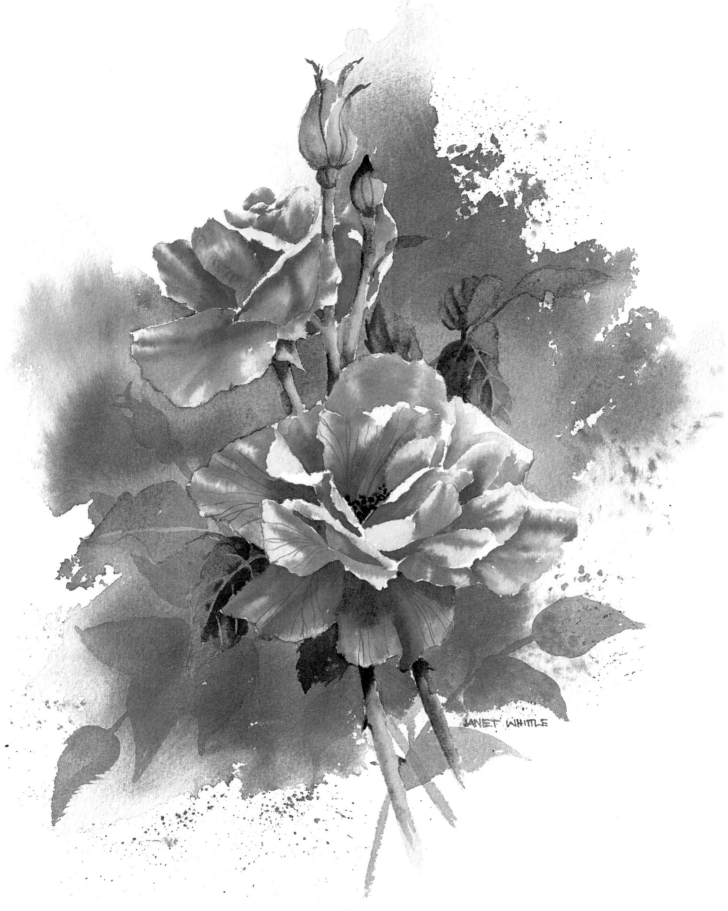

Rose

Size: 27 x 35cm (10½ x 13¾in)
To add more texture at the edges I have used a spatter
technique – flicking paint off the tip of a flat brush
over the painting – but make sure the first wash is
dry and cover the flowers before you start to spatter.

Techniques

As you become more experienced with different watercolour techniques, it is a common mistake to try to incorporate too many in a painting. Different approaches suit different flowers, so you should try to imagine how your subject would look best, and use the most suitable technique to enable you to achieve the effect. I have included the techniques I use most so you can practise and decide for yourself. I hope you enjoy it.

PUTTING IN A BACKGROUND

This exercise is extremely good practice, and there are no hard-and-fast rules: it starts with just an idea that you have in your head. Imagine the colours of the flowers, leaves and sunlight. Mix the colours you have imagined, wet the paper and drop them in. Tip the board to let the colours merge and leave it to dry, or wait until the shine has gone off and dry your work with a hair dryer.

Next, use the shapes that have settled in your wash and draw your composition on top, making the most of happy accidents: every wash will be different! The next step is to paint the negative shapes behind the flowers in a slightly darker tone, just to 'find' your composition. If any of the colours are not what you want, you can change them by glazing other transparent colours over the top (see page 326).

I have taken you step-by-step through this exciting technique in the following pages, with projects that give you plenty of practice putting in backgrounds and using masking fluid.

Put in the colours and tip the painting...

... so that they merge and blend

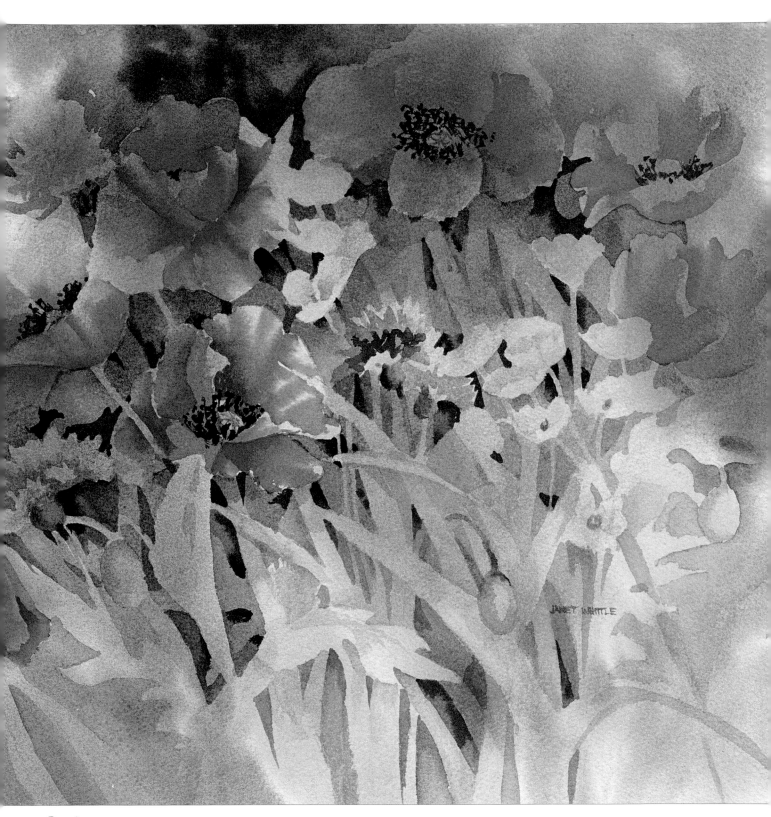

Poppies

Size: 55 x 38cm (21½ x 15in)

*For the background of this painting, I used an approach that is great fun.
I did not draw a composition on the paper before I began, but just flooded
in the colours of the flowers and foliage. I tipped my drawing board so the
colours merged and blended in the usual way, then let it all dry to see how
they settled on the page. Then I drew the composition on top of the wash.
This is really good practice for negative painting, because you paint behind
the flowers, stalks and leaves to make them appear.*

307

MASKING FLUID

Some masking fluid lifts off the colours underneath, so it is a good idea to experiment with different makes. Use a dip pen or an old brush and work a little neat soap into it first so the masking washes out easily.

If you want to use masking fluid with a pen to produce narrow lines (see page 313) but it seems too thick, it can usually be diluted with a few drops of water. Masking fluid can also be used over a first wash, so that when you rub it off the paper underneath is already coloured. Try this over a blue wash when you are painting bluebells. If you find it difficult to see the masking fluid against the paper, mix in a small quantity of either ultramarine blue or cobalt blue as these colours will not stain the paper.

Cow parsley with masking fluid

This exercise can be done with very little drawing, and is good practice for putting in backgrounds and using masking fluid. As the flower is white, you can use any colours you choose for the background. This technique is useful for flowers which have tiny florets, including forget-me-nots: masking fluid can be used over an initial wash and another wash can be added over the top. The butterfly can be used to add interest to any painting. I used the photographs below to help with the composition and detail.

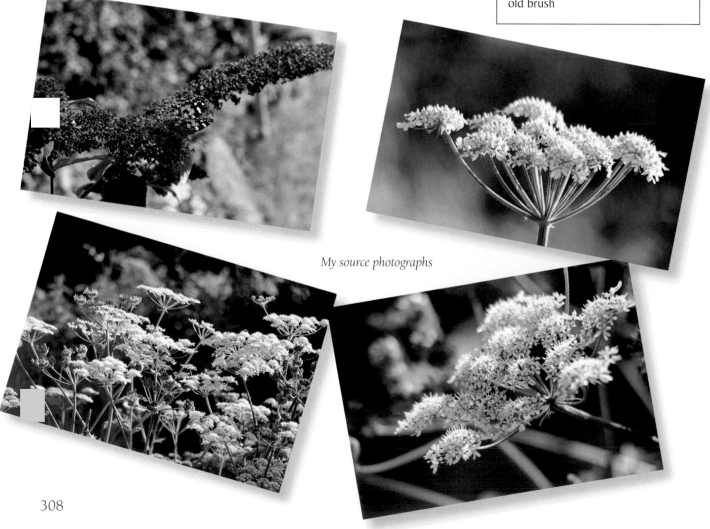

My source photographs

Mix the colours you want to use.
For this demonstration, I used
cadmium red, lemon yellow, cobalt
blue and sap green, and a dark mix
of burnt umber and Winsor blue for
the details on the butterfly.

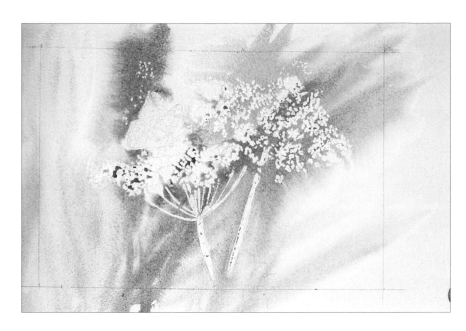

1 Pencil in a border and lightly draw
in the shape of the cow parsley. Mask
out the flower heads, stalks and the
butterfly outline and let it dry. Wet
the whole of the paper and, using the
flat brush, drop in the yellow, blue
and green. Tip the paper to merge the
colours. When you are happy with the
effect, leave to dry.

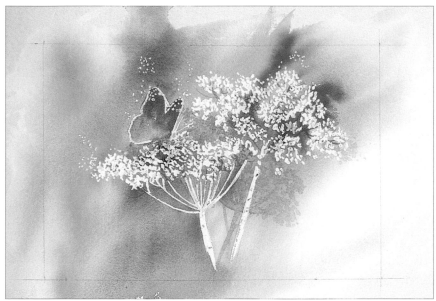

2 When the first washes are dry,
paint the background shadow of
the cow parsley using the No. 8
round brush and blue. Mask out the
tiny white dots on the wings of the
butterfly, allow it to dry and put in
a red wash over the top. Leave your
work to dry.

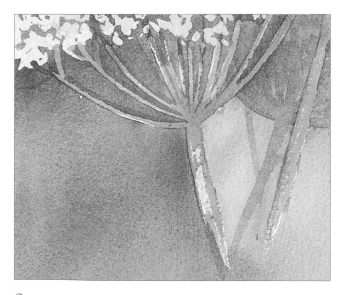

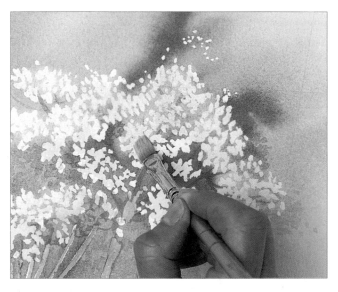

3 Remove the masking on the stalks and put a wash of pale
green, with highlights in yellow, over them.

4 Remove the masking fluid from the flowers and add a
wash of lemon yellow to some of them, varying the tones.

309

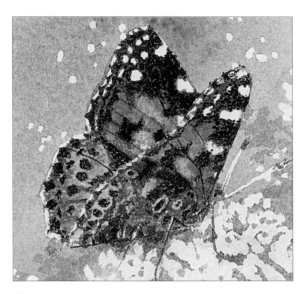

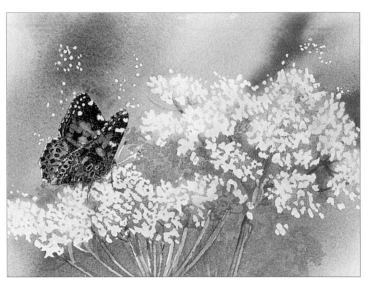

5 Stipple in the dark areas of the butterfly using a mix of burnt umber and Winsor blue. Use the point of a small brush (No. 00) to paint the colour in small dots, which gives the effect of a subtle blend of colour rather than a hard edge.

6 Allow your work to dry. If you want to add any extra flecks of white to the background or butterfly wings, they can be scraped out with the tip of a scalpel.

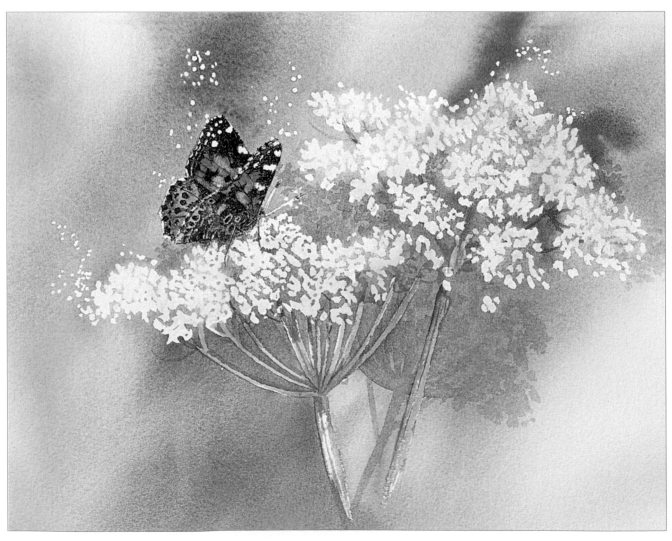

The finished painting

Butterflies

To add an extra touch of colour and interest to paintings, butterflies are ideal. The technique is easy, and you can practise different butterflies on odd pieces of watercolour paper. Mask out the outline and any white areas carefully and put in a simple wash of the main colour, for example red or yellow. Allow your work to dry, then put in the dark areas, stippling the paint in fine dots with the point of a small brush.

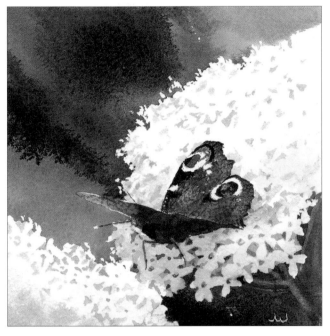

Peacock butterfly on cow parsley

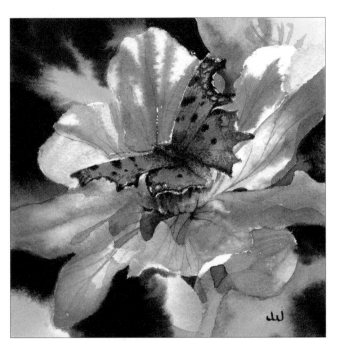

Comma butterfly on a dahlia

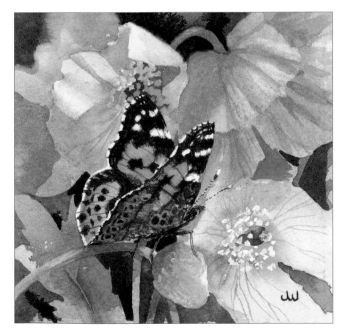

Painted lady on Welsh poppies

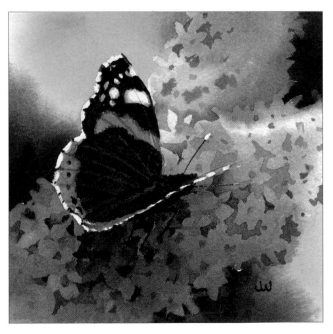

Red Admiral butterfly on buddleia

Spider's web

This is really just a background, painted following the method shown on page 306, plus some masking fluid. A cobweb can make a stunning addition to flower paintings.

 You can use any colours you like for this practice piece as you will not be adding flowers this time – part of the fun is seeing how it turns out! Draw the cobweb on your paper first. Reference photographs will help with this, but as every web is unique, you can use your imagination!

<div style="border:1px solid">

YOU WILL NEED

Watercolour paper: use any weight, but remember to stretch lighter weight paper
Pencil
Dip pen or small brush
Masking fluid
Round brush No. 7
Watercolour paints: choose a complementary combination of light and dark colours

</div>

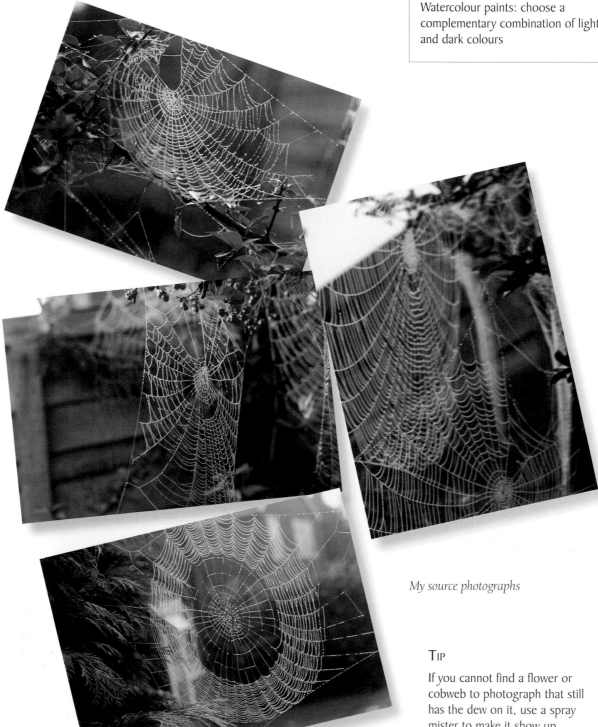

My source photographs

TIP

If you cannot find a flower or cobweb to photograph that still has the dew on it, use a spray mister to make it show up.

1 Pin or stretch your paper to your drawing board and draw a spider's web. Remember that the weight of dew pulls the threads down, so curve the lines gently.

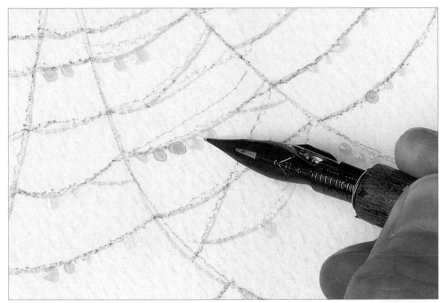

2 Go over the outlines of your drawing with masking fluid, using a dip pen or small brush, letting it form blobs of varying sizes to represent dew.

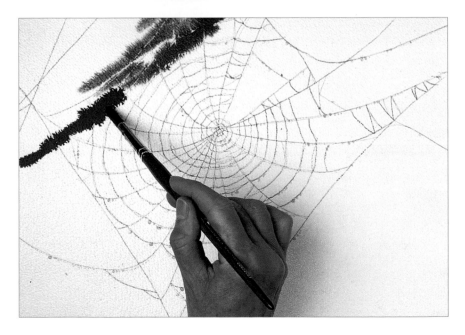

3 Mix the colours you want to use, then dampen the paper with a mister or brush. Begin to put on the paint, using a No. 7 brush, over the masking fluid as if you were just painting a background.

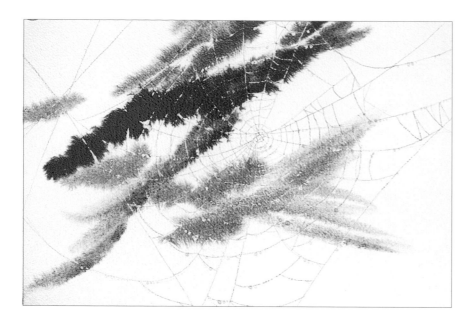

4 Build up the colour, painting gently so you do not lift the masking fluid lines off the paper.

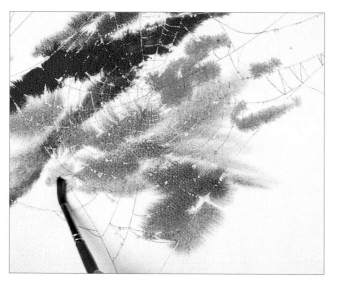

5 Add in some bright tones.

6 Put in some darker tones.

7 Push the paint gently over the masking fluid lines so there are no gaps.

8 Finally, drop in some very dark tones, and tip the board to blend the colours.

9 When the paper begins to dry, stop adding paint or the colours will not blend properly.

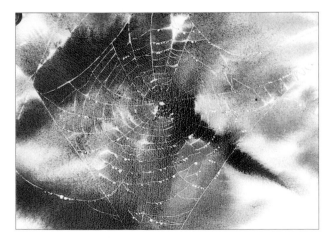

10 Tip your painting to merge the colours. Leave your work to dry,

11 Remove the masking fluid and paint in the dewdrops using a pale wash of cobalt blue, leaving a small highlight on each.

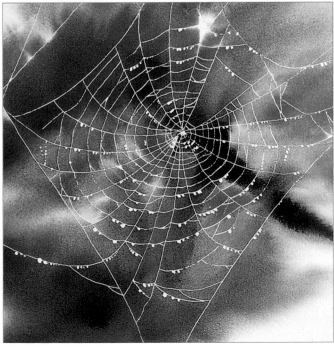

315

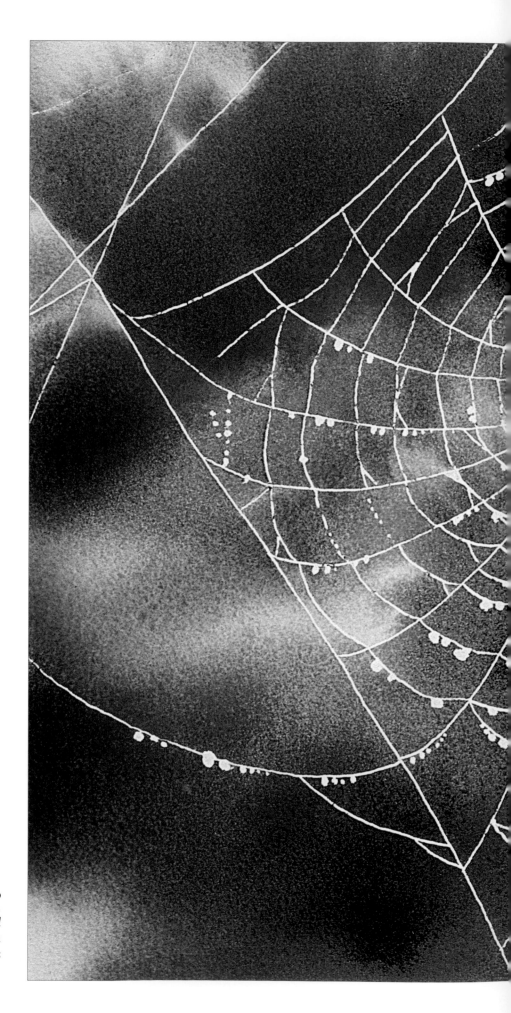

Spider's Web
Size: 28 x 38cm (11 x 15in).
Some areas of the web have been glazed
using cobalt blue, and some using lemon
yellow. Other areas have been left white as
though the sun is catching the web.

WET-IN-WET AND WET-ON-DRY

This exercise combines wet-in-wet and wet-on-dry, the techniques I use most. Mask the three main flowers completely – not just round the edges – and wet the background paper up to the masking, taking care not to leave gaps. Drop in your chosen colours. The three washes I used (viridian and Winsor blue; cadmium yellow and indigo, and Winsor blue) have blended in places to create other colours. The blues are used for the background flowers. Let this wet-in-wet stage dry completely before going on.

When your first wash is dry, draw some additional flowers and leaves in the background with a 2B or 3B pencil. Then, with the same colours as for the first washes, paint wet-on-dry behind these additional flowers and leaves – a technique also known as cutting out. Though the paper behind these shapes is dry, you should keep a wet edge to the paint so you do not leave hard lines: load the brush so the paint leaves it easily and you do not have to spread it on. When an area is evenly damp, you can also drop in other colours, just as you do with a first wash.

TIP
Use a flower mister or a well-rinsed empty plastic spray bottle to damp the paper. You can also do this using a sponge.

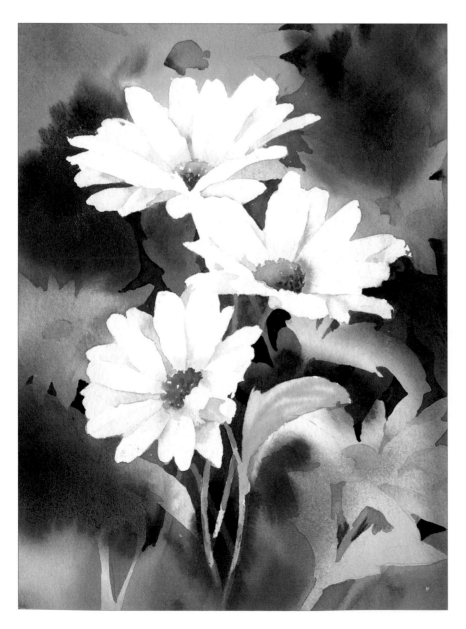

My outline sketch

Daisies

Size: 28 x 38cm (11 x 15in)
The centres of the background flowers are merely an indication, with little detail. The background was allowed to dry, then the masking was removed from the three focal flowers and the petals shaded with cobalt blue. The centres were painted using lemon yellow, then while the paint was still wet cadmium red was touched in on the side away from the light so it softened into the yellow. A touch of blue was added to darken one side, and the stalks were put in using a mixture of lemon yellow and cobalt blue.

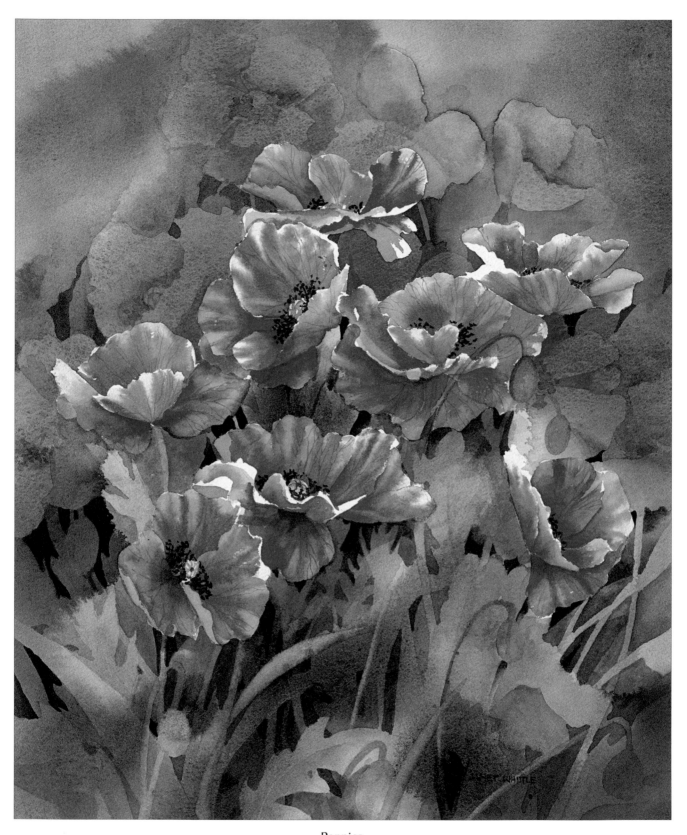

Poppies

Size: 52 x 33cm (20½ x 13in)

The red of the poppies was dropped in to the background wash and then 'cut out' with the next wash to make background flowers that fill out the composition and give another depth to the painting. Sunlight bleaches out colour and details, so on some of the edges of the focal flowers I have let the colour bleed out to the white of the paper to bring a lightness to the petals, as though the sunlight is catching them. The leaves and stalks were brought forward by painting in negative shapes, a technique I use often in my painting.

NEGATIVE PAINTING

Negative painting is a wonderful technique for picking out shapes in the background washes, and can be used for flowers or for leaves and stalks. If your background wash is quite dark you may need to reinstate your pencil guidelines before you begin. A 3B pencil is best for this as it does not dent the paper, and is more visible over a colour.

When you have done this, mix up more of the colours you have used for the background washes, and paint negative shapes behind the flowers and leaves you want to show up. Keep the effect soft and simple to ensure that the negative flowers complement rather than compete with your focal flowers. Do not add too much detail at this stage as it tends to bring things forward: you can add detail later if necessary.

Let your work dry, then plan and put in more leaf and flower shapes within the first layer of negative shapes. This gives more depth to the painting. These shapes should also be painted in negative, using a darker tone to produce a three-dimensional effect. It may sound complicated, but it will become easier with a little practice.

Clematis

The paintings below and right show two ways of approaching the same flower: you should always choose the colours and style of painting you feel happiest with. The painting on the right shows a more colourful, vibrant approach, while the one below is more ethereal and gentle.

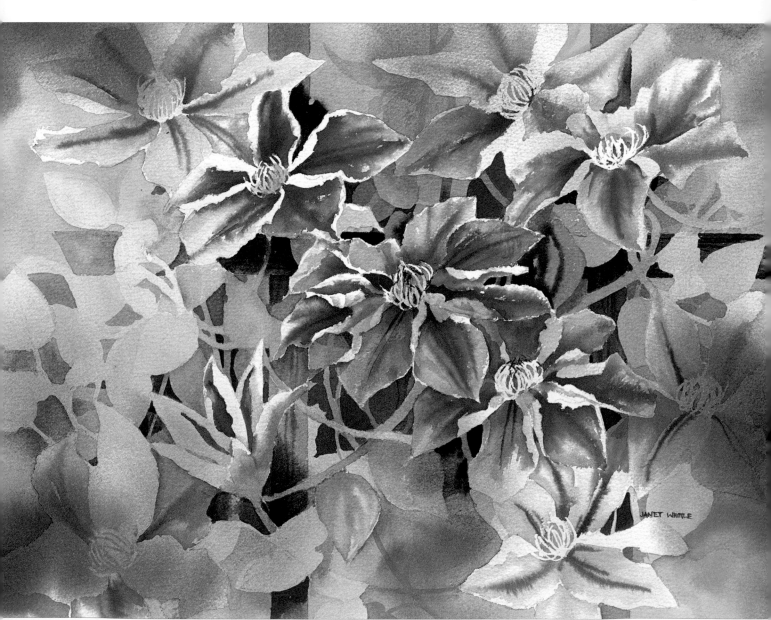

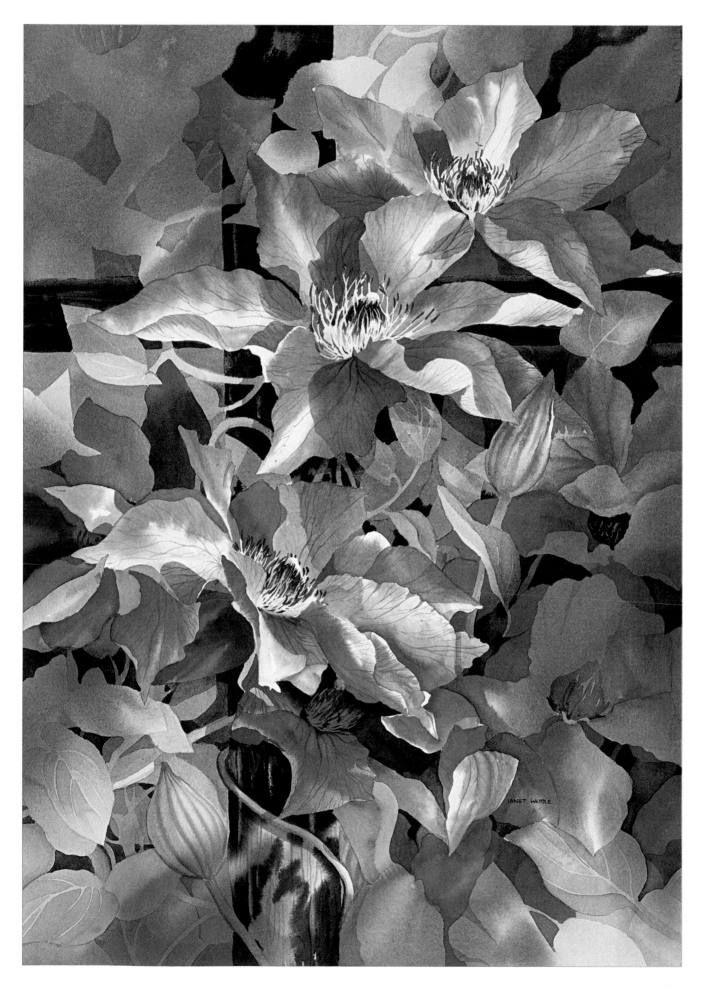

Hard and soft edges

Hard and soft edges or, as they are sometimes called, lost and found, are a very important part of painting. Too many hard edges can make a composition look overworked and bitty, so it is best to vary the type of edges. At first, I like to keep most of the edges within the flowers soft, using the wet-in-wet technique. When the painting is almost finished, I assess whether any part of the image needs to be sharpened.

If you want to control a soft edge within a small shape, for example a petal, paint in the deeper-toned area first. Rinse your brush, then paint up to the edge with clear water. This makes the colour bleed forward, and creates a soft edge that is more controllable.

Softening outside edges

It is easier to remove paint from some papers than others, and you will have to discover which you prefer by trying out different papers. With most papers, however, you can soften hard edges that have been produced by masking out by dampening a small flat brush and rubbing gently across the edge. Acrylic bristles are best for this as they are a little firmer. Blot with a tissue to remove any excess moisture.

In the examples shown below, which are part of the demonstration that begins on page 330, a flat brush has been used to rub the edges of the masked areas to soften them, so they look less 'cut out'.

Using a flat brush dampened with clear water, gently rub the edge of the coloured area to soften it and blot with soft tissue.

Repeat with the rest of the flowers, neatening any jagged edges.

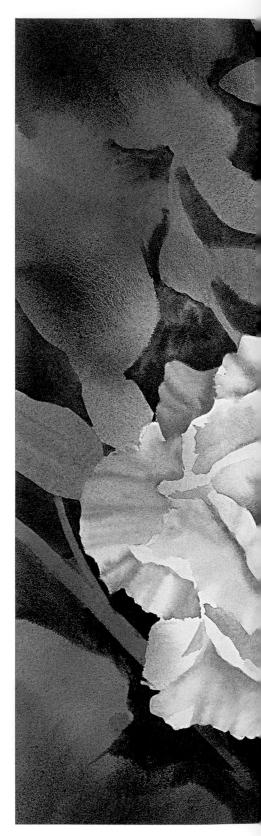

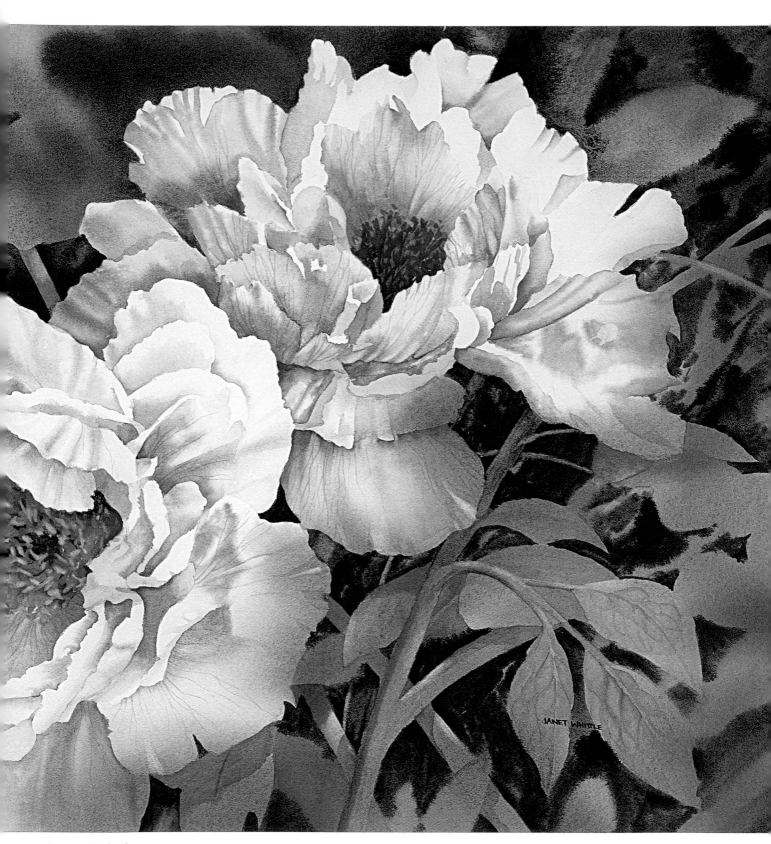

Peony *Godaishu*

Size: 55 x 38cm (21½ x 15in)

I have used hard and soft edges to paint this peony. Too much detail would make the flower form confusing to the eye. The main areas of counterchange – where the lightest lights are next to the darkest darks – have been accentuated in the middle and on the outside edges.

Veining on pansy leaves

VEINING

The technique you use will depend on the type of flower or leaf you are painting: some have light veining against a dark background while others are dark against light. Do not add veining to all the petals, as it can be too much. The sun will also bleach out details. It is usually sufficient to vein just a few focal petals and leaves.

For light veining against dark, you can mask out the veins over the colour of the background, then add another wash over the top. Alternatively, you can draw them in and paint the negative shapes carefully between them. Unless you want a botanical illustration, it is unnecessary to add too much detail to leaves or petals. Concentrate on the focal flowers to make them stand out more.

For dark veining against a light background, I use a small round brush (No. 00) or a small (No. 3) rigger, and paint in the vein following the contours of the leaf or petal. If there are any cast shadows, I put these in on top and darken the veining within the shadow.

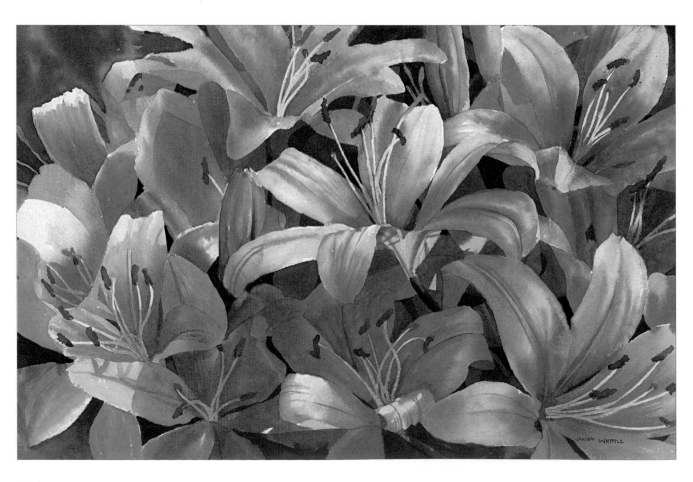

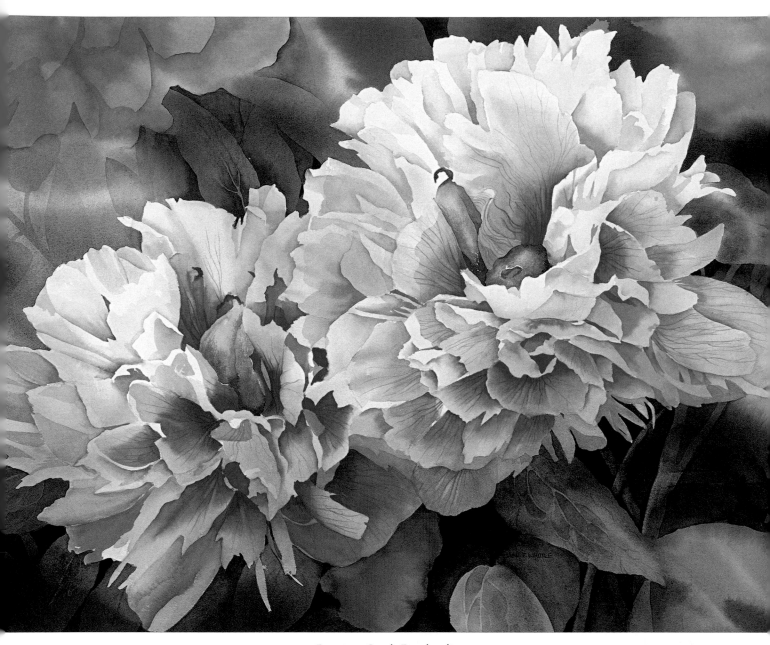

Peonies *Sarah Bernhardt*
Size: 52 x 33cm (20½ x 13in)
This is a simple treatment of an extremely intricate flower, with the sunlight catching the petals from above left. I have been sparing with the amount of veining so the effect did not become too complicated, but have deepened the veining within the shadow areas.

Opposite:
Lilies *Red Night*
Size: 52 x 33cm (20½ x 13in)
This is a good example of a painting done with a limited palette (see also Cabbage White on Syringa Blossom, page 293). I masked out the stamen and used the full tonal range of white through orange to burnt orange, taking the colour to dark by adding burnt umber. These flowers are often sold in pots, making it easy for the painter to position them where the light is best. As the petals have a sheen on them, I have used the white of the paper to represent the sunlight catching them. The veining on the petals was put in using a small rigger brush.

TIP

When you are painting a larger picture, use a small rigger (No. 2 or No. 3) for veining. The hairs are longer and will hold more paint, and you will not have to reload the brush so often.

Glazing

Glazing is a technique that can be used to warm up or cool down areas of a painting, and the best results are obtained with washes of transparent colour. If leaves or stalks look dull or pale, a light wash of aureolin or lemon yellow will brighten them. A cobalt blue glaze will help to accentuate focal flowers by cooling or pushing back surrounding areas. In the example below (see also page 354) the glazing gives definition and shape to the daisy petals.

The daisies look too stark because they are just white paper ...

... but glazing with a pale wash of cobalt blue when the flowers are dry helps to give them definition.

Wisteria

Size: 55 x 38cm (21½ x 15in)
In this example, some of the flowers have been glazed back with a purple mix to make the focal flowers more prominent.

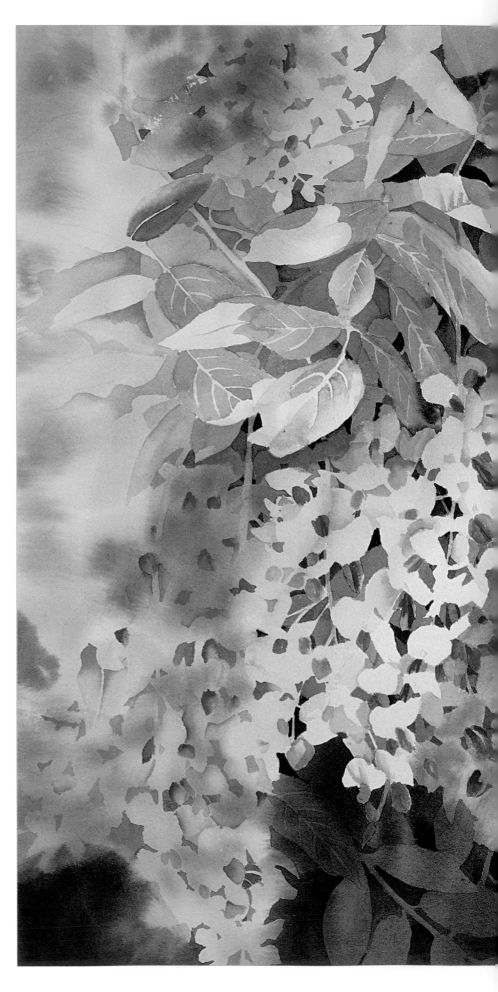

326

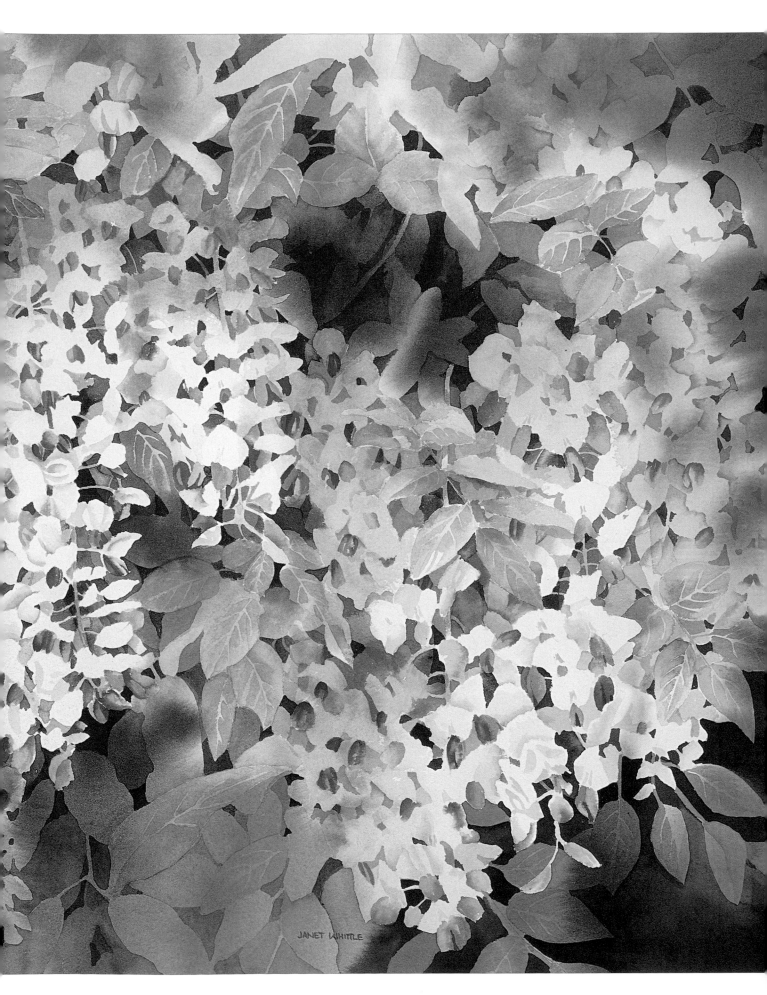

JANET WHITTLE

LIFTING OUT

Some papers allow you to lift off paint more easily than others. On certain types of paper, if you are not happy with the way your first wash has gone on, all you need to do to remove it is to rinse your work off under a tap and scrub it gently with a brush. Some types of paint leave more of a stain on the paper, so that a light blush of colour will always remain, while others can be removed completely allowing you to start again. Beginners should experiment with different paints and papers to find which ones suit different techniques.

If you want to remove definite shapes, dampen the area first with clear water (see top right), then rub the shape gently with a brush and blot it with tissue (see bottom right). For larger areas, a soft toothbrush can be used. If, when your work has dried, you find that you want to lift out more colour you can simply repeat the procedure.

You should also take care if you want to use masking fluid over colour. Because it is a rubber solution, certain types may lift off some of the colour when you try to remove it, as well as some of your pencil lines.

Dampen with clear water

Lift off colour with a tissue pad

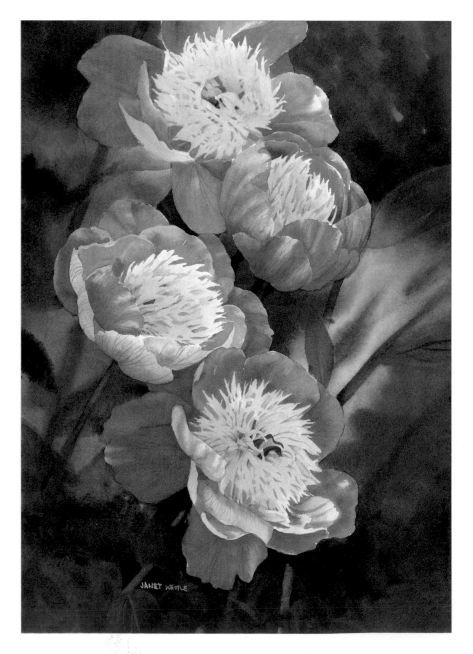

Stamens and stalks

Lifting out is a useful technique for putting in the stalks of flowers, as in the painting left.

In the painting of hollyhocks opposite, negative painting was used to indicate the stalks, and the stamens were masked. You can apply a first wash before masking if you like, so there is a base colour when you remove the masking fluid.

When stamens are light against dark, including hellebores (see page 302), or some types of clematis (see pages 320–321), it is easier to mask them out before you begin to paint.

When the stamens of flowers are dark against light, they can be painted in last over the colours of the flower. This technique is quite easy – see the poppy demonstration on page 354.

Peony *Bowl of Beauty*
Size: 28 x 38cm (11 x 15in)
The main stalks on these flowers were lifted out using a 13mm (½in) flat brush to give the impression that they run behind the leaves. A stalk was painted dark against light in the background.

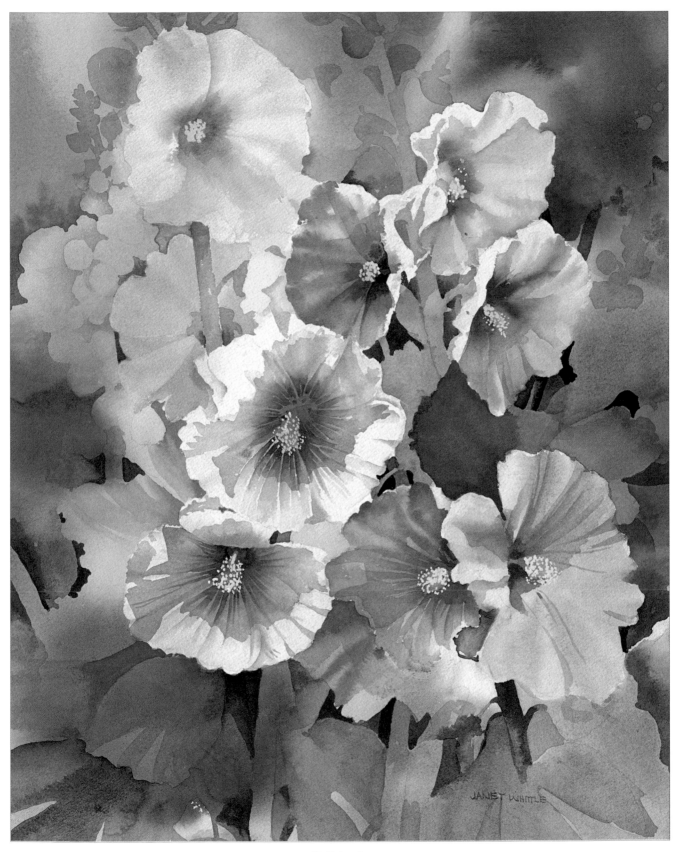

Hollyhocks

Size: 52 x 33cm (20½ x 13in)
The shadows on the flowers are cobalt blue with a touch of light red: the
darker the shadows, the more the illusion of bright sunlight is created.
Dramatic shadows can turn a painting into something special. Complete the
flowers before removing the masking fluid and paint in the stamens.

Snowdrops

These have lovely, simple shapes to practise masking-out techniques on. Because they are so small, you will need to mask out the whole flower so the first washes can be put on over them. Draw the flower heads and stems carefully before you begin painting. You can draw the leaves in at this stage too, or you can leave them until you have completed the first wash if you prefer.

This project is a good exercise for practising a background wash, and also incorporates the lifting out technique. The colours were chosen because some pigments will lift off back to white, while others are more staining and leave some colour on the paper. It was carried out on watercolour board, which you can buy in most good art shops. This allows the paint to lift off more easily.

Make sure you choose your paper according to the techniques you are hoping to use. A surface which lifts off as easily as watercolour board is not suitable if you want to do a lot of negative painting: when one colour is applied over another – unless it is done extremely gently – it will lift off the colour underneath and make it muddy. The negative shapes in this composition are small, so this characteristic should not cause too much trouble. The light in this composition is coming from the left, so the shadows and highlights are put in accordingly.

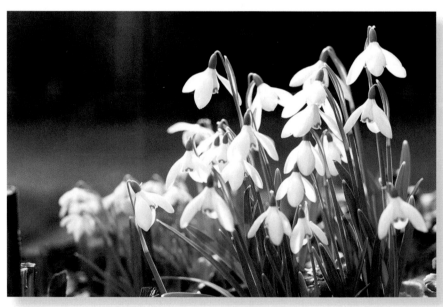

The photograph I used as reference for this composition

The finished painting
Size: 55 x 38cm (21½ x 15in)
I have used my imagination for the background colours, choosing tones that complement the delicacy of the flowers.

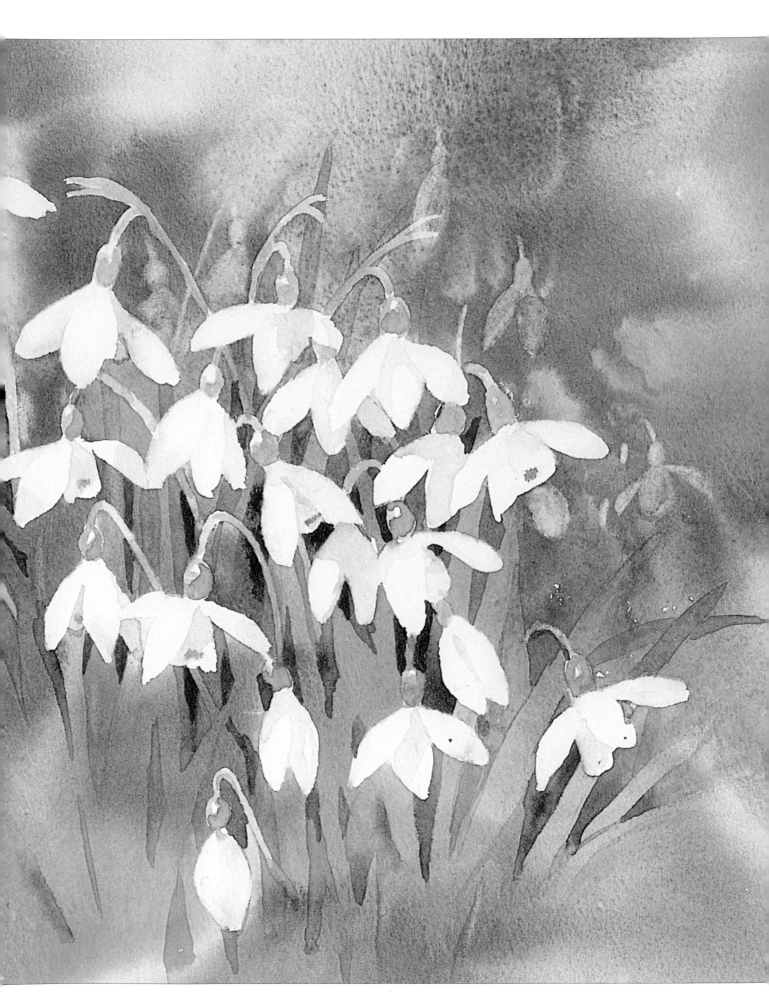

Before you begin to paint, mix the main washes you will need:

1) Cobalt blue
2) Winsor blue and viridian
3) Winsor blue and burnt umber
4) Viridian and burnt umber
5) Cadmium yellow and sap green

YOU WILL NEED

Watercolour board
Brushes Nos. 8 and No. 00
Flat brush: 13mm (½in)
Masking fluid and old brush
Palette for mixing
Watercolour paints: cobalt blue;
Winsor blue; viridian; cadmium
yellow; sap green, burnt umber
and lemon yellow
Plastic eraser

My outline sketch, with the masking fluid tinted blue for clarity

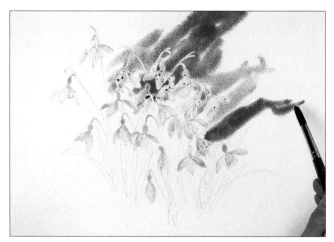

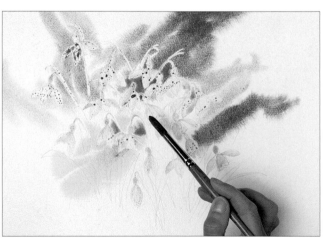

1 Draw an outline sketch and apply masking fluid to the main flower heads and stems. Mix the main colours you want to use. Wash over the paper with water until the surface is shiny, then repeat the process so the water sinks in more. Add the Winsor blue and viridian wash using a No. 8 brush.

2 When putting in backgrounds I generally work from light to dark. Add the cadmium yellow and sap green wash...

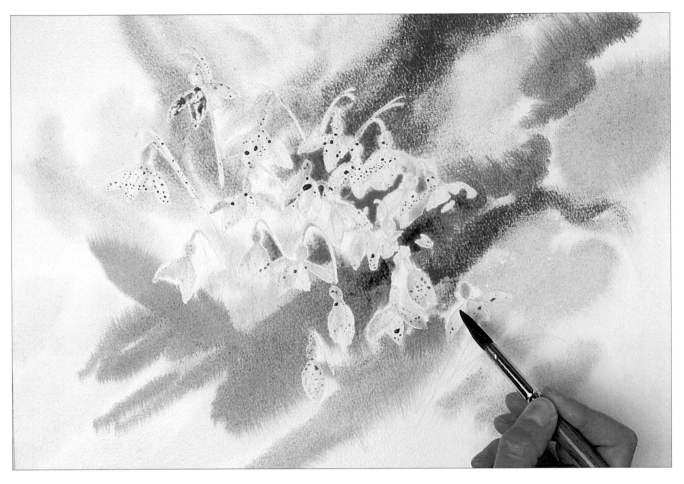

3 ...and the cobalt blue, working very quickly.

TIP

If your paper begins to dry too much, you can damp it down with plain water from a spray mister rather than touching the paint.

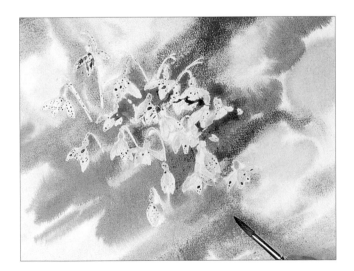

4 Finish adding the washes so that they cover the paper, remembering that they will spread when you tip the board...

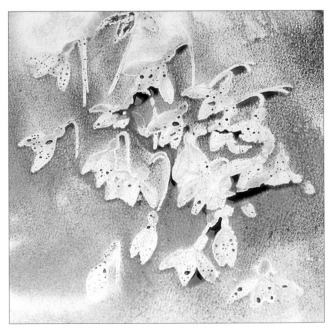

5 ... and tip the picture so the colours merge.

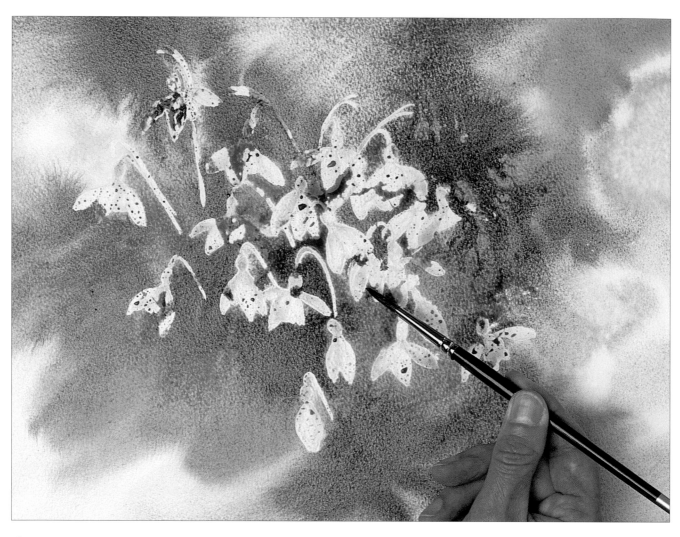

6 Put in some darks beside the flowers to make them stand out, remembering
that everything will diffuse on the wet paper, and will also dry lighter.

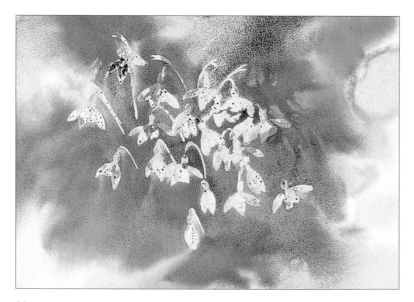

7 Leave your work to dry thoroughly, or wait until the shine has gone
off and use a hair dryer to speed up the process.

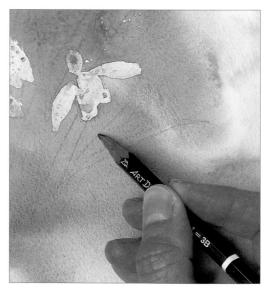

8 Reinstate the lines with a 3B pencil, using
the initial sketch for guidance if necessary.

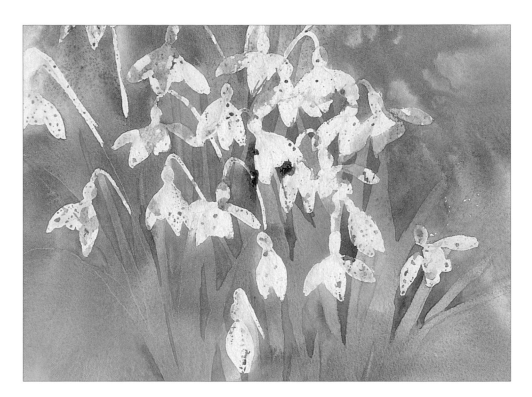

9 Using a mix of viridian and burnt umber, paint in negative shapes behind the flowers and leaves.

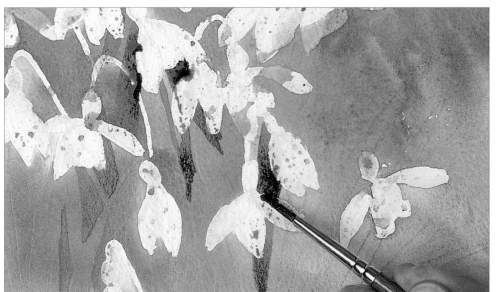

10 Using a deeper mix of viridian and burnt umber, darken some areas to show up the main flowers and give the painting more depth.

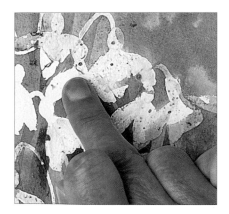

11 Leave your work to dry thoroughly then rub off the masking fluid with your fingertips.

12 With a flat brush and plain water, gently rub the edges of the coloured areas to soften them.

13 Repeat with the rest of the flowers, neatening any jagged edges.

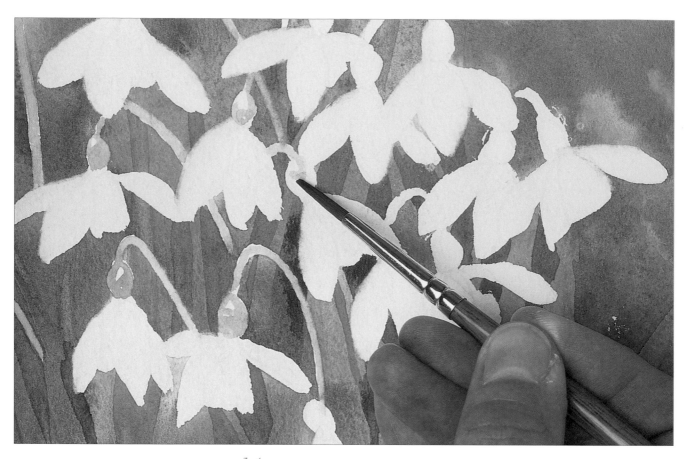

14 Using the No. 8 brush, mix viridian and cadmium yellow and paint in the tops of the flowers and the stalks, adjusting the intensity of the wash throughout to vary the tones. Remembering where the light is coming from, reserve highlights throughout the painting.

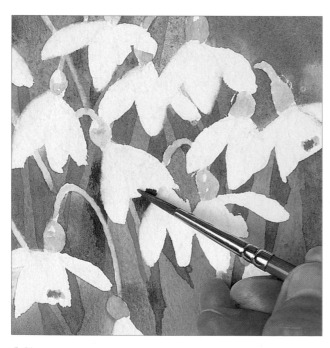

15 Put in detail on the inner petals using lemon yellow, adding a dab of viridian wet-in-wet on top.

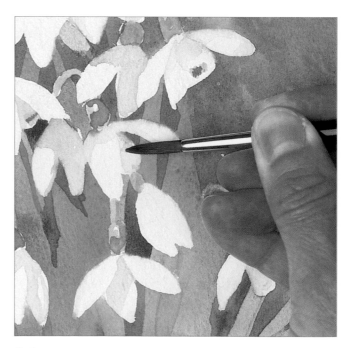

16 Using a pale mix of cobalt blue, shade in the petals away from the light and then the petals inside the flowers.

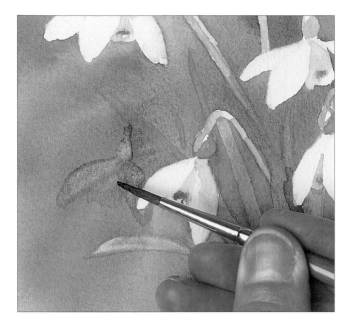

17 With plain water and the point of a fine (No. 00) brush, dampen an area of the background in the shape of a snowdrop.

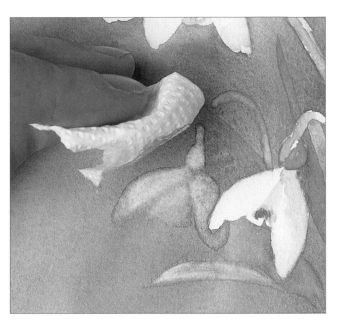

18 Blot with a pad of absorbent paper to lift out the shape of the flower.

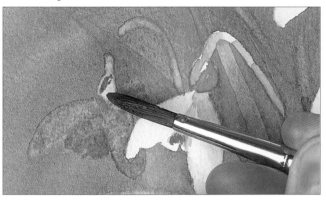

19 Knock the starkness of the lifted-out flower back with a pale wash of cobalt blue. Put in the green top of the flower.

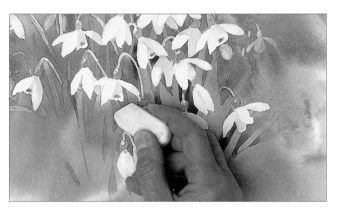

20 Leave the picture to dry thoroughly then remove the pencil lines with a plastic eraser.

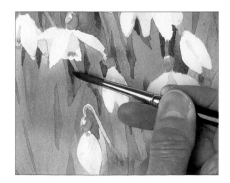

21 Work over the whole painting as necessary, redefining, adding more negative painting in a dark mix of viridian and burnt umber, and generally sharpening up the detail.

The finished painting.

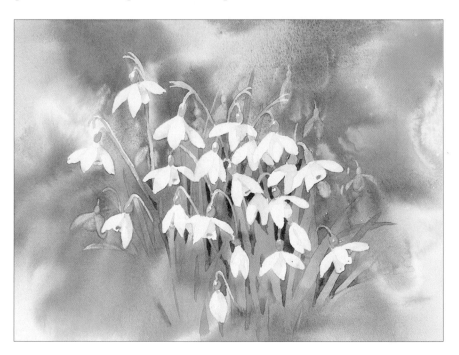

Above: Foxgloves

Size: 55 x 38cm (21½ x 15in)

For this letterbox-format composition, I added the background trees to create the impression of the woodland or hedgerows where these flowers often grow, and to show up the main flowers.

Below: Irises

Size: 61 x 74cm (24 x 29in)

I like to vary the style of presentation, and the stalks of these flowers are so long that a letterbox format seemed to suit it. I also like to vary the colours within a composition.

338

Irises

Size: 38 x 38cm (15 x 15in)
These flowers were very bright and fresh, so I
preserved areas of white to create this effect, putting
the whites next to the blues and yellows to keep the
whole composition vibrant and alive.

Himalayan Poppy

Watercolour has a reputation for being wishy-washy, but used properly it can be as bright and colourful as any other medium, as this demonstration shows. I have many photographs of this flower as it is one of my favourites, and I used a selection to develop the composition. The negative painting in the background is fairly basic. The petals of the poppies were put in wet-in-wet and the stamens were masked out with dots. I interlocked some of the stamens as, depending on the angle of the flower, they appear more dense in some areas than in others.

The more extremes of tone you can create in a painting, the more vibrant it will be. The green and the blue I used are very similar in tone. This could result in a bland painting, so I compensated by exaggerating the tonal values. I accentuated the brightness of the petals by leaving the white of the paper in places, and towards the centre of the flowers, I deepened the intensity of colour to show up the stamens, making the flowers appear lighter. I placed some of the darks in the background next to the lighter areas of the petals to create depth.

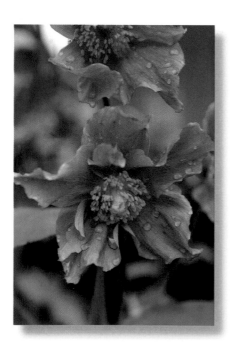

My source photographs

The finished painting

These lovely flowers, Meconopsis Betonicifolia, *are among my favourites and I paint them often. I have tried to grow them several times, but they are not happy with the soil in the area where I live. I take reference photographs whenever I get the chance.*

340

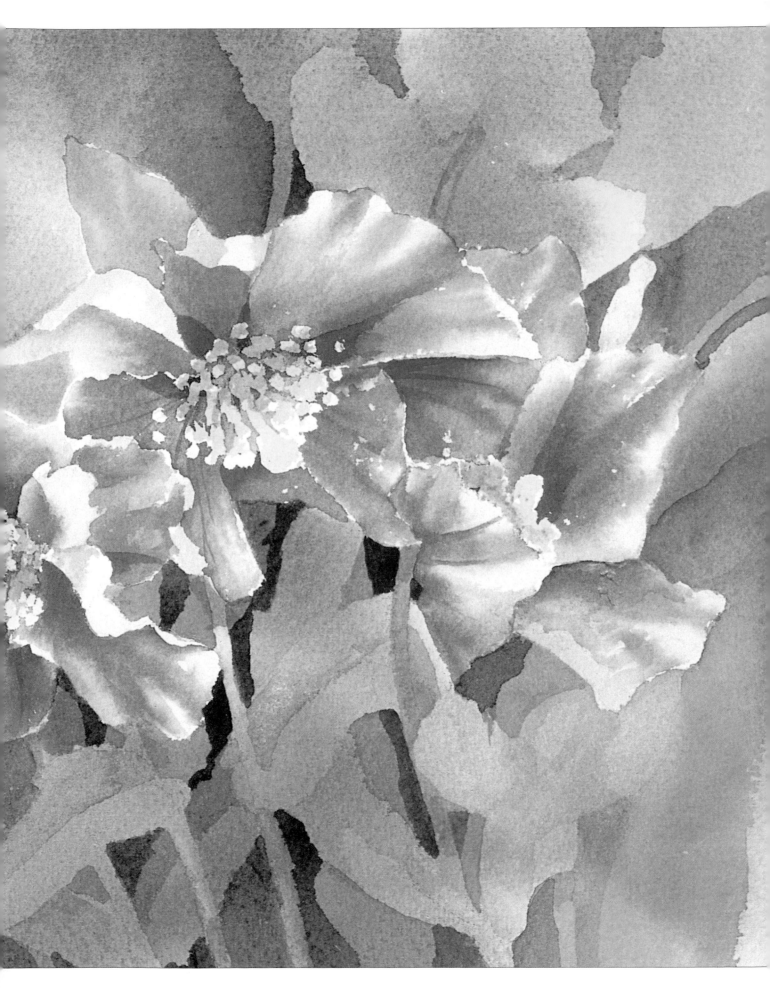

Before you begin to paint, mix the main colours you will need:

1) Viridian and Winsor blue
2) Cobalt blue
3) Cobalt blue and viridian
4) Burnt umber and viridian
5) Permanent rose
6) Sap green and cadmium yellow

You WILL NEED

Watercolour paper 300lb (640gsm)
Drawing board and pins
Masking fluid and old brush
Round brush No. 6
Rigger No. 3
Watercolour paint: I used Winsor blue; cobalt blue; cadmium yellow; burnt umber; permanent rose; sap green; viridian and alizarin crimson

The outline sketch, with masking fluid added to outline the main flowers.

1 Pin or stretch your watercolour paper to the drawing board. Mix up the main colours you want to use. Wet the paper up to the masking fluid outline. Using the No. 6 round brush, put in the background colours. Working from light to dark, begin with the yellow mix of sap green and cadmium yellow and follow with the green mix of cobalt blue and viridian and the plain cobalt blue. Let the colours spread right up to the edge of the masking fluid.

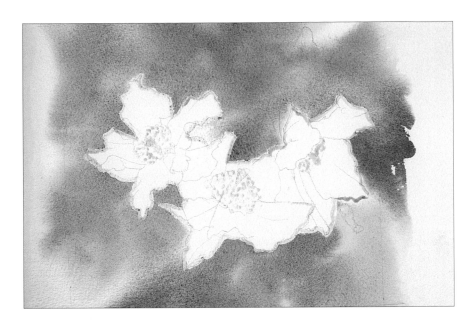

2 Tip the paper to merge the washes. Leave your work to dry.

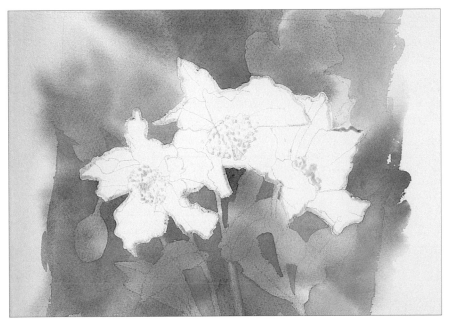

3 Begin to put in the negative painting using the wash of viridian and Winsor blue and following the pencil lines. Let your work dry.

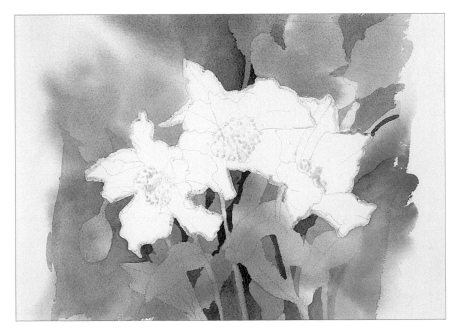

4 Change to the mix of burnt umber and viridian and put in more negative painting, cutting out again within the first negative shape you painted.

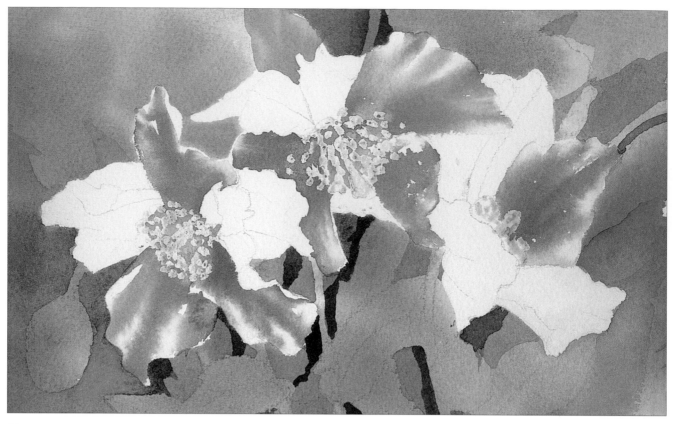

5 Rub the masking fluid off the petals, but leave it on the centres. Wet the petals using a No. 6 brush, and put in the cobalt blue wash, followed by a touch of alizarin crimson.

6 Still working wet-in-wet, paint in the rest of the flower petals, dampening each petal and running in the colour, following the tonal values as closely as possible, leaving some hard-edged white areas of dry paper.

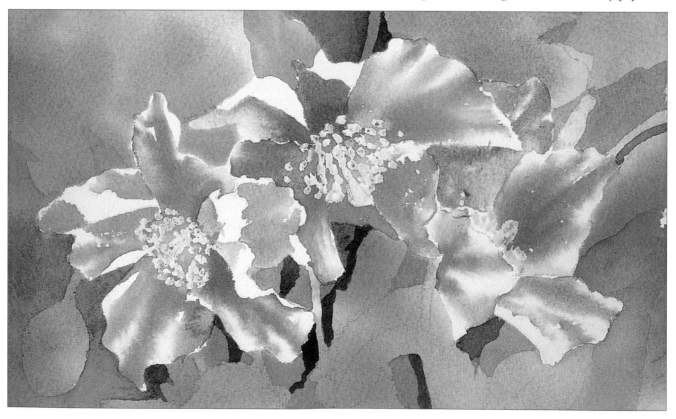

7 Deepen the blue on the petals using a mix of Winsor blue with a touch of cobalt blue. Work wet-on-dry and soften the edges with a little water.

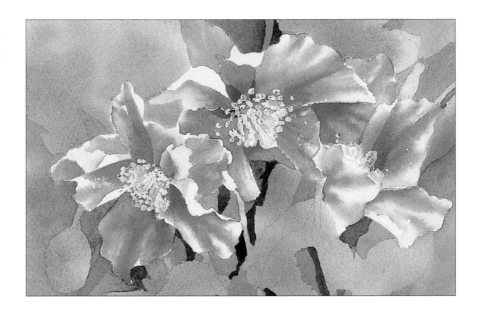

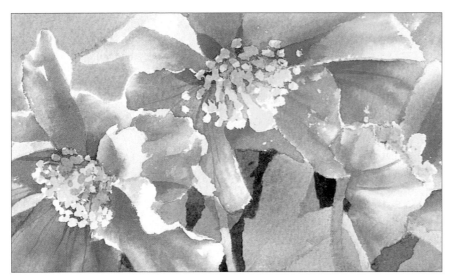

8 When your work is dry, remove the masking fluid and paint the stamens in lemon yellow, leaving some white flecks. Deepen the tone with cadmium yellow in the direction away from the light and where the petals would cast a shadow on the stamens. Produce the effect of veining on one or two leaves by putting a slightly deeper wash between the veins so they are light against dark.

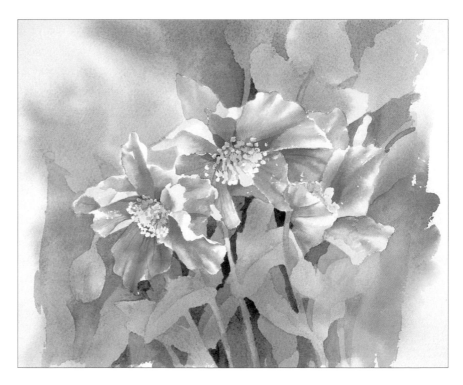

The finished painting, before cropping.

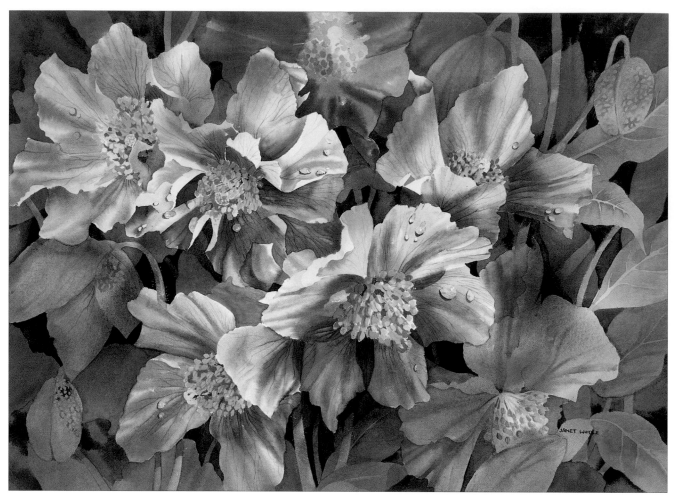

Himalayan Poppy *Meconopsis betonicifolia*
Size: 55 x 38cm (21½ x 15in)
A different study of one of my favourite flowers. I worked this painting from photographs taken at Hampton Court Palace, London. It was just after a shower of rain, and they looked absolutely stunning. The delicate blue of the petals with the light shining on them were all the inspiration I needed to paint.

Tree Poppy *White Cloud*
Size: 55 x 38cm (21½ x 15in)
Before masking out the shapes of the main flowers, I put in pale washes of yellows, pinks and blues to take a little of the stark whiteness off the flowers. Negative shapes have been painted in the background wash to cut out the flower shapes.

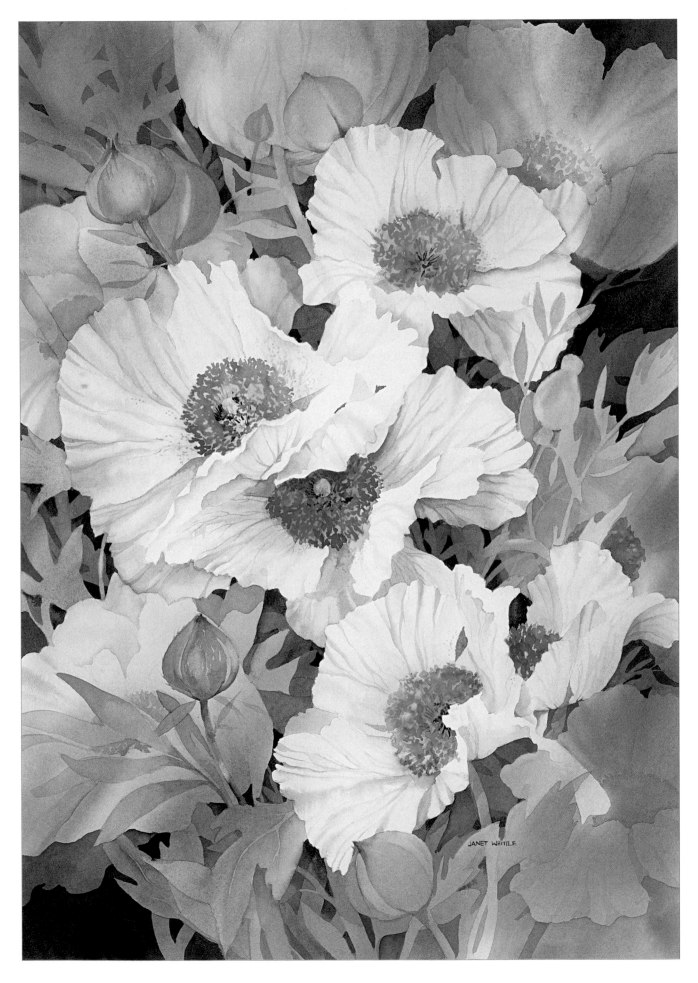

Poppies and Daisies

This demonstration shows how flowers of very different sizes can be used to complement the focal flowers. The petals of the poppies are painted first in cadmium yellow and, while they are still damp, the red is painted in. The yellow glows through the red, giving a luminous effect. I used the best aspects of several photographs to produce the final composition.

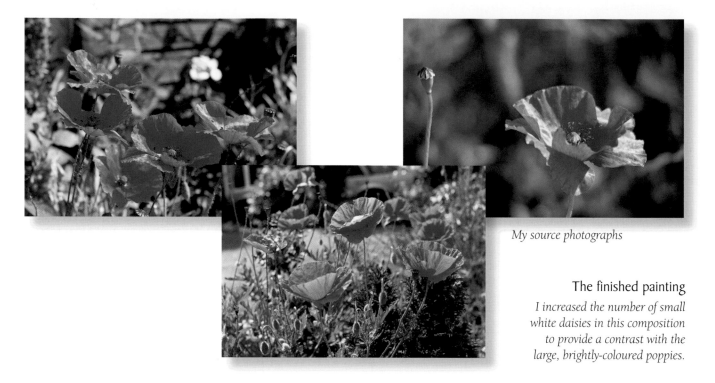

My source photographs

The finished painting

I increased the number of small white daisies in this composition to provide a contrast with the large, brightly-coloured poppies.

The outline sketch I used

Sketch with masking fluid to outline the main flowers

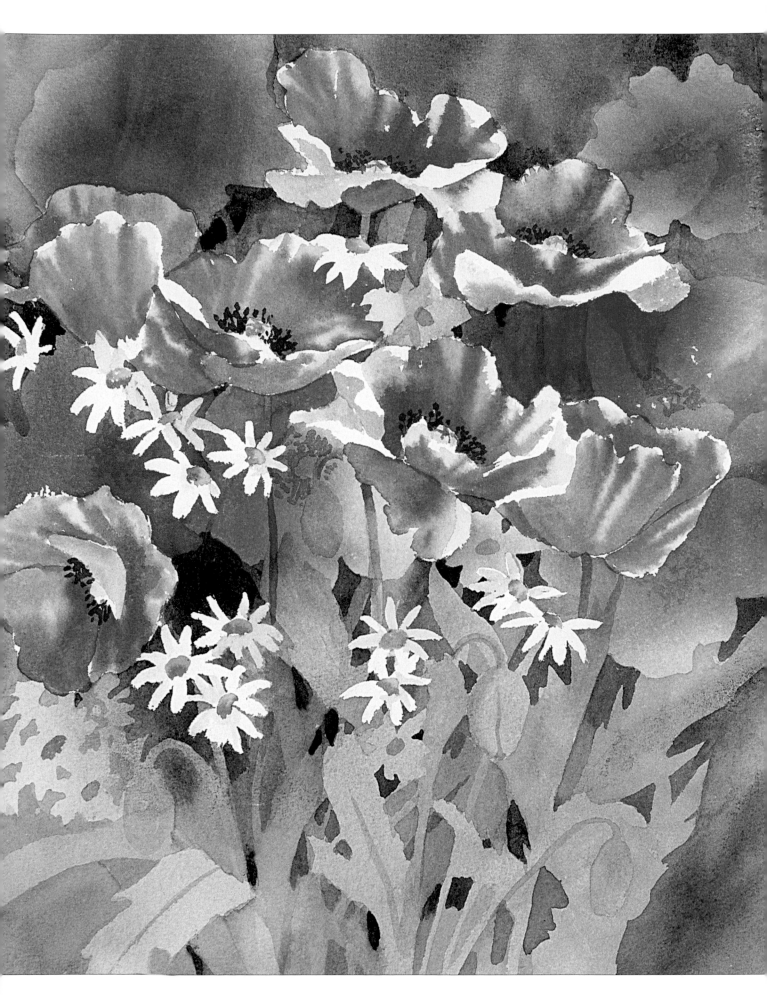

Before you begin to paint, mix the main colours you will need:

1) Burnt umber and viridian
2) Cadmium yellow
3) Translucent orange and cadmium red
4) Lemon yellow and viridian.
5) Cobalt blue
6) Viridian and Winsor blue

You will need
Watercolour paper 640gsm (300lb)
Drawing board and pins
Pencils: HB and 3B
Masking fluid and old brush
Round brushes: No. 6 and No. 8
Large soft brush
Watercolour paints: I used cadmium yellow; lemon yellow; cobalt blue; viridian; Winsor blue; translucent orange; cadmium red and burnt umber.

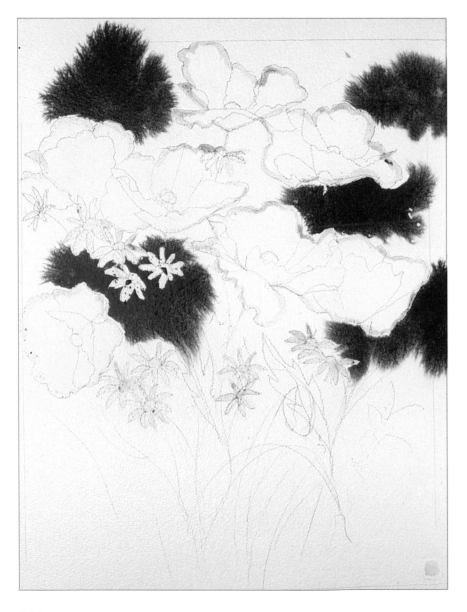

1 When the masking fluid has dried on the outline sketch (see page 348), use a large round brush, No. 8 or larger, to wet the paper up to the masking lines, leaving the flower shapes dry. Load your brush with the mix of translucent orange and cadmium red and drop it in behind the flower shapes, making sure the colour runs up to some of the masking lines.

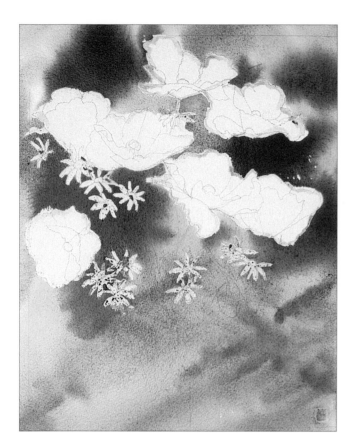

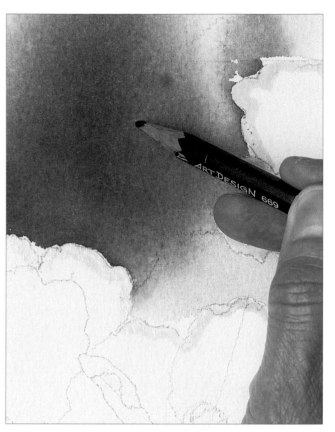

2 Continue dropping in background colours, working from light to dark, while the paper is still wet. Begin with cadmium yellow, followed by cobalt blue, the bright green mix and the red mix. Tip the paper to blend the colours slightly. Leave to dry.

3 If you are not happy with the effect, dampen the painting using a brush and drop in more colours. Pick up any excess droplets with a damp brush and leave to dry flat. Draw in the poppies in the background and any additional leaves and stalks you want to include, using a 3B pencil.

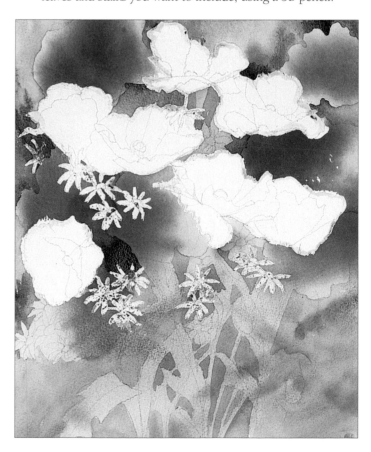

4 Paint in the negative shapes behind the background poppies, leaves and stalks using more concentrated mixes of the colours used in the first washes – not too dark, but so that you can see the shapes of the composition.

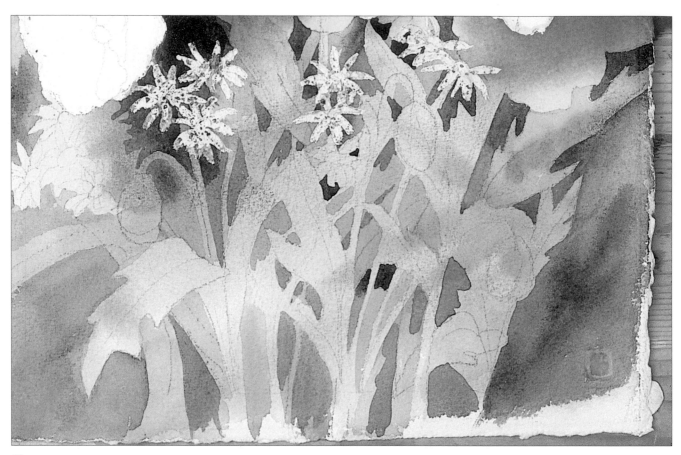

5 Add some darker negative shapes within the negative shapes you have painted to give the background more depth. Leave your work to dry.

6 Remove the masking fluid by rubbing it gently with your fingertips, then brush away the residue with a large soft brush.

7 Dampen the foreground petals with the No. 8 brush. Painting one petal at a time, put in the cadmium yellow wash then quickly add the translucent orange and cadmium red wash so that it merges as shown.

8 To achieve the right effect, paint in the back petals first so they go from dark at the centre to light at the edge ...

9 ...then paint in the petals at the front, leaving a light, soft edge at the top.

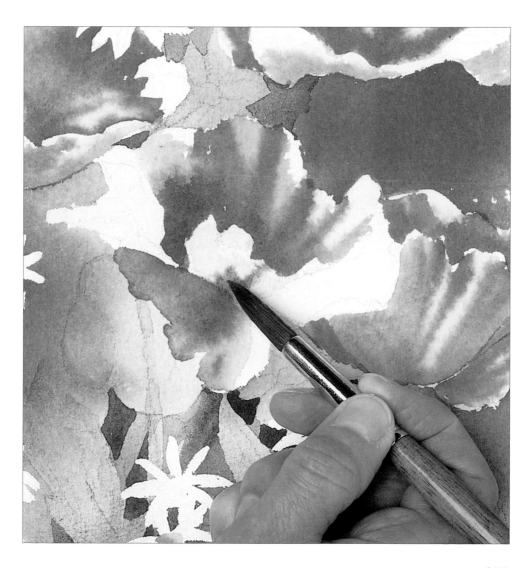

10 Complete all the poppies, following the tonal values as closely as possible, as shown here.

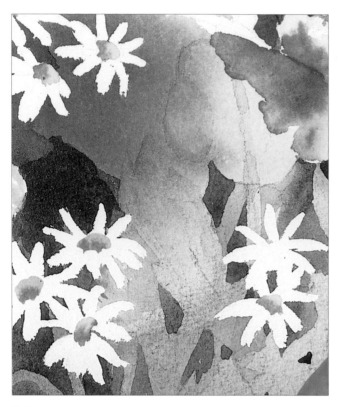

11 Put in the centres of the daisies, using a wash of cadmium yellow first, then drop in some of the cadmium red and orange wash on the side away from the light.

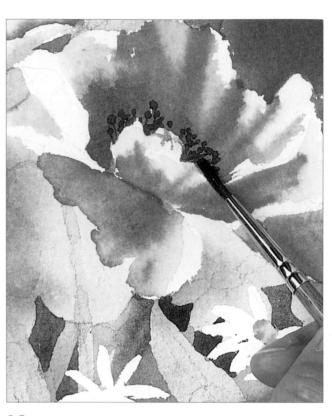

12 Put in the stamens of the poppies using a dark mix of Winsor blue and burnt umber.

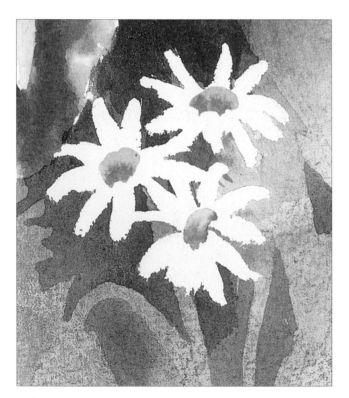

13 The daisies look too stark because with the masking fluid removed they are just white paper...

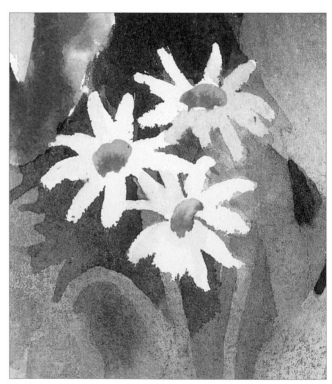

14 ...so add glazing with a pale wash of cobalt blue to some of them to make them recede into the background slightly and give them some form.

354

15 Work over the areas of negative painting, sharpening up detail if necessary and adding veins to some of the leaves.

16 Knock back some of the poppies in the background using a pale wash of cobalt blue.

17 Put in the stalks of the poppies that are dark against light using cadmium yellow with a touch of viridian and a No. 6 brush. When dry, remove the pencil lines.

The finished painting.

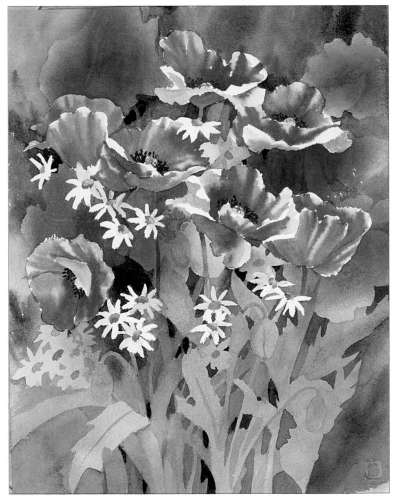

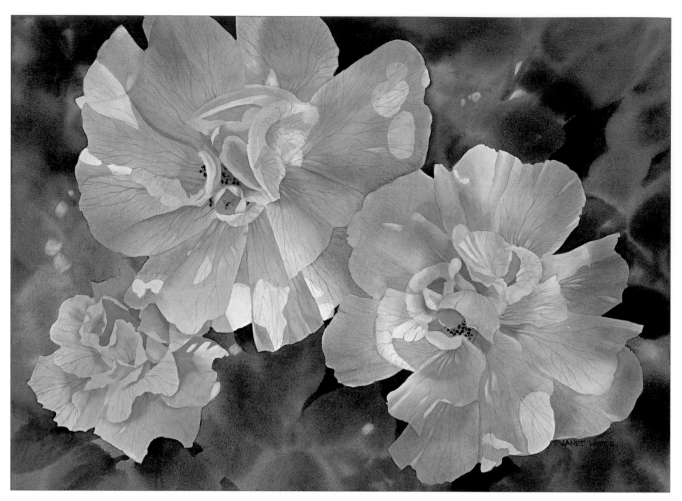

Rose *Buff Beauty*

Size: 55 x 38cm (21½ x 15in)

For this painting, a series of light blushes of colour were put over the paper and allowed to dry, then the flowers were masked on top of the washes. The sunlit areas were also masked to preserve them from the later washes. I mixed different tones of blue and put in the lighter tones first, then dropped in the darker areas wet-in-wet. I painted the flowers with yellows, pinks and orange mixes, then removed the masking and softened the edges. As these areas were now white and a little harsh, I toned some of them down with glazes to push them back.

Irises After the Rain

Size: 55 x 38cm (21½ x 15in)

This painting shows how effectively dewdrops can be used in a composition to capture the lovely effects of sunshine after rain. I think it is pure magic, which was why I was inspired to paint these irises. Capturing the moment, and effects which have the power to move you, is what painting is all about. The background was painted wet-in-wet. I dropped in the colours including the purple I wanted to use on the flowers, so that I could cut out some of the background flowers when it was dry to fill out the composition. The petals were painted wet-in-wet. I dampened the petal area first, then dropped in the yellow so it softened off, then, working from the outside edge I dropped in the purple mix so it too would soften forward, leaving a paler area in the centre of the petal. Timing is all with this technique: if your paper is too wet the colours will bleed too far, and if it is too dry they will not bleed far enough. Practice is essential, but if you find doing the whole thing too daunting, do one colour at a time, wait for it to dry, then wet it again and drop in the other colour.

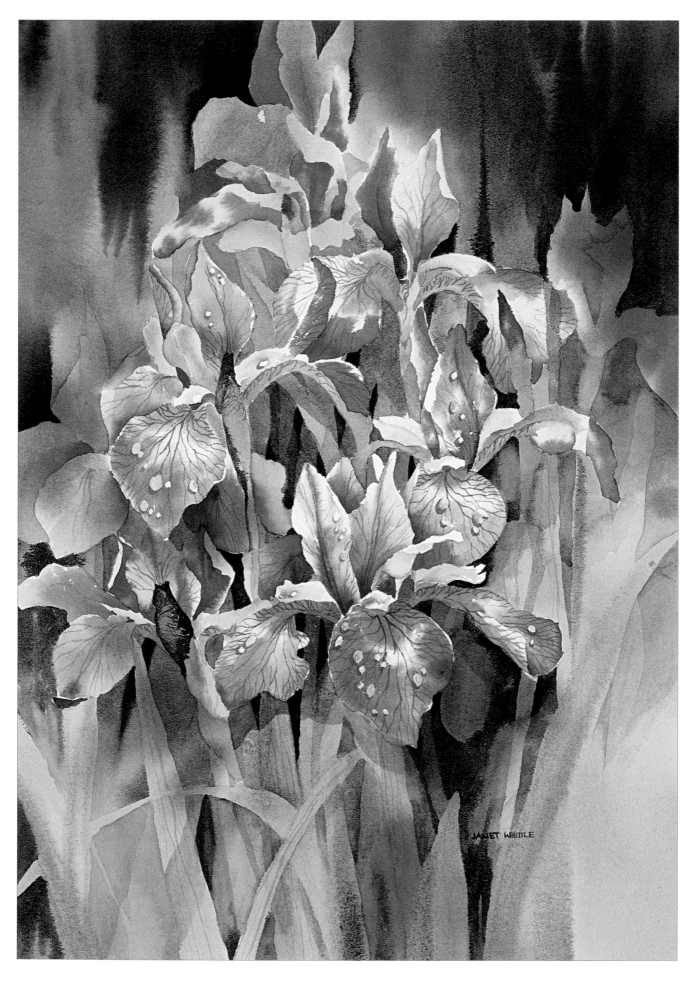

Scabious

I have painted the background for this demonstration almost entirely wet-in-wet. This is because scabious leaves are very small and grow mainly at soil level, so I wanted the background to suggest other foliage to add interest and colour to the painting. The centres of these flowers look different when they are newly opened, which makes an interesting feature on some of the blooms.

More interest is added by the way the shades of the flowers vary from white to lavender. Remember if you have good reference material for the flower form you can paint it in different colours as long as they are true to the type of flower. This will add variety to your composition. I have interlocked some of the focal flowers rather than placing them separately like a flower arrangement. I feel this is important because these flowers also grow in the wild and I like to give the impression that they are growing in woodland or hedgerow.

Perspective is also important when you are painting flowers like these. If the flowers tip towards you or away from you, make sure the shape of the centres changes from circular to oval, and that the petals are lengthened or foreshortened accordingly.

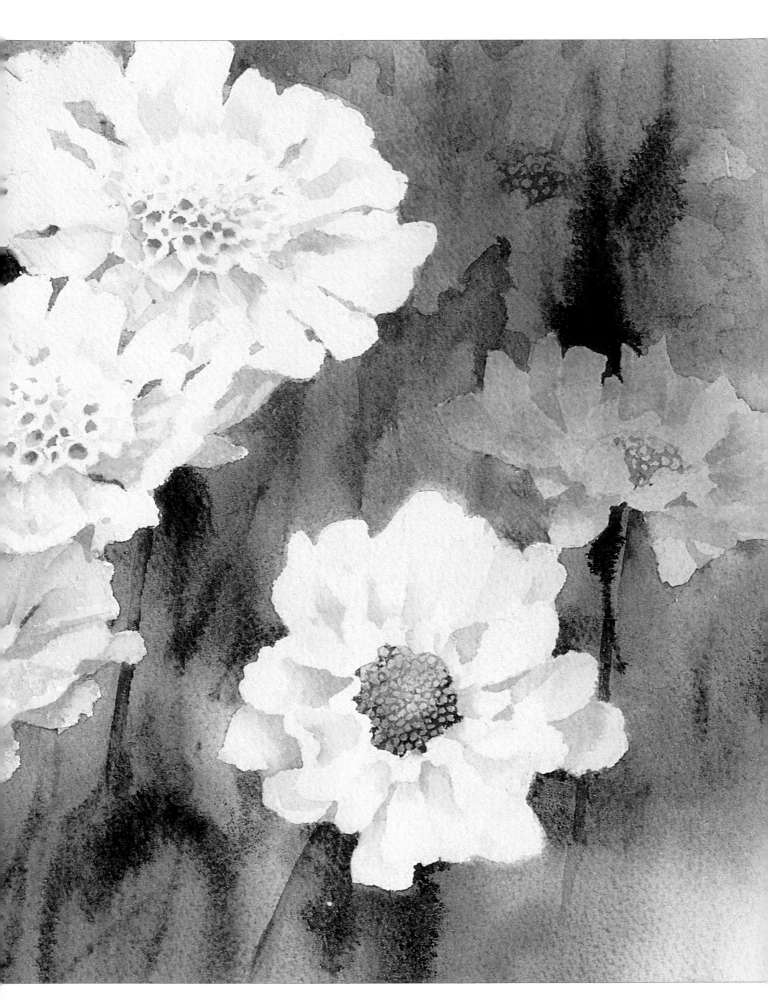

Before you begin to paint, mix up the main washes:

1. Indigo and Winsor blue
2. Cobalt blue
3. Viridian and Winsor blue
4. Cobalt blue and lemon yellow
5. Permanent rose and Winsor blue
6. Sap green and lemon yellow

You WILL NEED

Watercolour paper
Round brush No. 6
Rigger No. 3
3B pencil
Drawing board and pins
Masking fluid and old brush
Watercolour paints: I used cobalt blue; Winsor blue; indigo; viridian; lemon yellow; cadmium yellow and sap green

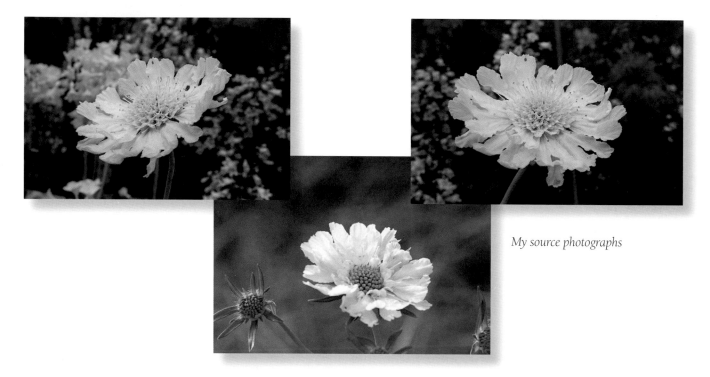

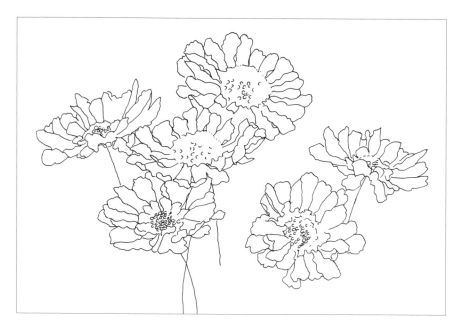

My source photographs

My outline sketch

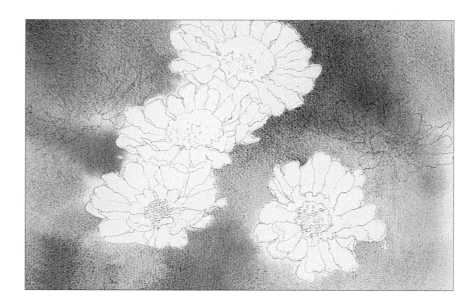

1 Mask the focal flowers and allow the masking fluid to dry. Using a No. 6 brush, wet the background right up to the masking fluid, and put in the background colours starting with the lightest and working through to the darkest. Tip the board (see page 306) and let the washes blend.

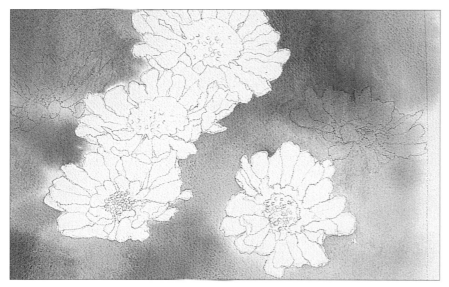

2 Leave these first washes to dry, remembering that they will dry quite a lot lighter. Draw in the background flowers using a 3B pencil.

3 Dampen the paper with plain water. Put in a wash of sap green and lemon yellow using a No. 6 brush, working round the background flowers, then change to a No. 3 rigger and indicate the darker stalks and leaves using a dark mix of indigo and Winsor blue. The shapes can be left abstract, as only an indication rather than detail is required.

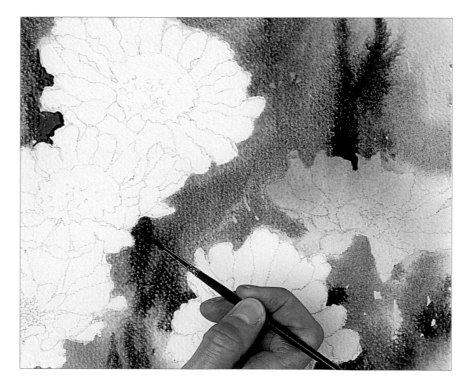

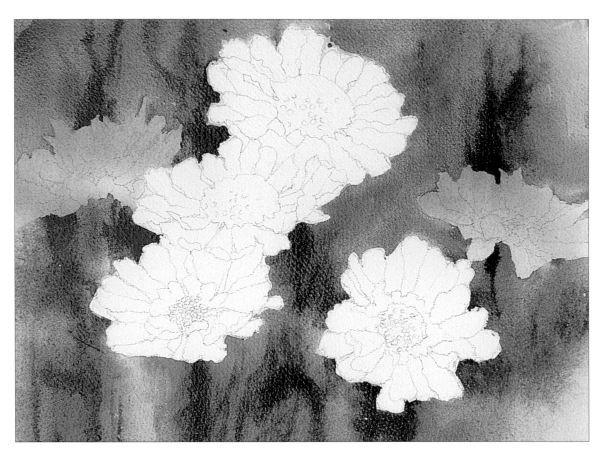

4 Let your work dry flat.

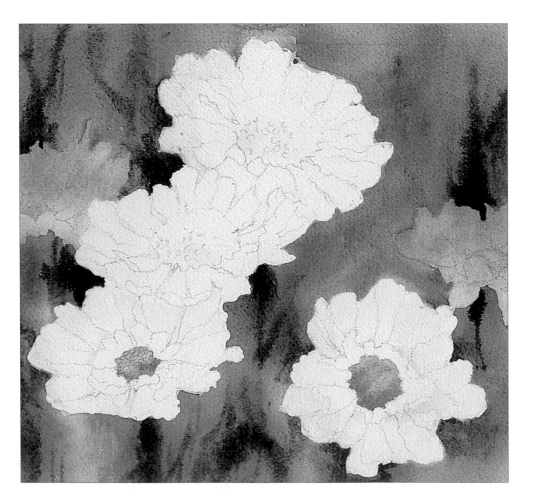

5 Put the first colour on the focal flowers using a pale wash of lemon yellow. Paint the centres of the two flowers at the bottom, then drop in some of the sap green mix so that it blends and varies the tone from light to dark.

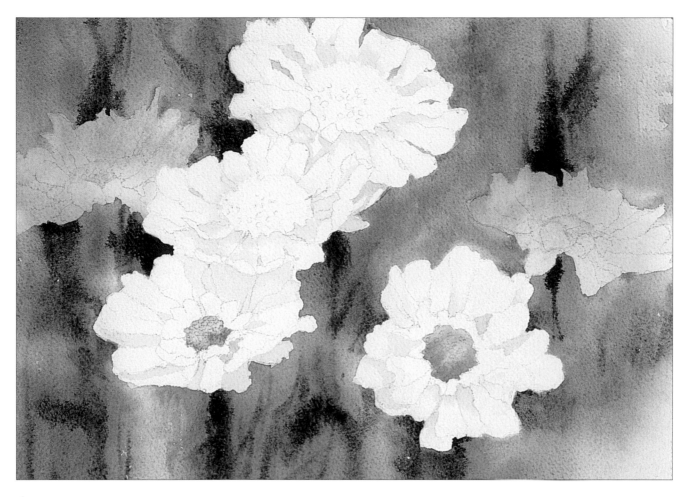

6 Using the mix of permanent rose and Winsor blue, deepen some of the shadows on the flower heads to give them more depth. Using the dark green mix and the small rigger, paint in between some of the petals next to the centres to indicate separation.

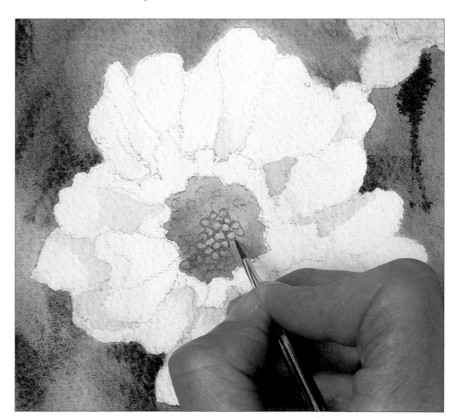

7 Still with the small rigger brush, and with a darker mix of green paint, add detail to the centre of the nearest flower by painting in tiny circles.

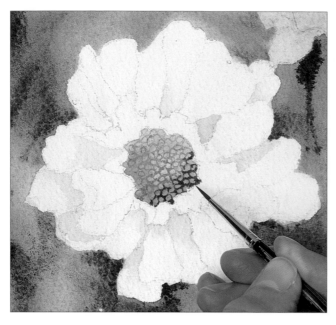

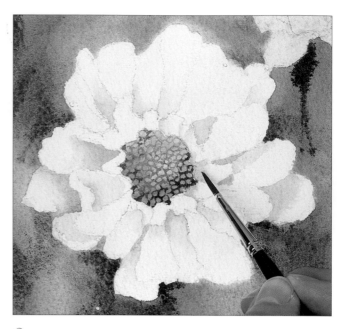

8 Darken the circles away from the light on the right-hand side and round the edges. This will give the illusion that the middle is raised as the light catches it.

9 Using the permanent rose and Winsor blue mix, deepen some of the shadows on the flower heads to give more depth to the form of the flower, using hard and soft edges.

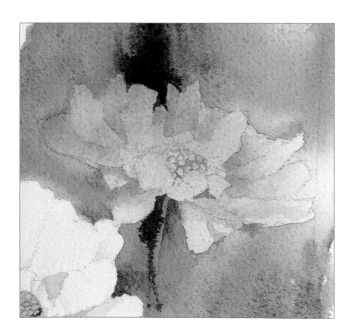

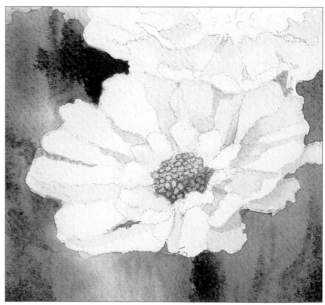

10 Add circles to the centres of the background flowers, making them fainter because too much detail would bring them too sharply into focus.

11 Glaze over the middles of the foreground flowers to warm them, using a mix of lemon yellow and cadmium yellow. After this, you may need to darken the circles a little on the right.

12 The centres of the two main flowers are slightly different. Paint the hollows using a deeper mix of lemon yellow and cadmium yellow, leaving the edges as white paper. At this stage you should stand back and assess the painting, adjusting the depth of colour where necessary.

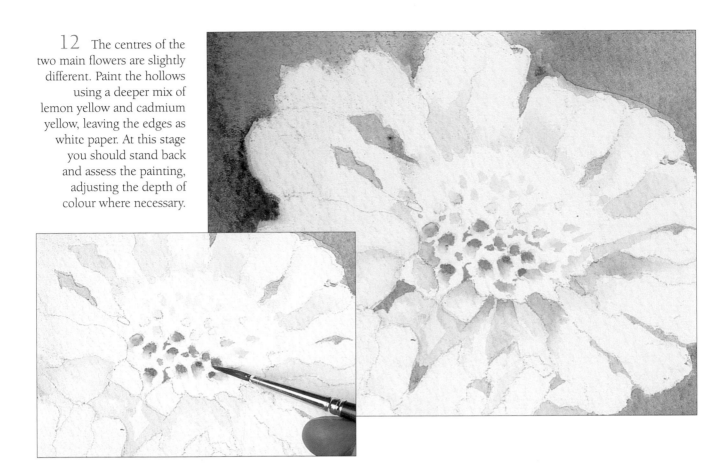

The finished painting.

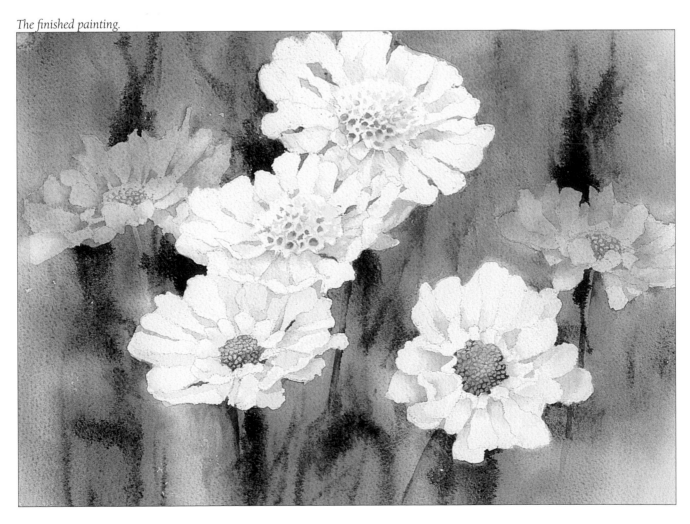

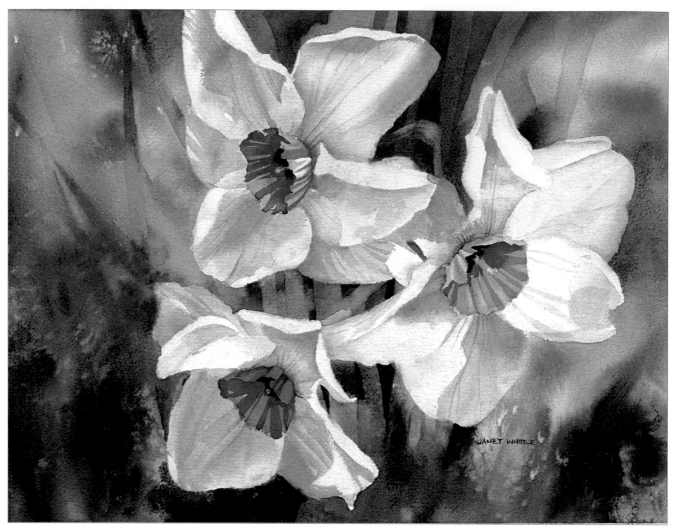

Narcissi

Size: 38 x 38cm (15 x 15in)
After dropping in washes in the background, I sprinkled salt in the
wet paint to give a textural effect. If you try this, do not dry your
work with a hair dryer, but let it dry naturally. Some colours will
give a better result than others, so it is wise to experiment first.

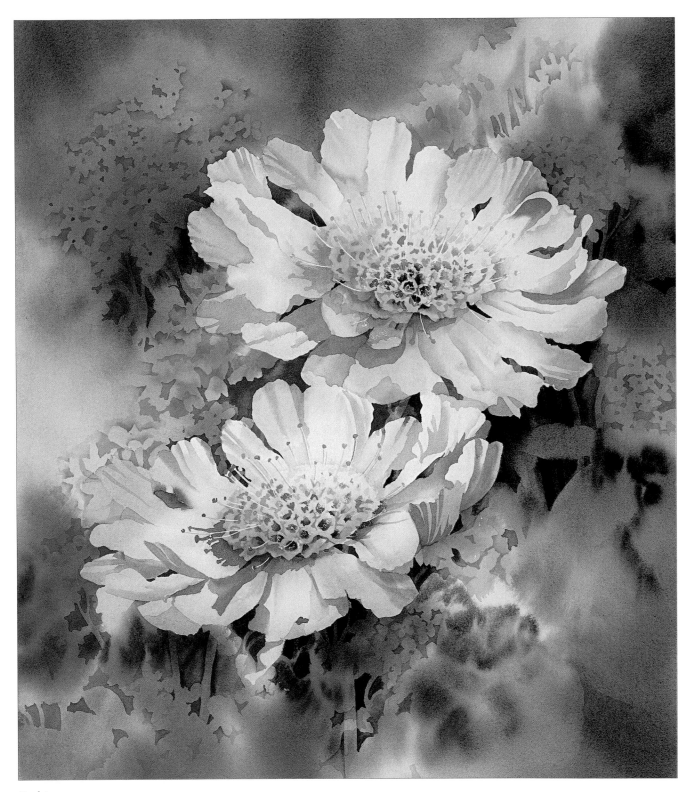

Scabious

Size: 37 x 48cm (14½ x 19in)

I dropped soft washes of colour into the background, then allowed it to dry. Negative shapes were added to the background to indicate smaller blooms and one or two stalks. The effect was kept deliberately minimal so the focus of attention would remain on the two main flowers.

Clematis

This demonstration brings together many of the techniques found in this section. If you work through it, referring to previous instructions where necessary, it should help to consolidate your newly-acquired skills.

I used photographs from my archive to plan the composition and produce an outline sketch.

The project is carried out in just four stages: putting in the background; masking the stamens of the flowers (which can be done with a small brush or even a cocktail stick); using negative painting to bring out the detail and putting in the petals wet-in-wet. The colour of the flower has been used in the background to suggest more out-of-focus blooms and buds. Pink is a delicate colour, and to make it more vibrant I have left sunlit areas of white to counterchange the background against it.

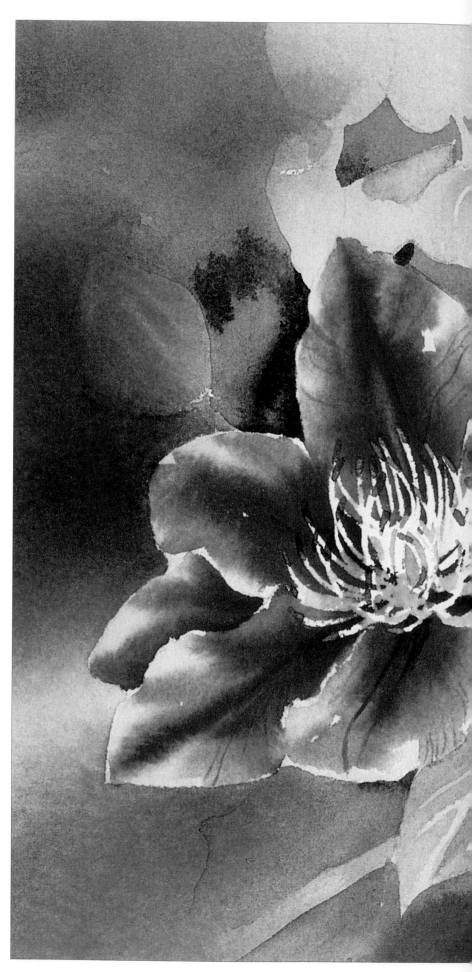

The finished picture
Size: 55 x 38cm (21½ x 15in)
These lovely flowers come in an enormous variety of shapes and hues, so you can change the colours to suit yourself.

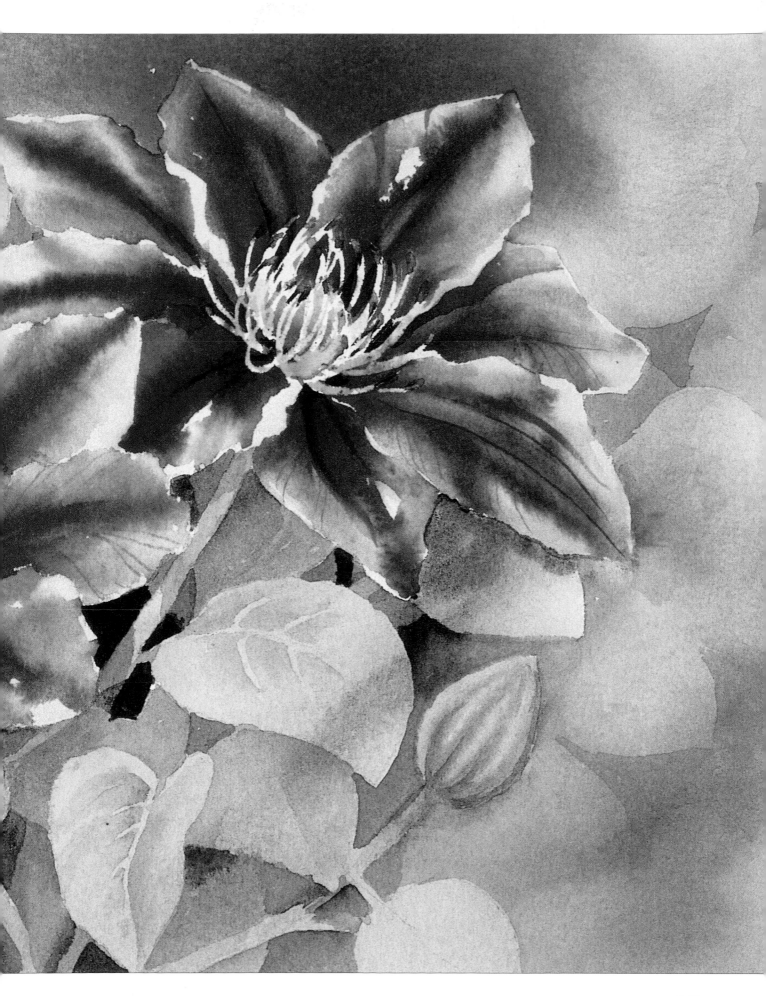

Before you begin, mix up the main colours you will use:

1. Permanent rose and lemon yellow
2. Permanent rose
3. Sap green
4. Cobalt blue
5. Viridian and Winsor blue
6. Viridian and burnt umber
7. Permanent rose and magenta

YOU WILL NEED

Watercolour paper 640gsm (300lb)
3B pencil
Masking fluid and old brush
Round brush No. 6
Rigger No. 3
Large wash brush
Watercolour paints: permanent rose; cobalt blue; Winsor blue; viridian; lemon yellow; burnt umber; magenta, sap green and alizarin crimson

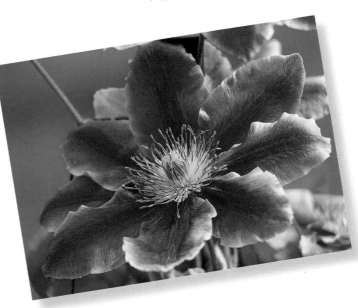

My source photographs

1 Using the large brush, dampen the paper up to the pencilled outlines of the flowers and put in the background, using permanent rose and lemon yellow; permanent rose; sap green, and touches of viridian and Winsor blue. Tip to merge the colours and leave to dry.

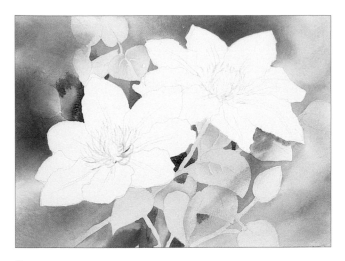

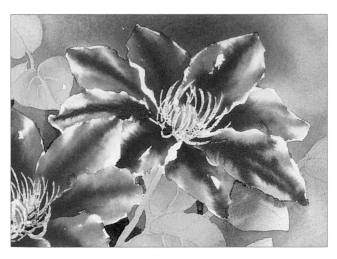

2 Using the No. 6 brush, paint in negative to bring out the leaves and buds using the viridian and burnt umber mix. Leave to dry. Remove the masking fluid at the edges of the flowers, but leave the stamen masked.

3 Wet the white area and paint in the petals wet-in-wet, with the mix of permanent rose. Use a small (No.3) rigger to drop in a darker mix of permanent rose and magenta. Leave areas of white paper to counterchange against the background.

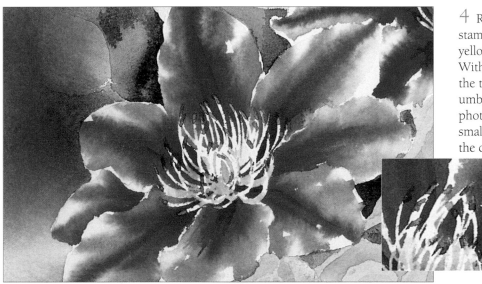

4 Rub off the masking fluid on the stamen and use a pale wash of lemon yellow to push back some of the white. With the small rigger brush, paint in the tips of the stamens using burnt umber and alizarin crimson (see inset photograph). With the cobalt blue and a small rigger brush, add very fine veins to the centre of some of the petals.

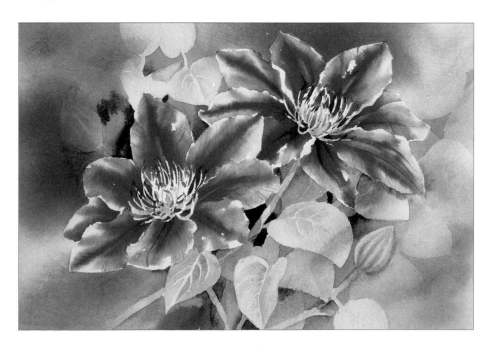

The finished painting.

Cosmos

Size: 55 x 38cm (21½ x 15in)

Flowers with an overall 'white' effect often have very little white on them when you come to paint them, as this example shows. I saw these growing in France, and the lavender in the background meant that the composition is about blues, pinks and purples. The shadows on the flower petals capture the effect of sunlight. The veining of the flowers has been darkened within the shadow area.

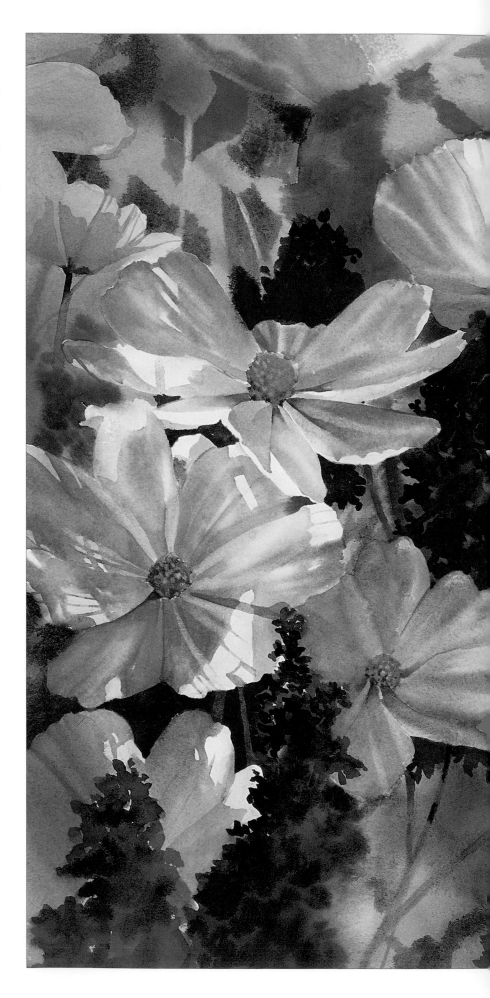

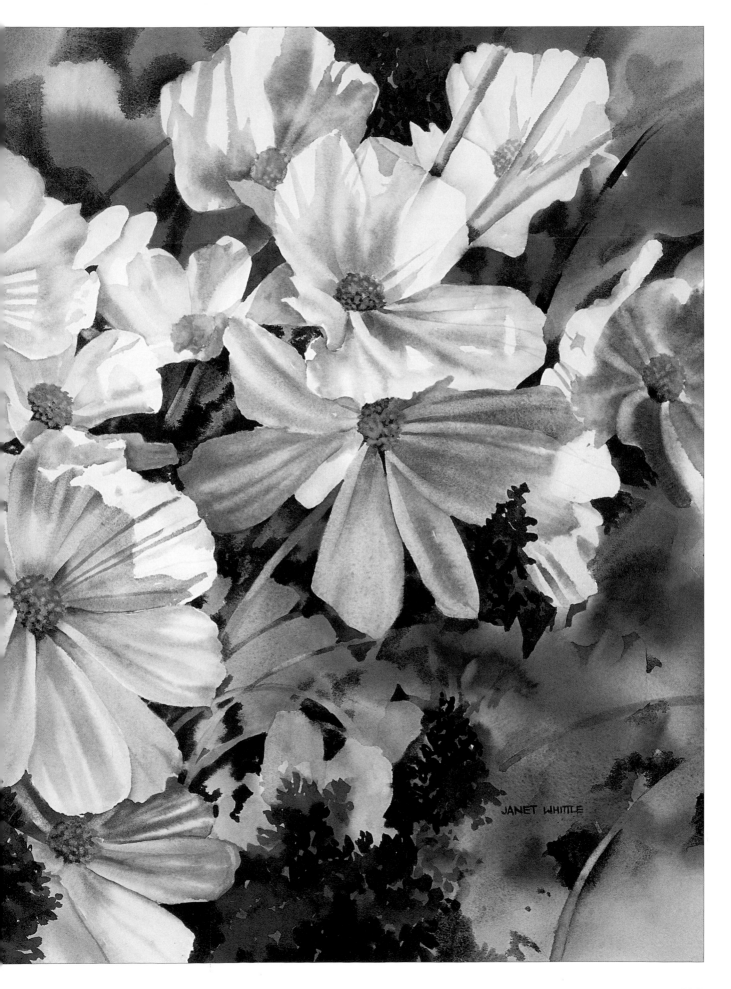

About the authors

RICHARD BOLTON

Richard Bolton is a professional watercolour artist who enjoys travelling and painting. He has written a number of successful art books from his visits around the world. He now lives and works in New Zealand with his wife.

JOE FRANCIS DOWDEN

Joe Francis Dowden has drawn and painted on site from early childhood. The third of nine children, he comes from a family of artists, musicians and writers. He endeavours to paint things the way he sees them. Though known worldwide as a painter, Joe's foremost artistic concern is the beauty and integrity of creation. This drives his work. He is known for light, texture, and realism. He regularly paints for audiences while taking questions and explaining his methods. He has presented DVDs and painted on TV. He is a member of the Society for All Artists. He believes in helping fellow artists of all levels develop their work.

GEOFF KERSEY

Geoff Kersey is an experienced watercolourist and is much in demand as a teacher and demonstrator. He has had articles published in *The Artist and Illustrator* and *Paint* magazines. Geoff has written many books for Search Press and made several DVDs. He lives and works in the Peak District and runs regular watercolour painting breaks and workshops. He exhibits extensively and many of his paintings are inspired by the landscape surrounding him.

JANET WHITTLE

Janet Whittle is a professional artist and qualified teacher. She specialises in flowers and landscapes in watercolour and pastel. Many of Janet's paintings are published as greetings cards throughout Europe and in the USA, and some have also been published as fine art prints. Janet has contributed articles to several magazines and her work has featured in other books. She exhibits regularly with the Society of Women Artists, the Society of Botanical Artists and the Society of Floral Painters, and her work has won several awards. Janet teaches watercolour painting and drawing and runs classes in her home town of Grantham, and workshops at home and abroad.

Index

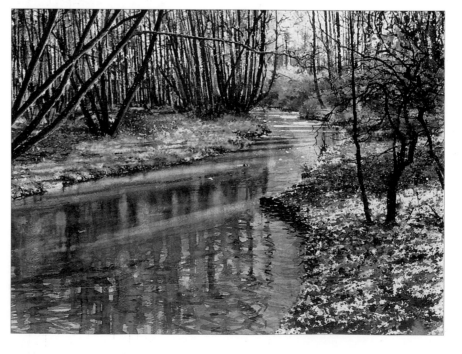

Wonham Way

by Joe Francis Dowden
Size: 405 x 305mm (16 x 12in)

In this winter scene of a muddy, fast-flowing river, the trees are a mass of lines worked with the point of a brush. Some long sky holes – vertical gaps between the trees – were painted roughly with an old brush. Nearby trees were masked along one edge to depict the sunshine glancing off them and a streak of light was lifted off the water nearby.